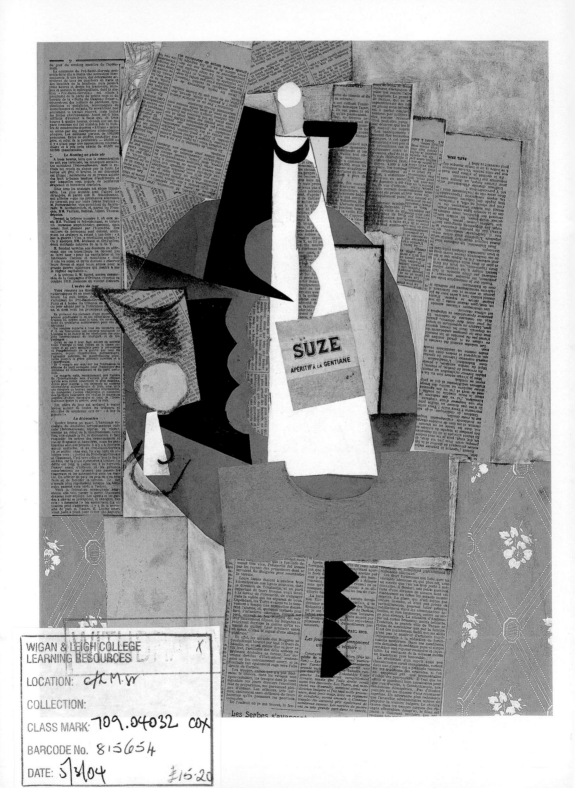

Cubism

Introduction 4

A New Century and a New Language

1 **Before Cubism** Paris and the Art World in 1900 9
2 **Buffalo Bill Meets Wilbur Wright** Braque, Picasso, Photography 41
3 **The Wild Men of Paris?** Braque and Picasso 1907–10 71

Cubism at Large

4 **Avant-gardism and Modernity** Salon Cubism 133
5 **Golden Sections** Philosophy and Science 171

The Play of the Real

6 **The Word as Such** Cubism and Language 1910–12 225
7 **A Glass of Absinthe** From Collage to Construction 1912–14 259

Cubism and Twentieth-Century Art

8 **New Forms, New Places** Cubism on the World Stage 307
9 **War and Order** Cubism and Classicism 355
10 **Charting the Legacy** The Ways of Cubism 389

& Glossary 426
 Brief Biographies 428
 Key Dates 432
 Map 436
 Further Reading 438
 Index 442
 Acknowledgements 446

**Opposite
Pablo Picasso**, *Glass and Bottle of Suze*, 1912. Pasted paper, gouache and charcoal; 65·4×50·2 cm, 25³⁄₄×19³⁄₄ in. Washington University Gallery of Art, St Louis

A tiny painted object made of tin (1) dates from the same year as a vast bronze figure (2). Each is now called a sculpture, but when they were made the tin piece would not have seemed like sculpture at all to most art lovers. Perhaps they were right. This wistful object did not merely expand the definition of sculpture; it played with the very notions of 'sculpture' and 'sculptor'; it rejected conventions of noble subject matter and professional technique. Cubism – for this little thing is a 'Cubist' work – posed every artistic question all over again. Cubism does not aim to destroy art, but it puts 'art' in quotation marks and holds it up for all to see.

From the vantage point of the beginning of a new century, Cubism remains perhaps the single most important development in the history of twentieth-century art. It is generally agreed that it was the creation of just two artists, Georges Braque (1882–1963), a Frenchman, and Pablo Picasso (1881–1973), a Spaniard, between the years 1907 and 1914. These two men worked alongside each other in Paris, then the artistic capital of the world, and invented a way of making pictures and sculptures that broke with conventions established five hundred years earlier in the Renaissance. That said, their new art was a result of seeing non-Western art in new ways, and of the extraordinary ruptures that had taken place in the art of the previous decades. In particular, the work of Gustave Courbet (1819–77), the Impressionists, Vincent van Gogh (1853–90), Paul Gauguin (1848–1903), Georges Seurat (1859–91), Henri de Toulouse-Lautrec (1864–1901) and above all Paul Cézanne (1839–1906) had a decisive impact on the young Braque and Picasso. Although Cubism was invented by only two people, it was an idea of such power and flexibility that it spread across Europe and the Americas with astonishing speed, thanks in part to the artists from across the globe who became disciples of the new art. Many of these had in fact seen relatively little of the strange images made by Picasso and Braque.

Among these early followers were some weaker artists, but also brilliant talents who figure among the great names of modern art: Juan Gris (1887–1927), Fernand Léger (1881–1955) and Marcel Duchamp (1887–1968). This widening circle of Cubists proclaimed themselves representatives of the latest and most radical artistic movement in Europe. Cubism penetrated artistic activity far beyond painting and sculpture: it reinvigorated architecture, graphic design, music and poetry; it transformed the possibilities of photography and film as art.

This book is broadly chronologically organized, and is almost exclusively concerned with the visual arts of painting and sculpture produced in Paris before 1914. Some serious attention is given to architecture in France and elsewhere, and to photography and film. Since it concentrates on the visual arts, relatively little is said of the significant contribution made by 'Cubist' poets to literary history, nor is music considered in any detail. That said, the reader will hear much of both the literary and musical allusions in Cubist painting and sculpture. One of the book's most important strands is that of the historical background to Cubism, conceived as much on a local as on a national and international scale. The first part of the book examines the early flourishing of Braque's and Picasso's creation, and the second part outlines how their invention became a public modern art, an 'avant-garde' movement. The third part returns to the inventors, and the historic changes they wrought in their own Cubism between 1910 and 1914, through the introduction of new ways of making art. The last part looks at the rapid spread of Cubism, at the impact of World War I on Cubist art, and at Cubism's legacy.

Unlike, say, Impressionism, Cubism has never been an easily accessible modern art form, and it remains hard to offer a simple definition of it. The study of Cubism has today reached a very detailed level of research and analysis, and has moved a long way from the initial attempts to write its history in the years after World War I. This book is intended to provide an up-to-date, accurate but also accessible account of the movement and its interpretation. It considers the many strands of thought about Cubist art, and the numerous areas of debate about Cubism in current art history. Some argue that Cubism is best

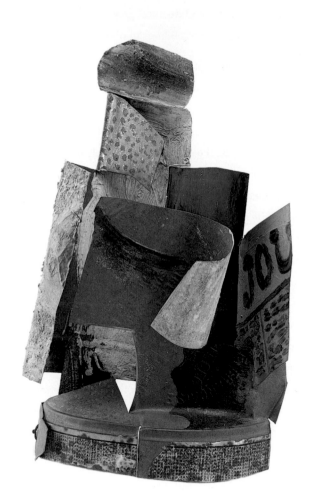

1
Pablo Picasso,
*Bottle of Bass,
Glass and
Newspaper*,
1914.
Painted tin,
sand, wire and
paper;
20·7 × 14 ×
8·5 cm,
8⅛ × 5½ × 3⅜ in.
Musée Picasso,
Paris

2
**Émile-Antoine
Bourdelle**,
*Monumental
Dying Centaur*,
1914.
Bronze;
288 × 80 ×
184 cm,
113⅜ × 31½ ×
72⅝ in.
Musée
Bourdelle,
Paris

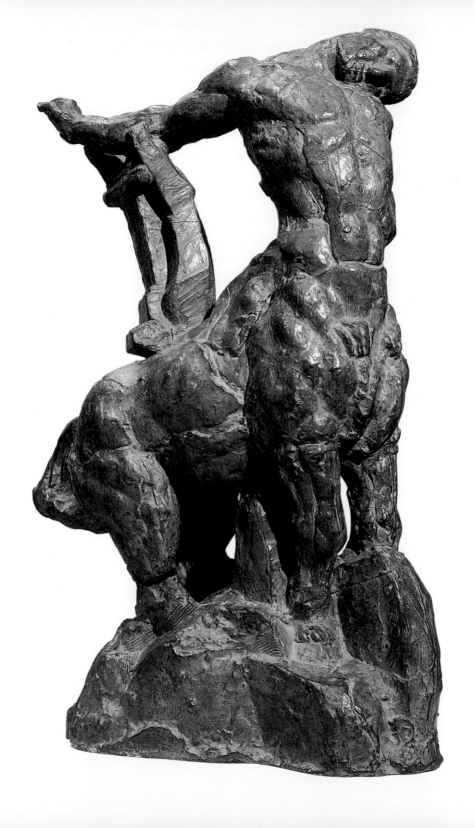

understood in relation to its wider historical context. Others focus on the purely aesthetic characteristics of Cubism to the exclusion of historical and political questions, while a few attempt to show how the aesthetic challenges of Cubist art are intrinsically political. All of these approaches have strengths and weaknesses, and all develop polemics found in early writings by artists and critics associated with the movement. This book aims to guide the reader through this occasionally complex field. Where the material demands it, philosophical ideas form part of the story. However, I have attempted never to lose touch with the exuberance and optimism that underlies Cubist art. The book is meant to stimulate questions rather than offer definitive answers about visual art in early twentieth-century Paris – for it argues that there are no such answers to be had. Readers who wish to find out more about any of the persons, events and works discussed can refer to the annotated bibliography, which is organized on a chapter-by-chapter basis.

Although it is known who invented Cubism, it is not known for certain who invented the name. In 1908 the painter Henri Matisse (1869–1954) saw a painting by Braque in Picasso's studio (3). Matisse did not admire Braque's new work, and as a member of the jury of the Salon d'Automne, which had been founded in 1903 to show the work of younger and lesser-known artists, he voted to reject Braque's submissions. Describing them to his friend the art critic Louis Vauxcelles, he drew a sketch and spoke of 'little cubes'. When Braque decided to show his work privately at Daniel-Henry Kahnweiler's gallery, Vauxcelles used Matisse's phrase in his lightly mocking exhibition review. However, the word 'cubist' was not used in print until 24 March 1909, in an article in the newspaper *Le Figaro* announcing that all the artistic groups in Paris would be represented at the spring exhibition, the Salon des Indépendants, 'from the "impressionists", the "pointillists", and the "symbolists" to the "cubists"'. Finally, 'Cubism' was christened only a few weeks later in another journal. In talking of 'Cubism', then, we are adopting a term of popular abuse, not one created by the artists themselves. Moreover, it is unhelpful as a description of works that the artists made. Looking at Braque's *Houses at L'Estaque*, for example, it is easy to see why Matisse might have mentioned cubic shapes in trying to describe the painting to Vauxcelles. But if one were asked to imagine a painting made up of 'little cubes', even in terms of what painters had so far dared to experiment with in 1908, the result would probably be much more geometric. In other words, the 'cube' of Cubism is not of the essence. It gives the viewer something to hold on to, but as a description it is misleading. Braque's painting, a homage (as will be seen) to the work of Paul Cézanne, is clearly a landscape, and the 'cubes' are houses (which are normally cubic anyway). If anything, what is peculiar is that the cubes are irregular and that the spatial relations between them are ambiguous. Cubist art is in fact notoriously difficult to describe (even though many

3
Georges
Braque,
*Houses at
L'Estaque*,
1908.
Oil on canvas;
73 × 65·1 cm,
28¾ × 23⅝ in.
Kunstmuseum,
Bern

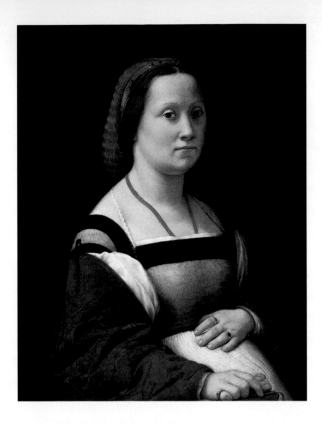

4
Raphael,
La Donna Gravida,
1505.
Oil on wood;
66 × 59 cm,
26 × 23¼ in.
Palazzo Pitti,
Florence

impressive descriptions exist), since it is much more varied, inventive, organic and magical than the term 'Cubism' could ever suggest. Learning to look at Cubism is a process that, despite the unappealing idea of 'paintings made of little cubes', opens up entirely new ways of understanding how we see the world. All this said, just as it is now impossible to invent another name to replace the equally meaningless 'Rock and Roll', so we are stuck with 'Cubism'.

Art historian John Golding suggested in his pioneering study of Cubism that it was the greatest artistic revolution since the Italian Renaissance, when intellectuals and artists sought, within a Christian framework, to recapture the glories of pagan classical civilization. The Renaissance achievement in painting rested on the rediscovery of the laws of perspective, leading to the treatment of the painting itself as a window through which to view 'real' space. The use of new oil painting techniques meant that Renaissance artists such as Raphael (1483–1520) could represent the textures and colours of objects and figures (4) in

that space ever more convincingly. The retrieval of so much knowledge of the art of the ancient Greeks and Romans bestowed grace and nobility on the human figure in both painting and sculpture. Cubism seemed to announce the end of all this: the space of the Cubist work was unstable, even unrecognizable; textures were treated arbitrarily, and colour reduced to a minimum. Worst of all, perhaps, the human figure in Cubism is diaphanous or melting – at times indistinguishable from Cubist still-life objects or landscapes, and often overlaid with comical or caricatured features. In trying to explain this radical departure from Renaissance art, writers on Cubism have offered three main explanations: that the Cubists were representing what the mind knows rather than what the eye sees; that they were creating a pure realm of abstract form; and that they were making paintings about how paintings work. All of these explanations have something to offer, but all overlook aspects of Cubist art. The art of Picasso, Braque and Gris is, for example, shot through with a humour and exuberance that these formulae neglect. Moreover, their challenge to the Renaissance is tempered by an awareness of the traditions of painting and sculpture without which their works, however radical, would not have seemed like works of art at all. In general terms it is true that Cubism rejects the commonplace notion that the work of art is a window on to another space, and insists that art can never deal with the world as it really 'is', but only with ways of seeing it and knowing it.

Louis Vauxcelles had in fact made the contrast between the values of the Renaissance and modern art in his famous newspaper review of Cubism's immediate predecessor in French modern art movements, 'Fauvism'. When Vauxcelles saw an exhibition of works by Henri Matisse and others in 1905 at the Salon d'Automne, he was struck by the presence of a much more traditional figure sculpture in the centre of the room, and wrote that he had seen 'Donatello among the wild beasts' or *fauves*. Donatello (*c*.1386–1466) was one of the great Florentine Renaissance sculptors, and Vauxcelles knew that he had captured the exhilarating anti-traditional shock with which this new art seemed to announce the end of the old world. The Fauvist 'movement' (considered at more length later in this chapter) was in reality a brief adoption of a bold expressionist style by a few artist friends.

In some respects it was comparable to the contemporary work of the so-called German Expressionists, since both were characterized by heightened colour and a child-like visual language. But whereas the radical nature of Fauvism was largely a matter of style, the Expressionists sought to challenge modernity with an alternative vision of human existence. In 1905 the Dresden-based group known as Die Brücke (The Bridge), which included the artists Ernst Ludwig Kirchner (1880–1938), Erich Heckel (1883–1970), Emil Nolde (1867–1956) and Karl Schmidt-Rottluff (1884–1976), made powerful works in all media addressing the extremes of sexual vitality and mental anguish. While their depictions of urban subjects revealed the alienation and aggression of the modern city, their studies of nature or of the artist's studio – often cluttered with 'primitive' art – were joyful hymns to the body. Some of these themes resurfaced in 1911 in a later German Expressionist grouping known as Die Blaue Reiter (The Blue Rider), based in Munich and led by Franz Marc (1880–1916), Auguste Macke (1887–1914) and the Russian abstract painter Wassily Kandinsky (1866–1944). These artists were to have close contacts with key figures in Parisian Cubism.

Only a few years after Fauvism and Die Brücke, another radical artistic group, the 'Futurists', would issue the provocation that 'a motor car is more beautiful than the *Winged Victory of Samothrace*', a famous Hellenistic sculpture that had recently been given pride of place in the Louvre. The hot-headed condemnation of the past by some early twentieth-century artists is often framed in precisely this way: the modern world is so much more exciting, beautiful and culturally rich than can ever be expressed by the rules of classical art taught in official academies. The poet Guillaume Apollinaire, one of Cubism's greatest defenders, began his poem 'Zone' of 1913 'finally you're sick of this old world ... Here even the automobiles seem old'.

Apollinaire arrived in Paris in October 1899 at the age of twenty, just in time for the new (modern) century, and the artistic world that he rhetorically rejected was a stifling institutional expression of the pre-eminence of classical and Renaissance art. 'You have had enough of living in Greco-Roman antiquity' he wrote in 'Zone'. Official

5
Jean-Léon
Gérôme,
*Young Greeks
Holding a
Cockfight*,
1850.
Oil on canvas;
143 × 204 cm,
56¼ × 80⅜ in.
Musée
d'Orsay, Paris

sponsorship of the arts in France, the largest and therefore most important centre for artistic activity in the nineteenth century, was channelled through the Académie des Beaux-Arts, whose forty members, appointed by the government, were champions of the classical nude and grand history painting. Painters such as Adolphe-William Bouguereau (1825–1905), a member from 1876 to 1905, and Jean-Léon Gérôme (1824–1904; 5), a vigorous opponent of Impressionism and a member from 1865 to 1903, were revered and wealthy. The academicians had considerable influence over the teaching of the main art academy, the École des Beaux-Arts, and many also ran their own teaching studios. Their artistic year was organized around the vast Salon de la Société des Artistes Français (renamed in 1864, but an official annual salon had been founded in 1737), which attracted hundreds of thousands of visitors each year. Not only did the academicians figure prominently amid the 5,000 or so artists on show, but many were also elected jurors required to vote on works submitted for exhibition by other hopeful artists. Nevertheless, the Salon was a highly democratic organization, and differences of opinion led to some diversity in the exhibitions.

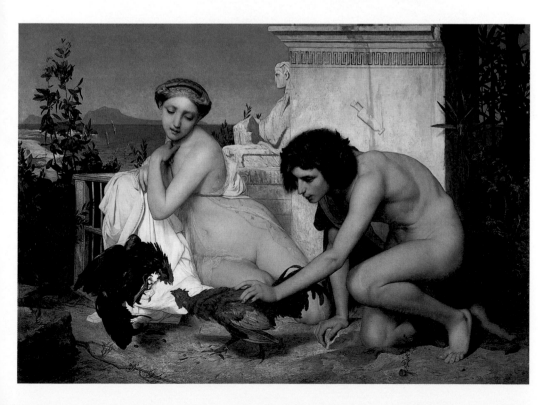

During the selection process the jury viewed 600 works a day from behind a cordon (6), in case their frequent disagreements ended in acts of violence against the disputed paintings.

The conservatism of the more opinionated establishment figures, intolerant of any departure from the rules of academic art, had also been openly challenged by the setting up of various independent salons, of which the most famous were the Impressionist exhibitions (1874–86), the Salon des Indépendants (founded 1884) and the Salon d'Automne. Some of the more open-minded academicians supported the secessionist Salon de la Société Nationale (founded 1890), and the École des

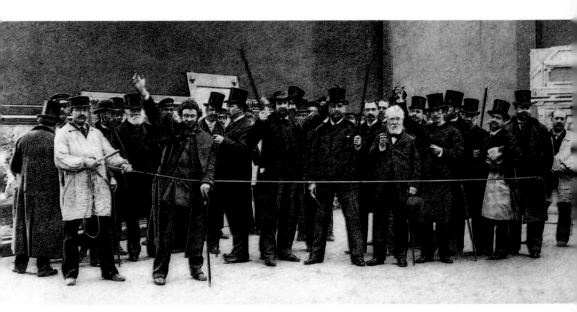

Beaux-Arts mounted important retrospective exhibitions of the work of radical opponents of the academy, including Courbet and Édouard Manet (1832–83). Some work was shown completely outside any official institutions: private galleries run by dealers such as Ambroise Vollard showed new art to a small public. In the spring of 1900, Seurat, an artist who was later deeply admired by Braque and Picasso, was given a posthumous exhibition in the reception rooms of a literary journal, *La Revue blanche*, whose new editor was the writer André Gide.

Two artistic events indicated that the grip of conservative officialdom on art was still strong as the nineteenth century drew to a close, but

that it was wildly out of touch with the taste of progressive sections of the art world as well as the public. The first, in 1894, was the bequest to the French state of a marvellous collection of Impressionist paintings that had belonged to the artist Gustave Caillebotte (1848–94). Some academicians wrote a letter to the government in 1897 condemning the 'unworthy' paintings, which had just been put on display at the Musée du Luxembourg. The works were described in the French Senate in the same year as 'a defiance to the good taste of the public'. Meanwhile, sale prices for non-academic paintings were beginning to rocket. The bequest was eventually accepted in 1914, after all legal and procedural issues invoked to obstruct it had been resolved. The second, in 1889, was the offer for sale by Édouard Manet's widow of his great and notorious painting *Olympia* (7), for 10,000 francs. This modern version of the classical nude, depicting a young prostitute in place of a goddess, had caused a scandal in the Salon of 1865. The Impressionist painter Claude Monet (1840–1926) organized a subscription to buy the painting for the Louvre, and succeeded in raising 15,000 francs by 1890. Yet it still took the museum authorities until 1907 to agree to accept the work. The Caillebotte bequest and Manet's *Olympia* both showed that the versions of classical and Renaissance art being offered up by the academicians were no longer the only definition of artistic achievement: modern art had arrived.

In 1907 Picasso's painting *Les Demoiselles d'Avignon* (see 37) would pay homage to Manet's *Olympia*, through its defiance of every principle of decorum in form and content held dear by the Academy. Cubism originated partly in this desire to break free of the academic rules of art, and of all the tired conventions of painting and sculpture they enshrined. Its anti-academic streak meant that, when it hit the public stage around 1910, Cubism was readily adopted by the press as the latest in avant-garde art: morally dangerous, excessive, outrageous, offensive – and, of course, great copy. 'Avant-garde' is a military term, meaning 'vanguard'. French utopian socialists of the 1820s originally applied the term to all artists, thinking of them as key figures in the progressive reform of society. It was only much later, after 1900, that people began to distinguish between avant-garde and conventional or traditional art and artists. Now, avant-garde art was construed as the

6
The Salon jury,
1903

enemy of order, both artistic and, by implication, social. The term began to be used to describe late nineteenth-century unofficial art, especially Impressionism and what would later be called Post-Impressionism. In making Cubism into an avant-garde movement, the press also in a sense politicized it. It is no accident that the word 'revolutionary' is often used of avant-garde art, since the moral shocks of modern art have always been equated in this way with social disharmony.

There was an enormous appetite for avant-garde art among the press in turn-of-the-century Paris, and new artists had an equal hunger for Parisian success. The year 1900 was auspicious: the Universal Exposition, which ran from 14 April until 12 November 1900, attracted 50 million visitors. Some artists arrived early for the spectacle, for example the German Paula Modersohn-Becker (1876–1907) was there on 1 January 1900, whereas others, such as Braque, did not manage to reach Paris until the autumn. Among the vast galleries of the new Grand Palais (one of the buildings erected as part of the programme of urban planning associated with the Exposition) hung the nineteen-year-old Picasso's inoffensive *Last Moments* (which the artist later painted over). The painter who was to become Picasso's rival in the Parisian avant-garde of the first decade of the century, Matisse ('King of the Fauves'), worked as a decorative artist on the ceiling of the Grand Palais.

7
Édouard Manet, *Olympia*, 1863. Oil on canvas; 130·5 × 190 cm, 51⅜ × 74⅞ in. Musée d'Orsay, Paris

Picasso himself arrived in Paris from Barcelona with his friend Carles Casagemas (1880–1901) in October 1900, in time to see his work on show. Picasso and Casagemas borrowed a studio in the cheap and bohemian district of Montmartre: 'Well, this is a kind of Eden or dirty Arcadia,' they wrote to a friend. While quaint old buildings in the centre of Paris had largely fallen victim to Baron Haussmann's programme of modernization in the mid-nineteenth century, Montmartre retained its rustic charm as a shanty town surrounded by farms and peppered with windmills. When favoured artists' haunts such as the Latin Quarter became too expensive, the new cafés and cabarets of Montmartre emerged as the centre of bohemian life during the 1880s. One of the most famous of these cafés was the Chat Noir, opened by Émile Goudeau and Rodolphe Salis in 1881, which published its own very popular newspaper. Here poets, writers and artists rubbed shoulders

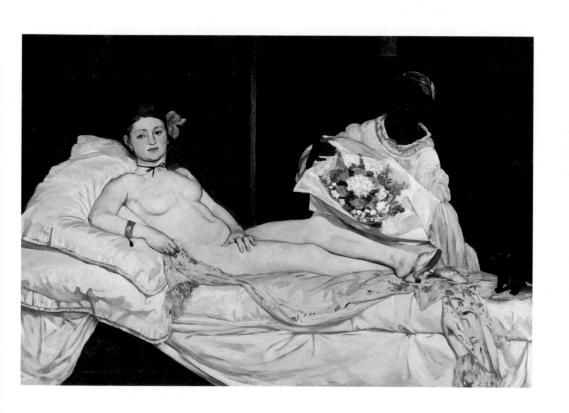

with prostitutes and middle-class Parisians. Cabaret performers such as Aristide Bruant delivered songs that combined sexual innuendo and political satire. The Moulin Rouge dance hall opened in 1889, and many other less famous cafés had appeared by 1900, as more and more aspiring artists from across Europe moved into low rent studios.

The Universal Exposition was a gargantuan affair, showcasing French manufacturing, design and economic power. As well as the vast Salons, one could see films with synchronized sound by the Lumière brothers (the first public film show took place in 1895), demonstrations of x-rays, the Palace of Electricity (Paris was already a city of 350,000 electric

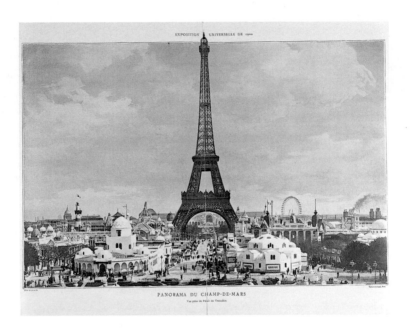

EXPOSITION UNIVERSELLE DE 1900

PANORAMA DU CHAMP-DE-MARS
Vue prise du Palais du Trocadéro

lights), and the spectacular dancer Loïe Fuller, her whirling veils illuminated from below by electric lighting. The American pioneer of modern dance Isidora Duncan arrived in Paris to see this techno-erotic spectacular – perhaps she saw the same performance as Picasso. The Exposition coincided with the second modern Olympic Games, which was the first to allow women to compete, perhaps in deference to the International Congress on the Rights of Women held in Paris in September. The dreamy heights of the great Ferris Wheel near the Eiffel Tower (8), and the picturesque plaster dioramas of Africa and Asia in the 'World Tour', were complemented by a huge funfair and an

extraordinary moving pavement 3.2 km (2 miles) long, which transported excited visitors to the various international pavilions along the River Seine. An underground railway was opened in the same year, and an electric train offered a twenty-minute tour of the whole site. These modern marvels were recorded on film and celebrated in advertisements and in the newspapers – the Exposition turned technology into an entertainment, which emphasized above all the sensation of speed. According to the organizers, the pace of modern life was going to be transformed by new modes of transportation and forms of energy.

The spectacle of the Exposition was a far cry from the bitter struggles and social injustices that racked France at the turn of the century. During the 1890s there were anarchist bombings, a disastrous financial scandal involving investments in the Panama Canal, and continuing friction resulting from the rise of feminism and communism. Oddly, the fate of a single Jewish individual, Alfred Dreyfus, seemed to symbolize all the tension these events produced. A captain in the French army, Dreyfus had been arrested in 1894 on charges of spying for the Germans, and sentenced to deportation for life to the penal colony of Devil's Island off the coast of French Guiana. There was a growing sense that his family's protestations of his innocence were well-founded, and that the corrupt state was colluding in the army's anti-Semitism. Tempers flared alarmingly all over Paris, and the novelist Émile Zola famously published a front-page newspaper article – 'J'Accuse' – in 1898, which called for truth and justice in France. In 1900 Dreyfus was given a presidential pardon, but the image of 'harmony and peace' with which President Loubet opened the Universal Exposition was in reality badly damaged. Europe in the early twentieth century was haunted by political ferment; the failed Russian Revolution of 1905 set off a series of general strikes, including one in France in 1906. In 1907 the wonders of modern electricity, so celebrated in the Exposition, were shown to be vulnerable to class struggle when the electricians of Paris turned off the lights in a strike.

When the Russian revolutionary leader Vladimir Ilyich Lenin published his *Imperialism, Highest Stage of Capitalism* in 1916, it exposed the dark side of the saccharine and civilizing visions of empire seen in the 1900

8
The Champs de Mars and the Eiffel Tower, with the Ferris Wheel in the distance, at the Universal Exposition, Paris, 1900

Exposition, the rapacious domination and exploitation of non-Western peoples by competing European powers. A number of artists collected and imitated 'primitive' art at the end of the nineteenth century, which was imported by fair means or foul from the colonies. The uses those artists made of it could sometimes turn an imperial curio into a weapon against the ideology of the 'civilized' European empires. Modern artists have never been necessarily more politically enlightened than any other social grouping, however, and it should be no surprise that expressions of anti-Semitism, extreme nationalism, and even proto-fascism could be found among the pre-war Parisian avant-garde. Some Cubist works, or works inspired in part by Cubism, were even made in service of such political myths or ideologies. On the other hand, there is in modern art, and in the wider cultural movement of which it is a part – modernism – a desire for social transformation that generally rejects the existing social order, often in favour of left-wing ideas. Artists were a group in society whose old-established role as purveyors of decorative and moral works to the social élite had gradually disappeared, and as a result some either sought meaning in forms of radical politics or politicized their activity in relation to the artistic establishment.

Just as the artistic order was challenged in 'alternative' Salons, and just as the political order was facing social turmoil, so the era of Cubism shares in this general destabilizing and revolutionary mood. Cubist art, in particular, has now come to represent the art historical equivalent of other intellectual and scientific developments in the early years of the century, which questioned accepted reality. The philosopher whom many would describe as the true harbinger of the twentieth century, Friedrich Nietzsche, died insane in 1900. Nietzsche's most admired work at that time in France was *Thus Spake Zarathustra* (1883–5), which exhorted artists, poets and philosophers to lead mankind to a new and higher form of existence. Nietzsche condemned the fetishization of narrow 'reason', and argued that scientific 'truth' was merely a crutch, an 'all-too-human' invention to protect people from the terrible truth of existing in an unknowable and hostile world. Nevertheless, he admired radical scientific 'positivism' (which insisted that direct sensation provides the only sure foundation for knowledge) for its stripping away of the false comforts of religious faith and morality. He attacked the 'nihilism' of

Christianity, its life-denying postponement of happiness to an afterlife, and the mediocre politics of social democracy. As in his view all attempts to grasp the truth about the real world must fail, and since nihilism and feelings of exhaustion and emptiness offer no solution to our need to find new values by which to live, Nietzsche argued that only the ecstasy of art could offer a satisfactory way of reinterpreting or reinventing our world. In his more zealous moments, its imperatives came before all else, the 'morality' and 'respect' preached by Church and State included.

In Vienna Sigmund Freud completed his *Interpretation of Dreams* in November 1899 but delayed publication – in a gesture towards a new era of human understanding, or perhaps in the hope of a more open-minded reception – until 1900. Freud argued that dreams were not simply irrational and meaningless but expressed unconscious wishes, usually connected with events in the past, especially childhood. He believed that socially unacceptable desires harboured by the individual are banished to the unconscious (repressed) by consciousness, finding expression only in bizarre disguised forms in dreams – or in extreme cases in pathological conditions (*eg* 'hysteria'). His new science of psychoanalysis attempted to unearth the individual's unconscious desires in order to free him or her from the gnawing anxiety or even trauma that they cause. Like Nietzsche, Freud regarded the adult mind as a site of raging inner conflict, and Christian morality as intolerant and ignorant of the desires and needs of all human beings. Nineteenth-century bourgeois society appeared intrinsically repressive and hypocritical to Freud, who preached empathy for those suffering from the guilt and shame handed out by the Church. A tragic victim of moral intolerance, the Irish decadent writer Oscar Wilde, previously imprisoned for no crime other than his homosexuality in Victorian England, was found dead (in self-imposed exile) on 30 November 1900 in his Paris hotel room.

While Nietzsche and Freud provided the new century with more complex pictures of the psyche and attacked the 'truths' offered by society and science, so science itself entered a period when all the broadest laws of nature were in crisis, as the brilliant positivist physicist and mathematician Henri Poincaré announced at the International Congress of Physics at the 1900 Exposition. In physics in particular a series of

theoretical and experimental discoveries effected a dematerialization of reality: invisible forces and effects were seen to govern all phenomena. Radio waves were discovered by Heinrich Hertz in 1887, x-ray photographs were produced by Wilhelm Röntgen in 1895 (while the 'rays' themselves were shown to consist of particles in 1897), and Pierre and Marie Curie measured the incredible and quite incomprehensible energy output of radium in 1903. A young amateur named Albert Einstein published several papers in 1905 that put paid to the last remaining fixed point of reference in human experience, absolute non-local time, thus launching the theory of special relativity (the equivalence of matter and energy). Einstein argued that the idea of universal and objective time is nothing but a fiction, and the only constant or fixed thing in the universe is the speed of light in a vacuum.

Cubism explored the world according to consciousness, providing a visual analogy for the contemporary ground-breaking literary developments now considered archetypes of the modern, notably Marcel Proust's *Swann's Way* (1913), the first part of his multi-volume novel *Remembrance of Things Past*, and James Joyce's *Portrait of the Artist as a Young Man* (1916). Similarly in music, the work of Claude Debussy and Erik Satie paved the way for Arnold Schoenberg's 'atonal' or discordant Second String Quartet (1908), and the primitivism of Igor Stravinsky's *Rite of Spring* (1913), both performed to combined catcalls and cries of 'genius' from the audience. The orchestral and chamber music of the conservatoires was in transformation thanks to the efforts of such young composers. This musical avant-garde was inspired in part by the energy and humour of popular music, some of it emanating from American commercializations of African-American forms: W C Handy wrote the first version of the 'Memphis Blues' in 1909, and Irving Berlin composed 'Alexander's Ragtime Band' in 1911. Cubism swept up every fragment of culture, 'low' or 'high': street songs and Bach sonatas, fashion pages and newspaper headlines, advertisements and poems. Like the 'jump-cutting' of film in the new invention cinema, it tried to grasp the modern world on its own whirlwind terms.

Such historic transformations in art are, of course, the result of the work of particular individuals and groups, whose concerns are not necessarily

9
Bateau Lavoir, 13 rue Ravignan, Montmartre, Paris, c.1904. Postcard with annotation by Pablo Picasso 'Windows of my studio 13 R. Ravignan'

so grand, nor their visions so precise, at the outset. Although both Braque and Picasso had visited Paris in 1900, in the early years of the century they had followed very different paths. Braque, born in 1882 in Argenteuil (a favourite haunt of the Impressionist painters in the 1870s) but brought up mostly in Le Havre in Normandy, was the son of an entrepreneurial painter and decorator (his firm had the contract for the Le Havre opera house) who was also an amateur artist. Having failed to do well in the local art school, the young Braque began training as a house painter himself, and then studied in Paris with a master decorator. The experience of Paris from 1900 to 1901 led Braque to change his career plans, and with the support of his father he set up a permanent base in Montmartre in 1902. Braque's workspace for the coming years was at 48 rue d'Orsel, five minutes' walk from the studio complex at 13 rue Ravignan known as the Bateau Lavoir or 'floating laundry' (9), where Picasso would establish himself from 1904 to 1909.

Braque set out on his career as a painter in Paris at an auspicious time. His two-year 'training' was largely undertaken at a so-called 'free academy', which meant that little formal tuition was offered, and he

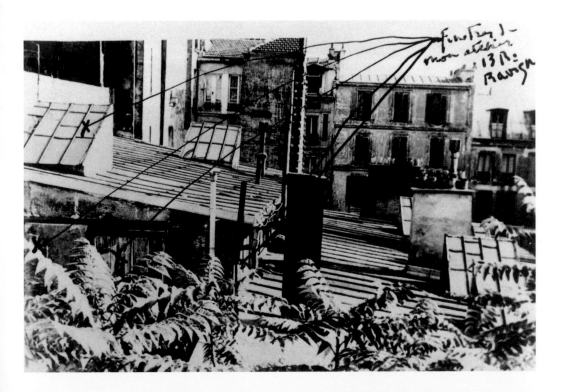

enjoyed the wild social life in the *café-concerts* and dance halls of Montmartre. His artistic ambition gradually led him into the circle of artists and writers with whom Picasso was connected, and he spent the summer of 1905 with critic Maurice Raynal and sculptor 'Manolo' (real name Manuel Martínez Hugué; 1872–1945) in Le Havre, where he also met the painters Othon Friesz (1879–1949) and Raoul Dufy (1877–1953). Braque returned to Paris in time to see the 1905 Salon d'Automne, the highlight of which was the Fauve room. Friesz and Dufy also showed their work in the Salon; it was close in character to that of the key Fauvist painters, Henri Matisse, André Derain (1880–1954) and Maurice de Vlaminck (1876–1958). This contact with Fauvism – and its ringleader Matisse – had a profound effect on Braque, and thus on the development of Cubism. Why was this so?

Fauvism is well known as one of the first avant-garde group manifestations in twentieth-century art, but in many respects it was even less a 'movement' than Cubism, and was certainly much shorter-lived. It had a forceful impact on public perceptions of modern art, because it was presented in press coverage as an orchestrated and wilful challenge to canons of beauty, composition and finish. In stirring up a controversy, the newspapers were greatly assisted by the fact that the same President Loubet who opened the 1900 Universal Exposition refused in disgust to enter the Fauvist room (number seven) at the Salon d'Automne, and the paintings were duly reproduced on many front pages. The Fauves' innovation of hanging their work as a group was in fact perfectly suited to the art critics' practice of reviewing the Salons room by room. Fauvism thus became one of the first movements to produce a corresponding record of the public outrage that has been so important to true avant-gardism in the twentieth century. A series of ideas became linked in popular discourse to the style of the works presented, including notions of excessive passion, childishness and other 'primitive' characteristics, and even political anarchism.

Despite the illusion of a sudden coup, the style of painting called Fauvism had in fact been developing fairly publicly for several years. In particular, the painter consistently recognized as its most important exponent, Henri Matisse, had been pursuing the idea of vibrant colour

since around 1900. Matisse was born in 1869, hence he was appreciably older than his peers and less keen than they were to reject tradition on principle. He was attempting to reconcile the study of the visible world or 'nature' and the representation of emotional responses to this nature, the 'expression' that he was to make central to his art and artistic theory. Despite his reputation as one of the pre-eminent modern artists of the century, Matisse was not at all by inclination a rebel possessed of anti-establishment attitudes. Matisse's art and career are a peculiar combination of bourgeois decorum and fiercely challenging innovation. This complex persona helps to explain why Matisse's development and maturity are hard to encapsulate, and often deeply puzzling, notwithstanding the apparent simplicity and calm of his late works.

A pupil of Symbolist Gustave Moreau (1826–98), Matisse was particularly impressed by the theories of art prioritizing sensibility and imagination over literal description promoted by Symbolist poets such as Paul Valéry and Stéphane Mallarmé and painters like Édouard Vuillard (1868–1940) and Pierre Bonnard (1867–1947). He also sought to radicalize the ideas of the late nineteenth century, by drawing on the achievements of the Neo-Impressionist artist Seurat, and his self-proclaimed successors and reinterpreters. Where Seurat had sought a quasi-scientific systematization of colour, studying the correspondences of colour and emotional effect, Matisse took the fragmented extremes of colour that Seurat had distilled and, like Van Gogh, interpreted them freely. This process culminated in the work that presaged the arrival of Fauvism in the Salon d'Automne of 1905, *Luxe, calme et volupté* shown in the Salon des Indépendants in the spring of the same year (10). This work is the closest that Matisse came to Neo-Impressionism, and indeed it was immediately purchased by his friend and supporter the Neo-Impressionist artist Paul Signac (1863–1935), a disciple of Seurat who had encouraged Matisse along that road. By October of the same year, Matisse had abandoned the constraining dotted strokes, and showed such paintings as *The Open Window: Collioure*, where the only discernible rules are of spontaneity and delicacy in marshalling a feast of colour. This departure was in part due to the presence of Derain in Collioure during the summer of 1905, who seems to have encouraged Matisse to explore extremes of colour contrast and surface quality.

Braque, like many others, was deeply impressed by the 1905 Salon d'Automne, and during the winter he set about preparing his own contributions for the 1906 Salon des Indépendants. The seven works he showed were later destroyed, but he must have relished exhibiting alongside many of the artists he now admired. The restless Matisse showed his most ambitious modernizing work to date, *Le Bonheur de vivre* (*The Joy of Life*; 11), a work that already anticipated the end of Fauvism and responded to the late 'bather' compositions of Paul Cézanne (one of which he owned). In the summer of 1906 Braque set off for a crucial painting expedition with Friesz in Antwerp. A comparison of

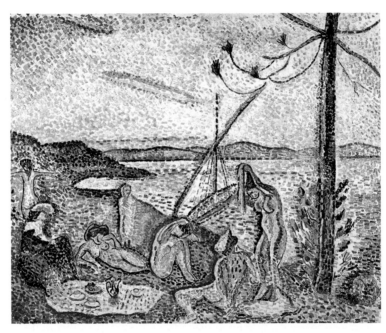

10
Henri Matisse,
Luxe, calme et volupté,
1905.
Oil on canvas;
98 × 118 cm,
38⅝ × 46½ in.
Musée
d'Orsay, Paris

11
Henri Matisse,
Le Bonheur de vivre,
1906.
Oil on canvas;
175 × 241 cm,
69⅛ × 94⅞ in.
Barnes
Foundation,
Merion,
Pennsylvania

works they produced shows how closely – even competitively – Braque had studied the Fauve style and the new work of Matisse (12, 13), but it also demonstrates his ability to resist or reinterpret the pictorial achievements of others. Whereas Friesz painted a rather undynamic composition that depended on its colour effects for radical credentials, Braque's is vigorously composed of planes in subtle deviation from each other, complete with bold brushwork in the sky and a vertical that increases the illusion of spatial recession in the scene. Braque gives a far greater sense of the high viewpoint from which they both surveyed the harbour. This ability to play with the image of space never left him.

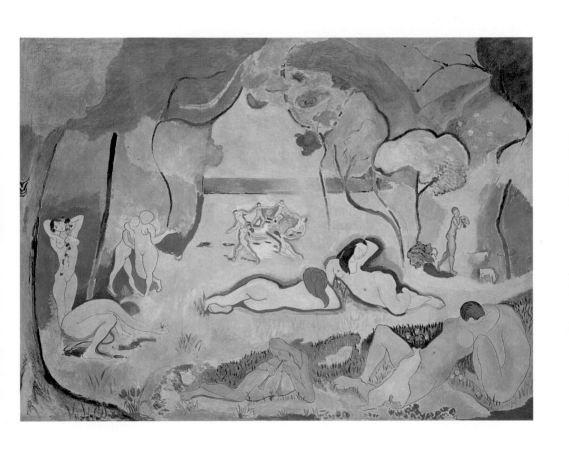

Braque's strong sense of structure, evident even in this 'Fauvist' work, was to be the basis of his own response to the ten paintings by Cézanne in the Salon d'Automne of 1906. This grand old man of modern art, who had been close to the Impressionists and to the author Émile Zola in the 1870s, was to die on 23 October 1906, half-way through that year's Salon. After years of obscurity, Cézanne was becoming something of a cult figure, whose single-minded development of a new way of painting had been pursued far from Paris, in Aix-en-Provence. Cézanne's almost mystical pronouncements on the experience of gazing at still-life objects or the Mont Saint-Victoire (14), gathered up by devotees such as Émile Bernard (1868–1941) and Joachim Gasquet (1873–1921), who had made the long pilgrimage to the master, lent an aura of profound authenticity to his work. After his death a major memorial exhibition was staged at the Salon d'Automne of 1907. Braque saw the ten paintings in October 1906, and left to spend the winter in L'Estaque in the south of France, where Cézanne had frequently painted.

Picasso's development before his encounter with Braque's new L'Estaque works in 1907 had been much more protean. Born the son of an art teacher in the Andalucian port of Malaga in 1881, Picasso had shown ability and interest in drawing from an early age. Unlike Braque, Picasso was exposed only to conservative artistic standards in his teens, and his embrace of the 'modernista' movement in Catalonia was all the more vigorous as a result. Having studied at the academies in Corunna, Barcelona and Madrid, Picasso became disaffected with academic art and had fallen in with the growing number of young artists and writers in Barcelona interested in French and other northern European avant-garde movements. Picasso and his friends flirted with political anarchism and dressed flamboyantly. Picasso's drawings and paintings immortalized them as 'bohemians' by emulating the graphic style of Toulouse-Lautrec's posters.

This longing for France must have meant that the pleasure of showing a painting in the Universal Exposition at the age of nineteen was sweet. After his visit to Paris to see his *Last Moments* in 1900, Picasso returned to Barcelona with his friend Casagemas in December. Casagemas, who had fallen morbidly in love with a woman named

12
Georges
Braque,
*The Port of
Antwerp*,
1906.
Oil on canvas;
49·8 × 61·2 cm,
19⅝ × 24 in.
National
Gallery of
Canada,
Ottawa

13
Achille Émile-
Othon Friesz,
*The Port of
Antwerp*,
1906.
Oil on canvas;
80 × 100 cm,
31½ × 39⅜ in.
Private
collection

14
Paul Cézanne,
*Mont Saint-
Victoire from
Les Lauves*,
1904–6.
Oil on canvas;
60 × 72 cm,
23⅝ × 28⅜ in.
Kunstmuseum,
Basel

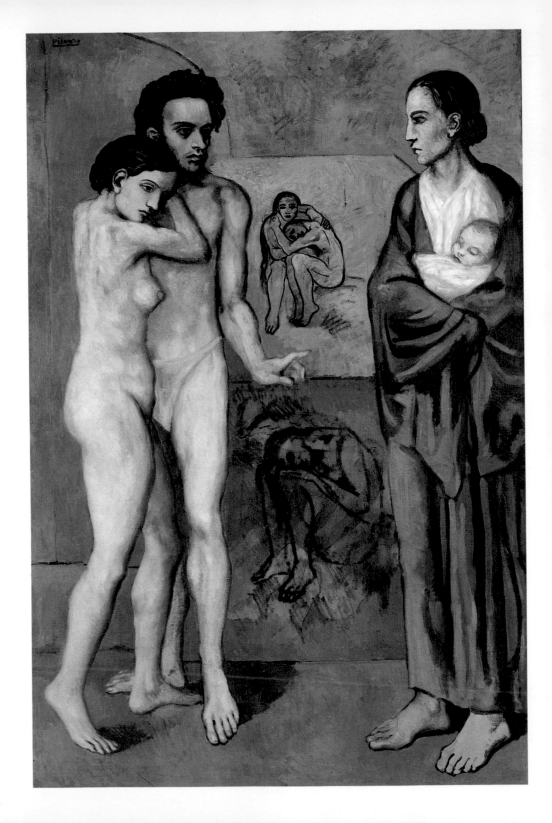

Germaine Gargallo, immediately returned to Paris and was to shoot himself before the eyes of friends in a Montmartre restaurant in February 1901. Picasso returned to Paris in May and began working on his first major show, which would be held at the gallery at 6 rue Lafitte belonging to Ambroise Vollard. Vollard had given Cézanne an important exhibition in 1898, and was a well-known figure on the Parisian avant-garde scene. Picasso's large show was a considerable success, although he was accused of imitating other established artists such as Toulouse-Lautrec and Théophile-Alexandre Steinlen (1859–1923). Towards the end of the year, Picasso changed tack from this colourful style and started to work with a predominantly sombre blue palette. Until April 1904 Picasso travelled back and forth between Paris and Spain, producing prodigious quantities of work and some of his now famous 'Blue Period' paintings.

15
Pablo Picasso,
La Vie,
1903.
Oil on canvas;
197 × 127·3 cm,
77⅝ × 50⅛ in.
Cleveland
Museum of
Art, Ohio

Unlike Braque at this time, Picasso was exhibiting and selling work, and he admired very different artists. Picasso was drawn to emotionally intense depictions with either a dramatic or a symbolic mood. The 'Blue Period', heavy in tone both literally and metaphorically, was marked by a series of major canvases meditating on desire, love, birth and death. In 1903 *Last Moments* was painted over, no doubt symbolically, with a work known as *La Vie* (15), showing the almost naked Casagemas intimately embraced by a woman, and gesturing enigmatically towards a clothed mother and child. In the background several unfinished canvases depicting huddled figures add to the mood of emotional stagnation and lassitude. In this fictional artist's studio, the lower of these canvases, with its mock overpaintings, is an artful clue to the actual overpainting of *Last Moments*.

While Braque was to become interested in questions of painterly technique and pictorial order as represented by Cézanne, Picasso was fascinated by narratives of sexuality, death and poverty. Rather unmoved at this stage by Cézanne, Picasso was haunted by the exotic imagery of another artist who had recently died far from Paris, Gauguin. Gauguin had left Europe where, as he wrote in 1890, 'men and women survive only after increasing labour during which they struggle in convulsions of cold and hunger.' He sought instead the 'paradise of Oceania' in

the French colony of Tahiti. His efforts to depict the 'sweetness of life' of the island's indigenous people were admired in Paris not only for their decorative qualities but also for their symbolic potency. Both qualities characterized Picasso's Blue Period works, but his real exploitation of Gauguin's example was still to come.

Settling in Paris in 1904, Picasso became the centre of a social circle known as 'la bande à Picasso', 'the Picasso gang'. At the same time, his art changed radically again, and the rose tint through which he now viewed his mysterious cast of acrobats and clowns offered a somewhat lighter poetic mood. Crucially, in 1905, Picasso met Guillaume Apollinaire (16), who reviewed his latest exhibitions very favourably, paving the way for the true beginning of his commercial success later in the year. The German art dealer and collector Wilhelm Uhde met Picasso shortly after having purchased The Tub, a tender Blue Period work of 1901. The American writer Gertrude Stein and her brother Leo had also just set up home in Paris and begun collecting avant-garde art. At the Salon d'Automne they bought one of the controversial Matisse works, Woman with a Hat. A few weeks later, they bought Picasso's Acrobat's Family with a Monkey through the art dealer Clovis Sagot.

16
Pablo Picasso,
Guillaume
Apollinaire in
the boulevard
de Clichy
studio,
1910.
Gelatin silver
print;
21·9 × 17·4 cm,
8⅝ × 6⅞ in.
Musée
Picasso, Paris

It can be seen that the destinies of Braque and Picasso were inevitably linked in these early years to that of Matisse. Yet if Braque was a kind of apprentice to Matisse, Picasso was his rival. Picasso and Matisse met around the time of the Salon des Indépendants of 1906, and their friendly competition to be king of the moderns, and to find favour with important patrons and dealers, certainly greatly increased over the next few years. A third member of the Stein family, Michael, together with his wife Sarah, began avidly collecting Matisse. Picasso, meanwhile, painted a major portrait of Gertrude (17). Picasso was no doubt also forcefully struck by the older Matisse's main contribution to the 1907 Salon des Indépendants, Blue Nude (Souvenir of Biskra). This work (18) is an example of orientalism, a well-established fashion in Western art for representations of the supposedly decadent and sensuous culture of the Islamic world. Matisse's orientalism is underwritten by the same notion of the decline of Islamic nations into a kind of erotic lassitude that can be found in more conventional academic paintings of harems and

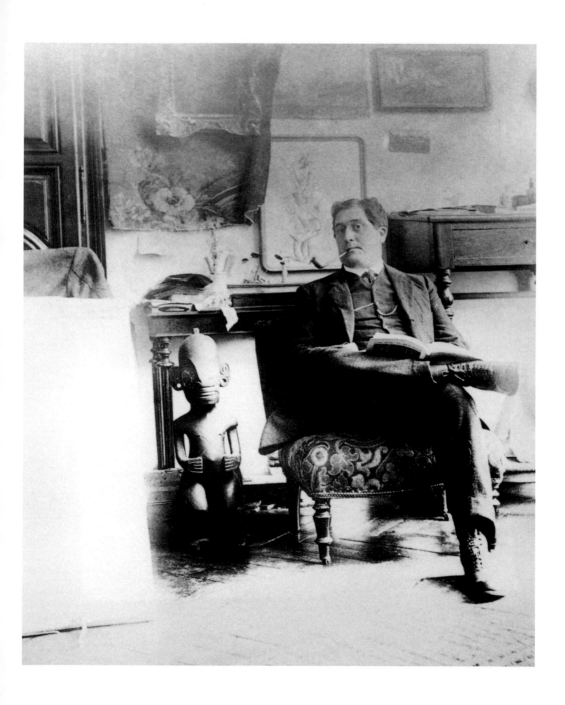

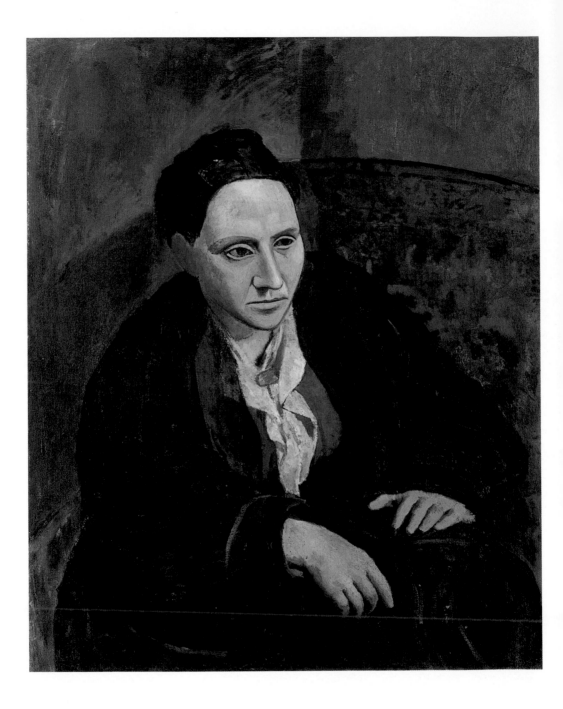

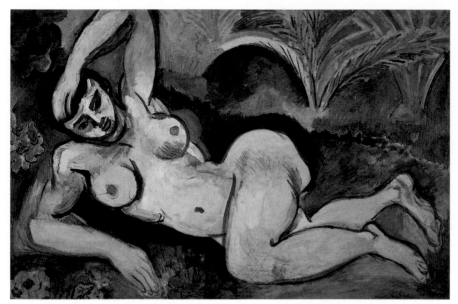

Turkish baths (see 38). The woman languishing in Biskra, an oasis in colonized Algeria, surrounded by superabundant vegetation, stands for the sensuous promise of this imagined 'orient'. But Matisse's painting challenged some aspects of the convention – the curious blue colouring and the contortions of her body made the blue nude difficult to enjoy for some contemporary viewers, perhaps because they suggested something of Matisse's developing admiration for the art and peoples of sub-Saharan and North Africa.

This work spurred Picasso in his current efforts to create a major nude figure painting. Picasso and Matisse made a friendly exchange of two radically different paintings at the end of the year, but by the beginning of 1908 relations had reputedly become bitter when Matisse founded his own independent teaching academy, and Braque and Derain seemed to have drifted away from him into the orbit of Picasso. One significant result of this struggle for supremacy between Matisse and Picasso in 1907 – *Les Demoiselles d'Avignon* – is discussed in Chapter 3, but before addressing this and related paintings, which enabled Braque and Picasso to recognize the mutual benefits of working together, the next chapter will examine the atmosphere of their partnership through their own photographs.

2

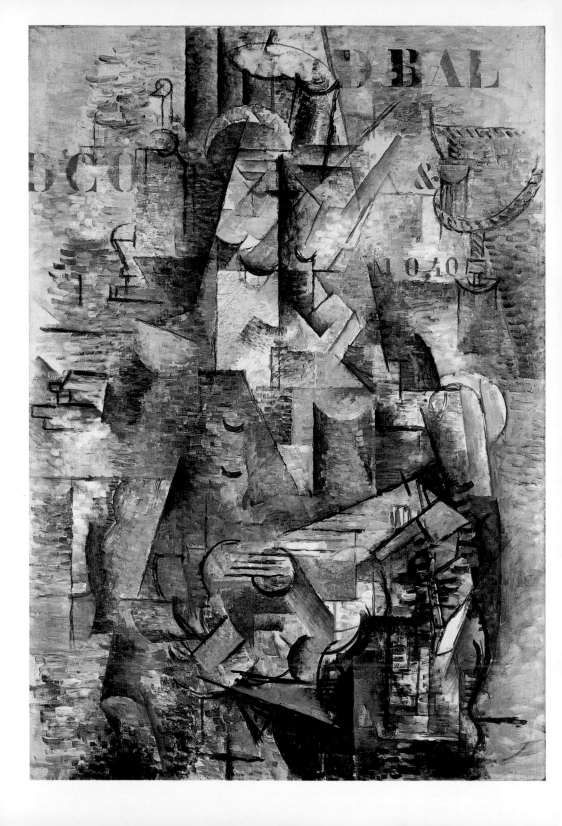

One of the most famous Cubist paintings was made by Georges Braque in 1911, and is known as *Le Portugais* (19). In 1956 Braque told an interviewer that this work represents a musician he had seen playing in Marseilles (on other occasions he said Le Havre). Seeing the musician in the painting is not easy, however, and seeing where in Marseilles (or Le Havre) he is sitting is even more difficult. Across the surface of the canvas Braque stencilled the letters and numerals 'D BAL ... OCO ... & ... 10,40'. The letters frame the figure, helping to locate what may be a top hat, and beneath it a head, with downcast eyes and moustache, and the forms of shoulders. Towards the bottom of the painting is the fragmentary image of a guitar, strings running in impossible horizontals against the angle of its body and neck. As the viewer peers at the painting's details, searching for more clues, some forms leap momentarily into view – there is the pale P-shaped area to the mid-right that is sometimes just 'shoulder', then becomes the 'back of a chair', and then plunges vertiginously into the depth of the painting as the top of a handrail or some other right-angled form. The black outlines to the top left could be a glass and a bottle, but could as easily indicate something else. To the upper right are rope-like shapes, perhaps the ties of a curtain swag, perhaps something more nautical, such as the bollards along the edge of a dock.

19
Georges
Braque,
Le Portugais,
1911.
Oil on canvas;
117 × 81.5 cm,
46 × 32 in.
Kunstmuseum,
Basel

Most people who have written about the painting have identified the setting as a café. This is partly because of the letters, which have been read as fragments of a poster advertising a dance hall '[GRAN]D BAL'. In fact, a recently discovered letter written by Braque to Kahnweiler at the time tells of a picture that represents 'an Italian emigrant standing on the bridge of a boat with the harbour in the background'. If this is the same painting, the rope-like forms must indeed be ropes, and the area 'behind' them is the sea in the dock itself. Yet it is virtually impossible to differentiate this 'sea' from the fabric of the musician's coat. This ambiguity is carefully injected into the image, and the

longer one looks at the surface the more one notices the subtle modulations of tones and textures that draw the figure of the musician out of the glistening space around him. Before taking too much pleasure in having cracked the code of the painting, however, it is worth noticing that virtually identical rope-like forms appear in another painting of 1911, *Man with a Guitar* (see 149), where they may not stand for the same harbour-side at all. Picasso certainly took up these rope forms as curtain ties in a painting of autumn 1911 (20). The most experienced researchers on Cubism now disagree as to whether or not *Le Portugais* should be retitled *The Emigrant*, and thus as to whom it represents and where he sits – café, harbour or bridge of a boat. Not even the date of this painting is agreed; and dating is indeed a constant problem with paintings from this phase of Cubism. The same forms in the painting are read in different ways, depending on the subject one imagines it depicts.

This conundrum of interpretation is quite typical of many of the paintings made by the inventors of Cubism. It is easy to become frustrated with the problems these objects pose, which perhaps explains the response of many of those who lampooned Cubism. The ridiculing of 'modern art' as the work of pranksters and incompetents is frequently encountered even today. Yet present-day audiences have an advantage over Braque's outraged contemporaries, in that Cubist works are a long way from the extremes of abstract and conceptual art that came after them. Today it is easier to accept that there is a figure with a guitar in an illusionistic space in Braque's painting, and that there *is* a rationale of some kind for this art, even if it is not immediately obvious. So why did Braque make this painting so ambiguous? What kind of artist would want to conceal his subjects behind such a veil of ambiguity? Are there any rules at all for the kind of art that Braque and Picasso invented? Answers to these questions are complex, and in the first instance rest on a deeper knowledge of the origins of Cubism in the youthful ambitions of its inventors, and of the surprisingly small world in which they moved.

How did the two artists actually meet? Braque left two calling cards for Picasso sometime in 1907. In an effort to get a response from

20
Pablo Picasso, *Mandolin Player,* 1911. Oil on canvas; 100 × 65 cm, 39⅜ × 25⅝ in. Private collection

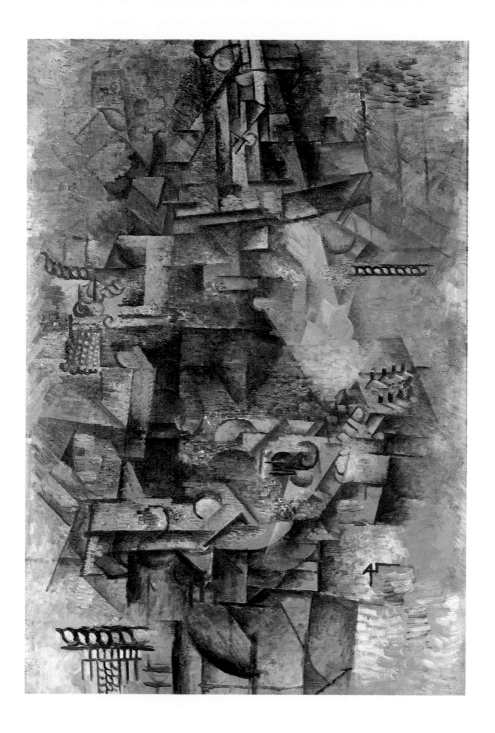

the Spaniard, he scribbled 'Regards' and 'Anticipated Memories' on them. Reminding himself of the need to return the compliment, Picasso noted in his sketchbook of March or April 1907, 'Write to Braque', and 'Braque. FRIDAY'. As is clear from their number of mutual acquaintances, Braque and Picasso must have known of each other long before this, and may have met as early as 1905. Braque was anxious to make contact with Picasso in the spring of 1907, however, because he had some paintings on show in the important Salon des Indépendants that he wanted Picasso to see. Braque knew that the paintings he had made at L'Estaque that

winter (21) were an achievement, and perhaps he had an intuition that a dialogue with Picasso would help them both. It is not known whether Picasso discussed the paintings with Braque, though he certainly saw them. Nor is it known for certain the exact date in November or December when the poet Apollinaire finally accompanied Braque to Picasso's studio to see a new and unprecedented work representing five nude women, now known as Les Demoiselles d'Avignon (see 37). Whenever it took place, Apollinaire's introduction of Braque to Picasso is usually said to be the real beginning of their friendship.

Picasso's energy and ambition had given him artistic success some years before Braque, but this success had been achieved through the courtship of dealers and private collectors, and without participation in the major avant-garde Salons. Picasso had not exhibited in either the Indépendants or the Salon d'Automne. He watched developments in these exhibitions closely, however, and when Braque showed his new L'Estaque works in the 1907 Indépendants, he was surely persuaded that an original talent, and a way of painting very different from that of Matisse and his followers, was emerging.

Competition with each other, then, as well as with other artists, was an important factor in bringing Braque and Picasso together and keeping them in close contact for seven years. This spirit of rivalry, sometimes playful, sometimes in earnest, lies behind some of the myths Braque and Picasso created about themselves during the Cubist years. They thrived on ribbing, role-playing and in-jokes. Two nicknames in particular give a strong sense of the play-acting, of the invention of new images for 'the modern artist', and of the peculiar metaphors of bonding these games involved. In several letters Picasso referred to himself as Braque's 'Pard', Buffalo Bill's boy sidekick or 'Pardner'. William 'Buffalo Bill' Cody's 'Wild West' show had been a hit at the Universal Exposition of 1889, and had visited Paris again in 1906. (Amazingly, Cody kept travelling with his show until 1913.) Pulp novels based on the show were read by the artists, and they were clearly both amused and attracted to the 'man's world' of frontier survival. Picasso painted a 'portrait' of Buffalo Bill, and the words 'COW-BOY' and 'PARDO' appear in Braque's *Checkerboard: 'Tivoli Cinéma'* (22), showing that the image of the Wild West was also already a staple of cinema (Edwin Porter's *The Great Train Robbery* was released, for example, in late 1903). But if Braque and Picasso were Buffalo Bill and his boy Pard, they were also Orville and Wilbur Wright. In an amusing coincidence, immediately beneath Louis Vauxcelles' review of Braque's show in late 1908 was an article announcing the 'conquest of the air' by the Wright brothers. The American aviators had made their first successful powered flight as early as 1903, but in 1908 had regained the record for altitude. Thanks to this coincidence and due to a fascination with things American, Braque became 'Wilbourg'. (Neither

21
Georges
Braque,
*Jetty at
L'Estaque*,
1906.
Oil on canvas;
38.5 × 46 cm,
15⅛ × 18⅛ in.
Musée National
d'Art Moderne,
Centre Georges
Pompidou,
Paris

artist later adopted the name 'Louis' after France's own contemporary pioneer aviator Louis Blériot, who flew the English Channel in 1909.) Yet it was probably the fact that 'Wilbourg' had a brother, a 'Pardner', that made him another stock character in the daily studio charades. Aviation, unlike buffalo-hunting, was quintessentially modern, though both shared mythic pioneering qualities.

Some of these myths revolved around the image of 'the modern artist', supplanting the rather serious and socially conventional archetype embodied by Matisse. By parodying this image, Picasso and Braque represented to each other their own artistic radicalism, their rejection not only of Salon success in preference for the rarefied support of a few connoisseurs, but also of the social life and polite culture that went with it. These parodies were postures, of course, since the world of private collectors and dealers had its own very important etiquette, but it is clear that Picasso and Braque made a special effort to change at least their own image.

In November 1908 Picasso's studio hosted a banquet in honour of Henri Rousseau (1844–1910), known as *Le Douanier* or 'the customs officer'. Rousseau was a so-called 'naïf', or untrained painter, whose art was nevertheless championed by some dealers and who exhibited his exotic fantasies regularly in the various progressive Salons. The Rousseau Banquet, which has entered into art history as a deeply significant event, was in fact as much a mockery as a homage. The ageing Rousseau, by all accounts, was nevertheless deeply moved. He declared to Picasso: 'You and I sir are the two greatest painters of our time. You in the Egyptian style, I in the modern.' References to Egyptian style were not uncommon in criticism of the day, which attempted to explain 'deformation' or non-realistic art: the Symbolist critic Georges Albert Aurier had used it to describe the 'decorative ... subjective, synthetic ... ideist' art of Gauguin in 1891. More to the point, Louis Vauxcelles had compared Braque's work to that of Derain, Picasso and 'the static art of the Egyptians', in his review of Braque's work published on 14 November 1908. As this was only one week before the probable date of the banquet, it may be that Rousseau's remark was much better informed than has been thought.

22
Georges Braque, *Checkerboard: 'Tivoli Cinéma'*, 1913. Gesso, pasted paper, charcoal and oil on paper, mounted on canvas; 65.5 × 92 cm, 25³⁄₄ × 36¹⁄₄ in. Private collection

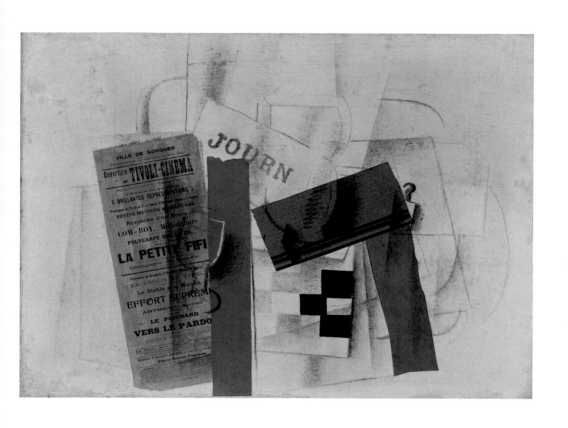

Picasso made a photographic portrait of Rousseau in 1910, the year of his death. The photograph shows Rousseau in his own studio, wearing his customary artist's smock, sitting beside the painting *Monkeys in a Virgin Forest* (23). He attempted a photographic trick with a second portrait, a double-exposure with a photograph of the painting itself, concealing the painter amid the thick tropical undergrowth he had lovingly depicted. Such photographs show Picasso's awareness of conventions of the photographic portrait of the artist in his studio, and his desire to play with these conventions. Rousseau in his artist's smock was an alternative father figure to Matisse. More importantly, his supposed *naïveté* was to be preferred to Matisse's cultivated innocence.

The reinvention of the image of the modern artist, so important for the confidence and courage of Braque and Picasso in the Cubist years, took place not just through wordplay and nicknaming, then, but also through photography. Photography allowed the two artists to make a mostly private visual record of their work, their antics and their fantasies of being modern. Picasso in particular took a large number of photographs of himself, his studio, his works and his friends. For example, when it was opened again by Picasso scholars in the 1980s, the sketchbook containing the reminder to 'Write to Braque' also contained twenty-three black-and-white photographs of the artist's studio, with Cubist works propped against the wall and piled one upon the other. Such photographs provide a remarkable insight into the excitement and the lyricism of the times. Beyond this documentary role, however, photography has a number of other meanings that help to illuminate the nature of Cubism as invented by Picasso and Braque, and taken up by artists all over the Western world.

The camera was not a new invention — the earliest photographs date from the late 1830s — but the technology had gone through some significant changes in the late nineteenth century. Early cameras were enormously expensive and cumbersome. They required long exposure times, leading to those strange rigid poses in portraits by such photographers as Louis Daguerre (1789–1851) or David Octavius Hill (1802–70) and Robert Adamson (1821–48), and the chemical

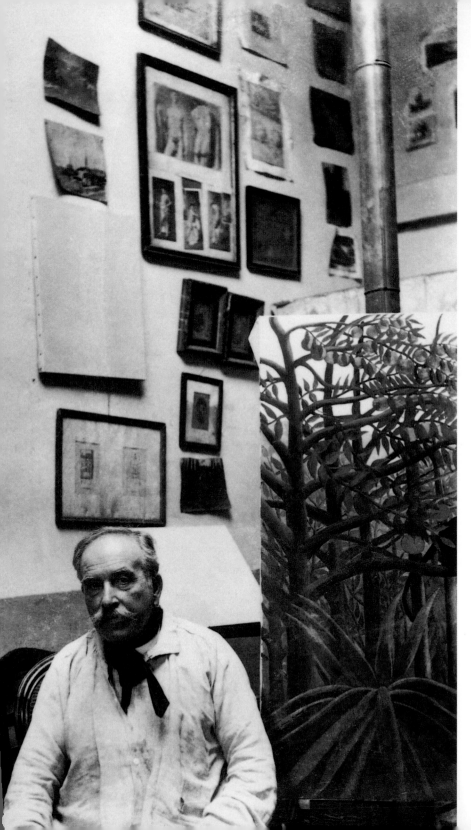

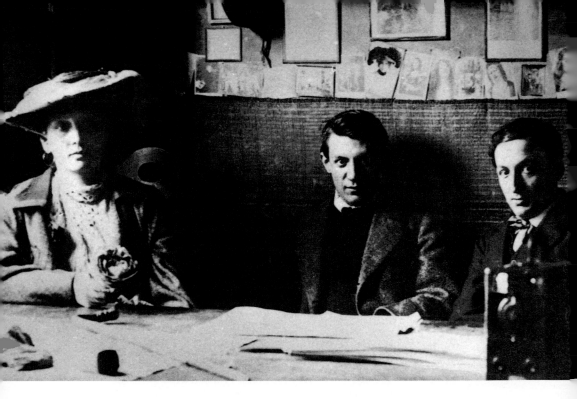

processing of the glass plates was troublesome. By the 1890s,
however, Kodak and others built on earlier advances to introduce box
cameras, nicknamed 'Detectives', which made use of roll film and
faster exposure times – allowing for sequences of hand-held shots.
Other new features made photography more accessible to a wider
audience, including various forms of timer or remote shutter release,
which meant that self-portraiture was no longer dependent on a
mirror. Manufacturers aimed their new cameras at a mass market,
not just at the specialist. It was this sort of camera that Picasso and
Braque seem to have used, as can be seen in a photo of Picasso
taken by a friend (24), where a 'Detective' camera sits on the table
in the foreground.

Early photographs of Picasso and Braque already reveal some of the
themes that would feed into their Cubist art and suggest something of
their personalities. Braque, for example, a keen exponent of 'physical
culture' and sports, was pictured around 1904 in his boxing gear (25).
He and his friends Derain and Vlaminck sparred in their studios in

Paris, and later Braque probably attended boxing matches in Paris with Picasso. Perhaps pugilism stood for the fight between 'the modern artist' and the critics and public, or perhaps Braque and Picasso imagined themselves stepping into the ring with each other – although Picasso, according to his then partner Fernande Olivier, was afraid of being hit.

Braque was curiously described by Fernande Olivier as a 'white negro' on account of his build and rugged appearance. Among the circle of painters, sculptors, writers and poets into which he was moving, boxing was always a talking point (in fact it had long been a part of studio culture in nineteenth-century Paris), and Braque's boxing prowess was increasingly admired. By 1912, when Picasso painted *The Negro Boxer*, he also knew several African-American boxers resident in Montparnasse, and his painting *Violin, Wineglasses, Pipe and Anchor* (*Souvenir du Havre*) has been identified as a tribute not only to Braque's home town of Le Havre (26), but also to Braque's hobby (the letters in the painting probably refer to a boxing match featuring Willie

24
Joan Vidal
Ventosa,
Fernande
Olivier, Pablo
Picasso and
Ramón
Reventos,
1906.
Gelatin silver
print;
15·5 × 20·5 cm,
6⅛ × 8⅛ in.
Musée
Picasso, Paris

25
Georges
Braque as a
boxer,
c.1904–5

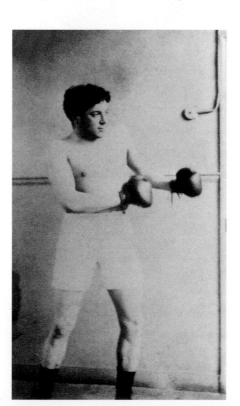

26
Pablo Picasso,
*Violin,
Wineglasses,
Pipe and
Anchor*,
1912.
Oil on canvas;
81 × 54 cm,
31⁷⁄₈ × 21¹⁄₄ in.
Národní
Gallerie,
Prague

27
Pablo Picasso,
Georges
Braque in the
boulevard de
Clichy studio,
c.1909–10.
Gelatin silver
print;
10 × 8·7 cm,
4 × 3⅜ in.
Private
collection

Lewis). A photograph taken by Picasso in the winter of 1909–10 in his studio (11 boulevard de Clichy) shows Braque in full swagger, cane in hand, sporting a wide-brimmed hat and bow tie (27). He stands amid picture frames and between a lithograph of Cézanne's *Large Bathers* and, on the floor in the right-hand corner, Picasso's *Nude with Raised Arms* (1908). Braque was a strong and handsome man, who delighted in wearing a suit – the poet André Salmon described him in 1911 as a 'dandy in his own fashion'.

Braque and Picasso enjoyed a number of conventional and unconventional relationships during their formative years. Braque formed a close friendship early on with Marie Laurencin (1883–1956), a fellow art student who would later become Apollinaire's partner. He then fell in with Paulette Philippi, who introduced him to opium. Philippi had several lovers other than Braque, but this did not appear to deter him. According to John Richardson, it was Picasso and Fernande Olivier who introduced Braque to his future wife, Marcelle

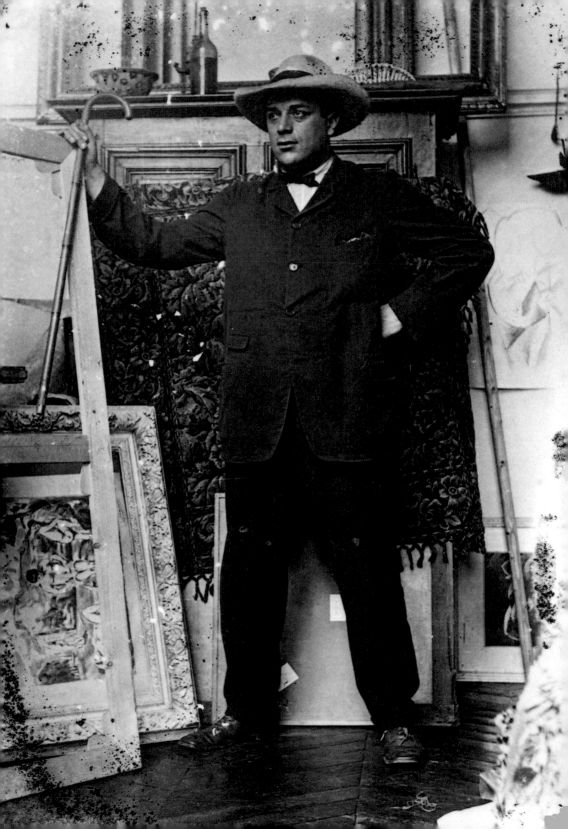

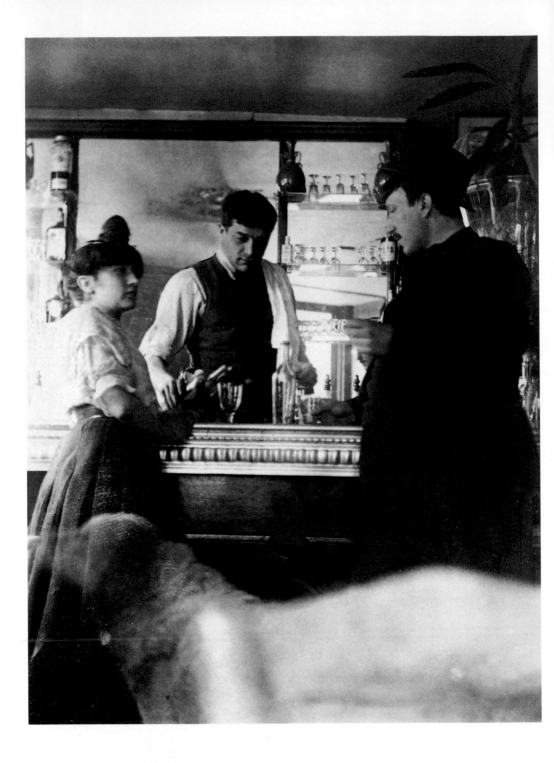

Lapré, also known as Madame Voranne, in the winter of 1907–8. Lapré was not regarded as particularly beautiful, but Braque began to court her in earnest in 1909. They began living together in 1911, though they did not marry until the early 1920s.

Picasso's personal life during the Cubist years was no more complex, but has been more thoroughly and sometimes sensationally researched. Beyond his early visits to Spanish brothels, not much is known of his sexual partners before his encounter with Fernande Olivier, with whom he embarked on his first long-term relationship in the summer of 1904. Olivier (real name Amélie Lang) had been forced into a disastrous marriage at the age of eighteen and had been left unable to bear children after a miscarriage. After leaving her husband she took up a career as an artist's model. She later wrote an important memoir of their affair, *Picasso and His Friends*, from which much of the information on life in the Bateau Lavoir now derives. The relationship between Picasso and Olivier broke down in 1911, when she took up with an Italian painter called Ubaldo Oppi (1889–1942), and he fell in love with Eva Gouel (also known as Marcelle Humbert). Eva died of cancer in December 1915 after a series of operations, but during her illness Picasso became involved with another woman. He married for the first time in 1918 to a Russian ballet dancer, Olga Khokhlova. So it is that both artists were in relationships with women throughout the Cubist period, but neither had entered into thoroughgoing domesticity.

Braque the dandy, much admired by the ladies, loved hats. He bought a Kronstadt hat like the one Cézanne used to wear in late 1908, and sent Picasso a parcel containing a selection of hats in the early summer of 1911. '[Y]ou can't imagine how much I laughed', wrote Picasso in his thank you letter from Céret where he was staying, 'above all in the nude'. Picasso and his friend Manolo put on the hats and painted false moustaches and side-burns on their faces, before setting off for an evening drink. Sadly, Picasso and Manolo did not photograph themselves in their hats and whiskers, but this sense of play-acting is perhaps evident in a photograph Picasso took of Braque and Fernande Olivier at a bar (28). Some commentaries on this

28
Pablo Picasso,
Georges
Braque (?),
Fernande
Olivier and
André Derain
at a bar,
1908–10.
Gelatin silver
print;
10·7 × 8·2 cm,
4¹⁄₄ × 3¹⁄₄ in.
Musée
Picasso, Paris

photograph suggest that Braque is the figure on the right leaning on the bar, and assume that this is nothing more than a snapshot taken of friends in an ordinary public situation. The resemblance of the 'barman' to Braque is very strong, however, and if correct this identification would require a different reading of the scene. The man on the right may then be the painter Derain (the dog is probably his, too), who was tall, had a moustache and often wore a bowler. If so, the photograph would represent a complete *mise-en-scène* by the group of friends, a charade. This photograph may not merely be a record of playing-up to the camera, like the portrait of Braque in the wide-brimmed hat, but a theatrical fiction posing as a 'real' scene. In that case, the play is not just a role-play, but rather a playing with the 'reality' habitually expected from photographs. This is something that Picasso in particular would experiment with in later photographs from the Cubist period.

Braque and Picasso recorded other costumes. As early as 1901 Picasso was photographing himself wearing a top hat, creating a ghostly image by superimposing himself on a shot of his studio wall. On the back of this picture Picasso wrote: 'This photograph could be titled, "The strongest walls open as I pass. Behold!"' (29). As well as conjuring up an image of the artist as divinely powerful, it has been suggested that this might refer to the evil hero of the comte de Lautréamont's *Chants de Maldoror*, who escapes through walls like a ghost after committing his ghastly crimes, but the source might also be the *Fantômas* crime stories, which Picasso loved. Picasso thus imagines himself stealing in to commit unspeakable crimes on painting. Once again role-play is also a playing with the 'real'.

This early and rather overblown fantasy of magical power gave way in the period of Cubism to fantasies of proletarianism: Braque and Picasso took to wearing various kinds of worker's outfit (mechanic, plumber), which they ordered from a shop called La Belle Jardinière. Sporting their so-called '*bleu mecano*' or 'Singapour' suits, 'they arrived one day cap in hand acting like labourers,' wrote their dealer Kahnweiler, '"Boss, we're here for our pay."' These special rough get-ups were undoubtedly practical (30), but once again they also

29
Pablo Picasso, Self-portrait in the studio, 1901. Gelatin silver print; 12×9 cm, 4³⁄₄×3¹⁄₂ in. Musée Picasso, Paris

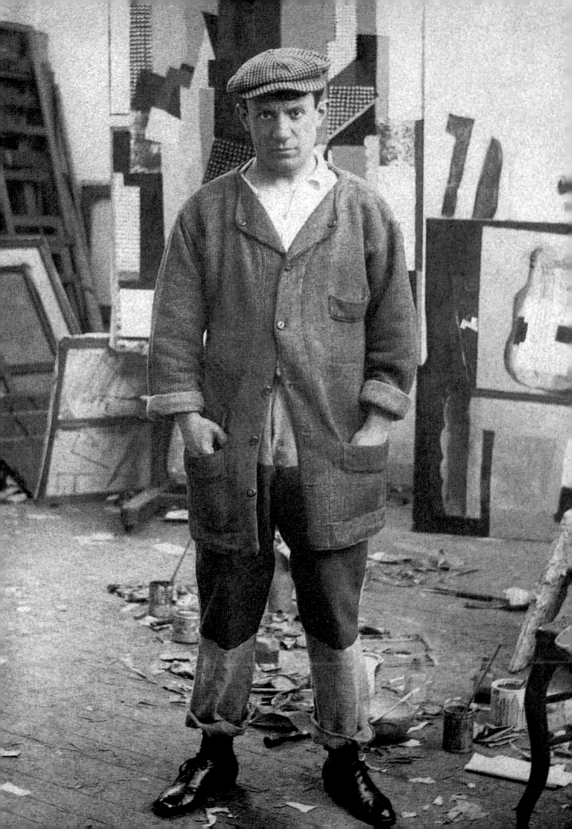

expressed attitudes – Cubism was an art made by technicians, workers, not artists; it was an art for everybody that could be engineered, mass-produced. Picasso and Braque posed as workers in order to celebrate craft over genius, thus pointing to aspects of their artistic practice (using industrial paints, sand, cardboard, etc.). Like the outfits themselves, these aspects were guaranteed to offend bourgeois art dealers and public alike. Their workerism, this analogy between artist and mechanic, perhaps a game for them, was taken seriously by Russian artists such as Vladimir Tatlin (1885–1953), who visited Picasso's (and probably Braque's) studio in 1914 and went on to become a leading Constructivist in the new Soviet Socialist Republic in 1917 (see Chapter 8). Yet just as Tatlin attempted to make a sculpture that was also a flying machine, so the workerism of Picasso and Braque was not, perhaps, without a hint of romanticism, a belief in a new kind of genius. Like the Wright brothers, they were to be pioneer aviators, but of a new aesthetic. Picasso's studios seemed a terrible mess to his visitors. Fernande Olivier recorded that his studio on boulevard de Clichy had been a private chaos that was never cleaned, and a Swedish artist, Arvid Fougstedt (1888–1949), published an account of a visit to the rue Schoelcher studio, where he noted:

The studio is as vast as a church. Four or five hundred canvases of varying sizes are stacked against the walls, on the table and on the easels. The floor is scattered with pieces of cut-out paper that he glues on to his canvases – because Picasso utilizes also newspapers, wrapping paper, cinema tickets, which he glues on his paintings here or there as it pleases him. At each step, I trample palettes, empty tubes of paint, brushes ... I consider the studio and am stupefied by the number of canvases; what imagination, what profusion of ideas! ... I don't know where to start in this mess. The pictures are arranged like the scales of a fish to take up the least possible space and Picasso circles around ceaselessly to displace and relocate them.

However, despite the mess, Picasso dressed up elegantly in a photograph taken against an almost identical background. Another photograph from around the same date shows the artist posing with a palette, which he probably rarely used (see 234). There are in fact few

30
Pablo Picasso,
Self-portrait
with *Man
Leaning on a
Table* in
progress,
1915–16.
Gelatin silver
print;
18·8 × 11·6 cm,
7⅜ × 4½ in.
Private
collection

photographs of either Picasso or Braque at work, and when they are
sitting or standing at an easel, it is clear that they are posing rather
than painting. One other example is a photograph (31) that Braque
probably made of himself at home at 5 impasse de Guelma in spring
1911 (or possibly in his temporary studio in Céret around the end
of 1911). Braque sits at his easel, upon which rests the unfinished
Le Portugais (hence the dating problem; see 19). Braque has the
painting in a frame, a practice that presumably helped him to visualize

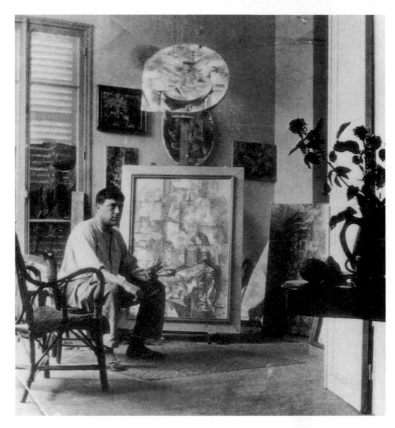

31
Georges
Braque in
his studio at
5 impasse de
Guelma with
Le Portugais,
Paris,
c.1911

32
Georges
Braque in
his studio at
5 impasse de
Guelma, Paris,
c.1911

the relationship between it and the work, or even to gain a stronger
sense – by emphasizing the limits of the canvas – of how the
composition would occupy its given space. Above *Le Portugais* is an
oval canvas, possibly an early stage of *Table with a Pipe*. On the wall
behind the easel are a number of works that are difficult to identify.

Braque holds his brushes, sitting on a chair, and looks directly at
the camera. The camera is set on a low surface, and the photographic

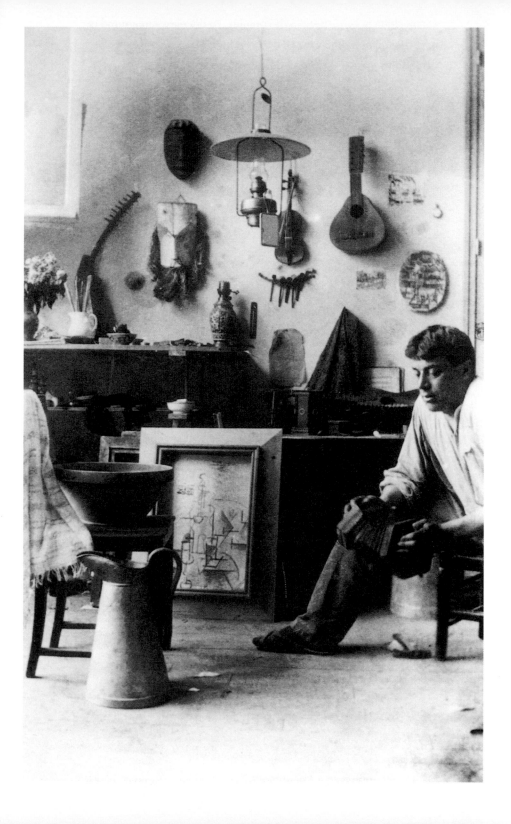

composition is correspondingly complex. To the right foreground is an elaborate pedestal table on which stands a jug containing flowers. Behind this an open partition door creates a spatial confusion as it rhymes or links up with the angled wall in the deepest space of the image. The spatial logic allowing the viewer to grasp the relationship between this door and the wall is obscured by the leaning canvas beyond. This photograph is in some ways a parody of the genre of paintings of artists at work in their studios. More conventional Salon painters were often photographed posing in pristine and beautifully decorated studios. Braque aims at a more down-to-earth effect, and to give a more concrete sense of the work of art in the making. The photograph thus serves not only to present the artist but also to record the development of *Le Portugais*.

Braque was interested in using photographs to create an artistic atmosphere. In another rather different photograph, probably taken on the same day (32), the image is eccentrically composed and once again shot from a low angle. The louvered windows just visible behind him are probably the same ones on the left of the other photograph. Braque sits to the far right, half out of the shot, on a low stool or chair. His legs are spread wide and he leans forward to play his concertina, gently forcing the notes from it as he appears to hum a tune to himself. Braque is distracted, musing: a poet, a musician, as well as an artist. All about him is a complex composition of objects – both domestic and artistic. Tribal masks, a violin, a mandolin, a watch, a harp and a collection of pipes hang on the wall. Around them are a few postcards and a small oval painting. Below are shelves scattered with other curios, sheet music and a mandolin. In the foreground to the left is a wash basin and metal jug, the basin on a chair draped with a rug. Just off-centre is a framed painting. An oil lamp hangs from the ceiling. Where are the artist's easel and paints? This is not a photograph that directly illustrates the making of Cubism – rather it is about the atmosphere in which Cubism is made. Picasso once said that the reality of a Cubist work is not one 'you can take in your hand. It's more like a perfume – in front of you, behind you, to the sides. The scent is everywhere but you don't quite know where it comes from.' In the same way, the photograph of Braque's studio is filled

with a whispering melody, enveloping the coarse textures of cloth and wood and the musty smell of old flowers. It is an intimate photograph that sets out to seduce, to bring the viewer close to an artistic world, whose stillness evokes Braque's thoughts in his state of distraction. The materiality of all those objects is like an insistent musical motif for his imaginative world.

If Braque's photographs of his Cubist studio convey the savour of Cubism, Picasso's bring Cubism momentarily to life, subtly playing with reality and fiction by creating relations between the world of Cubist painting and the 'real' world. He experimented with photography in two very different ways in his lyrical attempts to show what a world infiltrated by Cubism would be like. In a photograph of several paintings, including *Woman with a Book* (33), Picasso grouped the works carefully so that space and the defining planes of recession formed by the edges of the canvases are hard to read. In a sense he was using the canvases as sculptural elements, as if they were themselves some of the impossible surfaces that meet in the early Cubist paintings of Braque.

33
Pablo Picasso, *Woman with a Book* in progress and other paintings, 1909. Cropped gelatin silver print; 11 × 5·1 cm, 4⅜ × 2 in. Private collection

Confronted by the resulting photographic print, and in what would become a typical act of improvisation for this artist, Picasso cropped it on the right hand side, picking up the lines of the female figure represented on the bottom right, and then of the canvas on which she is shown. His manipulation of the very shape of the photograph suggests that it is not only the space of Cubist pictures that is under scrutiny but the 'real' space of the photograph itself, a space that at first glance seems so clearly ordered. This work is a telling example of a Cubist world, or of the ways in which the Cubist vision would transform seeing the world.

A second experiment comprising a number of photographs, equally but differently prophetic, involved a canvas from the spring–summer of 1913 that was subsequently destroyed or painted over. Here once again it is a question not of photographs of Cubist works but of a set of photographs that are themselves the works in question. In a photographic composition with *Construction with Guitar Player* (34), Picasso shows a studio interior that is at first rather confusing to look at. On the top left is part of a poster for an exhibition of the artist's work that had just taken place in Munich, and below it a small pasted-paper work, *Au bon marché*. To the right of this is a crumpled paper drawing of a bottle of Anis del Mono, one of Picasso's favourite still-life objects. Beneath these pictures is a stack of canvases, mostly with their faces turned to the wall. Thus far it resembles other studio photographs. The right half of the picture, however, is very unusual. A large white canvas, partly drawn and painted, dominates the space. At the extreme top right is a strange three-dimensional object, actually a sculptural 'construction' of a violin. Suspended on a string in front of the canvas is a guitar, which is clasped by two paper arms reaching out from the canvas. In front, in the centre foreground, is a small table, on which a bottle, pipe, coffee cup and newspaper are visible objects. Beneath the table is a sheet of paper curling down from the edge of the canvas to the floor. It is possible to see another canvas behind and above the main one, on which, at the very top of the picture, are several more scaffold-like lines.

The suggestion is clear. The Cubist guitarist is seated at this real table, and is drinking real wine. The absurd heterogeneity of these things –

representational and real objects – would normally pose a disruptive challenge to the viewer's powers of synthesis. Through the intercession of the realistic effect of photography, Picasso creates a fantastic modernity, where representations and material things circulate and interrelate without hindrance. The emergence of the Cubist figure from the canvas to take up the guitar and play it is not only a surreal dream, but a wistfully ironic comment on the modern faith in the truth of photography. Having created this installation using his camera, Picasso then began to manipulate several photographic prints of the scene. In two cases he made cardboard masks that allowed him to isolate a part of the image or make the space of the room into flattened collage-like fragments (35). This effect of flattening, of returning the photographic space of the real world to the homogeneous material of representational art, is precisely controlled in this print. The strong spatial illusion created by the passage from the bottle to canvas to guitar is blanked out, and the spatial relations between the figure and the fragments of the room to the left are impossible to determine. Picasso took another, more frontal photograph of his Cubist guitar player, which allowed him to treat the whole more readily as the shallow space of a Cubist painting (36). Using an ink pen, he drew further lines over the surface of the carefully cropped print, seeming to add another left arm to the guitarist. Almost duelling now with the camera, Picasso thus once again returned the 'real' space to the space of his own Cubism.

The 'reality' of photography, then, was no more stable, no more convincing to Braque and Picasso than the reality of academic art and the illusion of perspectival space. The invention of photography, however, made the public demand for the supposed reality of the visual world all the more pressing, and the task of the visual artist correspondingly more challenging. Finding a way of making visual art in this context meant coming to terms with a public exposed to a plenitude of photographic recording of the visual world, and armed with a faith in the reality of this world that seemed to make painting redundant. Braque and Picasso cultivated their keen sense of wit and rivalry in this context as a means of artistic survival and ultimate 'heroism', and in an effort to out-perform the camera and the very

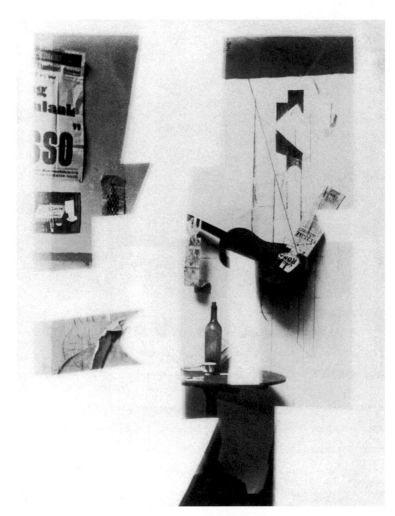

34
Pablo Picasso,
Photographic
composition
with
*Construction
with Guitar
Player*,
1913.
Gelatin silver
print;
11.8 × 8.7 cm,
4⅝ × 3⅜ in.
Private
collection

35
Pablo Picasso,
Photographic
composition
with
*Construction
with Guitar
Player*,
1913.
Masked gelatin
silver print;
11 × 9 cm,
4⅜ × 3½ in.
Private
collection

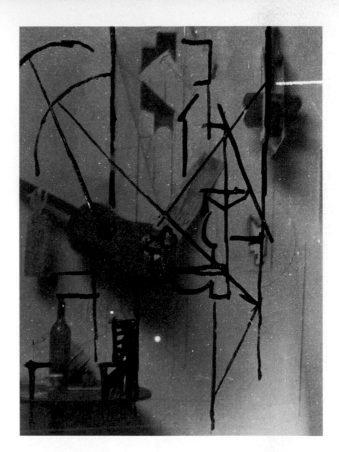

36
Pablo Picasso,
Photographic
composition
with
*Construction
with Guitar
Player,*
1913.
Cropped
gelatin silver
print with ink
drawing;
7·8 × 5·8 cm,
3⅛ × 2¼ in.
Private
collection

notion of the real visible world. They blurred the boundaries between
seriousness and play, between truth and fantasy; between the
identities of things and between things themselves.

It has been possible to outline where these two artists came from
and what they had done before the adventure of Cubism began, and,
thanks to these photographs, to sample something of the spirit of
their collaboration. Although this material does not completely answer
the questions about Braque's *Le Portugais* with which this chapter
began, it does situate the nature of the painting's mysterious and truly
ambiguous character. The sense of being caught in an unstable visual
world is not a sign of one's failure to get the point of a Cubist painting
but is an intrinsic part of seeing Cubism. Capturing the precise nature
of the shimmering realm of Cubism, however, means following its
story more closely.

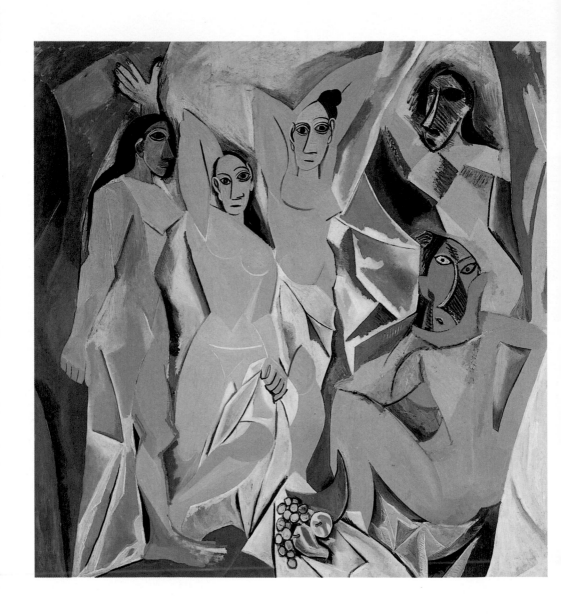

This chapter tracks the development of Cubism through the increasingly private dialogue between Picasso and Braque. Cubism was a playful but austere and even cerebral art, so it is surprising to discover that, for a long time, it was presumed to originate in an intensely shocking picture about sexual desire. Picasso's *Les Demoiselles d'Avignon* (37) is an art historical landmark, and has been called 'the first truly twentieth-century painting'. It is a large work showing five naked or near-naked women in an interior. In the foreground is some fruit on a table. It is a painting of prostitutes in a brothel; but these women have a horrifying ugliness and exist in a distorted world. The painting is unsettling – in its subject matter and its appearance, in its origins and its achievement. There is no doubt that the work marked a turning-point in Picasso's development, and that it provoked an extreme reaction in Braque, bringing the two artists into creative dialogue. On the other hand, almost nothing of the subject, scale, colour, form or mood of this painting – nothing of its ambition – survives into Picasso's Cubism proper. *Les Demoiselles d'Avignon* is not so much the first Cubist painting, then, as the traumatic rupture that enables Cubism to begin.

37
Pablo Picasso,
*Les Demoiselles
d'Avignon*,
1907.
Oil on canvas;
243·9 × 233·7 cm,
96 × 92 in.
Museum of
Modern Art,
New York

There are hundreds of drawings and many paintings relating to *Les Demoiselles* that reveal how the idea for a brothel painting evolved. Exotic 'harem' paintings (a form of the orientalism discussed in Chapter 1) were popular in the official Salon in the eighteenth and nineteenth centuries, and pornographic prints and photographs of brothels were widely available. Picasso had seen the major retrospective of the work of Jean-Auguste Dominique Ingres (1780–1867) at the Salon d'Automne of 1905, and had been impressed by *The Turkish Bath* (38), a work in the 'harem' tradition. The other artist to benefit from a retrospective at the same Salon was Édouard Manet, whose *Olympia* (see 7) was exhibited. Although not a brothel scene as such, it was recognized as a depiction of a prostitute. Detailed

studies of its reception in the 1860s have shown how various features of her body (*eg* underarm hair, the choker implying unchaste nakedness rather than aesthetically delectable nudity, and the 'phallic' fingers of her hand concealing her crotch) infuriated and offended the bourgeois Salon-going public. Perhaps its greatest insult was delivered by Olympia's unforgiving gaze. Picasso himself would re-use, intensify and multiply this gaze in the *Desmoiselles*, turning all eyes on the implied male spectator.

Current research suggests that the first compositional study proper is in a sketchbook from the winter of 1906–7, and a colour version of the same seven-figure idea is now in Basel, Switzerland (39). In 1972 Picasso said that the figure on the left was a medical student, who was to enter a brothel carrying a skull, though in the Basel drawing he carries a book. The medical student raises a curtain with his left hand, and in some drawings the other male figure in the picture – whom we know was meant to be a sailor – looks towards him as he enters. In front of the seated sailor is a *porrón* (a Spanish drinking-flask) and a plate bearing three watermelon slices. Beyond this the only other still-life object is the vase of flowers in the foreground. Five nude women surround the sailor. Between the two men a prostitute is seated with one leg crossed over her knee. In the right foreground another woman squats on a stool, apparently turning her head towards the medical student, as does the woman entering through a pair of curtains behind her. In the centre of the drawing a woman raises her arms behind her head, and a fifth woman stands with her hand resting on the armchair by the medical student. This, then, is the assembled cast with which Picasso worked for some five months, and it was only late in the day that he took the radical decisions to exclude the medical student, or rather to transform that figure into a naked prostitute, and to remove the prostitute standing behind the chair, and finally to remove the sailor as well. The resulting five-figure composition, known from a watercolour of June 1907 (40) is what became the basis for the final painting.

Picasso effected a major transformation by eliminating the male characters and turning the whole focus of the image outwards. This

38
Jean-Auguste Dominique Ingres, *The Turkish Bath*, 1862. Oil on canvas on wood; diam.108 cm, 42½ in. Musée du Louvre, Paris

39
Pablo Picasso,
Sketch for *Les
Demoiselles
d'Avignon*,
1907.
Pencil and
pastel on paper;
47·7 × 63·5 cm,
18³⁄₄ × 25 in.
Kunstmuseum,
Basel

40
Pablo Picasso,
Sketch for *Les*
Demoiselles
d'Avignon,
1907.
Watercolour
on paper;
17·4 × 22·5 cm.
6⅞ × 8⅞ in.
Philadelphia
Museum of Art

change was accompanied by others. The format of the composition was gradually compressed laterally, so that it ended up almost square. The sense of compression comes through in the glacial blue angular shapes between some of the figures, and in general in the folding and buckling spaces and solids around them. A glance back to the Basel drawing, with its steady rhythm of dark and light flowing drapery in the background, shows just how intense the act of compression was. Another effect of the reduction of the number of figures and the compositional compression is that the women seem closer together in space because they now seem closer to each other in scale. Yet paradoxically Picasso preserved their poses, so that the bizarre shapes between them dramatize the strange spatial relationships the viewer is invited to resolve. Look, for example, at the two figures to the left, whose feet seem to almost touch – the raised arm of the inner figure is surely not meant to touch the tip of the nose of the outer one? If not, then the inner figure must somehow be reclining (this is the descendant of the woman in the armchair in the Basel drawing). Yet she seems bolt upright like the standing semi-clothed woman raising the curtain. Studies again suggest that this figure is indeed a reclining nude inexplicably seen from a bird's-eye view.

Picasso did not publicly exhibit *Les Demoiselles* until July 1916 (at the Salon d'Antin), when it acquired its present title. *Les Demoiselles d'Avignon* might be translated as 'The Maids of Avignon', and was used by André Salmon in the exhibition catalogue. Picasso was later irritated with Salmon for convincing him of this prudish choice, and insisted thereafter that the title was a nonsense. Apollinaire invented what seems to have been the original title *Le Bordel philosophique* (*The Philosophical Brothel*), a thinly veiled allusion to the Marquis de Sade's pornographic book *La Philosophie dans le boudoir* (*Philosophy in the Bedroom*) of 1795. Apollinaire, who wrote outrageous pornography himself, was a great admirer of Sade. The painting had another nickname: *Les Filles d'Avignon* ('The Girls of Avignon' as in 'fille de joie', a French expression for prostitute), which supposedly referred to a brothel in Barcelona. The poet and the painter joked unpleasantly that the women in the picture were their own girlfriends or grandmothers, naming each one accordingly.

It is salutary to note that Salmon's less shocking title enabled later commentators to ignore the subject matter in favour of the supposedly pure concern with 'form' in Picasso's work. In *The Way of Cubism* (1920, the revised version of a text originally published in 1916), his dealer throughout the Cubist period, Kahnweiler, described the right-hand side of the painting as containing 'the beginnings of Cubism'. The problem that continued to tax Kahnweiler in this and later essays was not its subject, but what he perceived as the stylistic disunity of the painting. It is obvious that this painting presents at least two, maybe three, ways of representing the human body, and especially the human face. This pluralism led Kahnweiler to believe that it was unfinished or unresolved. In particular the lack of resolution revolved around the repainting of the two right-hand figures. It seems that Picasso also repainted the face of the left-hand figure raising the curtain at the same time or slightly later. These radical revisions took place soon after June 1907 when the first more uniform version of the work had been completed. Picasso changed his mind about the picture fairly swiftly, finishing it – or leaving it unfinished – perhaps by the end of July. The jarring heterodoxy of the painting as we see it today appears as if a deliberate attempt to heighten the shock effect of the work – to attain an appropriate sense of discord both in the individual figures and in the composition. Such malformation was a way of marking out resistance to even the most advanced canons of beauty, and at the same time was made a powerful sign of the artist's creative will.

Picasso found his solution that summer through a free interpretation of African and Oceanic artefacts. He had owned a copy of Paul Gauguin's Tahitian journal *Noa-Noa* since 1902, and he admired Gauguin's memorial retrospective at the Salon d'Automne in 1906, which included sculptures and ceramics that emulated the style of Polynesian art. Fauve artists such as Matisse, Vlaminck and Derain were all buying African objects by 1906 (41). It is likely that Picasso did not acquire his first examples of 'tribal' art until 1908, but he clearly adopted something of the visual character of African and Oceanic art for the *Demoiselles*. Describing his difficult new art, friends resorted to epithets referring to ancient or extinct non-Western cultures: Picasso's

41
Mask made
by the Fang
people of
Gabon, owned
by André
Derain.
Wood;
h.48 cm,
18⅞ in.
Musée
National d'Art
Moderne,
Centre
Georges
Pompidou,
Paris

new painting was called 'Assyrian' and 'Aztec' by those who had seen
it freshly completed. Douanier Rousseau would of course call Picasso
an 'Egyptian' painter in 1908. The 'primitive' sources that Picasso
used were in fact not at all ancient, but were widely regarded as
equally remote from self-consciously civilized Europe. From an artistic
point of view, the word 'primitive' is historically unstable and now
deeply contentious. At the turn of the century it had already been
used by art historians to designate pre-Renaissance Italian and
Flemish art, and had been generalized to refer to ancient non-classical
cultures (Picasso sometimes used it this way) as well as, crucially,
contemporary Melanesian and Polynesian art, for example. Picasso's
'primitivism' is thus marked by dubious notions of cultural superiority
and inferiority. Describing Picasso's work as Aztec or, as Salmon did in
1912, as inspired by 'African and Oceanic enchanters', thus carries a
whole range of related ideas, such as 'crude', 'inferior', 'uncivilized',
'immoral' and at the deepest level 'inhuman'. For example, Salmon
thought the 'masks [in the painting] delivered of all humanity', and

continued, 'in choosing primitive artists as his guides [Picasso] was in no way unaware of their barbarity.'

The nature of Picasso's interest in 'primitive' art of various kinds has been a vexed question. In writings on the *Demoiselles* itself, discussion has largely focused on the issues of when Picasso first saw 'tribal' objects and to what extent such objects provided visual models for him. As far as we know, Picasso first visited the Trocadéro Ethnographical Museum in 1907, probably on Derain's advice. In a famous statement from the 1930s he described this visit as the occasion of an epiphany in which he grasped the meaning of tribal objects as works of 'exorcism':

The masks weren't just like any other pieces of sculpture. Not at all. They were magic things ... The Negro pieces were *intercesseurs*, mediators ... They were against everything – against unknown, threatening spirits. I always looked at fetishes. I understood; I too am against everything. I too believe that everything is unknown, that everything is an enemy! ... all the fetishes were used for the same thing. They were weapons. To help people avoid coming under the influence of spirits again, to help them become independent. They're tools. If we give spirits a form, we become independent. Spirits, the unconscious (people still weren't talking about that very much) emotion – they're all the same thing. I understood why I was a painter. All alone in that awful museum, with masks, with dolls made by the redskins, dusty manikins. *Les Demoiselles d'Avignon* must have come to me that very day, but not because of the forms; because it was my first exorcism painting – yes absolutely!

This passage is profoundly influenced by Freudian notions of the unconscious and the concern with anthropology evident in the work of Picasso's Surrealist friends at the time, such as the writer Michel Leiris. Earlier in Picasso's career, before he came into contact with such ideas, he trenchantly denied having any interest in 'tribal' art, and denied its influence on his own work. This denial may have been a symptom of Picasso's own anxiety, and that of his admirers, over the idea of his passing off appropriations from 'tribal' art as his own original inventions. The authenticity of modern art's relation to

non-Western art has been defended by the notion of an intrinsic affinity between them, which makes formal similarities inevitable. Yet it remains true that, just as notions of 'relative development' reveal only the motives of colonialism and say nothing about the colonized, so Picasso's primitivism reflects only on Picasso, and has nothing reliable to say about the objects it embraced. The recent discovery of a cache of forty postcards among Picasso's papers in Paris, all the work of colonial photographer Edmond Fortier, suggests that he was intrigued by erotic fantasies of the primitive. The packaged exoticism of these postcards (42) and the 'artistic' poses of the models were as much part of Picasso's invocation of Africa as his retrospective celebration of the potency of tribal masks in the Trocadéro.

Whatever the case, it is clear that the late additions to the *Demoiselles* had radical consequences for its figuration. The two 'African' figures on the right were deliberately merged by the artist, as the head of the squatting female, cupped in her hand as it swivels outwards, was grafted into the crotch of the standing figure behind her. This juxtaposition, as was suggested in a pioneering essay by John Nash, makes the face into the fundament, the mouth into an anus or vagina. If one were to look for a single detail of the *Demoiselles* that acts like the black hole into which representation and contemplation had been sucked, it might be in the lozenge-shaped breast of the standing right-hand figure. The irrational shading of this breast, the armpit that adjoins it, and the uniform lozenge of almost equal proportions below it – all these taken together make a nonsense of what they are supposed to stand for. One critic, writing in 1960, saw this breast as detaching itself from the body, and thus as symptomatic of a general threat to the integrity of mass as distinct from space. This is the fragmentation, the dislocation of the ordering principles of representation. Ultimately, Picasso was not lying when he said that this 'exorcism' painting was against everything, since it threatens to break down the rules by which anything can appear in art.

Many of Picasso's friends seem to have found his painting disturbing or ridiculous. Braque was hardly close to Picasso in 1907. He had shown his new paintings of L'Estaque in the Salon des Indépendants

of 1907, and Picasso's friend Wilhelm Uhde bought five of the six, but Picasso was an artist whose career was already much more advanced. Returning to Paris in November, Braque went with Apollinaire to Picasso's studio. When Braque saw the *Demoiselles* he said something like, 'it's as though you wanted to make us eat tow or drink kerosene.' One way of reading this suggests that Braque obviously felt all the rage and hysterical fear that Picasso had harnessed in his picture. A bewildered and traumatized Braque compared looking at the *Demoiselles* to being tortured or force-fed petroleum. Kahnweiler offered another version of Braque's remark: 'It's as if someone had drunk kerosene to spit fire.' This gives a

42
Edmond
Fortier,
Malinké
woman,
West Africa,
1906

different mood, and makes Picasso into a street daredevil, his painting a circus act. Yet even a fire-eating stunt still leaves a disgusting taste in the mouth, and whatever Braque's precise retort, he obviously realized that this was an extreme and wilfully radical departure. A young ambitious artist, Braque was certainly hugely impressed. Picasso now stood for transgression and the new art, and Braque had his own reasons for joining him. A third artist, Derain, played an important role throughout the ensuing period during which Picasso's primitivism and Braque's Cézannist style were brought together.

Beyond this small group, other young artists (who will be properly introduced in Chapter 4) were rapidly becoming aware of similar artistic questions, but they remained more connected to the public through the Salons than would Picasso and Braque, whose work sold mainly through private galleries. Picasso's work was not formally exhibited in Paris after 1905, although it was on view in every other major European city up until World War I. Braque had five exhibitions between spring 1908 and spring 1909 – but after that none in Paris until after the war. This process of withdrawal was facilitated by Kahnweiler, who arrived in Paris in spring 1907 and quickly moved to establish a stable of leading radical artists.

Kahnweiler was intelligent and astute, and believed that absolute control of his artists was fundamental to his success and theirs. He therefore discouraged them from showing in the Salons and sometimes even abroad, and instead kept a watchful eye on visitors to his tiny gallery (4 x 4 m; 13 x 13 ft) on the rue Vignon, deciding what to show to whom and when. In return his artists received constant advice and encouragement, and regular payments. Although neither Derain, Picasso nor Braque signed a contract with Kahnweiler until 1912, and Picasso in particular profited from playing Kahnweiler off against such rivals as Vollard, the German was the artists' principal dealer from 1908 on, and an ad hoc arrangement of steady purchasing allowed them to work in relative freedom from financial worries. When contracts were finally signed, Picasso's was worth four times as much as Braque's. Ultimately, it is nearly impossible to know how many people saw their works after 1908, as it is not known what Kahnweiler had on display at any one time or what he might have pulled out of the store for a special viewing. Nevertheless, it is clear that many people noticed the calculated absence of Picasso, and to a lesser extent Braque, from the scene. 'I am afraid the mystery in which Picasso shrouds himself feeds his own legend,' wrote Vauxcelles in October 1912, 'Why doesn't he have a show, quite simply, and we shall judge him.'

If *Les Demoiselles d'Avignon* was not exhibited until 1916, and not well-known until after 1937, it was nevertheless reproduced at a surprisingly early date. In 'The Wild Men of Paris', an article in the

May 1910 issue of the New York journal *The Architectural Record*, an enthusiastic journalist, Gelett Burgess, wrote with now familiar fake indignation about the shocks of modern art, and the effrontery of modern artists:

Picasso is colossal in his audacity. Picasso is the doubly distilled ultimate. His canvases fairly reek with the insolence of youth; they outrage nature, tradition, decency. They are abominable. You ask him if he uses models, and he turns to you a dancing eye. 'Where would I get them?' grins Picasso as he winks at his ultramarine ogresses. The terrible pictures loom through the chaos. Monstrous, monolithic women, creatures like Alaskan totem poles, hacked out of solid, brutal colours, frightful, appalling! How little Picasso, with his sense of humour, with his youth and deviltry [sic], seems to glory in his crimes! How he lights up like a torch when he speaks of his work! I doubt if Picasso ever finishes his paintings. The nightmares are too barbaric to last; to carry out such profanities would be impossible. So we gaze at his pyramidal women, his sub-African caricatures, figures with eyes askew, with contorted legs and – things unmentionably worse, and patch together whatever idea we may ...

Burgess, on the advice of Matisse, visited Picasso's studio in 1908, and when the article eventually appeared Picasso seems to have been entertained rather than offended by it. Picasso was not the only 'Wild Man' it featured, and the inclusion of a number of former 'Wild Beasts' – Braque, Derain, Friesz and Auguste Herbin (1882–1960) – makes it clear that Burgess's title is a reference to Fauvism, which he still took to be the name for the most radical art in Paris. Alongside the *Demoiselles*, Burgess also got his photographer to make portraits of the artists themselves (43). In contrast to the 'insolent' and intense Picasso clutching his pipe and attended by his recently acquired New Caledonian sculptures and a bleached skull, Braque lived down the 'Wild' image by posing in his suit and tie. On the other hand, the Braque drawing that Burgess reproduced (44) was more appropriately 'abominable' and was presented in the article with a defence by the artist:

I couldn't portray a woman in all her natural loveliness ... I haven't the skill. No one has. I must, therefore, create a new sort of beauty,

the beauty that appears to me in terms of volume, of line, of mass, of weight, and through that beauty interpret my subjective impression. Nature is a mere pretext for a decorative composition, plus sentiment. It suggests emotion. I translate that emotion into art. I want to expose the Absolute, and not merely the factitious woman.

Braque's *Woman* is in fact three views of the same woman. Although it was not so different in conception from academic subjects of the Three Graces or the Three Theological Virtues, in which three figures stand for facets of a single idea (beauty or Christianity respectively), Braque explained his work to Burgess with the architectural metaphor of the plan, elevation and section that add up to the complete view of a house. Even at this early stage, Braque saw his art as based on sound and serious principles. The painting for which the drawing was a study is now lost, but it is known that it was shown in the Salon des Indépendants of 1908, alongside Derain's related work *La Toilette*, also now lost. Whatever the conventional compositional precedents

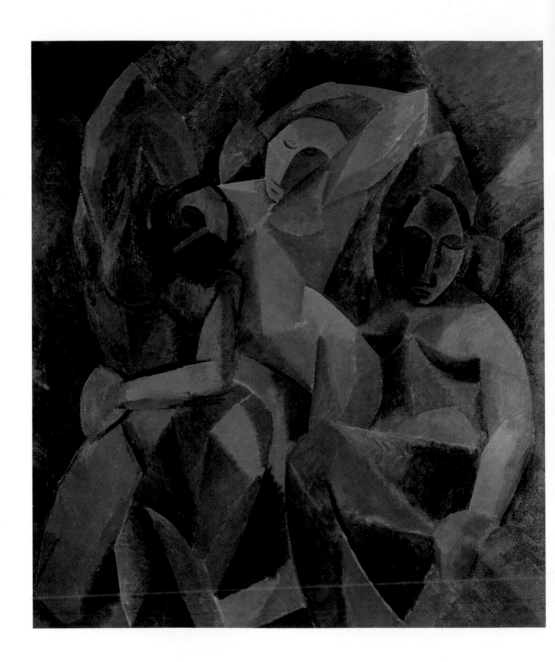

for Braque's work, it is also obvious that it constitutes some sort of response to Picasso's 'sub-African caricatures'. Moreover, Braque's philosophy of art is echoed in the earliest reports of Picasso's admiration for non-Western objects. Just as Picasso is said to have described African sculpture as more '*raisonnable*' ('sensible' or 'rational'), 'rigorously logical' and 'geometrically simple' than Western art, so Braque defended his work as an ideal vision of the 'Absolute' woman – a figure existing beyond the fugitive world of everyday perception. As will be seen, such remarks have led to the influential but inaccurate

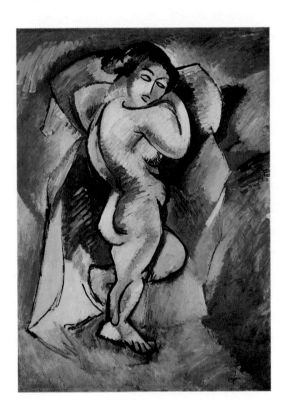

45
Pablo Picasso,
Three Women,
1907–8.
Oil on canvas;
200 × 178 cm,
78³⁄₄ × 70⅛ in.
Hermitage,
St Petersburg

46
Georges
Braque,
Large Nude,
1907–8.
Oil on canvas;
141·6 ×
101·6 cm,
55³⁄₄ × 40 in.
Galerie Alex
Maguy, Paris

view that Cubism represents the 'conceptual' rather than 'perceptual'. In the two-year period between Burgess's visits to the studios of Braque, Derain and Picasso and the publication of his article, Cubism was invented, and the distinction between Kahnweiler's private gallery artists and the wider circles of the avant-garde in Paris began to form.

Until recently it was thought that Picasso suffered a hiatus in his production after the *Demoiselles* received such disappointing

reactions. It now seems, however, that he completed other primitivist works already in hand (eg *Nude with Raised Arms*), moved straight on to a number of still-life pictures, and by the autumn to other figure paintings, including *Nude with Drapery* (now in the Hermitage, St Petersburg), *Three Figures under a Tree* (now in the Musée Picasso, Paris) and the first state of an important work called *Three Women* (45). All of these were probably present in the studio when Braque visited in November, and his lost *Woman*, as well as the awkward painting known as the *Large Nude* (46), were indeed closer to *Three Women* than to the *Demoiselles*. Picasso's *Three Women*, and another work, *Friendship* (also in the Hermitage, St Petersburg), may be studies for, or by-products of, a planned five-figure work representing a strange meeting by a riverbank, which never got further than some elaborate compositional sketches. This subject has none of the obvious and potent meanings that the brothel had, and the dark woodland tonality reflects a sombre, not to say somnolent, atmosphere in both works. The closed eyes of the right-hand figure in *Friendship*, and of all the *Three Women*, suggest introspection or only nascent awareness in the forest gloom. These works have indeed been interpreted as depicting a kind of primordial striving for consciousness, and – given their ambiguous gender – for sexual difference. Despite this underlying sexual theme, *Three Women*, even in its first more 'African' form evident in a photograph of Salmon in Picasso's studio (47), was a less fraught and hysterical work than the *Demoiselles*, which stood behind it covered with a dust-sheet.

It can be surmised that Picasso was fascinated by 'tribal' art at this time. One of his first acquisitions as a collector of 'primitive' art, besides the New Caledonian roof-post carvings in the Burgess photograph (see 43), was an Oceanic Tiki figure that accompanies Apollinaire in Picasso's photographic portrait of 1910 (see 16). This collecting did not cease with what is misleadingly – given the equal importance of Oceanic art – called his 'African' style, and by 1910 he is known to have owned a Fang sculpture and a Muyuki mask (from Punu, Gabon) visible in the top right corner of a photograph of Kahnweiler (48). Although his works are not direct imitations, Picasso's figure style up to 1909 borrows much from African and Oceanic art, and

47
Pablo Picasso,
André Salmon
in front of
Three Women,
1908.
Gelatin silver
print;
11·1 × 8·1 cm,
4⅜ × 3¼ in.
Musée
Picasso, Paris

48
Pablo Picasso,
Daniel-Henry
Kahnweiler,
1910–11.
Modern
gelatin silver
print from
original glass
negative.
Musée
Picasso, Paris

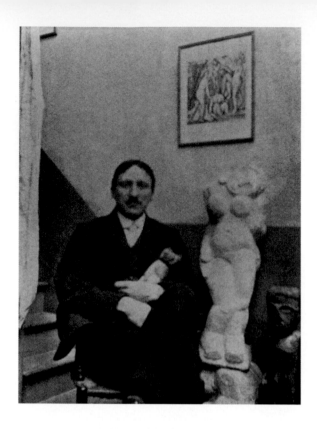

many texts apply the epithet 'sculptural' to his paintings. It is known
that Picasso and Derain worked on primitivist sculptures in wood and
plaster in the years 1907–8, and Derain proudly sits among them in
his Burgess portrait (49). It is this sculptural interest that has been
widely interpreted as the basis of the interaction of Braque, Derain and
Picasso at this time, since it is thought to relate directly not only to
non-Western precedents but also to the interrogation of Cézanne's art
– a presence also signalled in the photograph of Derain by a print of
Cézanne's *Five Bathers* of 1885–7. Derain's own major canvas of 1908–9,
Bathers (50), reflects his fascination with Cézanne, but also his attempt at
the studied awkwardness that now stood for the 'primitive' or 'savage'.

The Cézanne memorial show in the Salon d'Automne of 1907
coincided with Braque's exposure to Picasso's primitivism. Travelling
back and forth from L'Estaque that autumn, Braque finished several
works he had begun there (51) in direct response to late Cézanne
landscapes such as *The Cistern in the Park of the Château Noir* (52).

50
André Derain,
Bathers,
1908–9.
Oil on canvas;
180 × 225 cm,
70¾ × 98½ in.
Národní
Gallerie,
Prague

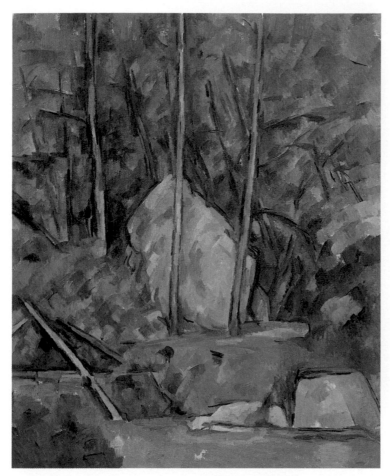

51
**Georges
Braque**,
*Terrace of the
Hôtel Mistral*,
1907.
Oil on canvas;
80 × 61 cm,
31½ × 24 in.
Private
collection

52
Paul Cézanne,
*The Cistern in
the Park of the
Château Noir*,
c.1900.
Oil on canvas;
74.3 × 61 cm,
29 × 24 in.
Private
collection

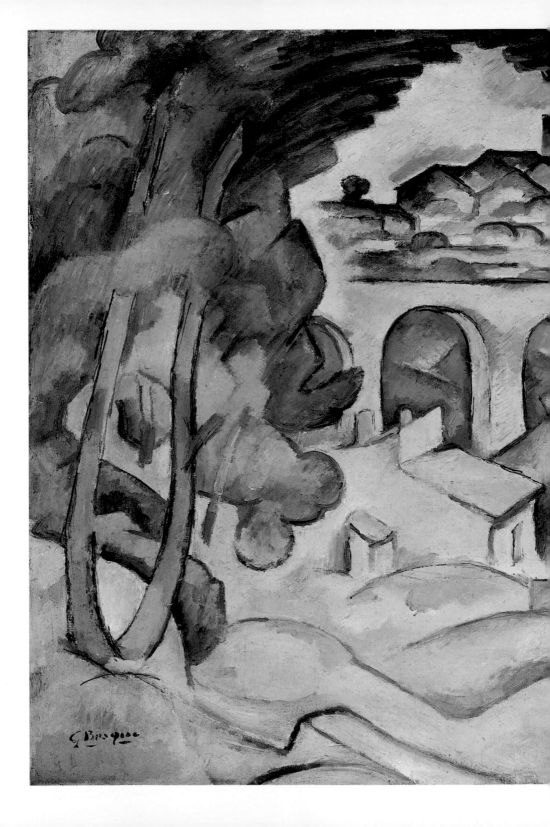

53
Georges Braque,
Viaduct at L'Estaque,
1907.
Oil on canvas;
65·1 × 80·6 cm,
25⅝ × 31¾ in.
Minneapolis
Institute of
Arts

The heavier and more restricted range of tones in Braque's work, and the use of the wall and trees to mark the relationship between deep and shallow space, reflect the impact of Cézanne. The simplified masses of the trees and buildings depart from Cézanne's complex visual translation of form into swatches of colour, however, and this tendency to draw only selectively on Cézanne is equally evident in pictures completed entirely in L'Estaque (53). Here other features of Cézanne's work come to the fore, while the palette is closer to Braque's earlier Fauvism.

The most striking aspect of *Viaduct at L'Estaque* is the layering of contours to suggest progression into distance, while leaving the precise spatial relationships between each plane unclear. The viaduct and distant factories largely dissolve into a yellow haze before they make contact with the framing trees – a decision that, far from pushing them into the distance, suggests a piling up of one mass on another. Cézanne frequently adopted a distant (and often high) viewpoint for his compositions. This viewpoint creates tensions, which the artist sought to activate, between the signs of recession in space and the surface patterns of the painting. In exploiting these tensions Cézanne was not attempting to create mere visual paradoxes but to respond accurately to the conditions under which we see the world, or rather contemplate it. Cézanne realized that the everyday world constantly oscillates in perception between breadth and depth, but as an artist he attempted to capture the strange dynamic of this oscillation, and thereby touch its ultimately mysterious or even religious character. In a statement published posthumously in October 1907 by Cézanne's admirer Émile Bernard, the artist attempted to explain his project:

... treat nature by means of the cylinder, the sphere, the cone, everything in proper perspective so that each side of an object or a plane is directed towards a central point. Lines parallel to the horizon give breadth, that is a section of nature, or, if you prefer, of the spectacle which the Pater Omnipotens Aeterne Deus [God the Almighty Eternal Father] spreads out before our eyes. Lines perpendicular to this horizon give depth. But nature for us men

is more depth than surface, whence the need of introducing into our light vibrations, represented by reds and yellows, a sufficient amount of blue to give the impression of air.

The obscurity of these ideas made it easy for later enthusiasts to ignore them and latch on to the opening statement as the sole basis for Cubist interest in Cézanne. In fact, neither Cézanne's argument nor Cubist responses to his art had much to do with any systematic application of geometry to painting, even acknowledging the fact that his perspectival advice derives from simple textbooks on drawing techniques. Cézanne was instead concerned with the mystery of how, in vision, nature appears both to exist independently of human needs and at the same time to offer itself up to them. It is extremely difficult to be precise about ideas that are so metaphorical, let alone apply them to the paintings, but a brief attempt is necessary before further discussion of Braque's 'Cézannism'.

Cézanne believed that the depth of the world was a product of the human place in it, and his art sought to relate this human depth to the divine field of dematerializing light. In pictorial terms Cézanne wanted both the field of light – which, as a late Mont Sainte-Victoire painting shows (see 14), he translated into patches in the more limited range of intensity found in the painter's colours – and the ordered recession

54
Paul Cézanne,
Still Life with Apples and Peaches,
c.1905.
Oil on canvas;
81·3 × 100·7 cm,
32 × 39⅝ in.
National Gallery of Art,
Washington DC

of the things that make up the world from a human point of view. Hanging on to both of these aspects of perception gave rise to the spatial conundrums of his paintings, but also to their astonishing density and energy. In paintings such as *Still Life with Apples and Peaches* (54), the folds of the curtain navigate depth while its pattern pulls it towards the viewer in a uniform closeness. The linking of the top and bottom of the canvas by the two pieces of cloth is another move in this dialectic between an ever-closer bubbling surface of colour and a journey into profound clefts or tunnels in space. The forwards and leftwards tilt of this world pulls and pushes objects between surface and depth too – the ellipse of the jug is hard to reconcile with the thinner lip of the bowl, at least according to the laws of single-point perspective.

Cézanne reflected at length on the task of painting, and other factors are in play in his rendition of this array of fruit, including his fascination with accounting for the effects of slight shifts in his own viewing position, and, according to one recent interpretation, to a belief in the power of colour to evoke tactile sensations. Whatever the case, it is clear that Cézanne, working in self-imposed artistic exile in Aix-en-Provence for many years, was attempting to overcome both the imperatives of everyday practical engagement with the world and the impact of artistic conventions for representing nature. His extended reflection on the act of painting was an effort to capture vision itself, the experience in which the distinction between us and the world is always provisional, and in which, for him, human and pre-human meet. Representing this foundational vision is probably possible only in an aesthetic activity such as painting, but at the same time Cézanne was redefining painting for the next generation as an art concerned not with beauty but with the fundamental nature and meaning of the visible.

Having spent the winter of 1907–8 in L'Estaque, Braque returned to Paris and painted another version of the *Viaduct at L'Estaque* (55), this time making more obvious reference to Cézanne's use of short directional colour swatches and ambiguous spatial transitions marked by patterning elements (foliage in this case). Yet there are elements of an arbitrariness unfamiliar in Cézanne – including the strange daub at top right – the vestige of the factory chimney from the earlier version.

55
Georges
Braque,
*Viaduct at
L'Estaque*,
1908.
Oil on canvas;
72·5 × 59 cm,
28⅜ × 23¼ in.
Musée
National d'Art
Moderne,
Centre
Georges
Pompidou,
Paris

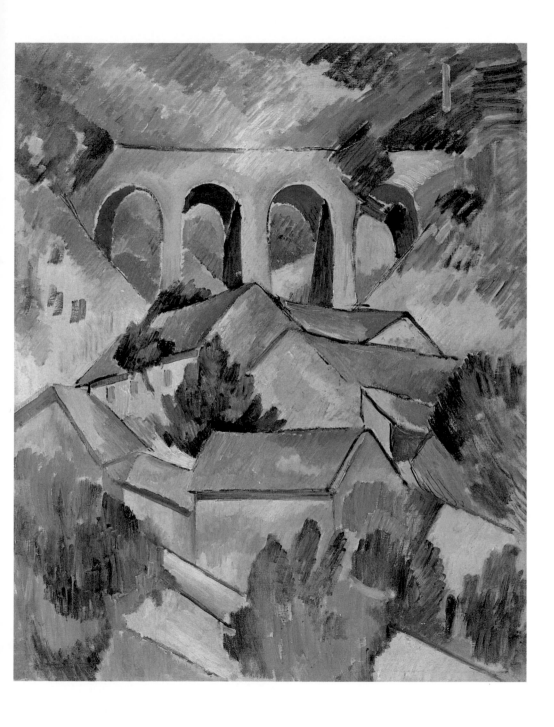

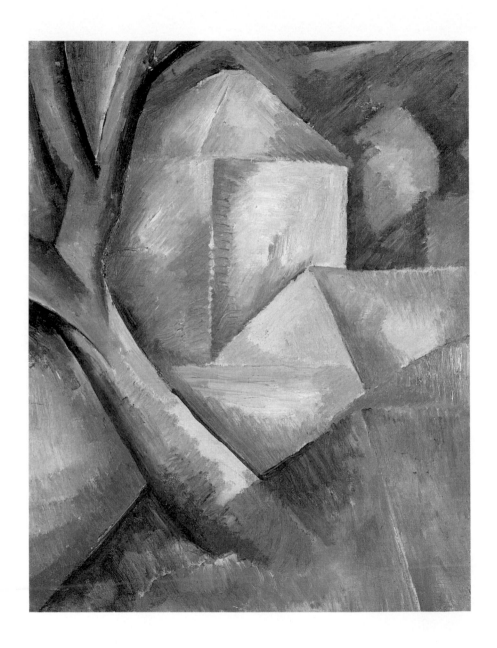

More significantly, Braque has been said to mis- or reinterpret the Cézannean device known as *passage*. In fact, the French word *passage* is used rather vaguely in the discussion of Braque's work. The dispute over the term conducted in the 1970s is a salutary reminder of the challenge posed by this kind of visual art. One art historian glossed it as the breaking of the contours of forms at some point 'so that the planes they define ... spill or bleed into adjacent ones' (William Rubin); another as 'the running together of planes otherwise separated in space' (Edward Fry); a third as the areas of the painting in which planes do not so much run together as 'desist from their task of convergence to

56
Georges
Braque,
*House at
L'Estaque*,
1908.
Oil on canvas;
40·5 × 32·5 cm,
16 × 12¾ in.
Musée d'Art
Moderne de
Lille
Métropole,
Villeneuve
d'Ascq

57
Daniel-Henry
Kahnweiler,
Photograph
of the motif
in Georges
Braque's
*House at
L'Estaque*,
1910

align with the picture plane ... they have [in other words] ceased to be planes' (Leo Steinberg). Looking at Braque's 1908 *Viaduct* painting, it is clear that there are few places where planes are left unbounded on one or more sides – the central area with the two gable ends is the best candidate – but many places where the edge of one plane is obscured by another. The roofs and walls of the houses also rhyme and their edges line up in a way that advertises artifice. As superficially similar as Braque's work is to Cézanne's, it is obvious that this bold artifice is not something that Cézanne aimed at, and it is a sure sign

of the difference between the two artists that Braque's painting depends heavily on line drawing – something that was anathema to Cézanne's project to render vision in terms of colour.

During his summer visit to L'Estaque in 1908, Braque made a number of paintings that reflect continuing Cézannean apprenticeship, perhaps a more profound one than hitherto. He took up subjects that for Cézanne had put the sense of depth under pressure, such as a road bending and winding into pictorial space. *House at L'Estaque* (56) and another similar work (see 3) are generally treated as both the culmination of this trip and among the first truly Cubist paintings.

In the summer of 1910 Kahnweiler visited L'Estaque and made a number of photographs of the motifs in Braque's 1908 works, including one of this same tree and the houses behind it (57). This comparison is illuminating, since it reveals not only how Braque improvised with Cézannean effects but also how he let ideas about the picture overtake what he saw before him. Pushing the tree over to the left of the house, Braque made the relationships between the walls and the roof more conspicuous. He applied an inconsistent chiaroscuro (modelling with light and dark tones), in which the light seems to fall now from the right, now from the left. At the same time, the shapes formed on the picture surface by the overlapping of objects in the represented space are made to relate to each other: the foliage at bottom right, for example, forms itself into a strange ridge that tries to link up with the eaves of the house above it. Finally, Braque inserts an area of house colour into the cleft in the tree to top left where, as is evident in the photograph, there should be foliage. Whereas Cézanne sought to capture depth and surface at the same time by representing the world in a logic of colours, Braque, reducing his palette to a crude code, has perhaps let the superficially odd effects of Cézanne's system overtake the logic. It could also be said that Braque has begun to abandon coherence of illusion – but what replaces it? The answer cannot be simply 'incoherence', since everything in the painting is obviously tightly controlled and balanced. The detached piece of 'house' colour, or the contagious ridges, or the rhyming triangles, are like elements of the world set free to circulate in the painter's imagination.

So far a number of 'sources' for Cubism have been outlined, including those most frequently mentioned in studies of the movement: Picasso's engagement with 'African' art and Braque's with Cézanne. There have been persistent attempts to explain the origins of Cubism, to account for its development in terms either of artistic sources such as these or of social factors. Furthermore, many writers have even been tempted to argue over which individual artist finally invented Cubism (recently the honour has usually gone to Braque). Nevertheless, even discounting the fact that Picasso had already shown awareness of Cézanne's art before meeting Braque, his race to convert himself from primitivism to Braque's strange Cézannean inventions produced its own rich vein of discovery. After a number of sombre still lifes reminiscent of Spanish seventeenth-century painting, Picasso made a crucial visit to the village of La Rue des Bois during August 1908. His *Cottage and Trees* (58), which begs comparison with Braque's *Houses at L'Estaque*, reveals an uncanny sense of common purpose between two artists working in different parts of France. The comparison is revealing for the differences as well as similarities, however: Picasso's use of arabesques and high contrasts gives his work an agitation absent from Braque's. Perhaps most significant is Picasso's willingness to push the chiaroscuro effects in the house at the top of the composition into an extreme contradiction with those in the wall below, so that concave/convex illusions wax and wane before the viewer's eyes. Choosing between Picasso and Braque as inventors of Cubism is going to be difficult, then – and may not even be necessary.

What of arguments that say Cubism was the product of the wider social context? Some focus on the political as well as artistic climate in which these artists were working. It has been said that Braque (like many other artists at this time) was seeking a more solid basis for his art than Fauvism had offered him – a reasoned, temperate, intellectual and even 'classical' art. The art historian Theodore Reff, for example, suggests a connection between resurgent political nationalism in France, the related promotion by some of artistic Neoclassicism after 1905, and the sculptural, austere and supposedly 'conceptual' or rational qualities of the early Cubist paintings. Braque later said that

he wanted to get away from the 'paroxysm' of Fauvism, and in turning to Cézanne he may have seen a parallel with Cézanne's struggle against the perceived superficiality of Impressionism in line with artist-theorists such as Maurice Denis (1870–1943). Reff uses a widely cited remark made by Cézanne, that he wanted 'to redo Poussin [the great seventeenth-century exponent of academic classicism] after nature', in support of his idea that Cubism was as much a conservative or reactionary invention as a progressive or radical one. Cézanne did have a sustained relationship to the art of Poussin, and this relationship had a cultural and political significance for him as well as an artistic one, relating to the resurgence of regionalism in his native Provence, which celebrated a perceived continuity from the greatness of classical civilization to a modern Provençal race. Yet visual comparisons between Braque and Poussin, or with any of the painters espousing Neoclassicism around 1908, do not bear out the same points for Cubism.

58
Pablo Picasso,
Cottage and
Trees,
1908.
Oil on canvas;
92 × 73 cm,
36¹⁄₄ × 28³⁄₄ in.
Pushkin
Museum of
Fine Arts,
Moscow

Few subsequent interpreters of Cubism see much in common between it and the Renaissance rules of perspective and composition that were Poussin's guide, and Braque himself later poured scorn on these rules. It is true that some later defenders of Cubism saw in it a new kind of 'classicism', but at the same time they were redefining this slippery term. Political context is evidently important for some other versions of Cubism, but it can have no simple causal relationship to the work of Braque and Picasso at this time. David Cottington has argued convincingly that, if Kahnweiler's artists are to be thought of in a political context, it should be precisely in terms of deliberate withdrawal from direct engagement with the nationalism of the Third Republic. In other words, the particular currents of French politics around 1910 are remote from the Cubism of Braque and Picasso. Perhaps the question to ask is not 'What were the origins and causes of Cubism?' but 'What did these paintings mean?' What exactly was this new art, and what had it achieved?

Unfortunately, the press reaction to Braque's hugely important small exhibition at Kahnweiler's gallery in November 1908 is not much help in providing answers. Braque showed L'Estaque landscapes, including

Houses at L'Estaque (see 3), possibly together with the now lost painting *Woman*, and Apollinaire provided a lyrical and perceptive catalogue preface. Writing in the paper *Gil Blas*, Vauxcelles hardly seems to have welcomed a return to a great French tradition, nor to have been bowled over by a new vision of the world:

Braque Exhibition. At Kahnweiler's, 28 rue Vignon

M. Braque is a young man of great audacity. The bewildering example of Picasso and of Derain has emboldened him. Perhaps, too, Cézanne's style and reminiscences of the static art of the Egyptians have obsessed him disproportionately. He constructs deformed metallic men, terribly simplified. He despises form, reduces everything, places and figures and houses, to geometrical schemas, to cubes. Let us not make fun of him, since he is honest. And let us wait.

Vauxcelles tries to explain Braque's style in terms of influences (Picasso, Derain, Cézanne, Egypt). Beyond the prophetic remark about cubes, for which there is at least some justification in the houses of the L'Estaque landscapes, Vauxcelles argues that Braque is an earnest if misguided opponent of proper art. In saying that Braque makes 'deformed' pictures and 'despises form', on the other hand, Vauxcelles goes further, suggesting that Braque is an outright enemy of beauty or traditionally noble and pleasing forms. A more thoughtful response came from Charles Morice (admittedly, writing at much greater length in the periodical *Mercure de France*), who sensed a systematic intelligence rather than hot-headed shock tactics at work in Braque's exhibition. Perhaps mindful of Cézanne's remark on the use of 'the cylinder, the sphere and the cone', Morice wrote: 'Visibly, he proceeds from an a priori geometry to which he subjects all his field of vision, and he aims at rendering the whole of nature by the combinations of a small number of absolute forms.'

This way of understanding Cubism was to become very influential among its early interpreters. A priori is a Latin term that was used by the eighteenth-century German philosopher Immanuel Kant to designate innate ideas or mental structures, as opposed to a posteriori ideas, which are based on experience. This language sounded impressive,

but, as will be seen in later chapters, the casual way the terms were applied to visual art makes it clear that they were often little more than jargon. Superficially it must have seemed strange to talk of an a priori visual art since, in the early years of the twentieth century at least, visual art by definition concerned itself with experience of the world rather than geometry or abstract ideas. Whereas Morice is careful to suggest that geometry is only Braque's starting-point, however, many who adopted this kind of language confused the matter and introduced other philosophical traditions into the argument. Looking back at Braque's early statement to Burgess, for example, his claim that he wanted to represent the 'absolute' woman rather than a particular woman is clearly reminiscent of Platonic philosophy. Plato, the leading philosopher in early fourth-century BC Athens, believed that the world existed as an imperfect reflection of a higher and more perfect realm of ideas, where all things were lucid, harmonious and true, and where no gap could exist between seeing and knowing. According to Plato, this 'absolute' realm was by definition beyond the reach of artists, at least insofar as they imitated the deceptive look of the everyday world. Braque's lost threefold *Woman* was designed to conjure up 'absolute' woman by abandoning visual appearances in favour of a rational scheme evoking architectural drawing. This painting was probably exhibited in the Kahnweiler show, in which case it would have been the object of Vauxcelles' erroneous reference to 'deformed metallic men', and a part of what Morice thought of not as Platonic idealism but as a Kantian a priori art.

Much later in life Braque suggested a very different view of his Cubism. Although he still thought Cubism freed painting of false illusionism, he believed that it was an art not of Platonic idealism and geometry but of intensified realism, which brought the world closer to the spectator, so close in fact that it was within reach:

You see, the whole Renaissance tradition is antipathetic to me. The hard-and-fast rules of perspective which it succeeded in imposing on art were a ghastly mistake which it has taken four centuries to redress: Cézanne and, after him, Picasso and myself can take a lot of credit for this. Scientific perspective is nothing but eye-fooling illusionism; it is

simply a trick – a bad trick – which makes it impossible for an artist to convey a full experience of space, since it forces the objects in a picture to disappear away from the beholder instead of bringing them within his reach, as painting should.

Like Plato, Braque clearly thought that mere 'eye-fooling' was not what painting should be about, but he does not go as far as suggesting that it should abandon the visual world or simply represent abstract (*eg* 'geometric') motifs. Rather, Braque argued that Cubism had overcome the false distancing effect of Renaissance perspective, and discovered a way of pulling the visual world to a point within the viewer's grasp. This discovery was in fact more of a rediscovery, since as far as Braque was concerned, Cubism simply restored an understanding of space in visual art repressed by Renaissance perspective. The important idea that medieval art offered some kind of precedent for Cubism did not go unnoticed by early critics either, but perhaps it has not been taken seriously enough in subsequent interpretations, as a brief look at Picasso's major work of the winter of 1908–9, *Bread and Fruit Dish on a Table* (59), might suggest.

This large painting depicts a drop-leaf table against a heavy green curtain not unlike those in Cézanne's still lifes. The far edge of the table shifts position behind the objects in the centre. The objects themselves are also partly Cézannean – the bowl brimming with fruit and the stray apple resting on the white folding cloth. On the right two loaves of bread are propped against the wall, and another rests over the edge of the table in the centre. The most unusual detail is perhaps the upturned cup – until the strange green legs beneath the table leaf are noticed. It is now known that these are the phantom limbs of the narrative figure painting that Picasso originally planned. The composition known as *Carnival at the Bistro* (60) showed Harlequin seated in the centre with a nude figure to the right and another carrying a plate of fruit behind him. The clothed figure to the left appears to have a halo. This composition has recently been read as a kind of Temptation of St Anthony (a religious subject dear to the young Cézanne). In a process not unlike the compression of the narrative in the *Demoiselles*, Picasso reduced the number of figures in a sombre

59
Pablo Picasso,
Bread and Fruit Dish on a Table,
1908–9.
Oil on canvas;
164 × 132.5 cm,
64⅝ × 52¼ in.
Kunstmuseum,
Basel

60
Pablo Picasso,
*Carnival at the
Bistro*,
1908–9.
Watercolour
and pencil;
21 × 22.5 cm,
8¼ × 8⅞ in.
Private
collection

61
Pablo Picasso,
*Carnival at the
Bistro*,
1908–9.
Gouache
and ink on
paper sheet;
32 × 49.5 cm,
12⅝ × 19½ in.
Musée
Picasso, Paris

gouache (61); the haloed figure is removed, and the seated figure to the right acquires a hat. Yet whereas the *Demoiselles* remained a figure painting, Picasso decided to transform his cast of characters into inanimate objects, and to let their heads and torsos vanish into spaces and shadows.

One convincing reading of this act of transformation is that it marks a crucial shift in Picasso's art from narrative to iconic, that is from a painting dependent on a story of sorts to one whose main interest is the painter's skill in representation. There is no doubt that the final work does show off remarkable powers in its sculptural effects, but it is hard to ignore the uncanny human characteristics of the oddly grouped objects. Picasso's biographer John Richardson has argued that the artist wanted 'to play Christ' in an act of pictorial (and inverted) transubstantiation – turning bodies into bread – and that in any case the original scene was a kind of parody or mockery of a Last Supper.

62
Jan de Molder,
Altarpiece
of the Mass of
St Gregory,
1513–14.
Polychrome
wood;
228 × 205 ×
33 cm,
89¾ × 80¾ ×
13 in.
Musée
National du
Moyen Age,
Paris

In this vein, a work that offers a particularly interesting point of comparison is a deep relief carving of a Mass – the ceremony that re-enacts the Last Supper – which was on display in the Musée de Cluny in Paris during the Cubist years. In terms of strict historical periodization, the Flemish artist Jan de Molder (fl. *c*.1513–18) made his altarpiece of the Mass of St Gregory (62) during the Renaissance, but its spatial illusions are nearer to the pre-Renaissance art that Braque thought was pre-eminently like Cubism. The tilting of the table in the scene to the bottom right, and the distended forms of the communion cups in the centre, provide neat precedents for Picasso's still life. In the Molder these deformations are the means to conjure up space in relief sculpture; in the Picasso they show painting (in an artistic game that becomes typical of his Cubism) emulating the weird look of a carved relief when seen from too close or to one side.

Some early explanations of Cubism refer to works by medieval artists (or the 'primitives' as they were often called) as sharing the same conceptual truth. This was a persuasive if rather crude argument, which took account of the kind of subtle play on medieval relief sculpture found in Picasso's painting, and was yet another version

of the claim that Cubism drew on either Platonic ideas or Kantian a priori knowledge. By 1912 Olivier Hourcade, a poet and defender of Cubism, made a similar argument using the example of Protestant (*ie* post-Renaissance) architecture:

The painter, when he has to draw a round cup, knows very well that the opening of the cup is a circle. When he draws an ellipse, therefore, he is not sincere, he is making a concession to the lies of optics and perspective, he is telling a deliberate lie. [The Cubist] on the contrary, will try to show things in their sensible truth ... length, height and breadth, as the Bibles are represented on the pediments of Protestant churches.

Whereas Cézanne's tipping of cups and bowls towards the spectator was motivated by a desire to express the tension between depth and surface, this argument suggests that Cubism, in adopting Cézanne's device, was simply trying to be more ideal, more rational, more a priori, than perceptual. A similar position was taken in 1912 by the important Cubist critic Maurice Raynal in at least three essays, except that here the attack on Renaissance values that Braque later adopted is made explicit. Here is the section of the first essay in which the argument appears:

If art is required to be not merely a means of flattering the mind and the senses but more the means of augmenting knowledge, its function will only be served by painting forms as they are conceived in the mind; the primitives understood this very well.

When Giotto painted that picture in which, behind the men seen in the foreground, there is a fortified town, he showed the town in bird's-eye view. He thus described it as he had conceived it – that is to say, complete, all of its parts at once. In this picture he respected neither perspective nor visual perception; he painted the town as he thought it and not as the people in the foreground might have seen it.

At the same time the primitives conceived not only the forms of the objects but also their qualities of form. When a primitive had to paint armed men crossing a bridge, the first thing that struck him was the idea 'armed man', which was indeed more important than the idea

'bridge', so the painter made the armed men much bigger than the bridge; which may be contrary to the laws of visual perception but it is not contrary to those of reason.

Hence it is altogether regrettable that the artists who came after the primitives should have thought it right to abolish the principle of conception and substitute that of vision.

What emerges from these arguments is that, first, although Braque was not necessarily theoretically inclined, he may well have found ideas in the writings of these critics that he could later use to interpret his own invention. Secondly, although the theories of Cubism as a priori were very generally conceived and bear little precise relation to the work of Picasso and Braque, medieval art figured as an example in arguments supporting Cubism. It is this strange point of comparison for Cubism that perhaps contains the best clue as to its early nature and makes it possible to identify what the two artists had achieved in their departure from existing pictorial conventions of spatial illusion. In *Bread and Fruit Dish on a Table* (see 59), earlier compared to Molder's relief carving, Picasso was running with the idea of 'sculptural' painting – significantly different from the idea of 'painting as sculpture'. The medium of relief sculpture is obviously closer to painting than free-standing figure sculpture, and this closeness allowed the paintings, by flirting so to speak with their immediate neighbour in another medium, to assert themselves and their own limits more forcefully than ever. In his review of the 1908 exhibition, Morice recognized this ultimately ironic 'sculptural' tendency in the work of Braque as well, concluding: 'These strange signs, which I am unable either to praise or condemn, remind me of an admirable and useful saying ... "Think of what it would be like as a statue".'

This throwaway phrase arguably had quite an impact on Braque and Picasso. During the winter and into the spring of 1909, the two became close collaborators for the first time, Braque concentrating on still life and landscape, and Picasso working largely on figure paintings. The summer of 1909 saw Picasso leave for Barcelona and then Horta de Ebro (now Horta de San Juan) on the western borders of Catalonia near Tortosa in Spain, and Braque travel to La Roche

Guyon, a riverside village with a dramatic castle on a cliff (painted by Cézanne) to the north-west of Paris. Just as Picasso's *Bread and Fruit Dish on a Table* seems like a literal depiction of an imaginary relief, so the extreme vertical stacking of buildings and trees in Braque's La Roche Guyon canvases (63) is not simply a Cubist invention but a partly literal rendering of the steep cliff-hugging castle – pictorial relief effects are thus matched by reality. Braque and Picasso periodically sought subjects that produced this paradoxically realistic result for Cubist devices. At the same time, it is clear that Braque uses many of the thoroughly non-realist devices he had developed in the L'Estaque pictures: the lozenge formed by foliage that holds the dynamic jostling of the houses in place; the limited range of schematic colours; the odd combination of extreme chiaroscuro and *passage*.

Picasso's paintings of Horta (64) do not have the same shallow and homogenizing quality that Braque was finding in La Roche Guyon. Instead the mass of the village is forcefully distinguished from the distant mountains, and the artist strives to create maximum spatial contradiction, largely without giving up the difference between solid things and the spaces between them. Most of the Horta visit was devoted to paintings not of the village but of the head and shoulders of a woman, loosely based on Fernande Olivier. Here Picasso's expressive but freewheeling exploration of the new idiom sometimes suggests that the woman in the picture is not merely stylized but – in contrast to the rounded pears in one painting (65) – really is faceted and carved. It is as if we were looking at a mysterious other world, rather than our own world translated into another language. The nature of the illusion here also means that, just as the compressed three-dimensional objects and space in Molder's altarpiece only make visual sense from one place, the woman in the painting is all forward-facing, and it is not clear what it would be to move around or 'behind' her.

On his return to Paris, Picasso made a move that would become characteristic of his long career. Having made pictures that included figures without backs in spaces that implied that they must have backs, he set about making the relief-like head of Fernande in the Horta paintings into a three-dimensional sculpture (66). The hair and

63
Georges Braque, *Castle at La Roche Guyon*, 1909.
Oil on canvas; 92 × 73 cm, 36¼ × 28¾ in.
Stedelijk van Abbe Museum, Eindhoven

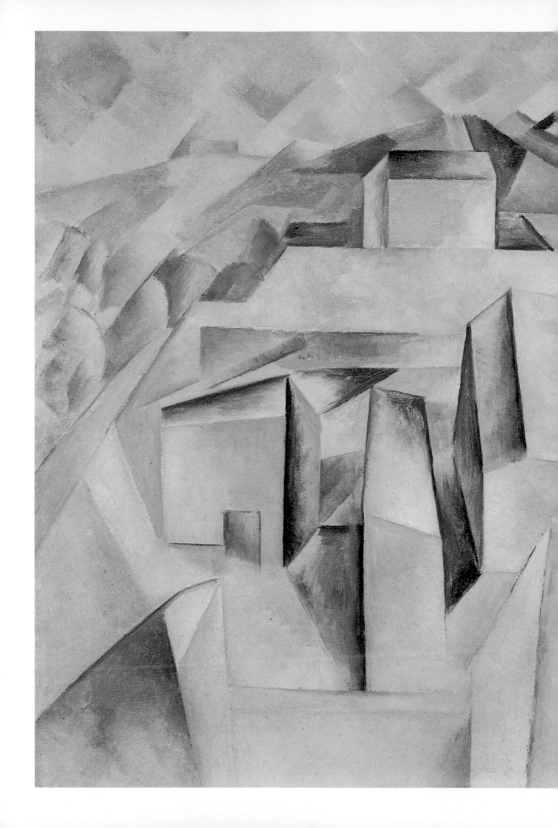

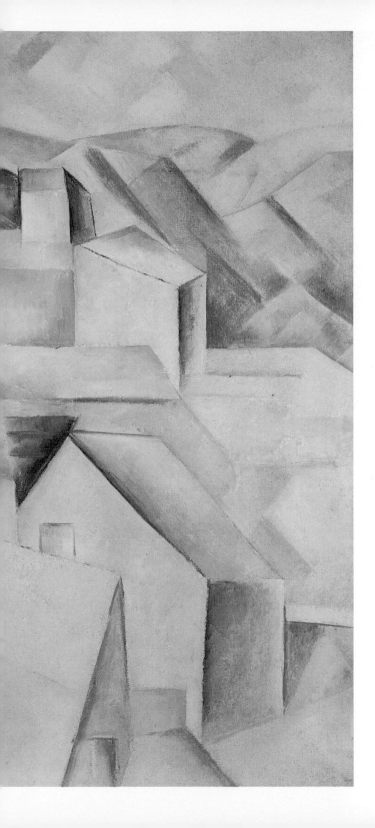

64
Pablo Picasso,
*Houses on
the Hill,
Horta de Ebro*,
1909.
Oil on canvas;
65 × 81 cm,
25⅝ × 31⅞ in.
Museum of
Modern Art,
New York

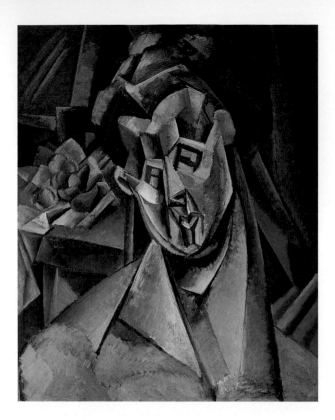

65
Pablo Picasso,
Woman
with Pears
(Fernande),
1909.
Oil on canvas;
92 × 73 cm,
36¼ × 28¾ in.
Museum of
Modern Art,
New York

66
Pablo Picasso,
Head of
Fernande,
1909.
Bronze;
41·3 × 24·7 ×
26·6 cm,
16½ × 9¾ × 10½ in.
Musée Picasso,
Paris

face of the woman are rendered in a series of ridges, while the whole
is twisted to energize the relationship between head and neck. This
work is often also read as a kind of research piece, which, according
to art historian Douglas Cooper in his book *The Cubist Epoch,* for
example, allowed Picasso 'to test, in the light of reality, his pictorial
technique of expressing volume through faceting'. There is an
important difference between Cooper's view of Cubism and the
one so far presented here: neither Picasso's nor Braque's technique
is reducible to such a simple formula. If Picasso was making the
facets of his paintings 'real', then we should recognize the element
of deliberate absurdity and imaginative play in the idea: 'Think of
what it would be like as a statue'.

The playful element certainly emerges in another plaster sculpture
Picasso made at the same time – a Cubist apple (now in the Musée
Picasso, Paris). In keeping with the parallels established in early
Cubist paintings with the illusions of relief carving, Picasso worked

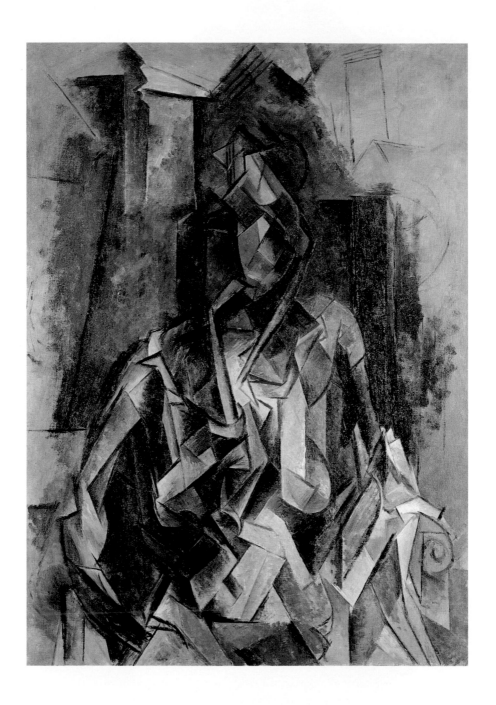

on the modelled plaster head to give it a carved appearance. This preference for the effect of carving over modelling is another clue to what Braque meant when he said that Cubist paintings brought things closer to the viewer, took 'full possession of things' or created 'a manual space'. The illusion was no longer of three-dimensional objects projected on to a perspectival screen – for that Renaissance illusion could indeed provide templates for modelled sculptures. Instead early Cubist paintings represented (unsystematically) layers of carved or etched surfaces on which the prominent aspects of objects, their peaks or saliences, jutted forward and jostled with each other. On one hand, the world of things and spaces would be crunched or corrugated into a pictorial fantasy like a deep relief carving (the viewer is not being asked to see the picture plane as resembling the plane of a relief; instead the ridges in the illusion are still set somewhere behind the picture plane). On the other hand, the 'manual space' or the full possession that early Cubism offered was like the surface of an imaginary shallow relief sculpture over which one might run one's hands, 'touching' not space but a ridged and curving surface. Yet just as a shallow relief works only when real light throws shadows across its surface, so the virtual light of Cubist paintings always pushes full possession back into the spaces of the imagination.

After he moved to a new studio in September 1909, Picasso's work into the beginning of the next year continued to concentrate on the female figure. In choosing to work on this most value-laden of subjects, Picasso was also locked into a struggle between the relief illusion and more traditional, if not properly perspectival, illusions of space. In *Woman in an Armchair* (67), for example, despite the frightening suggestions of a flayed or dissected figure conjured up by Picasso's new Cubist fragmentation, the chair and the space behind remain clearly distinguished from the solidity of the seated woman. It may have been a work such as this that led Apollinaire, in *The Cubist Painters* (1913), to say that 'A man like Picasso studies an object as a surgeon dissects a cadaver.' Surgeons adopt a scientific and dispassionate relation to the corpse, which is a source of knowledge about the living body, but they also hone their skills by dissection. It is tempting to think that Apollinaire's image was equally inspired by

67
Pablo Picasso,
*Woman in an
Armchair*,
1910.
Oil on canvas;
100 × 73 cm,
39⅜ × 28¾ in.
Musée
National d'Art
Moderne,
Centre
Georges
Pompidou,
Paris

the paintings that Picasso went on to make in the summer of 1910, in the Catalan fishing village of Cadaqués (68). These works, widely regarded as the nearest Cubism ever got to non-representational or abstract art, move Picasso's Cubism into an altogether new phase. The interest in mass and the illusion of relief are abandoned in favour of a mysterious effect sometimes called 'transparency'. It has been suggested that Picasso was in some sense emulating the appearance of the recently invented surgical aid the x-ray photograph (69).

As well as evoking ideas of visible layers of the body and the revelation of its hidden mystery, paintings from Picasso's trip to Cadaqués are important for their adoption of a compositional device that would figure heavily in the subsequent development of Cubism, and of the modern abstract painting that came after it, the 'grid'. Having abandoned the illusion of solid three-dimensional objects in space, and substituted a play of pictorial elements such as line, shading and texture, Picasso held his composition together with a loose or spontaneous grid-like structure. This brought the planes and lines into a kind of order crucially unrelated to conventional compositional systems. Perspective, convincing visual illusion and relative symbolic importance are all replaced by the uneven rhythm of light, shade and line tentatively aligned to the rectilinear edges of the canvas. There remains a vestigial sense of a figure standing or reclining in Picasso's painting, but it is easily possible to lose sight of the figure in the pattern or weave of the grid. Braque had arrived at a similar if less extremely deployed grid effect in the winter of 1909–10. His *Mandora* (70), a depiction of a small instrument in the lute family, shows the development of an orthogonal or parallax grid, in which objects and space appear refracted. The result is a filigree pattern of chiaroscuro planes, but spatial illusion and the related impression of gravitational pull are considerably more persistent than in Picasso's slightly later Cadaqués works.

The game of 'sculptural' painting, which is fundamental to the identity of the early Cubism of Picasso and Braque, does in the end lead back to the well-worn contrast with Renaissance perspective, but in a new way. The important point is not that Cubism overthrows the illusion of

68
Pablo Picasso, *Nude Woman*, 1910. Oil on linen; 187.3 × 61 cm, 73³⁄₄ × 24 in. National Gallery of Art, Washington, DC

69
William Morton, First whole body x-ray of a living person, 1907. The woman's skeleton, heart and liver are visible, as are her rings, necklace, bracelet, hatpin, button boots with nailed-on heels, and around her hips a whalebone corset

perspective, but that it overthrows the certainties of the viewer. If Renaissance perspective conveys the assurance that there is a correct place from which to see the world, Cubist paintings never finally declare whether there is anywhere to stand at all. The relief effects of Cubist paintings suggest a constant displacement of position, and their unresolvable refraction and (by 1910) ethereality mean not only that the world slips away from the image but also that the viewer slips away from the world.

Braque's last public exhibition in Paris before World War I was at the Salon des Indépendants of 1909. Only one of the two works he exhibited survives, and it was probably repainted in 1910. It was the first state of this canvas, entitled *Harbour* and now in the Museum of Fine Arts, Houston, that led Morice to use the term 'Cubism' in his review. In terms of public perceptions then, this, and certainly not Picasso's *Les Demoiselles d'Avignon*, was the first 'Cubist' painting. Something about the word 'Cubism' caught the imagination of young painters and poets in Paris in 1909. The most adventurous among them heard things through the art grapevine and made strenuous efforts to find out about artists they hardly knew. Fernand Léger, one of the first artists to respond to Braque and Picasso, remembered how it happened:

... if Apollinaire and Max Jacob hadn't come to see us, we would never have known what was going on in Montmartre. They told us to go to Kahnweiler's, and there fat Delaunay and I saw what the Cubists were doing. Well, Delaunay, surprised to see their grey canvases, cried 'But they paint with cobwebs these guys!'

It is difficult to be sure when this early visit took place, and therefore which pictures produced such an amusing and evocative remark. This joke by Robert Delaunay (1885–1941) seems prophetic of the diaphanous weave that would overtake mass and space in the Cubism of Picasso and Braque by 1910. Léger's *Woman Sewing* (71), now dated by experts to 1909–10 and purchased by Kahnweiler not long after it was finished, shows clear evidence of a response to the austere colour of early Cubism, and is resolutely massive and spatially coherent rather than ethereal and paradoxical. Similarly, in May 1909 Delaunay began his impressive series representing the medieval church of Saint-Séverin (72),

70
Georges
Braque,
Mandora,
1909–10.
Oil on canvas;
71·1 × 55·9 cm,
28 × 22 in.
Tate Gallery,
London

71
Fernand Léger,
*Woman
Sewing*,
1909–10.
Oil on canvas;
73 × 54 cm,
28³⁄₄ × 21¹⁄₄ in.
Musée
National d'Art
Moderne,
Centre
Georges
Pompidou,
Paris

72
**Robert
Delaunay**,
*Saint-Séverin
No. 1*,
1909.
Oil on canvas;
116·8 × 82 cm,
46 × 32³⁄₈ in.
Private
collection

using spatial compression more expressively than Braque and Picasso, but clearly aware of their achievements, as the Cubist tiles on the church floor suggest. If Braque and Picasso had invented the means of this new art, and Braque's *Harbour* gave birth to the name Cubism, it was Léger and Delaunay who first took it up and, by exhibiting in high-profile shows in the coming years, helped to make it into a household word in pre-war Paris. Publicity is not always welcome, however, and the sudden arrival of a Cubist craze to which many noisily hitched their fortunes was, in turn, to have its own effect on the increasingly secretive Picasso and Braque.

The early twentieth century was a time of extremes. Its modernity was exhilarating and terrifying. From the standpoint of ordinary citizens in many countries, the world had changed faster in the previous two centuries than it had in the preceding millennium. Karl Marx and Friedrich Engels, in their *Manifesto of the Communist Party* (1848), celebrated the destruction of the illusions of absolute authority on which the pre-modern world was built. They admired the power of capitalism, the economic expression of modernity, in which 'all that is solid melts into air', but argued that the march of progress under capitalism led to ever greater levels of exploitation of the new 'working classes' rather than emancipation. As the divine authority of priests and kings was questioned, nothing beyond the everyday world guaranteed the truth and rightness of anything in human society. The Western world was becoming irrevocably secular, with science and its expression in technology seen as the only reliable measures of truth. Yet the freedom from religion that modernity promised, and the frantic pace of change it brought about, had persistently proved difficult for people to endure. It was thus no accident that the process of modernization was accompanied by the rise of new and bizarre religions and myths, and a desire to discover in the lost social life of the past some kind of anchorage in the storm.

73
Robert
Delaunay,
The City No. 2
(detail of 89)

Avant-gardism was shot through with these paradoxical tendencies. The avant-garde artist transfigured the terrible beauty of modernity, which he or she both celebrated and vilified in the same breath. For the Italian avant-garde movement, Futurism, the machines of modernity swept away the filth and ignorance of the old world and became the new gods. Like gods they had a dazzling beauty: 'A motor car is more beautiful than the *Winged Victory of Samothrace*', said the poet and Futurist leader Filippo Tommaso Marinetti, prophet of modernization, in 1909. Avant-garde art persistently confounded gods and machines, made the urban seem pastoral or revealed the primal

in the urban, and found the classical in the contemporary. It was built on an extraordinary muddle of the most conservative and the most progressive ideals. The paradoxes of modernity were expressed not only in the imagery and ideals of the avant-garde, however, but also in actions. The thirst for order and leadership, for new kings and gods, which was central to modernity, was ruthlessly exploited in certain avant-garde strategies. Publicity stunts, political manoeuvring within art institutions, attacks on rival groups, and implausible announcements of the beginning of a new age offered a spectacle both hilarious and troubling. In this chapter the public debut of Cubism, and its early challenge from Italian Futurism, play out these general themes of avant-garde art.

As if to reinforce the difficulty of arriving at a precise definition of the work explored in Chapter 3, many books on Cubism draw a sharp distinction between the work of Montmartre-based Braque and Picasso, and that of the so-called 'Salon Cubists' – most importantly Albert Gleizes (1881–1953), Jean Metzinger (1883–1956), Léger, Delaunay and Henri Le Fauconnier (1881–1946) – based largely in Montparnasse. This contrast has been expressed in evaluative (or some might say biased) fashion by calling Braque and Picasso (and sometimes Gris and Léger) 'True Cubists' or 'Essential Cubists'. In recent years this hard distinction has been questioned. First, the simple notion that Braque and Picasso were absolutely aloof from other painters for a number of years, and that their innovations were hardly known, has been qualified as the process by which the Salon Cubists adopted their styles has come to light. It now seems clear that such artists as Léger and Delaunay visited Kahnweiler's early, and that another enthusiast, Metzinger, knew quite a lot about Braque and Picasso by 1910. Secondly, while accepting that the two groups produced radically different art, some say that there is reason to be suspicious of the supposed aesthetic superiority of Braque and Picasso, Gris and Léger, since their brilliance was zealously touted by interested parties such as Kahnweiler and his followers. In this spirit, the term 'Gallery Cubists', recently proposed by art historian David Cottington as an alternative to 'True Cubists', provides a more neutrally descriptive distinction between the groups.

Perhaps a more important consequence of Cottington's term is that it removes the temptation to think that the artists now regarded as the most interesting exponents of Cubism were always seen that way, for, ironically, as far as the interested Parisian public was concerned around 1912, the artists now called 'Salon Cubists' were really the 'true', the *only* Cubists. Braque and Picasso were a well-kept secret, their Cubism a tantalizing rumour put about by art critics. Yet there is no escaping the fact that the practical distinction between Kahnweiler's artists and the Salon Cubists is widely accepted as reflecting relative artistic merit, even by those historians trying to reconstruct the original public face of Cubism. It is certainly true that the dominance of critical or aesthetic criteria over historical ones, brushing aside the very artists whose names were once most closely connected with the movement, has led to a simplification of the history of Cubism. However, it is also true that, for all the excitement, gossip and socio-historical interest that Salon Cubism opens up, some (though not all) of its artistic achievements now seem quaint and unchallenging compared to the persistently controversial and profound works of Kahnweiler's main artists.

Beyond the tendency to demote the Salon Cubists and to ignore the changes in the critical fortunes of the two groups of artists, there is another way in which the history of early Cubism has been simplified. Two artists had a role in the development of the art of Braque and Picasso in the crucial 1907–10 period. One of these was Raoul Dufy, who had known Braque since 1905, and spent a brief period painting with him in L'Estaque in 1908. Dufy's efforts were not confident and no doubt his faltering helped Braque to toughen his own method. It is thus understandable that no one has tried to make Dufy, who returned to a post-Fauvist style straight away, into a 'True Cubist'. The changing direction of another artist, Derain, is of more interest, since he had a sustained friendship with Picasso, whom he met towards the end of 1906, after moving into Montmartre in October. As has been seen, Derain and Picasso shared a series of attempts at making primitivist sculptures. It was probably Derain who persuaded Picasso to go to the Trocadéro to see the non-Western objects so crucial to the evolution of the *Demoiselles*. Derain was

taken up by Kahnweiler in 1907, and from then on he was intimately connected to the Bateau Lavoir circle. In 1909 he worked alongside Braque at Carrières-Saint-Denis near Chatou, and made a series of woodcuts to illustrate Apollinaire's suite of poems *L'Enchanteur pourrissant* (*The Rotting Magician*). In 1910, Derain painted in Cagnes and then in Cadaqués alongside Picasso. To these bare facts, which show how closely Derain was associated with Braque and Picasso during the crucial early years of Cubism, it can be added that some early accounts credit him with a starring role: both Apollinaire's 'The Beginnings of Cubism' (1912) and his 'Modern Painting' (1913) do so.

Why not treat Derain as an inventor of Cubism, and a 'True Cubist'? One reason is that in a fit of self-doubt Derain burned some of the evidence that might now help to clarify his role during the winter of 1907–8. It is not known what was destroyed then, but the paintings that do survive bear witness to his importance. His *Bathers*, exhibited at the Salon des Indépendants of 1907 and now in the Museum of Modern Art, New York, was almost certainly another precursor to *Les Demoiselles d'Avignon* (see 37), and his primitivist *Bathers* now in Prague (see 50) makes an interesting comparison with Picasso's *Three Women* or Braque's *Large Nude* (see 45, 46). Another reason is that Derain's interest in Cézanne is clearly coloured by notions of a classical revival that are hard to connect to the radical departures of Braque and Picasso in the same period. Derain's *The Old Bridge at Cagnes* of 1910, now in the National Gallery of Art, Washington, DC, reveals an earnest acknowledgement of classical landscape paintings in the Louvre by Poussin and others, and one of his Cadaqués landscapes was compared by Salmon in 1912 to El Greco's famous sixteenth-century *View of Toledo*. The Cadaqués paintings show how much Derain had looked at Cézanne, and had been impressed by Picasso's Horta landscapes of the previous year (74). Yet working alongside the Spaniard – now producing those unprecedented shimmering grids – Derain insisted on the integrity of spaces and solids, on coherent scale, and on an impressively realized but ultimately merely updated traditional landscape painting. This was, in other

74
André Derain,
Landscape at Cadaqués,
1910.
Oil on canvas;
60 × 73 cm,
23⅜ × 28¾ in.
Národní Gallerie, Prague

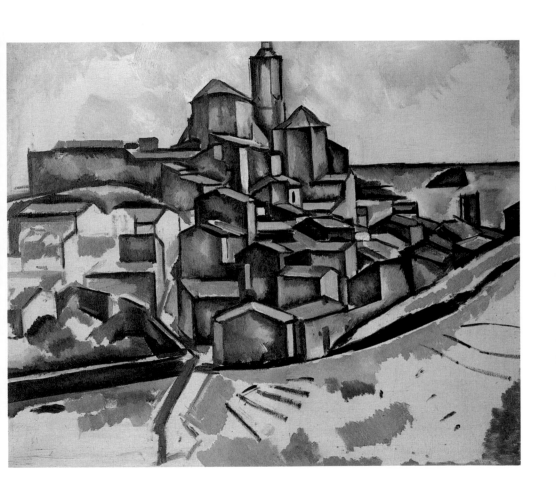

words, as close as Derain ever got to the work that Braque and Picasso produced in the Cubist years. After 1910 he largely turned from this to a radical combination of primitivism with still more insistently traditional subjects and styles – an artistic venture outside the scope of this present book – although he did produce a number of still-life works in 1912 that acknowledge some Cubist devices.

The divide between 'Gallery' and Salon Cubists was similarly not necessarily a physical one – many of the artists concerned could well have seen recent works by both Braque and Picasso and spoken to them on a regular basis. The desire to constitute an artistic movement is a key component that defines avant-gardism, and the gap is best signified by the willingness of those exhibiting in the Salon to be represented to the wider public as members of a 'Cubist' movement, and to defend their art in those terms. The problems already encountered of describing what Picasso and Braque had really achieved, the resistance of their work to any easy formula, and their almost complete unwillingness to be co-opted as leaders of a 'movement' – all this meant that the artists of Salon Cubism made much more dramatic progress in terms of public renown.

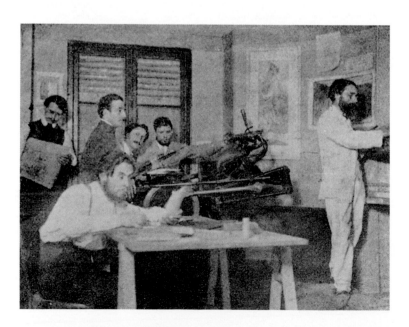

The texts and exhibitions that form key documents in the history of Salon Cubism show how four ingredients combined in what now seems a strange intellectual cocktail: 1. a (progressive) dream of a new scientific era in which reality would be transformed; 2. a (conservative) fantasy of a modern reinterpretation of the greatness of French classicism that would obliterate the artistic and cultural pretensions of all other nations and be expressed in all the arts; 3. a desire to claim for the artist absolute power to redefine art; and 4. a conflicting desire to demonstrate the absolute truth of Cubism philosophically. These somewhat contradictory currents were expressed by individuals belonging to different circles, giving the history of Salon Cubism an extraordinary diversity of ideas and visual styles, touching on science, philosophy, domestic and international politics. In contrast, the art of Braque and Picasso in the same years was characterized by remarkable focus and unrelenting drive.

In the case of Cubism the story is particularly interesting, since for some participants Cubism as a movement was the continuation by another means of an earlier counter-cultural or even utopian artistic community, known as the Abbaye de Créteil. A commune in a country house outside Paris, the Abbaye de Créteil lasted for just under two years from 1906 to 1908. It was founded and financed by Henri-Martin Barzun, a former political activist who had become interested in promoting a kind of artistic youth culture. The key members of the community, aside from Barzun, were the painter Gleizes and the poets Alexandre Mercereau, René Arcos, Charles Vildrac and Georges Duhamel (75). Mercereau was more politically attuned than most of his fellow members, but he was equally important as a future defender of Cubism, 'networker' and exhibition promoter. Barzun went on to found the influential review *Poème et drame* in 1912. The aims of the Abbaye have been obscured by time. Some regard it as an anarchistic and utopian attempt to found a genuine creative community, some as a self-serving apolitical retreat from the realities of the art market. Certainly the Abbaye was not above employing a technician to run its printing press, but it also aimed to avoid commercialism, fashionable taste and individualism (all members supposedly had to work for four to five hours per day). The determining factor in the identity of the

75
The studio at the Abbaye de Créteil, *c.*1906. From l to r: Berthold Mahn, Alexandre Mercereau, Albert Gleizes (sitting at table), René Arcos, Lucien Linard and Charles Vildrac

Abbaye was a desire to resist the art-for-art's sake philosophy of late nineteenth-century Symbolism, while avoiding the furrow of social commentary ploughed by successful artist/caricaturists such as Steinlen. The artistic and literary efforts of the Abbaye do not always live up to this project, however. At one level, the Abbaye was an expression of a recurrent dream within the history of the avant-garde – the dream of escaping modernization and technology particularly associated with the ever-expanding capitalist city. The Abbaye de Créteil was far enough from Paris to make such a statement, and the vaguely monastic principles and production process, intended to

76
Robert
Delaunay
in front of
*Disc (The
First Disc)*,
1914

overcome what Marx called the 'alienation' of the modern worker, were meant to revive an earlier and (supposedly) more sympathetic social order. At the same time, members of the group were quite capable of reinterpreting the city itself as a utopia, whose overarching and pulsating energy could unify all individual lives and things in one great hymn to life. Such was the thrust of Jules Romains' poems in his *La Vie unanime* (*Unanimist Life*), published by the Abbaye press in 1908. The desire for unanimity amid the diversity and discord of the modern world was expressed in poetic incantations, but inevitably it also had ambiguous political resonances.

The ideas of the Abbaye, and the discussions that took place there, were profoundly important to Gleizes. The ambitious son of a furniture designer and the nephew of an academic artist, Gleizes' early paintings were attempts to assimilate Impressionist and Post-Impressionist styles. He exhibited in the Paris Salon de la Société Nationale in 1902 and the Salon d'Automne in 1904. Once the Abbaye folded in 1908 he began frequenting Paris and especially Montmartre, where over the next year or so he met the other artists who would soon be leading Salon Cubists: Metzinger, Léger, Delaunay, Le Fauconnier, Sonia Terk (later Sonia Delaunay; 1885–1979) and André Lhote (1885–1962), among others. In his memoirs Gleizes claimed that he did not know the work of Braque and Picasso until after he had begun to formulate his own version of Cubism, but since Gleizes' friend and former Abbaye member Mercereau was involved in an exhibition featuring Braque's work in 1909 this seems unlikely.

Metzinger, who would become Gleizes' closest ally in the following years, came from an extremely wealthy family in Nantes. He had moved to Paris in 1903 and was a regular contributor to the Salons, as well as a member of the hanging committee of the Salon des Indépendants from 1906. He knew Braque and Picasso from at least the end of 1908, when he exhibited with them at Wilhelm Uhde's gallery. He was also a lover of mathematics, attracted to the ideas of Maurice Princet, an insurance actuary and self-taught prophet of the new maths, non-Euclidian geometry. As a relatively senior figure in Montmartre and the Salons, Metzinger flattered Gleizes and others with the idea that they were engaged in a common purpose – to reform painting, long surpassed by photography and cinema, by concentrating on problems of 'structure'. The five key artists of Salon Cubism – Robert Delaunay (76), Le Fauconnier (77), Gleizes, Léger (78), Metzinger (79) – all exhibited in the Salon des Indépendants of 1910. Even though their twenty paintings were spread among the 6,000 or so other entries, something of a common aesthetic doctrine was detected by the ever-vigilant Vauxcelles, who dismissed these 'ignorant geometricians, who reduce scenery and the human body to dull cubes'.

The Salon d'Automne of 1910 featured all five artists again, but this time their works were displayed in close proximity – probably not by chance. Metzinger was ably assisted in forging a shared sense of identity among his new friends by the sympathetic critic Roger Allard, and by the ever-mercurial Apollinaire. Allard, whose forthcoming suite of poems was to be illustrated by Gleizes, reviewed the Salon d'Automne of 1910 for a newspaper published in Lyons. This piece on Le Fauconnier, Gleizes and Metzinger set the tone for much of the Cubist criticism that was to come. Allard was apparently the first writer to use terminology that has since been widely adopted in classifications of Cubist works:

Thus is born, as the antithesis of impressionism, an art which, with little concern for copying some incidental cosmic episode, offers to the viewer's intelligence, in their full painterly quality, the elements of a synthesis situated in the passage of time. The analytical relationships of the objects and the details of their subordination one to another are henceforward of little importance, since they are left out of the picture as painted. They appear later, subjectively, in the picture as *thought* by each individual who sees it.

The idea that there could be such things as 'Analytic' and 'Synthetic' Cubism did not properly take hold on writers and artists until much later. These terms have now firmly entered the vocabulary of art history as convenient period definitions corresponding to stylistic changes in Cubism, particularly that of Braque and Picasso. Analytic Cubism (roughly 1908 to 1912) has come to refer to a process where three-dimensional objects are broken down into fragments – corresponding to their appearance from different viewpoints in space – which are then recombined in two-dimensions to produce a representation. Analytical Cubism supposedly proceeds from observed reality to art, and the near monochrome works by Braque and Picasso discussed in Chapter 3, especially from around 1910–11, are usually treated as classic examples of the method. Although Analytic Cubist painting rejects single-point perspective, its combination of multiple viewpoints is thought to offer a fuller version of perceived reality. Synthetic Cubism (roughly 1912 to 1914) reverses the process, reassembling the elemental shapes and fragments of Analytic Cubism in order to make new kinds of reality. The arrival of Synthetic Cubism coincides with the invention of collage and the reintroduction of bright colour into Cubist art. Its use of combinations of bold compositional shapes is also thought to lead naturally to the creation of Cubist constructions – regarded as new realities in the object world. There

is no precise definition of these terms, however. While handy for the purpose of labelling and historical reference, they can lead to a misunderstanding of the subtleties of Cubist art.

The lure of scientific and philosophical jargon was also evident in an even more obscure statement written by Le Fauconnier in order to explain modern art, on the occasion of one of his paintings going on show in Germany. Le Fauconnier's text was published in the September 1910 catalogue of the Munich-based Neue Künstler-Vereinigung ('New Artists' Association' or NKV), an exhibiting society founded by the important Russian artist associated with German Expressionism Wassily Kandinsky. The NKV exhibition also included one of the bronze casts of Picasso's *Head of Fernande* (see 66), and works by Braque and Derain. In defence of the modern work of art, the earnest Le Fauconnier brought something of the Parisian cult of mathematics to his German readers:

A numerical work of art must represent numerical characters in its constructive and expressive arrangement. In its arrangement the number is simple or compound. Simple when a group of numerical quantities corresponds to the measurements of flat or figured distances between points ... compound when a group of primordial surfaces forms the constructional base and a group of points of weight results from their directional effects ...

Le Fauconnier came from the region around Calais, and an inheritance in 1907 allowed him to pursue a career as an artist. His partner was a Russian painter, Maroussia Rabanikoff, whose portrait he exhibited in the Salon d'Automne of 1910. His willingness to present himself as the spokesman and leader of the new art in Paris seems for a time to have worked in his favour, and it was around the end of 1910 that the burgeoning Salon Cubist group began to meet regularly at his studio. Here Le Fauconnier was working on a grand pictorial statement for the following year, and the conversation of the former members of the Abbaye de Créteil began to soar in the direction of new mathematics, sciences of painting and, to make use of Allard's oxymoron, a 'classicism of the future'.

As suggested in the previous chapter, there were clear links between many of the pictorial devices employed by Braque and Picasso and those to be found in pre-Renaissance art. The idea of a new 'classicism', which occurs repeatedly in texts on Salon Cubism, seems at first glance to relate to academic art from the Renaissance on, and of course to the Greco-Roman art it emulated. What becomes clear from reading the texts, however, is that 'classicism' could be made to mean all sorts of things at this time, and for all sorts of reasons. Spurred on by the interest in the Salon d'Automne of 1910, Metzinger – the only artist with something like a sure grasp of the progress of Braque and Picasso – attempted in his important 'Note on Painting' (1910) to link their unknown work with the efforts of Delaunay and Le Fauconnier then on show. He immediately resorted to appeals to a new classicism – which would be both non-doctrinaire and based on 'the triumph of desires that are centuries old'.

There are elements of Metzinger's 'Note on Painting' that seem to fit with deeply conservative, not to say ultra-conservative, views. Comparing Braque with the eighteenth-century still-life painter Jean-Siméon Chardin (1699–1779), for example, Metzinger offers to 'link the daring grace of his art with the genius of our race'. It is tempting to think here of the idea of the racial genius of France as ardently propagated by the extreme right-wing organization Action Française. For this racism, other 'races' were no longer welcome in France. The leader of the Action Française, Charles Maurras, founded a vigilante wing in 1908 called the Camelots du Roi, whose members threatened students and intellectuals whom they considered enemies of true Frenchness. The efforts of such artists and critics as Metzinger to link Cubism to a classical, especially French classical, tradition may thus be seen as having broadly nationalistic content and a political charge that could now be overlooked. It is difficult to be much more precise, however, since nationalism became the political currency in just about every walk of life in the build up to World War I, and the right-wing version of it blurred into the left-wing. Moreover, the idea of the French race also had an inclusive sense, referring for some to the idea of an alliance of diverse races united by political will. In any case, it is perhaps less interesting to point out the presence of these

nationalist sentiments in Cubist criticism and art than to see both
how and why they were so convincing – or convenient – to those
involved, and in particular why extremist and anti-democratic politics
on right and left appealed to avant-gardes. These issues become more
urgent when considering the attitudes of artists to the advent of war
in 1914 (see Chapter 9).

Metzinger was anxious to make a bridge between the public and
private faces of Cubism in order to underwrite the credibility of the
former. He may well have known of an article by Apollinaire that
appeared to question the merits of some contributions to the Salon
d'Automne that had been called Cubist. Famously, the poet declared:

There has been some talk about a bizarre manifestation of cubism.
Badly informed journalists have gone so far as to speak of 'plastic
metaphysics'. But the cubism they had in mind is not even that;
it is simply a listless and servile imitation of certain works that were
not included in the Salon and that were painted by an artist who
is endowed with a strong personality and who, furthermore, has
revealed his secrets to no one. The name of this great artist is Pablo
Picasso. The cubism at the Salon d'Automne, however, was a jay in
peacock's feathers.

80
Henri Le
Fauconnier,
Abundance,
1910–11.
Oil on canvas;
191 × 123 cm,
75 × 48 in.
Gemeente-
museum,
The Hague

For the time being, Le Fauconnier was to be the star of the Salon des
Indépendants of 1911 (21 April–13 June), the exhibition that can be
truly said to have launched Salon Cubism. The launch was far from
spontaneous, for during the winter of 1910–11, at meetings at the café
La Closerie de Lilas in Montparnasse and at Le Fauconnier's studio,
a plot to stage-manage the Indépendants to the advantage of Cubism
was hatched. Unlike the official Salon and the Salon d'Automne, the
Indépendants did not have a jury to vote on the works submitted by
hopeful artists, and this meant that the committee that decided where
works should be hung (within an alphabetical framework) was the
only means of controlling presentation. The hanging committee was
elected at an annual meeting of members of the Indépendants, and
it was to this meeting that the Cubists directed their efforts. Gleizes
recounts in his memoirs how they prepared a list of desirable
candidates, which they had printed and distributed, to be backed

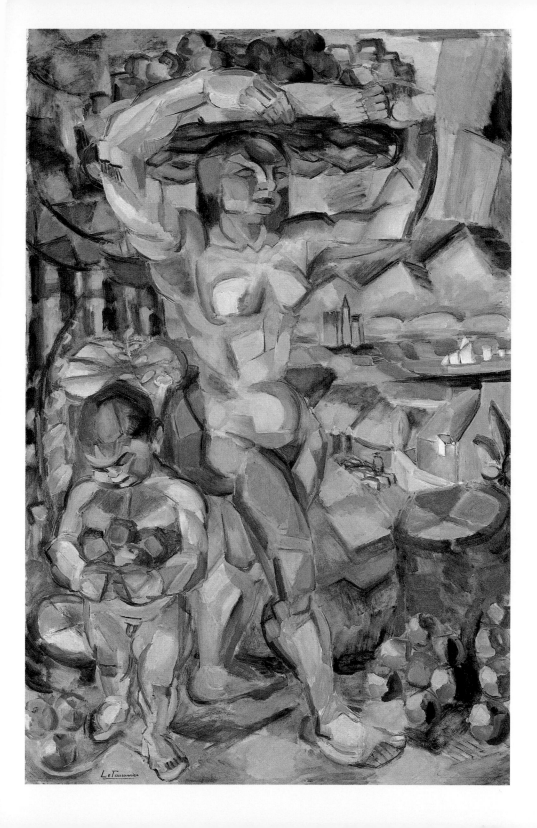

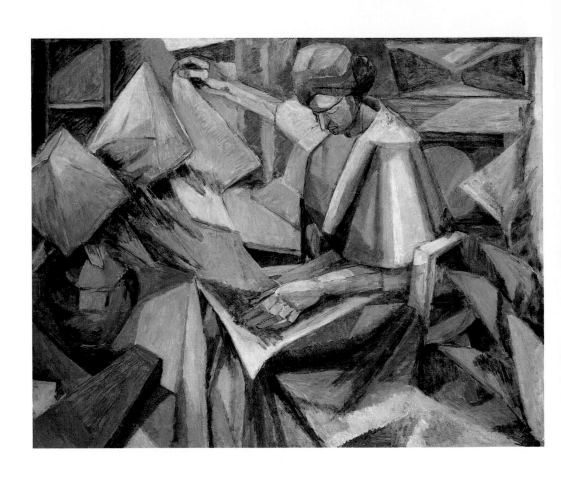

up by placards or posters that declared, 'Young painters you are misrepresented ... Vote for the hanging committee with the following names and the Salon will be organized according to your interests.'

On the evening of the meeting the president and the managing committee tried in vain to resist being bounced into a new election based on the list of names promulgated by Gleizes and his friends. The vote itself degenerated into a farce as the Cubists cast multiple votes – Metzinger, for example, won five hundred votes from a total constituency of three hundred and fifty. The farce was tolerated, however, perhaps with good humour, and the results for the Cubists could not have been bettered: the new hanging committee elected Le Fauconnier as its president. The young artists ignored the alphabetical rule and took charge of two rooms, the famous Room 41, and the neighbouring Room 43 (a memorial show for Douanier Rousseau, who had recently died, came between them). Room 43 featured artists such as Lhote, André Dunoyer de Segonzac (1884–1974) and Roger de la Fresnaye (1885–1925), some of whom would be drawn closer to Cubism in the coming years but who were not yet painting in the seemingly radical style of most of the artists in Room 41. There the Cubists orchestrated the room for maximum effect using works carefully conceived to astonish the public with their extremity, vigour and grand Salon scale. The centre of attention in Room 41 was Le Fauconnier's manifesto-like statement *Abundance* (80). Among the other important works were Léger's *Nudes in a Forest* (82), Metzinger's *Two Nudes* (now lost but known from an early photograph), Gleizes' *Woman with Phlox* (81) and two Eiffel Tower paintings by Delaunay (see 93).

The works exhibited, although not vast, were imposing in size. Delaunay's Eiffel Tower pictures were one to two metres (3^{1}_{4} to 6^{1}_{2} ft) high. *Woman with Phlox* is a metre across, and *Abundance* nearly two metres high. Léger's spectacular *Nudes in a Forest* was similarly grand. Le Fauconnier and Léger in particular had the clear intention of using scale to dominate the Salon and gain critical attention – a big eye-catching statement demands a public response in a way that an intimate work does not. This was a long-established principle in the

81
Albert Gleizes,
Woman with Phlox,
1910.
Oil on canvas;
81 × 100 cm,
$31^{7}_{8} × 39^{3}_{8}$ in.
Museum of
Fine Arts,
Houston

Overleaf
82
Fernand Léger,
Nudes in a Forest,
1909–11.
Oil on canvas;
120 × 170 cm,
$47^{1}_{4} × 67$ in.
Kröller-Müller
Museum,
Otterlo

Salons dating back to their development in the eighteenth century. In this context the fact that the artists had watched Le Fauconnier develop his painting over the winter only adds to the sense of an orchestrated and deliberate public coup. Le Fauconnier's *Abundance* represents a naked woman and child in a landscape with distant mountains, church and boats seen centre right. Beneath these features is a house in a lane with a man driving sheep or cattle. In the foreground the woman strides along carrying a huge pannier of apples. She stands between three tree stumps resembling schematic slices of lemon. More apples lie piled on the ground, and clutched in the boy's arms.

The picture is thus fairly easy to decode: it represents an allegorical scene of pastoral fertility, an autumn harvest in which harmony exists between humanity and nature, and where an equation is drawn between cycles of natural production and the fertility of idealized womanhood. It is easy to find precedents for *Abundance* in the most tedious of academic paintings, and in Rococo-style decorative cycles based on the theme of the four seasons. Furthermore, the idea of a naïve or Arcadian fertility was pervasive, not only in the official but in the avant-garde Salons around 1900. A woman in a landscape as an image of fertility carried a number of meanings. She was fundamentally natural rather than cultural, creative physically rather than mentally, and the close identification of her with nature meant that the tilled earth of France itself was to be equated with womanhood.

Such ideas were the subject of much debate in both the popular and the intellectual press at the time, since there was growing anxiety over the falling birth-rate in France, which, in the eyes of the establishment, was a potential cause of future military and industrial weakness. This meant both calls for a reassertion of the 'feminine' virtues of domesticity and motherhood, and a denigration of women's claims for suffrage and financial independence. Many supported the view that women were intellectually inferior to men as a result of biological differences. Particular scorn was poured upon women who appeared to demand intellectual respect, access to 'masculine' professions, or who blurred the distinction between the sexes by adopting masculine

habits and clothing. In this light Gleizes' *Woman with Phlox* might appear as simply another representation of timeless domesticity. By contrast, Delaunay's Eiffel Tower works could be considered assertions of engineering prowess in the modern world, with what Freud would have seen as decidedly 'phallic' associations. There is no doubt that the Room 41 artists would have sympathized with some of these ideas, and although they did count a few female artists among their number, these were all partners of the male artists or supporters. Thus Maroussia Rabanikoff (Le Fauconnier's partner) and Marie Laurencin (partner of Apollinaire) were both included; but Apollinaire tellingly called Laurencin's art 'graceful', and Rabanikoff was, according to some, the model for the figure of *Abundance* herself.

Approaching *Abundance* with the benefit of a detailed exploration of Braque and Picasso's achievements of the previous years, it is clear that many of the representational devices that they had subjected to such scrutiny remained unquestioned by Le Fauconnier. Notwithstanding his pronouncements on mathematics, the painter has left the integrity of objects undisturbed, and the ample roundness of flesh and apples is reassuringly integrated and fixed in its proper place, bounded by descriptive lines and given careful local colouring. There is no difficulty in seeing the woman, boy and landscape, since the method adopted amounts to nothing more than a mannerism, and the results are hardly elegant. The area around the woman's hips and buttocks shows just how much trouble Le Fauconnier had in drawing this way. The contributions of an artist such as Gleizes were not much better. It is true that *Woman with Phlox* is somewhat harder to decipher, though obscurity as such is not a virtue in itself. The strange pyramidal forms to the left appear to represent the flowers of the title, and some have seen a landscape painting on the wall behind the woman. Overall the palette is more restrained and less naturalistic than Le Fauconnier's, but still the work remains content with the notion of spatial illusion, and offers only a small challenge to conventional notions of art.

By contrast, Léger and Delaunay clearly found alternative visual languages and made more dramatic use of their subject matter. Léger,

the son of a Normandy cattle merchant, destroyed almost all his work before 1908 in an effort to conceal his first faltering steps on the road to avant-gardism. The curious forms and the extremely muted palette of his *Nudes in a Forest* make it difficult to decipher. It appears to represent a group of three figures, thought by Apollinaire to be woodcutters but more likely female nudes, who have taken on a wooden appearance themselves. Some of the assimilation of figure to space as found in the work of Braque and Picasso around 1909 is present here, but only in terms of the uniformly cylindrical vocabulary. The boundaries between figures and space around them are firmly sealed. As Léger himself recognized, his fascination was with an overall experience of the volume of things: 'I spent two years struggling with the volumes in the *Nudes in a Forest* ... I wanted to stress the volumes to their maximum degree ... The painting for me consisted of a battle between volumes. I felt that I could not cope with colours. Volume alone sufficed.'

Léger's work had already been jokingly referred to as 'Tubism', and his obsession with cylindrical forms in dynamic arrangements was to carry him to highly abstract compositions in the coming years. In a sense there is only a difference in degree between Léger's battle of volumes and the manner adopted by Le Fauconnier and Gleizes for their figures, but Léger's lively and jostling work calls up a more dreamlike and mysterious world than the rather mundane *Woman with Phlox*, or the awkward *Abundance*, can muster.

Although he had made studies of the tower in 1909, most of Delaunay's Eiffel Tower series date from after May 1910. In the same month the radio mast on the top of the tower began marking the time at midnight, supplementing the illuminated electric clock displayed on the tower since 1907. Erected in 1889, the tower still stood for modernity, and especially for modernity's optimism. It was the focus of technological and physical stunts: Marconi sent his first radio signal from the top of the tower in 1898; a Brazilian piloted an airship around it in 1901; and 227 runners competed to scale the first two levels in 1905 (83). In 1910 the dream of global communication was symbolized by the tower, and this dream was intimately linked with a feeling

83
Championship of the Eiffel Tower stairs, Paris, 1905

for the pressing rush of time. 'The Tower addresses the Universe', Delaunay inscribed on his first painted study. These meanings of the icon are still there: in 1999 a huge digital display on the Eiffel Tower counted down the days to the new millennium.

The numerous paintings Delaunay made of the tower are a hymn to the modern age. Moreover, the latticework of iron was the perfect embodiment of sublime transparency and spatial ambiguity with which to explore the strange devices of Braque and Picasso. The tower was in any case recognized in an article of 1909 as an 'abstract' product of a 'purely geometric art'. Yet Delaunay's contributions to the Salon des Indépendants in 1911 were hardly cool exercises in regular geometry.

Delaunay sought to dramatize the vertiginous world of the tower, seen both from below and, in press photographs, from above. The lower storey of the tower with its great arching feet seems to loom above the city, but the walkway of the second storey tips forwards as if the

viewer were soaring around it. Two other works in the series include shapes that clearly represent the gravel paths of the Champ-de-Mars, on which the tower stands (84), as seen by airborne photographer André Schelcher (85). These photographs, taken from the airship *Quo Vadis*, were on show in the First International Exhibition of Air Travel in September 1909 at the Grand Palais. Delaunay made extensive use of press photographs and postcards in his art and thus attuned himself to the popular culture of modernity.

The Eiffel Tower was both a focal point for technological tourism and a site from which the city spectacle could be viewed. The tower stood for the spectacle of modern life, and the airships that whirred around it collecting its image were symbols of the new perspectives from

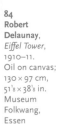

84
Robert
Delaunay,
Eiffel Tower,
1910–11.
Oil on canvas;
130 × 97 cm,
51⅛ × 38⅛ in.
Museum
Folkwang,
Essen

85
André
Schelcher,
*Eiffel Tower
Seen from an
Airship.*
Photograph
from
L'Illustration,
5 June 1909

which modernity could see itself and be seen. This idea of multiple and shifting viewpoints became a characteristic way of understanding Cubist devices, and sometimes relied on a comparison with the new popular medium of cinema. In his 'Note on Painting' in 1910, Metzinger saw in Picasso's art 'a free and mobile perspective', while Metzinger's art was in turn 'cinematic' for Apollinaire in 1911. The Pathé newsreels regularly on show in Paris condensed the world's physical distances and compressed day-long events into a few minutes. Space and place revolved before the eyes of the cinema audience. The pioneering French film-maker Georges Méliès described how he discovered the dizzying and magical effect of the jump-cut:

One day, when I was prosaically filming the place de l'Opéra, an obstruction of the apparatus that I was using produced an unexpected effect. I had to stop a minute to free the film and started up the machine again. During this time passers-by, omnibuses, cars, had all changed places, of course. When I later projected the reattached film, I suddenly saw the Madeleine–Bastille bus changed into a hearse, and men changed into women. The trick-by-substitution, soon called the stop trick, had been invented, and two days later I performed the first metamorphosis of men into women.

What technologies of transportation meant, and what the jump-cut revealed, was that the centre of experience was time. As early as 1855, the German poet Heinrich Heine noted that 'through the railroads space has been abolished and the only thing left for us is time'. Everything in the world was gathered in the time of consciousness, and visual experience now leapt from moment to moment and place to place, to be resolved and ordered only according to memory and consciousness.

The response to the exhibition was perhaps exactly what the artists expected. Gleizes recounts the events of the opening day:

I arrived at the Cours-la-Reine around 4.00 pm, the opening of the show having been at 2 o'clock. It was a marvellous spring day in Paris, sunny and warm. I walked across the first rooms, which were not especially crowded. But as I advanced, the crowd became more dense, and finally I met my friends who had arrived earlier than I, and they let me know what was going on. 'They are crushed into our room, shouting, laughing, protesting, giving vent to their feelings in all kinds of ways; they push about on the edges to get in, and there are violent disputes between those who approve, defending our position, and those who condemn it.' We could understand nothing of it. All afternoon it was like that. Room 41 was always full.

Gleizes protests his innocence too much. There is no doubt that the strategy of the Salon Cubists was designed to maximize their impact, and that enough jokes about a new movement called 'Cubism' had already been made in the popular press to guarantee a scandal. In the

early editions that evening, and the following day, the newspapers were full of it. Apollinaire, no doubt heavily primed, rushed out an important account of 'Today's Young Artists and the New Disciplines'. The Salon that year comprised some 6,745 works by 1,388 artists, but Apollinaire nevertheless singled out Metzinger as the only real example of Cubism, while finding plenty of equal interest in the other 'stark and sober' works on show in Rooms 41 and 43. If Apollinaire used the name Cubism sparingly, the same was not true for other writers, who latched on to the catch-all term with glee, and were happy to focus on this tiny fraction of the exhibition. On 23 April, an anonymous writer in the *Gazette de la capitale* let rip: 'What is a Cubist? A Cubist is a painter from the Picasso–Braque School. He makes little men in cubes, dice, hexagons. It's stupid and horrible. A picture puzzle.'

Meanwhile, another wit in the magazine *Fantasio* invited inquisitive readers who had not seen the new art form to imagine a picture of a woman cut up into green fragments – should the public laugh or cry at such outrages? Some journalists invented dialogues with thinly disguised members of the Room 41 set, which purported to explain the aims of the new movement. In *Paris-Journal* of 29 May 1911, the artist 'Metzi' assures journalist Cyril Berger that the day will come when only Cubist paintings of women will be called beautiful. In their conversation Metzi defines Cubism for the public as the stripping away of superficial and accidental forms of objects in favour of the fundamental and purely geometric forms beneath ('cubes, squares, triangles, lozenges, parallelograms, trapezoids, pyramids, cylinders ...'). Finally, Metzi speculates on the 'new rhythm' that the Cubists have created for humanity, and on the day when future painters will gather up all colour into pure white, and exhibit nothing but white canvases 'with nothing, absolutely nothing on them'. The prophesy was, of course, meant to be laughable, and in fact monochrome canvases had already been exhibited in Paris as a kind of joke at the spoof 'Salon des Incohérents', while a poetic eulogy to the white canvas had appeared in the London-based *Magazine of Art* in 1891, under the title 'Untrammelled Art'. Serious efforts in this regard were only years away in the unfolding history of modern art in the work of

Kasimir Malevich (1878–1935) discussed in Chapter 8, for example. Perhaps their appearance became something of an inevitability as soon as such jokes were made.

In a second article on the Room 41 event, Roger Allard connected Delaunay's Eiffel Tower paintings with a new Italian movement, Futurism. Delaunay's tendency to displace the spectator's viewpoint, and install him or her in the centre of the picture, was regarded by Allard as a dubious Futurist device. The term Futurism had been coined by Marinetti in a manifesto published in the French newspaper *Le Figaro* in February 1909. The very name implied a headlong rush towards the new, and his hyperbolic but brilliant text declared the end of all tradition and the celebration of the fiery automobile and blinding electric light. It is a commonplace of the history of Futurism, however, that for all the extravagance of his claims to represent a radical artistic movement, the artists who gathered around Marinetti in 1909 were slow to develop recognizably Futurist paintings and sculptures. In April 1910, just before Delaunay took up the Eiffel Tower subject in earnest, five Futurists published their 'Technical Manifesto of Futurist Painting' in both Milan and Paris. They invented a name for the whirligig of modernity, focused on the city (86) in which 'all things move, all things run, all things are rapidly changing'. They called this 'universal dynamism', and claimed that the flow of the world in consciousness, or 'the dynamic sensation' should now be the only subject for painting. Amid this portentous language were clear references to two pictorial devices, the merging of objects with each other and the space around them, and the 'division' of light into the spectrum of colours.

86
Umberto Boccioni,
The City Rises,
1911.
Oil on canvas;
199.3 × 301 cm,
78½ × 118½ in.
Museum of
Modern Art,
New York

'Divisionism', or the application of paint in distinct strokes or dots of colour, was borrowed from late nineteenth-century French Neo-Impressionist painting, and had been a key ingredient in the formation of Fauvism. In Italy, where it had been adopted by such artists as Giovanni Segantini (1858–99) and Gaetano Previati (1852–1920), it was still regarded as cutting-edge art. The Futurists, like the Parisian Fauves, were as much interested in its expressive and spontaneous power as in its scientific basis. A painting of a street lamp by one of the leading Futurist artists, Giacomo Balla (1871–1958) shows both

interests at work (87). It would be several years before Futurist art would come into its own, but in terms of avant-garde claims to cultural supremacy it represented a clear rival to the Salon Cubism that made its debut in 1911. The publication of the 'Technical Manifesto of Futurist Painting' was greeted with some snobbish as well as vulgar amusement in the Parisian press. A cartoon from May 1910 imagined Venice before and after Futurism took control (88). Here an Italian Eiffel tower is orbited by an airship and a box aeroplane, while the vast new city is illuminated by electric lamps.

Delaunay's Eiffel Tower series was indeed remarkably close to the ideals expressed by the Futurists in 1910: shifting viewpoints and

87
Giacomo Balla,
Streetlight,
1909.
Oil on canvas;
174·7 × 114·7 cm,
68³⁄₄ × 45⅛ in.
Museum of
Modern Art,
New York

88
André Warnod,
*Venice Before
and After
Futurism*.
Cartoon from
Comoedia,
18 May 1910

'dynamic' shuddering. In the related 'City' series (89) Delaunay even combined Cubist facets with a stippling reminiscent of his earlier Neo-Impressionist and Fauve influenced works. Here, however, rather than a dazzling shimmer of contrasting colours, the stipples are a moody veil of monochrome out of which the pure red of the tower emerges. Nevertheless, Delaunay's art was in many ways a more adequate response to some of the ideas touted by the Italians in 1909 and 1910 than their own work. The subsequent development of both Delaunay and the Futurists was to reveal the differences between them, particularly as Futurism clarified and amplified its aims. In the coming years Delaunay was, as will be seen, increasingly drawn to a

89
Robert
Delaunay,
The City No. 2,
1910–11.
Oil on canvas;
146 × 114 cm,
57¹₂ × 44⁷₈ in.
Musée
National d'Art
Moderne,
Centre
Georges
Pompidou,
Paris

90
Robert
Delaunay,
Eiffel Tower,
1911.
Oil on canvas;
202 × 138·4 cm,
79¹₂ × 54¹₂ in.
Solomon R
Guggenheim
Museum,
New York

science of painting and went on to use colour contrasts in increasingly abstract patterns to suggest 'simultaneity', where the vibrant coexistence of reds and oranges could stand for the flux of distinct times and places in modern consciousness.

Paradoxically, then, Salon Cubism depicted both pastoral scenes of harvest and modern monuments. Even though Delaunay seems to be the most technologically inclined of the Room 41 artists, it is important to see that he is really most interested in how the modern world appears to its citizens, in its turbulence as well as its radiance. One of the paintings shown at the Indépendants, which belonged to a German collector named Koehler and was destroyed in bombardments in 1945, closely corresponded to a version now in the Guggenheim Museum, New York (90). The composition appears, if taken literally, to show a city and tower trembling or crumbling in an earthquake. There are some fascinating examples of popular science fiction from the time which show that this cataclysmic reading of the pictures is not completely out of the question (91, 92). It is also known that

La Tour 1910 r delaunay 1910

91
Juan Gris,
Cover for
*L'Assiette au
Beurre*,
no. 476,
14 May 1910

92
Louis Tinayre,
Ice Flood.
Cover of
*Journal des
Voyages*,
19 January
1902

Journal des Voyages

ET DES AVENTURES DE TERRE ET DE MER

(SUR TERRE ET SUR MER; MONDE PITTORESQUE; TERRE ILLUSTRÉE réunis)

DIMANCHE 19 JANVIER 1902.

Journal hebdomadaire. ABONNEMENTS : UN AN : PARIS, SEINE ET SEINE-&-OISE, 8 fr. — DÉPARTEMENTS, 10 fr. — UNION POSTALE, 12 fr. rue Saint-Joseph, 12, Paris, 2e.

| N° 268 2e SÉRIE | LA FIN DU MONDE | LE DÉLUGE DE GLACE | PAR VICTOR FORBIN | PRIX 15 c. |

Au premier choc de l'avalanche, l'orgueilleuse Tour de trois cents mètres s'écroulera comme un château de cartes. (P. 131, col. 3.)

Delaunay was in close contact with Kandinsky, the leading exponent of abstraction, then resident in Germany, and Kandinsky's art and writings were replete with apocalyptic references. In Delaunay's image the catastrophic vision of Paris, and the apocalyptic vision of the communication tower as a Tower of Babel, is probably a kind of unconscious anxiety about technological modernity, one that might now be more striking than it was in 1911. Delaunay's other painting in the exhibition, *Tower with Curtains* (93), may have made a curiously archaic reference to a *Portrait of Charles VII* (94) by the French 'primitive' Jean Fouquet (*c*.1420–81). This could be read either as expressing an unconscious fear of modernity, or as the crowning of 'engineering' as the new king of France. Perhaps there is no need to choose between these meanings, since the technological optimism of early twentieth-century art, even including Futurism, is never entirely free from its anxious opposite. Futurist 'universal dynamism', Delaunay's 'simultaneity', Salon Cubism's 'mobile perspective' – all owed much to the ideas of the French philosopher Henri Bergson. The real artistic import of Bergson's thought for both Cubism and Futurism was only fully explored in the crucial year of 1912, to which the next chapter now turns.

93
Robert
Delaunay,
*Tower with
Curtains*,
1910.
Oil on canvas;
116 × 97 cm,
45⅝ × 38⅛ in.
Kunst-
sammlung
Nordrhein-
Westfalen,
Düsseldorf

94
Jean Fouquet,
*Portrait of
Charles VII*,
c.1445.
Oil on wood;
86 × 72 cm,
33⅞ × 28⅜ in.
Musée du
Louvre, Paris

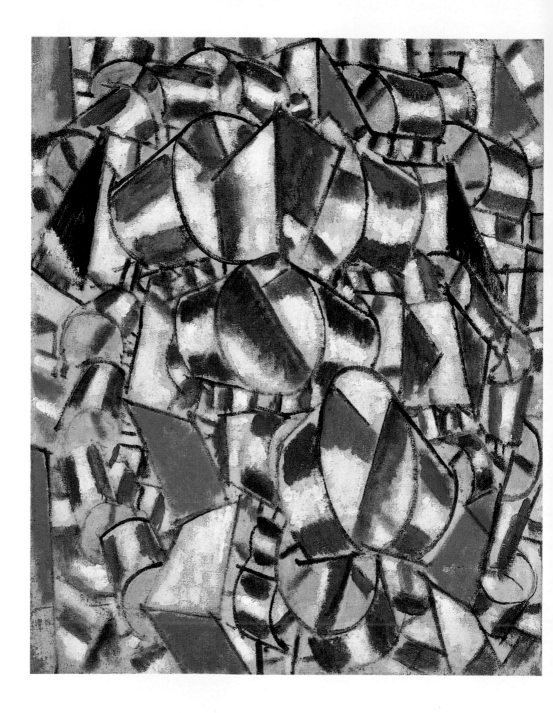

One admirer of the Cubists, the critic Olivier Hourcade, argued that Cubism overcame the 'sloppiness of Impressionism'. Impressionist art was thought (rather inaccurately) to aspire only to capturing particular scenes of everyday life in their momentary appearance. Its interest in the particular meant that, like the superficial world it imitated, it lacked an underlying structure and rationale. Cubism, by contrast, was an intellectual art, idealist rather than trivially realist, which evoked the enduring interplay between the human mind and the world. The contrast between the eternal truth of Cubism and Impressionism's supposedly mundane snapshots made sense in the years before World War I because it connected with a bigger cultural shift. In the mid-nineteenth century scientific positivism held sway, arguing that all knowledge is based on experience and that the world can be explained by reasoning based on scientific observation. This theory was applied to society and culture as well as natural phenomena – the historian, philosopher and critic Hippolyte Taine famously declared that 'virtue and vice are products like sugar and vitriol'. However, by the early twentieth century, scientists themselves raised doubts about the existence of such absolute truths, even in physics and chemistry, and poets and philosophers sought alternatives to positivism in religious mysticism and aesthetics.

95
Fernand Léger,
Contrast of Forms,
1913.
Oil on canvas;
100·3 × 81·2 cm,
39½ × 32 in.
Museum of Modern Art,
New York

Cubism was deeply affected by several thinkers associated with what has been called the revolt against positivism. Most of the Salon Cubists participated in regular discussion groups that debated the nature of the mind, reality and science. In late 1911 the studio and home of Raymond Duchamp-Villon (1876–1918) and his older brother Jacques Villon (Gaston Duchamp; 1875–1963) in the Paris suburb of Puteaux (96) became a Sunday haunt for many Salon Cubists, while on Mondays another related group met at Gleizes' home in Courbevoie. Meetings of the post-Abbaye de Créteil group associated with the review *Vers et prose* also continued on Tuesdays at the café

Closerie de Lilas. The 'Fourth Dimension', the 'Golden Section', 'non-Euclidean geometry' and other such mysteries were the topics of excited speculation. The common thread linking the buzzwords, cults and pseudo-science at Puteaux and Courbevoie was the idea that reality was merely an appearance, behind which lay some order or energy or essence of a quite different kind. The Salon Cubists imagined an art that could pierce the veil of the physical, exposing the metaphysical – whatever it might be – to view. Such speculative realms inspired works that represented the apogee of Salon Cubism.

Cubism gathered momentum after the 1911 Salon des Indépendants. Having shown their work in Brussels in the summer, the Cubists made another big splash in Room 8 at the Salon d'Automne of 1911. This time the collective presentation of like-minded artists in a single room was arranged thanks to Duchamp-Villon, a sculptor and member of the hanging committee of the Salon d'Automne who did not personally

know the Salon Cubists, but was sympathetic and willing to help them. His co-conspirator on the hanging committee was the painter and sculptor La Fresnaye, who already knew Gleizes and his circle.

Duchamp-Villon was the second of three brothers of considerable importance in the history of modern art. They came from a village near Rouen, where their pragmatic father was a notary, but their grandfather was the successful landscape engraver Émile Nicolle (1830–94). All three were well-educated and free-thinking. The two elder brothers settled in Paris before 1900, and both gradually abandoned their professional training as lawyer (Gaston) and doctor (Raymond) in favour of careers in art. Gaston Duchamp began publishing cartoons in 1897, and this may have necessitated the adoption of a pseudonym to avoid family embarrassment. He also used the pseudonym as a mark of his aesthetic vocation by choosing the name Jacques Villon (François Villon was a famous French vagabond poet of the Renaissance), and Raymond half followed suit in 1899. Marcel Duchamp, tenaciously keeping his original family name, joined his brothers in pursuit of artistic success in Paris in 1904.

96
Jacques Villon,
Raymond
Duchamp-
Villon and
Marcel
Duchamp,
Puteaux, 1913

97
**Raymond
Duchamp-
Villon**,
Baudelaire,
1911.
Stained plaster;
40 × 21 × 25 cm,
$15\frac{3}{4} \times 8\frac{1}{4} \times 9\frac{7}{8}$ in.
Musée des
Beaux-Arts,
Rouen

Raymond's plaster bust of the poet *Baudelaire* (97) was not shown in Room 8, but did feature elsewhere in the 1911 Salon d'Automne. Its simplified lines and strong sense of volume were taken by some as signs of Cubist influence, but the conventional nature of this posthumous portrait (based on a well-known photograph) was of course a long way from Picasso's little-known *Head of Fernande* (see 66) of two years earlier. Artists drawn into the orbit of Cubism during 1911 included the sculptors Alexander Archipenko (1887–1964) and Joseph Csáky (1878–1971), the painter Lhote, as well as Jacques Villon and Marcel Duchamp. Importantly, Delaunay, who held a grudge against the Salon d'Automne for rejecting a painting in 1907, refused to participate that October.

Room 8 provided another opportunity for the Salon Cubists to demonstrate their seriousness and ambition. At the same time it generated more scandal and ribald mockery than the Salon des Indépendants' Room 41, and brought accusations of gratuitous sensationalism. 'An unquenchable thirst for noise and publicity: basically that is the true evil which rages violently at this moment above all amongst young painters,' wrote the critic Armand Fourreau. The brilliant caricaturist Luc Métivet (98), meanwhile, punned on the resemblance in French of the words *cube* and *cul* (arse): the title reads *The Cubist School Again*, and the passing gent refusing the seductions of an allegorical figure of Cubism cries out something like 'No thanks, old thing! Not every year!' In the pages of satirical magazine *Fantasio*, Roland Dorgelès offered the ignorant mocking public photographic translations of the Room 8 paintings (99). The art historian Jeffrey Weiss has discovered that Cubism even featured in *Et Voila!*, a music-hall review that opened in October 1911 (100). The hilariously costumed Cubist painter in the photograph measures the bosom of a glamorous society woman. The reference was almost certainly to that infamous Cubist devotee of mathematics, Metzinger.

Le Goûter (*Tea-time*), a Cubist version of traditional paintings of one of the five senses, earned from Salmon the nickname 'The Mona Lisa of Cubism' (101). This was presumably because of its composition and the half-smile on the woman's face, but also because of its notoriety in the

98
Luc Métivet,
*The Cubist
School Again*.
Cartoon in
Le Rire,
10 October
1912

ENCORE L'ÉCOLE CUBISTE

— Ah ! non ! ma vieille ! pas tous les ans !

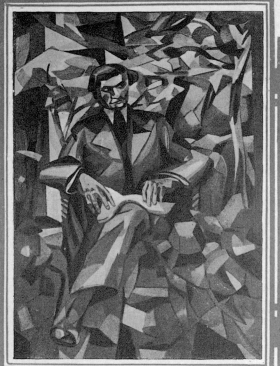

Portrait, par Albert Gleizes.

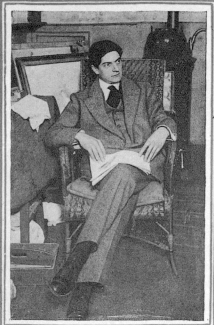

Le même, d'après nature.

Le goûter, par J. Metzinger.

La même, d'après nature.

nous divertit, mais, malgré tout, il nous semble qu'il serait bon de ne pas imiter plus longtemps l'indifférence hautaine des artistes bafoués et de fournir à la foule quelques éclaircissements qui suffiront peut-être à étouffer son rire outrageant. S'ils l'avaient voulu, les cubistes, dès le premier Salon, eussent dissipé un malentendu dont ils étaient les seules victimes, mais ils ont préféré s'enfermer dans un silence dédaigneux et c'est une attitude qui n'est pas sans beauté.

D'un mot nous allons justifier les cubistes et révéler leur doctrine. Pourquoi des visiteurs sans culture rient-ils sans retenue devant les Metzinger et les Fauconnier ? Parce qu'ils ne comprennent pas. Et pourquoi ne comprennent-ils pas ? *Parce qu'ils n'ont pas traduit !* Or, c'est là l'erreur fondamentale. Que dirait-on d'un homme qui, ignorant totalement la langue allemande, aurait la stupidité de lire Gœthe dans le texte et de prétendre ensuite que l'ouvrage est incompréhensible ? On dirait que cet homme est un sot.

Cette année encore des badauds d'intelligence moyenne se rendent au Salon d'Automne dans le seul but d'y rire et l'on retrouve, dans la salle des « fauves », les ordinaires nigauds que la vue d'un tableau cubiste met en joie.

Certes ce spectacle pénible nous indigne moins qu'il ne

Salon. The *Mona Lisa* was on everyone's mind, especially the Cubists: the renowned work by Leonardo da Vinci (1452–1519) had been stolen from the Louvre on 21 August 1911, and the newspaper *Paris-Journal* led a campaign for its restitution that resulted in Apollinaire's arrest on 8 September and detention as a potential accomplice. Apollinaire was released from La Santé prison on 12 September. In November a writer called 'The Masked Satyr' (probably Apollinaire) suggested that the *Mona Lisa* had now reappeared in Cubist form.

Whereas the Mona Lisa sits before a landscape, Metzinger's tastefully half-naked woman is in an interior with a fireplace and vase in the

99
Roland Dorgelès,
What the Cubes Mean ...
From *Fantasio*,
15 October 1911

100
Armand Berthez as a Cubist painter in *Et Voila!* at the Théâtre des Capucines, Paris, 1911

background. Once again his composition showed some awareness of the work of Braque and Picasso in the ochre colouring, the corrugated forehead and the schematic frontal/profile views of the woman's eyes. As if in fulfilment of his own description of a 'free and mobile perspective' in his earlier 'Note on Painting', Metzinger represented the teacup from two distinct angles. As recently as August 1911, Metzinger had published another programmatic text on the new art to which *Le Goûter* could act as illustration: the Cubists, he argued,

have allowed themselves to move round the object, in order to give, under the control of intelligence, a concrete representation of it, made

up of several successive aspects. Formerly a picture took possession of space, now it reigns also in time. In painting, any daring is legitimate that tends to augment the picture's power as a painting. To draw, in a portrait, the eyes full face, the nose in semi-profile, and to select the mouth so as to reveal its profile, might very well ... prodigiously heighten the likeness ...

This way of explaining Cubist method, as the combination of multiple viewpoints gathered over time purportedly producing a more convincing representation of reality, has endured in popular accounts and art gallery guidebooks. There were potentially two ways of injecting the idea of time into Cubist painting, however. Either the work could represent the 'intellectual' distillation of the painter's long and shifting attention to his immobile subject, as with Le Goûter, or it could capture the successive temporal stages of a moving subject. Some other works in Room 8 brought out the contrasting approaches. Gleizes showed his confident Portrait of Jacques Nayral (reproduced by Dorgelès with the title Portrait; see 99), Léger his Study for Three Portraits (102), and Marcel Duchamp his Portrait (Dulcinea) (103).

These major works were all figurative, but the multi-figure compositions of Léger and Duchamp were distinguished from Gleizes' contribution in this use of Cubism to represent movement. The bottom right-hand corner of Léger's work includes the depiction of a succession of hand positions, and Duchamp's painting – literally a 'strip cartoon' – shows the same woman walking through five different stages of undress. The reinterpretation of Cubist faceting as the fragments of continuous time was doubtless facilitated through the interest of Salon Cubists, and especially the Duchamp brothers, in chronophotography. This expert craft involved devising methods for capturing motion in still photography, either as a blurred after-image of the body moving through space in a single frame, as in the work of Étienne-Jules Marey (104) published in La Nature in 1893, or in a series of frames representing the movement in different stages (as in the work of Eadweard Muybridge reproduced in the The Human Figure in Motion, 1895). Raymond Duchamp-Villon may have made his own chronophotographs, or at least simulated them.

101
Jean
Metzinger,
Le Goûter,
1911.
Oil on canvas;
75.9 × 70.2 cm,
$29\frac{7}{8}$ × $27\frac{7}{8}$ in.
Philadelphia
Museum of Art

102
Fernand Léger,
Study for
Three Portraits,
1910–11.
Oil on canvas;
194·9 × 116·5 cm,
76³⁄₄ × 45⁷⁄₈ in.
Milwaukee Art
Museum

103
Marcel
Duchamp,
Portrait
(Dulcinea),
1911.
Oil on canvas;
146·5 × 114 cm,
57⁵⁄₈ × 44⁷⁄₈ in.
Philadelphia
Museum of Art

Towards the end of 1911 the young Marcel Duchamp became particularly fascinated by what he later called 'a static representation of movement' in his work. His series of paintings on the theme of a game of chess attempted to suggest the evolving patterns of the pieces on the board and in the minds of the players. Duchamp was drawn to such technical-sounding projects, the solutions to which interested him far more than their aesthetic impact. His casual, even desultory attitude to the finish of his work is obvious in a remarkable little painting on the theme of machine movement that he made for Duchamp-Villon as a kitchen decoration (105). Here the schematic

rendering of the mechanics of the coffee mill are complemented by the startling addition of a directional arrow. The crudeness of the painting deliberately resisted delectation (though some might now find it delectable), while the sign language of the arrow evokes engineering diagrams. These ideas resulted in more finished works at the end of the year, such as Sad Young Man on a Train (106). Duchamp invented a jargon name for his theoretical approach to painting at this time: he called it 'elementary parallelism', a new 'ism' reducing the moving world to parallel linear 'elements'.

104
Étienne-Jules Marey,
Study of a Man Walking,
c.1887.
Chronophoto-graph

105
Marcel Duchamp,
Coffee Mill,
1911.
Oil on cardboard;
33 × 12·5 cm,
13 × 4⁷⁸ in.
Tate Gallery,
London

Similar ideas relating modern art to a kind of technical drawing representing new scientific theories were rapidly taking hold among the Puteaux and Courbevoie circles. The art historian Linda Dalrymple Henderson has uncovered evidence showing that these artists were committed to the serious study of the latest scientific ideas. They read some fairly difficult texts that argued that the long-standing certainties of geometry and physics concerning time and space were without foundation. Duchamp's 'parallelism' is doubtless a reference to nineteenth-century challenges to Euclid's system of geometry, in particular to the ancient Greek mathematician's assertion that only one parallel to a given line can ever be drawn through a given point. The assumption of this postulate is that space is infinite and without curves. However, some pioneer mathematicians such as Karl Friedrich Gauss, Nikolai Lobachevsky and Georg Riemann suggested that the Euclidean model of space and time might be both mathematically suspect and inadequate for understanding the cosmos. This in turn had the consequence, spelled out by leading French mathematician Henri Poincaré in a famous article of 1887, that modern principles of geometry (and much science) were merely conventions or relative forms of knowledge, rather than absolute truths.

The curved space that non-Euclidean geometry postulated had another consequence of special attraction to the Cubists: the idea that objects moving through space would deform or undergo an effect like anamorphosis. Duchamp's late 1911 studies of the figure, such as *Sad Young Man on a Train*, show the trail of movement as an emanation resembling a comet's tail, blurring the boundaries of the figure with its past positions. This hardly amounts to a representation of deformation in stretched or curved space, though Duchamp would soon latch on to something like this theme in his notes and studies for his most ambitious work, *The Bride Stripped Bare by Her Bachelors, Even*.

For a time Duchamp was an exceptionally dedicated student of non-Euclidean geometry, but for most Salon Cubists it was extremely difficult to grasp, notwithstanding the explanatory efforts of Metzinger's friend Princet. Similarly, the related idea of a geometry that would

106
Marcel
Duchamp,
*Sad Young
Man on a
Train*,
1911.
Oil on textured
cardboard
mounted on
board;
100 × 73 cm,
39⅜ × 28¾ in.
Fondazione
Peggy
Guggenheim,
Venice

account for more than the usual three dimensions, known as 'n-dimensional geometry', was formidable in its algebraic form, and the only artist later to attempt serious study of it was once again Marcel Duchamp. The broader and related notion of the 'Fourth Dimension' was more influential, not least because many of the mathematicians and philosophers who discussed it resorted to visual analogies. The 'Fourth Dimension' was somehow supposed to be perpendicular to the three dimensions of familiar space.

In 1884 the English writer E A Abbott published a popular novel entitled *Flatland: A Romance of Many Dimensions by a Square*, which became known in France (and to the Cubists) thanks to the writings of another popular pedagogue, Pascal Esprit Jouffret. 'Flatland' is a two-dimensional world in which all the inhabitants resemble shapes drawn on a sheet of paper. The hero of the story, a square, is visited by a sphere, who appears as a dot and then an expanding and shrinking circle as he passes through Flatland. The sphere lifts the square above the plane of Flatland so that he can see into his fellow shapes, lines, circles and triangles, from above. The square is deeply moved by the sight of their interior spaces, and imagines an ever-ascending passage through further dimensions. Having upset the sphere with this talk of dimensions beyond a third, however, he is tossed back down to Flatland, where he is then imprisoned for his lunatic ideas.

Such amusing books existed alongside more serious 'Fourth Dimension' literature, including the work of Charles Hinton, who attempted to make of the 'Fourth Dimension' a new philosophy. Hinton believed that grasping the Fourth Dimension would require the development of new powers of mental vision, akin to those of an artist who had become fully conscious of the normally unconscious processes of painting. Even more mystical pronouncements on the Fourth Dimension were made by members of the Theosophical movement, particularly Charles Leadbeater. Theosophy is a term referring to any body of ideas aiming at direct knowledge of the divine, usually through intuition or ecstasy. The Theosophical Movement, led by a Russian, Helena Blavatsky, offered a strange and highly influential mix of scientific, philosophical, religious and spiritualist ideas. While Blavatsky gave little attention to ideas of the Fourth

Dimension, Leadbeater believed that the quest for Fourth Dimensional vision was like the Theosophical quest for 'astral vision'.

The close friend and immediate neighbour of the two older Duchamp brothers in Puteaux for over a decade, the artist František Kupka (1871–1957), had been a practising Theosophist and medium in his native Czechoslovakia. His mystical interpretation of the Fourth Dimension – a rather unusual extension of late Symbolist ideas – complemented Salon Cubist theories and may have played some part in their evolution. In his notebook from 1910–11 Kupka speculated on 'perceptions and intuitions of the visionary, of an ultrasensitive film, capable of seeing even the unknown worlds of which the rhythms would seem incomprehensible to us'. Kupka's series of paintings entitled *Planes by Colours* (one of which, now in the Guggenheim Museum, New York, featured in Room 7) and his more schematic but cosmic *Disks of Newton* (107) of 1911–12, are clearly meant to evoke the experience of seeing through matter to the underlying energy of the universe. The almost abstract character of *Disks of Newton* must have been deeply challenging to many in the Paris art world. The advent of this abstract or 'pure' painting is something that will be discussed in more detail below.

The final ingredient in the popular landscape of the Fourth Dimension was perhaps the most important. The English science fiction author H G Wells published his book *The Time Machine: An Invention* in 1895, and with this gave rise to the common confusion between time (or 'duration') and the Fourth Dimension. A French science fiction writer and Wells fan, Gaston de Pawlowski, published his own time travel stories from 1910 onwards, including the 1912 *Voyage to the Country of the Fourth Dimension*. The idea that painting could now represent the Fourth Dimension, and that the Fourth Dimension was time in the sense of duration or time experienced, gained enormous currency towards the end of 1911.

The expanded group of Salon Cubists exhibited together at the Galerie d'Art Ancien et d'Art Contemporain in rue Tronchet from 20 November to 16 December. Most of the works were recycled from earlier Salons, but Apollinaire gave a lecture on the Fourth Dimension in modern

painting that repackaged them along the lines of the Puteaux discussions. The notes for the lecture are lost, but Allard reported that 'a select audience listened to him explain his observations, now aesthetic, now scientific in nature – although an argument of the second kind provoked in one hot-blooded listener latent apoplexy …'. So not everyone was persuaded that cutting-edge geometry explained Cubist art. Apollinaire's enthusiastic adoption of the 'Fourth Dimension' as a key to Cubism rested more on his familiarity with studio discussions than on in-depth study. Here he is in an essay entitled 'The New Painting: Art Notes' of spring 1912:

The new painters do not intend to become geometricians, any more than their predecessors did. But it may be said that geometry is to the plastic arts what grammar is to the art of writing. Now today's scientists have gone beyond the three dimensions of Euclidean geometry. Painters have, therefore, very naturally been led to a preoccupation with those new dimensions of space that are collectively designated, in the language of modern studios, by the term *fourth dimension*.

Without entering into mathematical explanations pertaining to another field, and confining myself to plastic representation as I see it, I would say that in the plastic arts the fourth dimension is generated by the three known dimensions: it represents the immensity of space eternalized in all directions at a given moment. It is space itself, or the dimension of infinity; it is what gives objects plasticity …

It is evident that either Apollinaire had a limited grasp of Fourth Dimension literature, or was using the term as a metaphor for the new pictorial space of Cubism, which his avoidance of the idea of time as the Fourth Dimension seems to support. There was another, much more convincing, authority to whom some of the Salon Cubists could appeal to legitimate their claims to have founded an art based on time as well as space: the philosopher Henri Bergson.

Bergson was immensely successful in the years leading up to World War I, becoming a kind of celebrity as a result of his dazzling public lectures at the prestigious Collège de France, and regular attendees

107
František Kupka,
Disks of Newton,
1911–12.
Oil on canvas;
49.5 × 65 cm,
19½ × 25⅝ in.
Musée National d'Art Moderne, Centre Georges Pompidou, Paris

earned the sobriquet of 'Five o'clock Bergsonians'. A key thinker in the 'revolt against positivism' in France, Bergson reasserted the importance of human freedom and creativity in the face of causal accounts of human consciousness. His brilliant use of metaphor and analogy in his writings made his work more accessible than was usual for a professional philosopher. Bergson was a vitalist, that is to say he wished to explain the nature of all life itself. The lofty and romantic metaphysics of his work, which proposed to outline the nature of the *élan vital*, the 'life-force' shaping the universe, endeared him to radical Catholics as well as artists, and his remarkable descriptions of the work of memory had a profound effect on modernist literature and the creation of the 'stream of consciousness' novel developed by Marcel Proust, James Joyce and Virginia Woolf.

In his popularizing work *An Introduction to Metaphysics* of 1903, Bergson argued that the human consciousness experiences space and time as 'duration', as ever-changing and heterogenous. It is, after all, a commonplace that time sometimes 'drags', or 'flies by', depending on circumstances, and that awareness of the present can sometimes be lost when reflecting on memories. By contrast, the intellect or reasoning faculty always necessarily represents time and space as homogenous. Space is supposed to extend like an endless sheet of graph paper, and the present to move along a straight line of time, which can be cut up into hours, minutes and seconds. Intellect has to do this in order to make use of the world, in order to mark out the edges of distinct objects and places, at distinct times. The pragmatic or utilitarian bias of intellect means that it also treats living things as static and as caught up in a system of causes and effects that can be measured and predicted. Although the utilitarian attitude of the intellect is absolutely necessary to human survival, Bergson argued that it was a fundamentally false representation of the nature of things. As well as noting the basic contrast that exists between time in our experience and measured time, Bergson used the famous paradoxes of the ancient Greek philosopher Zeno to reveal the inadequacy of the intellect's understanding of time. An arrow shot by Achilles must pass through an infinite number of points *en route* to its target; but how does it ever reach the target if it must traverse

infinity first? Bergson argued that such paradoxes result from the false application of the static symbols or linguistic models of the intellect to 'perpetual becoming'; the intellect cannot grasp that motion through a given point is not the same as stopping at that point.

In fact, Bergson believed that the absolute immobility normally ascribed to inert matter was probably a construction of the intellect, and that in nature nothing is ever absolutely still. Instead, the universe is in a constant state of change or flux. The task of metaphysics, said Bergson, is to find ways to capture this flux, especially as it is expressed in consciousness, in the inner life of the human mind, while avoiding the errors of utilitarian intellectual description. But if the intellect is our main way of thinking about the world, how is metaphysics to undertake its task? Bergson argued that there is a form of consciousness more fundamental than intellect – the intuition. Intuition is 'a sympathy whereby one carries oneself into the interior of an object to coincide with what is unique and therefore inexpressible in it'. When searching for examples of the work of intuition, Bergson nearly always turned to art and literature; in his *Laughter: An Essay on the Meaning of the Comic* of 1900, for example, he held up the figure of the artist as paradigmatic of a more true, creative and intuitive relation to the world and self than anything offered by mechanistic science or intellect. As an expression of intuition, art offered absolute knowledge of the thing, while intellect only afforded relative knowledge. The scientific view of the motion of Achilles' arrow is relative, whereas our intuition grasps its absolute motion.

Bergson developed these ideas in his extraordinarily successful book of 1907, *Creative Evolution*. Here he offered a definition of duration as 'the continuous progress of the past which gnaws into the future and which swells as it advances'. He went on to outline a dualistic view of the universe. The two tendencies at work are those of matter, which is a continuous vibrating flux, and life, which cuts a swathe through matter by organizing it into living beings. Life – or the life-force which is the *élan vital* – organizes matter so that it can arrest the chain of vibrations in it, thereby maximizing freedom. The more complex the living organization, the more delay it can introduce into the chain

reactions of the universe, and therefore the more opportunities for free acts. Evolution, which gives rise to ever more complex organizations of matter into biological life, is for Bergson a fundamentally creative process. Human consciousness is the highest agent of freedom in the universe, since it is able through the work of memory to maximize delayed reaction to the ever-changing circumstances of the world. This delay allows for the choices of creative free will. 'For a conscious being', wrote Bergson, 'to exist is to change, to change is to mature, to mature is to go on creating oneself endlessly.'

The Salon Cubists were no doubt inspired by the reassertion of creativity and freedom in Bergson's thought, and by his constant references to artistic creation. Although it is not known whether any members of the group attended Bergson's lectures, *Creative Evolution* was much discussed at Puteaux. As a result the Salon Cubists were able to appropriate certain elements of Bergson's thought to their own ends. Even before the larger group was formed, Metzinger's mid-1911 'Cubism and Tradition', in which he described the Cubist picture as 'reigning in time', and argued for the combination of several views of a head, was indebted to Bergson. 'No image will replace the intuition of duration', wrote Bergson in the *Introduction to Metaphysics*, 'but many different images, taken from quite different orders of things will ... direct consciousness to the precise point where there is a certain intuition to seize on.' The art historian Mark Antliff has shown how this discussion of the power of several dissimilar images to call up intuitive knowledge was codified by the critic Tancrède de Visan as a literary technique of 'successive or accumulated images' – very close to Metzinger's 'concrete representation ... made up of successive images'. Furthermore, Metzinger's idea of 'time' in painting was later restated using the Bergsonian word 'duration'. In their immensely influential manifesto-like text *Du 'Cubisme' (On 'Cubism')* of October 1912, Gleizes and Metzinger wrote: 'Today, oil painting allows the expression of notions of depth, density and *duration*, thought inexpressible, and encourages us to present within a limited space governed by a complex rhythm, a true fusion of objects.'

On 'Cubism' – the original quotation marks around the word Cubism in the title are often overlooked – insisted on the absolute power of artists to create myriad new visions of the self, which for them is the only reality worth the name. This promotion of artistic freedom has been seen as a radical version of Bergsonian intuition, or (by the art historian John Nash) as an embrace of Nietzsche's theory of the artist as an *Übermensch* ('superman') or shaper of the new age. Nietzsche's ideas were known to the Cubists through translations of his books, among which they particularly admired *Thus Spake Zarathustra* (1888) and the posthumous *The Will to Power* (1901). Both Bergson and Nietzsche criticized the nineteenth-century obsession with scientific certainty; both argued that biological necessity had played a great part in the formation of human consciousness; and both believed in the ultimate authority of art to capture the truth of existence. It is thus difficult to separate the impact of each thinker on Gleizes and Metzinger. What can be said is that such philosophies of consciousness aided the Cubists in defending their departures from more representational forms of art, and in asserting their leadership of the avant-garde.

Adopting Bergson's language was not without risk. At one level, the risk was that Bergson himself would reject Cubism's version of duration. Towards the end of 1911 Gleizes' friend Alexandre Mercereau claimed that Bergson had given his approval to Cubism. This was far from the case, since in a 1911 interview in the newspaper *L'Intransigeant* Bergson confessed to having never seen a Cubist painting, and finding Metzinger's essay 'Cubism and Tradition' rather incomprehensible. Rumours continued to circulate that Bergson would write a preface to a Cubist exhibition in 1912, but this never materialized. Invoking Bergson was risky for another reason, too: the Cubists were not the only avant-garde group with an eye on this thinker, and they might therefore seem more like followers than leaders in modern art. The hint of a different approach to time in Cubist painting, which the works of Duchamp and Léger had given in Room 8 of the Salon d'Automne, opened up new possibilities for the Cubist's rivals, the Italian Futurists, possibilities that they would exploit with their own highly effective adaptation of Bergson's thought

to a theory of visual art. Thus Cubism and Futurism entered into a struggle over which art was the more Bergsonian. The main victim of this contest was the Cubist with the most investment in depicting movement, Marcel Duchamp.

The Futurists, it will be recalled, had made a tentative start on the road to challenging all artistic traditions (see Chapter 4). Gino Severini (1883–1966), the only member of the Futurist group to live in Paris and thus the only one fully appraised of the latest developments in avant-garde art, visited his colleagues in Milan during the summer of 1911. He advised Marinetti, who was planning an exhibition of his artists in Paris in late 1911, to stall the show and send his artists on a fact-finding mission to the studios of the Parisian Cubists if he wished to avoid embarrassment. As a result, Marinetti brought Umberto Boccioni (1882–1916), Carlo Carrà (1881–1966) and possibly Luigi Russolo (1885–1947) to Paris for two weeks in October. Severini took them to see Picasso and Braque in their studios, and they saw Rooms 7 and 8 of the Salon d'Automne. The impact of the visit on Futurist painting was a jump from the 'divisionist' style proclaimed in the 1910 manifesto to a faceted and less colourist grid. Boccioni painted new versions of his major triptych *States of Mind*, and a comparison of the two versions of *Those Who Go*, one from early 1911 and the other completed after the Paris trip, makes the point very clearly (108, 109).

The Futurist Exhibition finally took place at Galerie Bernheim-Jeune during February 1912. The famous preface to the catalogue, 'The Exhibitors to the Public', began by praising the achievements of the Cubists, and then – disingenuously, given the recent work of Delaunay, Duchamp and Léger – declared that Futurism sought 'a style for motion, a thing which has never been attempted before'. The emphasis on motion, which resonated with ideas of constant flux and movement, was given further Bergsonian inflexion by reference to 'individual intuition'. The preface sketched out a theory of art in which the painting bridges the gap between the external world and the interior emotional or intuitive life of the mind. In accordance with Bergson, this intuitive life is characterized by the simultaneity of states of mind, where present perceptions are always encrusted with past

108
Umberto
Boccioni,
*States of Mind I:
Those Who Go*,
1911.
Oil on canvas;
70·5 × 96·2 cm,
27³⁄₄ × 37⁷⁄₈ in.
Museo d'Arte
Contemporanea,
Milan

109
Umberto
Boccioni
*States of Mind II:
Those Who Go*,
1911.
Oil on canvas;
70·8 × 95·9 cm,
27⁷⁄₈ × 37³⁄₄ in.
Museum of
Modern Art,
New York

memories. Crucially, the Futurists insisted that 'the spectator in future must be placed in the centre of the picture', an edict they illustrated in the following passage:

In painting a person on a balcony, seen from inside a room, we do not limit the scene to what the square frame of the window renders visible; but we try to render the sum total of visual sensations which the person on the balcony has experienced; the sun-bathed throng in the street, the double row of houses which stretch to right and left, the beflowered balconies, etc. This implies the simultaneousness of the ambient, and therefore the dislocation and dismemberment of objects, the scattering and fusion of details, freed from accepted logic, and independent from one another ... In order to make the spectator live in the centre of the picture ... the picture must be the synthesis of *what one remembers* and of *what one sees.*

Alongside the term 'simultaneity', which here refers as much to the Bergsonian merging of past memory and present vision as the merging of inner and outer worlds, the Futurists introduced two other terms with Bergsonian resonance but that also allowed them to recast Cubist devices. In Boccioni's paintings the Bergsonian vibrations of the external world are termed 'force-lines' (according to Boccioni's newly proclaimed doctrine of 'Physical Transcendentalism'). The philosopher Paul Crowther has argued that the Futurist adaptation of the Bergsonian ideas of flux and simultaneity, using dynamism and force-lines, also attempted to resolve the opposition in Bergson's thought between intuition and intellect. Whereas Bergson insisted that the homogenous and measurable time of the intellect was a false construct to be overcome by intuition, Futurist admiration for the dynamism or the speed of modern life recognized that rapid machine movements and technologies of communication could, by their very density and intensity, transform the utilitarian world of measurement and stasis into a new image of the underlying flux of reality discerned by intuition. Modernity provided an opportunity for the convergence of the dynamism of consciousness with a new dynamism required of the intellect.

By spring 1912 both the Futurists and the Cubists had thus adopted Bergsonian language in their writings. An acute sense of rivalry led to

secretiveness, spin-doctoring and espionage (by June 1912 Boccioni was instructing Severini to find out everything he could about the latest works by Braque and Picasso, for example). Apollinaire's review of the Bernheim-Jeune show poured scorn on the Futurists' claim to owe nothing to French art, and presented them as in danger of becoming mere illustrators, but his admiration for the bombast of Marinetti led him to celebrate the youthful energy of the Italians.

For the demagogues within the Cubist movement, such as Gleizes and Metzinger, everything in the upcoming Cubist showing at the Salon des Indépendants of 1912 had to appear untainted by Futurism. This sense of a party line led to a confrontation with Marcel Duchamp, who proudly presented his uncharacteristically finished *Nude Descending a Staircase No. 2* (110) for the exhibition. This second version of the composition was, Duchamp later claimed, fundamentally unlike Futurist attempts to represent the experience of motion using force-lines and show a simultaneist fusion of spectator and scene. Duchamp was rejecting such 'cinematic effects', which, like other contemporary critics of Futurism, he dismissed as a mere updating of urban Impressionism. The painting showed a machine-like 'figure' of uncertain gender clattering and lumbering down a staircase worthy of a ghost story. The white-dotted lines around hip level derived from chronophotography, and this arid and shockingly unsentimental approach to the academic tradition of the nude was matched by the dogged lettering of the title along the bottom of the canvas. Gleizes was appalled at the sight of this perversely androgynous machine-nude, which he took to be a clear homage to Futurism from within the Cubist camp. Duchamp's elder brothers were thus prevailed upon to persuade Marcel to withdraw the painting, which he did. This use of the party whip so nauseated him, however, that it led him to abandon painting 'in the professional sense' during the following year.

Meanwhile, major efforts had been made to ensure an impressive display of the superiority of Cubism at the Indépendants with a collection of very large paintings. Delaunay, for example, showed the vast *City of Paris* (111). This work reached back, as Apollinaire noted in one of his

NU DESCENDANT UN ESCALIER

ecstatic paragraphs of praise, to the ideals of Renaissance art: the three dancing nude women on the left referred directly to a postcard Delaunay had of a Pompeian fresco, as well as to countless other representations of the Three Graces. The bridge to the far left was a quotation from Douanier Rousseau's *Myself: Landscape-Portrait* of 1890. Notwithstanding the presence of Delaunay's trademark Eiffel Tower in the painting, the picture reflected his growing interest, then being encouraged by Maurice Princet, in light and colour rather than Cubist linear composition. This was a sign of Delaunay's imminent rejection of Cubism. Gleizes must have been content to see such a prominent place bestowed on the traditional nude by Delaunay. Gleizes' own major contribution to the Salon, a painting on the academic theme of bathers in a landscape (now in the Musée d'Art Moderne de la Ville de Paris), was completed with the token modernity of distant factory chimneys. As a result of the prominence given to the nude in such paintings, no one could have missed Salon Cubism's trenchant refusal to accept the Futurist 'total suppression of the nude in painting'. Thanks to the stage management role that Gleizes had adopted, the adherence of Salon Cubism to this symbol of the traditions of classicism was unpolluted by Duchamp's parodic mechanical nude.

Léger's main contribution was *The Wedding* (112), an energetic depiction of a wedding procession in a town whose tree-lined avenues and nestling houses are to be seen to the centre-right of the painting. The procession fills the centre from top to bottom, with what appears to be a blushed-white bride and comically smaller bridegroom in the foreground. The hands and faces of the friends and relatives in the procession merge into a bustling vision of hands, faces and the occasional flash of colour from someone's best dress. Léger's daring abstract evocation of subjective experiences was unified through dynamic angular planes. Among Cubist works in the Salon it came closest to showing signs of an interest in Futurism. The judgements as to what might constitute Futurist influence must have been very fine, and Léger's figuration and grid structure were far less overtly indicative of movement than Duchamp's rejected *Nude*. The other large works ostentatiously eschewed the radical dynamism of Futurist modernity.

110
Marcel
Duchamp,
*Nude
Descending a
Staircase No. 2*,
1912.
Oil on canvas;
147·3 × 88·9 cm,
58 × 35 in.
Philadelphia
Museum of Art

Overleaf
111
Robert
Delaunay,
*The City of
Paris*,
1912.
Oil on canvas;
267 × 406 cm,
105⅛ × 159⅞ in.
Musée
National d'Art
Moderne,
Centre Georges
Pompidou,
Paris

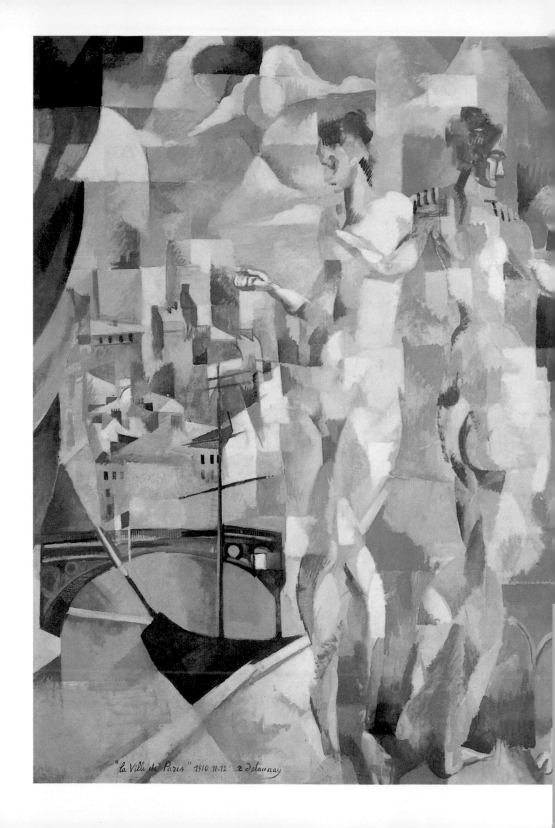

"La Ville de Paris" 1910, 11-12 R delaunay

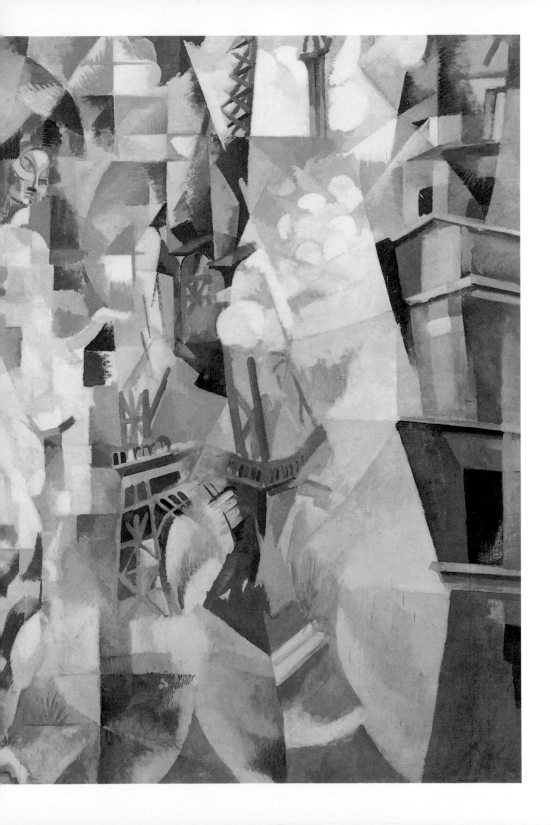

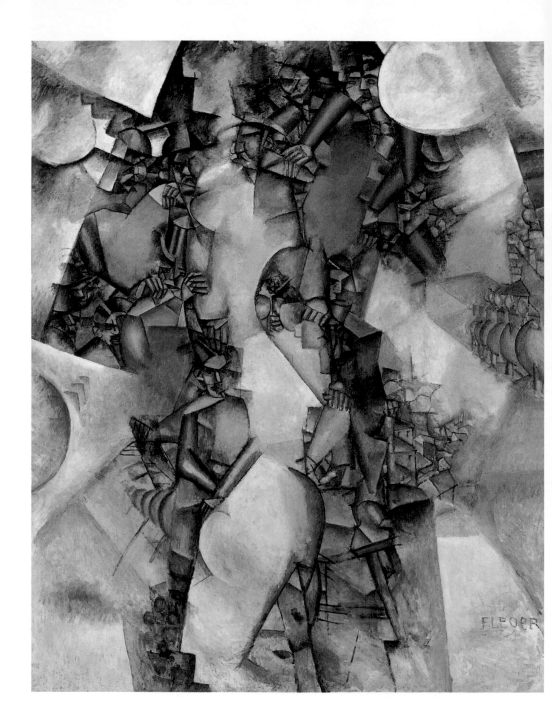

There was one other event of major importance to the history of Cubism at the Salon des Indépendants of 1912: the debut of Juan Gris. Arriving in Paris in 1906, having followed a commercially oriented basic arts training in Madrid, José González Pérez started work almost immediately as a cartoonist (see 91) under the deliberately bland pseudonym Juan Gris ('John Grey'). Although it was not unusual for cartoonists and caricaturists to adopt a false name (as had 'Jacques Villon'), Gris seems to have relished the task of reconstructing his identity even when it came to his arrival as a 'serious' artist. Gris moved to a studio in the Bateau Lavoir sometime around 1908, becoming one of his fellow Spaniard Picasso's immediate neighbours.

Gris seems to have dedicated himself to following the work of Picasso and Braque as it developed and, as a gifted draughtsman and painstaking technician, he gained a thorough understanding of early Gallery Cubism. The earliest surviving oil paintings by Gris are elegant and structured still lifes from around 1910, but by mid-1911 he had developed a profound knowledge of Braque and Picasso's Cubist *passage*, line, grid and palette, and had evolved his own artistic personality with which to reinterpret them. Already admired by Kahnweiler (with whom he would sign a contract in February 1913), Gris had his first solo exhibition in January 1912 at the gallery of the dealer Clovis Sagot. Thus the inner circles of Cubism were well prepared for his debut at the Salon des Indépendants with three paintings including the impressive and strategic *Homage to Pablo Picasso* (113), and *Still Life with Flowers* of 1912. In making his *Homage*, Gris was hitching his fortunes to the artist rumoured to be the greatest exponent of Cubism, since Braque's name was much less widely touted than Picasso's. In its composition and method the picture rivalled Metzinger's supposedly mathematical *Le Goûter*. The extraordinary poise and finish of Gris' Cubism, and the greater subordination of the representation to an evenly ordered faceting (especially in the upper part of the painting), announced an austere new talent. Salmon had proclaimed Metzinger 'the young prince of Cubism', but Gris was already vying for the title. Apollinaire now found a name for Gris' kind of painting: he called it 'Integral Cubism', borrowing the term from a debate of the previous year.

A Cubist show was organized at the Galleries Dalmau in Barcelona between 20 April and 10 May 1912. Jacques Nayral, with whose portrait Gleizes had seen some success in 1911, wrote a catalogue preface. The show featured work by Metzinger, Gleizes, Laurencin, Gris, the Spanish sculptor Auguste Agéro, as well as Le Fauconnier and Léger. The most surprising inclusion was Duchamp, whose *Nude Descending a Staircase No. 2* had not been tolerated in the heated atmosphere of rivalry with the Futurists in Paris but was found acceptable for Catalonia. Any hard feelings between Duchamp and Gleizes seem to have been quickly forgotten, even if, for Duchamp, the impact of the affair was not. Nayral's preface, which is not widely known, said little of note about Cubism in general, beyond expressing admiration for artists seeking 'profound reality' beneath superficial appearances. Nearly all the artists discussed were treated as logical and intelligent, with the predictable exception of Marie Laurencin, whose art was said to express the 'fragile emotion of the feminine soul'. She fared no better in Apollinaire's text, which treated her under the rubric of 'feminine aesthetics'. Laurencin apparently encouraged such approaches to her work, perhaps due to the high value that came to be placed on the 'decorative' around the end of 1912.

113
Juan Gris,
Homage to Pablo Picasso,
1912.
Oil on canvas;
93 × 74.1 cm,
36⅝ × 29⅛ in.
The Art
Institute of
Chicago

The third Salon de la Société Normande de Peinture Moderne in Rouen opened on 15 June 1912. Maurice Raynal wrote the catalogue preface. Gris had painted portraits of both Raynal and his wife, and in three important essays Raynal would develop one of the most influential accounts of Cubism's conceptual nature. Raynal's Rouen preface began by noting the coincidence of the new science and new art, and rejected the idea of art based on the servile imitation of nature. Raynal then attempted to sketch out a two-stage representational process adopted by the Cubist painters:

Before all else, they separate out – according to their own analytical methods and to the characteristics of the object – the principal elements of the bodies they propose to translate. They then study these elements in accordance with the most elementary laws of painting, and reconstruct the objects by means of their elements, now known and strictly determined.

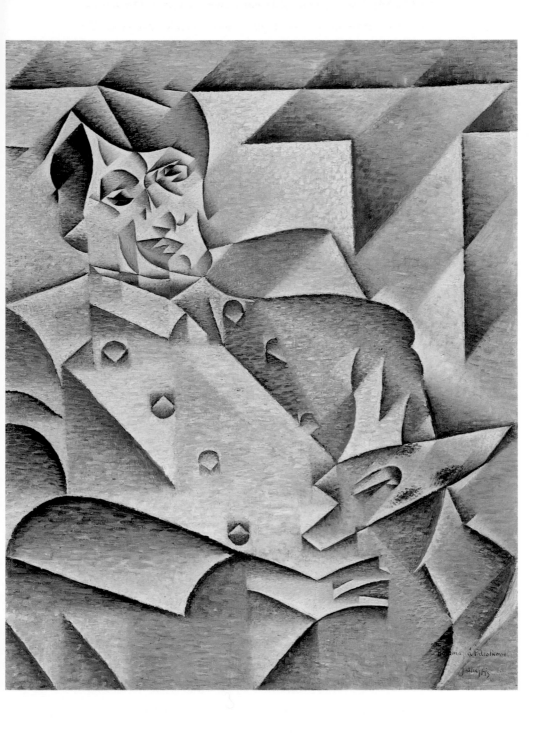

This clear-sounding summary gave more convincing form to ideas earlier touted by Allard and Metzinger, among others, and paved the way for the coherent application of the terminology of 'analysis and synthesis' to Cubism. Raynal took a different but related tack in 'Conception and Vision', an essay of August 1912, in which he insisted that Cubism sought an 'absolute' conceptual representation of the world, rather than a 'relative' perceptual one. The vaguely Bergsonian language here also allowed him to attack Futurism on its own ground when he argued that the 'movement which the Futurists have perceived is ...

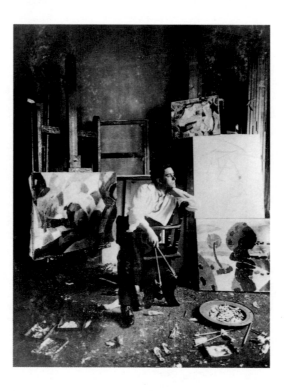

114
Francis Picabia in his studio at 82 rue des Petits-Champs, Paris, 1912

only relative to our senses and is in no way absolute.' Raynal's lucid championing of Salon Cubism made him the ideal candidate to write on one of its last two coherent exhibitions in the autumn of 1912.

The Rouen show was organized largely by the Duchamp brothers, and for the first time it included Francis Picabia (1879–1953; 114) among the Cubists. The wealthy Picabia was an extraordinary character who collected sports cars and invented wild stories about his youth, such as a meeting with Nietzsche while on a tryst with a much older

woman in Switzerland at the age of sixteen. Picabia was the son of a Cuban father and French mother, and he had grown up in Paris harbouring artistic ambitions and developing a profound contrariness. Like Marcel Duchamp – though with much greater initial success – he put himself through a rapid apprenticeship in all the latest styles of painting, and when the two met around the end of 1911 they became close friends. Picabia had exhibited alongside Kupka in Room 7 of the Salon d'Automne of 1911, and this may have spurred him on in pursuit of the 'pure painting' of which Apollinaire began to speak in 1912.

Picabia befriended Apollinaire, distraught over his recent estrangement from Marie Laurencin, after the Rouen show, and in the coming months these two extravagant personalities embarked on various adventures, including a trip to England, where they relied on Apollinaire's appallingly accented English to get them around night clubs in London. During this period Picabia painted two canvases that would attract much attention in the autumn: *Dances at the Spring I* (now in the Philadelphia Museum of Art) and *Dances at the Spring II* (115). The complex interplay of colour and rhythmic shapes in these works was the result of the systematic abstraction of two figures in a rugged landscape, and in the second of the two paintings it is hard to pick them out at all, though many of the forms are transferred from the smaller first version. These paintings were on the theme of a 'peasant dance' that Picabia witnessed on his honeymoon in Spain, although according to Apollinaire in *The Cubist Painters*, they were 'simply the expression of a plastic emotion experienced spontaneously near Naples'. Picabia got himself elected as an associate member of the Salon d'Automne in 1912, and took advantage of this by showing *Dances at the Spring I*, as well as the more abstract painting *The Source*, in Room 11 that year. A photograph of the 'infernal room', as it became known (116), reveals works by Metzinger and Le Fauconnier (who showed his vast but improbable *Mountaineers Attacked by Bears*) alongside Picabia's. Kupka's *Amorpha: Fugue in Two Colours* (see 125) is also visible in the photograph. Opposition to the Cubists among the hanging committee led to the allocation of a dingy room and a cluttered display.

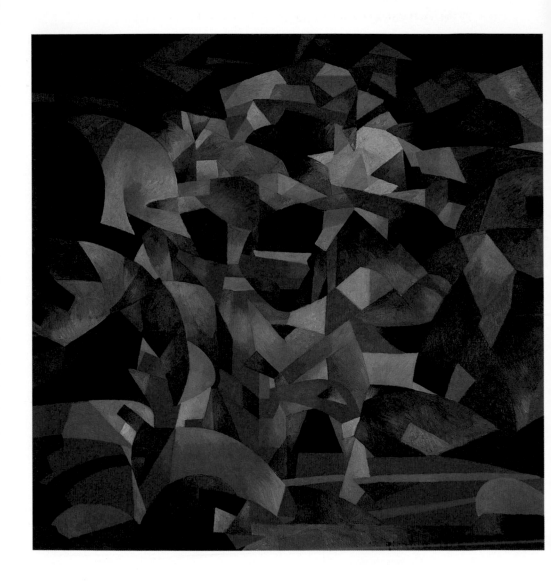

As a result of the works shown in Room 11 and elsewhere, Cubism was criticized as 'criminal' in an open letter from Monsieur Lampué, the elder statesman of the Paris town council, to Monsieur Bérard, the member of the government responsible for the arts, and a political debate on the issue continued for months. Lampué implored Bérard to visit the Salon and see the disgraceful display for himself. Those opposed to Cubism in the Chamber of Deputies argued implausibly that Cubism had been given pride of place in the Salon, and made frequently sinister allusions to the presence of foreigners among the artists and the hanging committee. The undercurrents of politically expedient nationalism and even various forms of racism in the debate were not out of step with the times. Xenophobia was exacerbated by the current conflict in the Balkans and the anxiety over German militarization that had been building ever since the 'Moroccan crisis'

115
Francis
Picabia,
*Dances at the
Spring II*,
1912.
Oil on canvas;
252×249 cm,
99⅛×98 in.
Museum of
Modern Art,
New York

116
Room 11 at
the Salon
d'Automne,
Paris, 1912

of June 1911, when the appearance of a German warship at Agadir was interpreted by the French (who had been policing Morocco since 1906) as a threat of war. Vauxcelles, by now an arch-enemy of the Cubists, was insulted by two of them on the opening day of the Salon, although (according to Vauxcelles the next day) they declined on Cubist principle to settle the matter in a duel.

Once again, however, all the apparently negative publicity probably helped rather than hindered the rise of Cubism in the public eye, and the presence in the Salon of the first example of Cubist architecture and decorative art stirred up even greater hostility and interest. The ensemble in question was the Maison Cubiste (Cubist House) designed by Raymond Duchamp-Villon. The plans for a display of Cubist decorative art were hatched at the dinners of yet another Salon Cubist

group that sprang up during 1912, the 'artists of Passy'. Presided over by Henri-Martin Barzun, editor of the new journal *Poème et drame*, this group included most of the Puteaux and Courbevoie artists, and the designer André Mare (1887–1932). It was Mare who invited Duchamp-Villon to create a plaster maquette for the façade of a house (117), which would then be built to full size for the Salon d'Automne. A series of three ground-floor rooms (118) would contain progressive examples of design and decorative art. Duchamp-Villon took a rather conventional French bourgeois town house and remodelled it with Cubist faceting around the windows, main door and balustrades. The façade was designed using a mathematical ratio regarded by the Puteaux Cubists as aesthetically significant: the 'Golden Section'.

A shortage of time and resources meant that only the ground floor of the full-size façade was constructed at the Grand Palais, and, in order to fit the allocated space, the façade was modified to form an L-shape with a right angle to the left of the main door (119, 120). For the

interior Mare recruited eleven other contributors, plus paintings from leading Salon Cubists including Léger, Metzinger and Gleizes. Laurencin painted decorative vignettes that were integral to the scheme. Mare's aim was to address the perceived inferiority of the French decorative arts when compared with contemporary German work. The idea that Cubism might become the decorative vernacular of modern France also appealed to those members of the Salon Cubist circle, Gleizes in particular, who remembered the project of the Abbaye de Créteil. The surviving photographs of the large room (121) reveal a surprisingly cluttered and not especially Cubist look to the furnishings – making Léger's *Railway Crossing*, visible in the mirror, seem all the more out of place. Nevertheless, it seems that Léger and the other contributors were excited by the whole project.

In the next twelve months, Apollinaire gathered together various newspaper articles, many from 1912, and repackaged them for his highly influential and richly illustrated *The Cubist Painters: Aesthetic Meditations* of January 1913. The opening chapter contained feverish prophesies of an imminent transformation. Apollinaire declared that 'the secret aim of the young painters of the extremist school is to produce pure painting ... still in its beginnings, and not yet as abstract as it would like to be.' The Fourth Dimension still figured in his account, as did the now familiar claim that Cubism was more 'cerebral than sensual', but the most important element of the text was the attempt

Opposite above
117
Raymond Duchamp-Villon,
Maquette for the Cubist House, 1912

Opposite below left
118
Plan of the Cubist House, 1912.
1. Facade,
2. Entrance,
3. A bourgeois living room
4. Bedroom

Opposite below right
119
Raymond Duchamp-Villon,
Façade of the Cubist House at the Salon d'Automne installation, Paris, 1912

Right
120
Raymond Duchamp-Villon,
Window of the Cubist House with reflections of onlookers, 1912

to sort the Cubists into four categories, of which two were supposedly expressions of the drive towards 'pure painting'. Integral Cubism disappeared from Apollinaire's list, to be replaced by (pure) 'Scientific Cubism' (Picasso, Braque, Gleizes, Laurencin and Gris); 'Physical Cubism' (Le Fauconnier); (pure) 'Orphic Cubism' (Picasso, Delaunay, Léger, Picabia and Duchamp); and 'Instinctive Cubism' (a catch-all term including some advanced art that had no real relationship to Cubism).

Having offered definitions of these types of Cubism, Apollinaire proceeded to treat each artist in turn, but missing out Le Fauconnier and adding an appendix on Duchamp-Villon. Apollinaire's categories have not, with the notable exception of 'Orphic Cubism', been widely accepted. (Art historians have adopted the term Orphic Cubism or Orphism, discussed further below, to refer mainly to non-figurative rhythmic colour compositions that express new levels of consciousness.) The scientific currents within Cubism were certainly worth pointing out, even if Apollinaire's list of artists under the

121
André Mare,
Bourgeois
living room,
Cubist House,
Salon
d'Automne,
Paris, 1912.
Left wall: Jean
Metzinger's
*Woman with a
Fan*; reflected
in the fireplace
mirror:
Fernand
Léger's *Railway
Crossing*;
fireplace by
Roger de la
Fresnaye;
tea service (on
the table) by
Jacques Villon

heading is bewildering. Yet the veritable chaos of Apollinaire's 'system', and the apparently arbitrary placement of the artists under the four headings, conveys more of a feel for the fragmentation, dissension and stylistic heterodoxy of Salon Cubism as the year 1912 progressed than any more disciplined theory of the movement.

The most ambitious Salon Cubist exhibition to date opened at the Galerie La Boétie for the month of October 1912 only a few days after the Salon d'Automne. Called the Salon de la Section d'Or (the Golden Section) it featured over two hundred works by thirty-two artists, and provided Apollinaire with the opportunity to air for the first time his four categories of Cubism in a lecture on 11 October. The group also published a review entitled *La Section d'Or*, which printed Raynal's perceptive essay on the exhibition. A work by Gris (*The Washstand*), into which the artist had incorporated a real mirror, offered one of the first interpretations of the practice of collage then being developed by Braque and Picasso (see Chapter 7). Overall, Raynal was conscious of the extreme diversity of work on show, arguing that the term Cubism had all but lost its significance.

Certainly there were huge differences between the works on show by key members of the group. Picabia's *Dances at the Spring II* (see 115) was near abstract, while Gleizes' grandiose *Harvest Threshing* (122) depicted relatively recognizable figures in a rural scene. On the right of the painting three figures, including a woman wearing a white-spotted scarf or shawl, seem to be leaving their picnic to return to work. Behind them is a country church. In the centre the harvest is in full swing, and two delicate stalks of corn can be seen in the golden patch of colour to the left. Meanwhile, Gris contributed *Man at the Café* (123), a modern man of taste, complete with top hat and black suit, resting one hand on a chair and leaning his head on the other. The rather earnestly programmatic application of Cubist fragmentation to the face is set off against the caricatural rendering of his patent leather shoes, and Gris even makes a knowing reference to his earlier *Homage to Picasso* (see 113) with the 'Pic ... ap' lettering to the left of the man's shoulder. Duchamp was now free to exhibit his *Nude Descending a Staircase No. 2*, as well as the mysterious (or for Vauxcelles offensive) *King and*

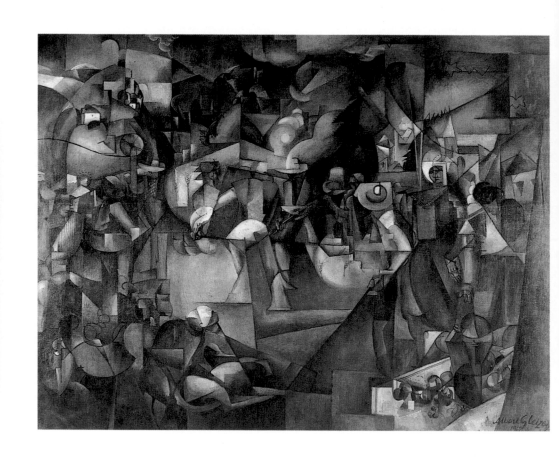

122
Albert Gleizes,
*Harvest
Threshing*,
1912.
Oil on canvas;
269 × 353 cm,
105$\frac{7}{8}$ × 139 in.
Private
collection

123
Juan Gris,
*Man at the
Café*,
1912.
Oil on canvas;
127·6 × 88·3 cm,
50$\frac{1}{4}$ × 34$\frac{3}{4}$ in.
Philadelphia
Museum of Art

Cubism at Large

124
Louis
Marcoussis,
*Portrait of
Guillaume
Apollinaire*,
1912.
Etching,
aquatint and
drypoint;
49·2 × 27·8 cm,
19⅜ × 11 in

Queen Surrounded by Swift Nudes. The newcomer Louis Marcoussis
(1878–1941), a Polish artist, revealed an admiration for Braque and
Picasso's current work almost as developed as Gris' in his series
of seven drypoints, which included a portrait of Apollinaire (124).
Marcoussis made a second drypoint portrait of the poet that year,
but added colour and shading later to produce one of the most
evocative images of this champion of Cubism.

One further symptom of this fragmentation of styles was the absence
of Delaunay and Le Fauconnier from the Salon de la Section d'Or. Both
artists publicly repudiated the Cubist movement, Le Fauconnier only
to fall gradually into obscurity, and Delaunay in order to promote
successfully one of the 'pure painting' styles just proclaimed by
Apollinaire, 'Orphic Cubism' or Orphism. Of the artists described
as Orphic Cubists by Apollinaire, only the Delaunays and Picabia
accepted the designation, but it is now sometimes used to describe
works of the period by Duchamp, Kupka and Léger. The leading

historian and proponent of Orphism as a category, Virginia Spate, defines Orphist painting as non-figurative art that expresses new forms of consciousness, especially non-conceptual consciousness. The name Orphism referred to the Greek mythological figure of Orpheus, whose music had charmed even the gods of the underworld. In *The Cubist Painters* Apollinaire made an analogy between the colour 'harmonies' of non-figurative painting and the harmony of non-mimetic music:

The music-lover experiences, in listening to a concert, a joy of a different order from the joy given by natural sounds, such as the murmur of the brook, the uproar of a torrent, the whistling of the wind in a forest, or the harmonies of human speech based on reason rather than on aesthetics.

In the same way the new painters will provide their admirers with artistic sensations by concentrating exclusively on the problem of creating harmony with unequal lights.

Apollinaire's text did not insist that 'pure painting' would be absolutely abstract, and his definition of 'Orphic Cubism' argued that it created new structures out of the artists' inner experiences, leading to a 'pure aesthetic emotion'. He believed that the rhythms, harmonies and compositional unity of non-figurative art mirrored the creative power of poetry. While these ideas were borrowed directly from recent aesthetic theories (which in turn reinterpreted Kantian aesthetics), pure painting had as much to do with the impact of Salon Cubism's mystical–scientific obsessions. For example, an unpublished note in Duchamp-Villon's papers, possibly from as early as 1909, gives a clear indication of fantasies of a new technologically inspired art form to be composed on a kind of cinematic painting-organ: 'A mobile art (certainly not painting) is about to be born. Colours will change on a screen, and the pictures thus composed may or may not derive from nature. To achieve this, a musical instrument, a modified organ, will be needed.'

It would not be long before Cubist artists would take up film as a medium for abstraction, but the first efforts at a pure art were paintings by Kupka and Delaunay. Kupka showed two large abstracts in the Salon d'Automne of 1912 (125). These works attempted to find visual

expression for Kupka's mystical belief – which paralleled Bergson's theory of life as stated in *Creative Evolution* and religions such as Buddhism – in the unitary nature of the cosmos beneath the multitudinous forms of particular existences. *Amorpha: Fugue in Two Colours* originated in a painting of Kupka's step-daughter playing with a coloured ball in the garden. Kupka became fascinated by the relationship between the girl and the moving ball, and made drawings that gradually simplified the forms of the figure and reinterpreted them in a series of interlocking circles. The three blue triangles with a small blue square

125
František Kupka,
Amorpha: Fugue in Two Colours,
1912.
Oil on canvas;
211 × 220 cm,
83 × 86⅗ in.
Národní Gallerie, Prague

126
Robert Delaunay,
Simultaneous Windows on the City,
1912.
Oil on canvas;
59 × 51·6 cm,
18 × 15¾ in.
Kunsthalle, Hamburg

at their crux, visible towards the bottom left of the painting, are a vestige of the pattern on the ball. The particular event has been transformed into an abstract structure, however, based on the interplay of shape and colour, and aiming for an effect analogous to the fugue in music.

Although Delaunay does not seem to have shared such metaphysical interpretations of the aim of pure painting, it is true that he drew much encouragement and inspiration from the Russian abstractionist Kandinsky. Kandinsky was co-editor of the new Expressionist 'almanac'

The Blue Rider, of which only one edition was ever published. This important book contained reproductions of works by Picasso, Le Fauconnier, Rousseau and Cézanne, as well as several of Delaunay's *Saint-Séverin* pictures. In May 1912 Kandinsky had shown three of his 'Improvisations' at the Indépendants, one of which was hung (in a chalk-and-cheese contrast) next to Gris' *Homage to Picasso* (see 113). Delaunay began writing regularly to Kandinsky, and had his wife Sonia and a friend, Elisabeth Epstein, translate Kandinsky's influential theoretical text *Concerning the Spiritual in Art*. Combining aspects of Kandinsky's colour theory with ideas on optics culled from Leonardo da Vinci, Delaunay set about a new series of paintings – the *Fenêtres* or *Windows* – in April 1912 (126). Here the modern city began to dissolve in veils of colour, and the sweeping lines of the Eiffel Tower suggested the meeting arcs of enormous chromatic wheels. In this decisive set of paintings for his embrace of abstract art, Delaunay also experimented with extending the weave of hot and cold colours onto the frame itself (no doubt he was conscious of Seurat's experiments in this regard). In so doing he was careful to ensure that some swatches of colour crossed the borderline between the canvas stretcher and frame, so that the two elements were truly integrated. The *Windows* were exhibited in the main commercial gallery exhibiting avant-garde art in Berlin, *Der Sturm*, at the beginning of 1913, and Delaunay attended the opening with Apollinaire, who published a 'conversation-poem' entitled *Les Fenêtres*, dedicated to Delaunay, in the journal *Poème et drame*.

Delaunay's apotheosis as a 'pure painter' came with pictures of the sun and moon, which included the works known simply as 'Circular Forms'. Although it was long thought that Delaunay began these works in late 1912, it is now clear that all were painted between April and September 1913. Among them is the work (127) whose title, insisting on its priority, declares a 'year zero' of abstraction – *Disc (The First Disc)*. Simultaneously imbued with solar mysticism and the science of optics advanced by colour theorists such as Michel-Eugène Chevreul and Ogden Rood (whose writings in the nineteenth century also influenced the Impressionists and the Post-Impressionists) these works dealt with the perpetual movement of colour. *Disc* consists of

seven concentric circles divided into four equal segments, a design intended to foil suggestions of representation, and to give presence, Delaunay later said, to the 'pure essence of painting'. Although it was not exhibited in Paris until 1922, a 1914 photograph shows Delaunay proudly seated before it, and the inscription records the fact that it was exhibited in Berlin in (late) 1913 (see 76). This 'first circle' inaugurates a theme to which modern art returned repeatedly in the twentieth century: the plenitude of the visual at the point where representation is reduced to the barest of minimums.

Compared with the ominous and dazzling sight of Delaunay's *Disc*, Léger's series entitled *Contrast of Forms* (see 95), with which he also staked his claim to 'pure painting' in mid-1913, seems joyfully varied, as well as closer in spirit to the Cubism from which it sprang. The series is typified by the so-called 'kite-device' in the upper centre, where a two-tone lozenge shape separates two cylinders. Colour is distributed in bands and stripes across the surface of the pictures, which have strong black line drawing marking out the interlocking

127
Robert
Delaunay,
*Disc (The
First Disc)*,
1913.
Oil on canvas;
diam.134 cm,
$52\frac{3}{4}$ in.
Private
collection

cylinders and planes, and there is often the illusion of the whole appearing against a striped background plane. Again, these apparently abstract works derived from studies of particular visible things, in this case perhaps the models in the artist's studio, but they turn this subject into a visible vocabulary that can stand for many different forms and spaces. In a lecture he gave at the time, Léger explained that:

The 'rapports' of volumes, lines and colours are becoming the generators of all artistic production and of all influence exercised on artistic milieu, as much in France as abroad ... Pictorial contrasts used in their purest sense ... of colours and line, of form, are from now on the armature of modern painting.

The emergence of abstract art from Cubism was an enormously important development for twentieth-century art, and Léger's stress on 'form' and the constituent elements of painting is an early example of one of the most significant forces in the understanding of abstraction, known as 'formalist criticism'. Yet, as this chapter has shown, 'form' in Salon Cubism was never far removed from philosophical and scientific ideas, and the race to conquer a new art was never clearly divorced from efforts to assert leadership of the avant-garde. The central importance to Salon Cubism of theory and public debate could not have been further, however, from the intuitive play of Cubism according to Braque and Picasso. Chapters 6 and 7 continue the story of their secretive dialogue, and examine their complex reaction to Salon Cubism.

In the autumn of 1909, Braque made a small still-life painting of a clay pipe, lighter and a newspaper (129). As a matter of course, Braque daubed in the letters of the folded paper's title 'GIL B[LAS]'. No doubt he decided on this paper remembering that it had carried Vauxcelles' 'little cubes' review of his 1908 show at Kahnweiler's. Braque was far from being the first artist to copy printed text in paint, but with this ironic gesture he opened a rich seam in Cubism that, together with Picasso, he would exploit in the coming years. As they realized the possibilities inherent in painted words, Braque and Picasso asked playful questions about the relationship between word and image, and about visual images themselves, that coincidentally echoed the latest researches, elsewhere in Europe, into the nature of language.

128
Pablo Picasso,
Ma Jolie
(*Woman with
a Zither or
Guitar*)
(detail of 150)

At the turn of the century linguists in Europe and the United States wondered what language really was, and how to describe it. This led to a new appreciation of the importance of structures and codes to linguistic meaning; of the social dimension of language; and of the arbitrary or accidental nature of the way language describes reality. Such ideas were the origin of 'semiotics', the study of 'signs', which has been enormously influential in the critical re-evaluation of language and other cultural codes, and has in particular had a huge impact on the study of visual art. It might be thought that, in their exuberant dialogue, Braque and Picasso could hardly have been further removed from such serious academic studies. Yet art historians employing semiotics have argued that the inclusion of words in Cubist paintings raises profound questions about art, language and representation.

These arguments continue a long-standing debate over the significance of the lettering, numbers and musical notes frequently introduced into paintings by Braque and Picasso in 1911. On the one hand there are those who argue that these letters inject a necessary

element of reality into Cubism, providing clues to subject matter and asserting the materiality of the picture surface. Others follow art historian Robert Rosenblum in arguing that the lettering is there to prompt the realization that the arcs and planes of Cubist paintings are 'no more to be considered the visual counterpart of reality than a word is to be considered identical to the thing to which it refers'. For Rosenblum, this emphasis on the contingent and symbolic in Cubist representation distinguished it from the Renaissance idea that paintings should create an illusion of reality. The problem is of course

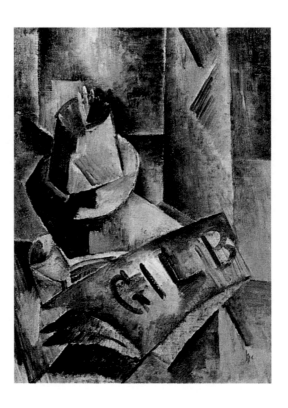

129
Georges
Braque,
*Lighter and
Newspaper:
'Gil Blas'*,
1909.
Oil on canvas;
35 × 27 cm,
13¾ × 10¾ in.
Private
collection

that, rather than eschewing pictorial illusion, Braque and Picasso are obsessed with it. This chapter and the next look at their ironic love—hate relationship with illusion, enshrined in the introduction of words, numbers and musical notes into the mute spaces of their new art, and reconsider the various different interpretations of their inventions. Recent followers of the 'reality' argument have explored the references to newspapers, songs and advertisements contained in Cubist works in order to relate them to social history. Semioticians have explored

the complex mechanisms whereby the signs in Cubism interact to produce a new awareness of the arbitrariness of representation.

The introduction of lettering into Cubism was originally just one more casual idea in the game of cat and mouse that Braque and Picasso played with their followers. To some extent, relations between the inventors of Cubism and the Salon Cubists are a matter of conjecture. It is known that Picasso and Braque visited the Salon des Indépendants of 1911, however, and that Picasso was not impressed: 'I well remember what I told [Braque and Gris] in the Cubist room at the Indépendants, where there were some Gleizes and Metzingers: "I thought we'd enjoy ourselves a bit, but it's getting bloody boring again."'

At the Salon d'Automne of the same year, Apollinaire arranged for Picasso (and probably Braque) to meet some of the key Salon Cubists (Le Fauconnier, Gleizes, Léger and Metzinger) for a drink. Afterwards the group went to Kahnweiler's gallery to see Braque's latest work. This did not lead to a closer relationship between Kahnweiler's artists and the Salon Cubists, however; as the latter made further progress in terms of public notoriety, so the former (on Kahnweiler's advice) kept an increasingly low profile in Paris. Braque later said that as soon as 'people started to define Cubism, to establish limits and principles, I got the hell out' – but Braque and Picasso were not simply passive in their response to the success of people they regarded as usurpers; they also tried to stay one step ahead of them. Their principal means of doing this was through competition with each other.

At around the same time as the *Gil Blas* still life, Braque produced the first of two paintings gleefully acknowledging the artifice of Cubism (130, 131). Both works feature an illusionistic 'nail' hammered into the wall at the top of the composition. In the first the artist's palette hangs on the nail, which casts a long horizontal shadow. Below it, in sharp contrast to this forceful indication of the laws of mass and gravity, staves of music from an open manuscript drift into neighbouring space on the left, and the '*f*' holes of the violin float and twist towards the picture plane. In the second and more famous work, nothing appears to hang on the nail, except perhaps the whole pyramidal landslide of objects which constitute the Cubist still life below it.

130
**Georges
Braque**,
*Violin and
Palette*,
1909.
Oil on canvas;
91·7 × 42·8 cm,
36⅛ × 16⅞ in.
Solomon R
Guggenheim
Museum,
New York

131
**Georges
Braque**,
*Violin and
Pitcher*,
1910.
Oil on canvas;
117 × 73·5 cm,
46 × 28¾ in.
Kunstmuseum,
Basel

132
Cornelis
Norbertus
Gysbrechts,
*Trompe l'Oeil
with Letters and
Notebooks,*
1665.
Oil on canvas;
69 × 59 cm,
27⅛ × 23¼ in.
Musée des
Beaux-Arts,
Rouen

By placing these nails close to the edge of the composition, Braque heightens our sense of painted illusion, just as the seventeenth-century Dutch or eighteenth-century French experts at the *trompe l'oeil* ('eye-fooling') painter's game had done before him (132). The difference of course is that, especially in the second painting, Braque's nail – which is only ever an evocation of *trompe l'oeil* in any case – disrupts the new spatial illusions of Cubism, and seems to imply that the whole picture is after all a mere surface, a strange or even silly contrivance with no more depth than a piece of paper pinned to a wall. Alternatively, it might be said that since the nail is no more real than the rest, the illusionism of *trompe l'oeil* is revealed to be just as counterfeit as the illusionism of Cubism. Braque sets up a tension, in other words, between one system of representation and another, undermining but at the same time highlighting both.

It took about a year before this ironic idea of competing modes of representation and the idea of painted lettering started to come

together. Before this turning-point, Picasso painted three renowned Cubist portraits of his dealers, Uhde, Vollard and Kahnweiler, and, as William Rubin has shown, worked on a major (but abortive) commission to decorate the library of the American amateur Hamilton Easter Field. It is generally thought that Picasso accepted the commission as an opportunity to compete with Matisse, who had just completed two major pictures, shown at the Salon d'Automne of 1910 (*Dance II* and *Music*), for the stairwell of the Russian collector Sergei Shchukin. However, responding to a commission was an exceptional and difficult task in Picasso's Cubist career, and of the eleven planned paintings, seven were later destroyed or painted over by the artist. The measurements that Hamilton Easter Field supplied show that the pictures were to be very large by the standards of Picasso's Cubism, and the large painting known only through a photograph and a written description suggests that Picasso resorted to a narrative subject (possibly of women swimming in the open air) more typical of the Salon Cubism of Gleizes than his usual single-figure works. The commission may explain the unusual format of some of the paintings Picasso did at Cadaqués (see 68), as well as the strange modifications evident in two pictures now in the Musée Picasso, Paris (133, 134), where in both cases the artist joined a smaller square canvas to a rectangular one, only half-concealing the join as the edge of a table or seat of a chair. The *Man with a Mandolin* in particular seems an ambiguous picture that, according to one recent view, could be a *Woman with a Mandolin*, or might even be seen as a pile of still-life objects on a pedestal table. This architectonic stacking of elements that can stand for either figure or still-life objects is even more evident in the sparse drawings Picasso began to make in Cadaqués and continued with in Paris.

With the dealer portraits Picasso was more at home, and he relished finding a different but equally convincing Cubist style for their very different personalities. These pictures reflect Picasso's increasing success in the art market, but they make no obvious concessions to flattery. The *Portrait of Wilhelm Uhde* (135) adapts Cubism to a kind of caricatural mode in the pursed lips, sharp nose and furrowed brow. It may be that this reflected Picasso's friendship with Gris, then working as a cartoonist. The portraits were based on both sittings and

133
Pablo Picasso,
*Man with a
Mandolin*,
1911.
Oil on canvas;
162 × 71 cm,
63¾ × 27⅞ in.
Musée
Picasso, Paris

134
Pablo Picasso,
*Man with a
Guitar*,
1911, reworked
1913.
Oil on canvas;
154 × 77.5 cm,
60⅝ × 30½ in.
Musée
Picasso, Paris

135
Pablo Picasso,
*Portrait of
Wilhelm Uhde*,
1910.
Oil on canvas;
81 × 60 cm,
31⅞ × 23⅝ in.
Private
collection

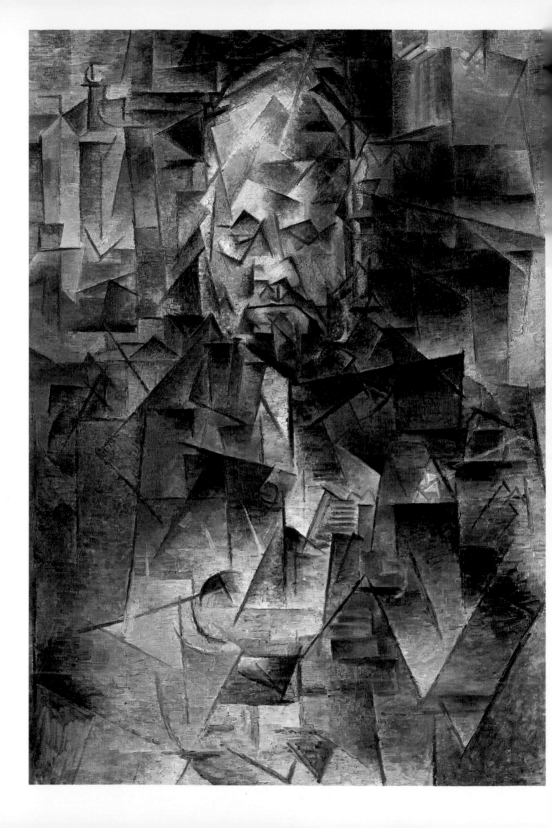

photographs, but may also evince Picasso's own attitudes to his subjects. His style suggests a prim and proper Uhde, almost as stiff as the wing collar he wears, easily mistaken for Cubist faceting. The *Portrait of Ambroise Vollard* (136) is an impressive likeness, as a later photograph shows (137), of a dealer painted by Cézanne in 1899. Uhde preferred Picasso's 'Rembrandtian' Vollard, in which the sitter's closed eyes reflect a murky inwardness, to his own portrait. Aside from the dark palette, the association with Rembrandt may have come about because the exaggerated faceting of the *Vollard* recalled the craquelure (the network of small cracks in paint and varnish) of Old Master paintings. This same Old Master feel inhabits the *Portrait of Daniel-Henry Kahnweiler*

136
Pablo Picasso,
Portrait of Ambroise Vollard,
1910.
Oil on canvas;
92 × 65 cm,
36¹⁄₄ × 25⅝ in.
Pushkin Museum of Fine Arts, Moscow

137
Thérèse Bonney,
Ambroise Vollard,
Paris, 1930s

of late 1910 (138), which features on the left the ghostly forms of Picasso's newly acquired Muyuki mask, also visible in Picasso's photograph of the dealer (see 48). In the painting, Kahnweiler sits with gloved hand beside a table bearing Picasso's medicine bottles; and in the centre of his chest, above a button, his gold watch-chain can be seen. Above the crevices of his Cubist face are the neat scallops of his oiled and combed hair, while behind him there appears to be a large picture, one of whose hooks stands proud to the right of the head.

It was Kahnweiler who first floated the 'reality' argument about lettering in Cubism. His early attempts to explain Cubist art gave an

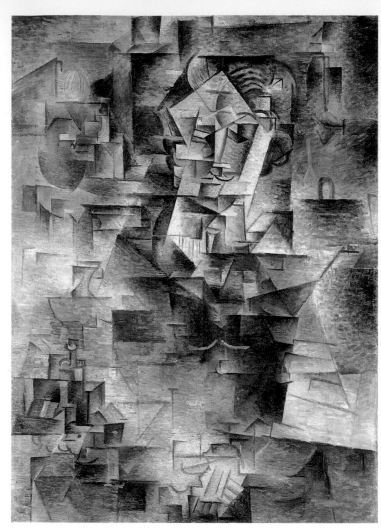

138
Pablo Picasso,
*Portrait of
Daniel-Henry
Kahnweiler*,
1910.
Oil on canvas;
100·6 × 72·8
cm,
39½ × 28⅝ in.
The Art
Institute of
Chicago

important role to the recognizable aspect of Braque's painted nail or the watch-chain in his own portrait. In *The Way of Cubism* he argued that these 'real' details are introduced in order to evoke memory images in the spectator, which, when combined with both the title and the formal structures of the paintings (their grids and intersecting planes, or what Kahnweiler called the 'scheme of forms'), conjure up either a person or a landscape or still-life subject. For Kahnweiler, painted 'lettering' was another 'real detail' in Cubism, introduced to qualify the strange 'schemas' stemming from Picasso's Cadaqués paintings, in which, the dealer thought, Picasso had 'pierced the closed form' of Renaissance art. Something about the appearance of letters

or recognizable details in Cubism would wake the spectator from the dreamy world of abstract structures and reassert a representation of an everyday subject. Apart from the awkward idea that the subject matter of the painting is complete only when the viewer brings memory images to it, there are other problems with this theory. What are visual cues for 'real' objects (*eg* the 'watch-chain', the 'nail') as opposed to textual ones, and what makes some elements more 'real' than others? How does a Cubist picture get seen as a picture *of* something?

To answer these questions it is necessary to look closely at the inventions of 1911–12. In light of the revelation at the Salon des Indépendants that they had become founders of a new 'movement', it was perhaps no accident that both Braque and Picasso conspired at the beginning of their crucial summer expedition to Céret, in southwest France, to make paintings featuring the newspaper *L'Indépendant* (139, 140). Each artist carefully renders not just the letters but the typography of the newspaper's title; Braque also includes the graphics around the price. Typography suggests iconic representation rather than mere writing – in other words that what is depicted is a real object (newspaper, the printed advertisement) rather than just a piece of text 'written on' the painting's surface. In this way it is the gothic script of '*L'Indép* ...' in Picasso's work, as much as the sound heard by the mind's ear, which immediately suggests that the painting includes a representation of a (folded) copy of the eponymous newspaper. Braque follows the same principle, but importantly he undermines the iconic aspect by lining up the typographical lettering with the picture frame, which, by assimilating the represented object to the physical object that is the painting, creates more ambiguity. Picasso paints his typography into the picture's space, but Braque raises the question in our minds as to whether '*L'In ...nt*' is writing *in* the picture or *on* its surface.

While Picasso was painting dealer portraits and still worrying about the Field commission, early in 1911 Braque had made a number of etchings that featured lettering, leading to the flowering of the idea in *Le Portugais* (see 19), which was probably completed by early summer, before his arrival in Céret. Here the fragmentary words and numbers are trenchantly two-dimensional motifs parallel to the picture

plane. Braque understood this effect when he said that letters were 'forms which could not be distorted because, being quite flat, they existed outside space and their presence in the painting, through contrast, enabled one to distinguish between objects situated in space and objects outside it'. In *Le Portugais*, of course, the letters also suggest the existence of different planes – the planes upon which they might be printed or the window panes on which they might be etched – through their variation in size. Nevertheless, Braque had begun to play with an idea that Picasso did not quite grasp when they both painted the newspaper still life. Depicting 'folded' lettered surfaces gave Picasso another way of signalling the tactile layering of objects and space in his Cubism, but for Braque it also opened up a realm of word-play in which the letters floated away from the represented newspapers to take on a non-iconic life of their own. '*L'Indépendant*' was the name of a newspaper, while 'Indépendants' was the name of a Salon exhibition. Braque's fragmentary word stimulates any French reader to fill in other letters in the middle to make different words (eg *L'In[différe]nt*), but interestingly Picasso's truncation of the word is less versatile. Just as the title of the paper is shortened in both paintings, apparently because the newspaper is folded, so none of the other words that come to mind are absolutely excluded from association with the picture. This is the other side to Kahnweiler's reality argument – if words in Cubism offer a realistic anchor, the fragmentary and typographic form they often take also creates a whole new type of spatial and referential ambiguity. The more concrete Cubism seems to get – the more it includes 'real' elements such as words – the more abstract it seems to become.

Kahnweiler was one of the most intelligent commentators on Cubism, and the problems of his own 'reality' argument did not escape him. Much later in life, after much reflection on the problem, he offered another account of Cubism based on the radical (semiotic) idea that painting is a kind of writing in signs:

A woman in a painting is not a woman; she is a group of signs that I read as 'woman'. When one writes on a sheet of paper '*f-e-m-m-e*', someone who knows French and knows how to read will read not only

139
Georges Braque,
The Candlestick,
1911.
Oil on canvas;
46 × 38 cm,
18 × 15 in.
Scottish National Gallery of Modern Art, Edinburgh

140
Pablo Picasso,
Still Life with Fan,
1911.
Oil on canvas;
61 × 50 cm,
24 × 19¾ in.
Private collection

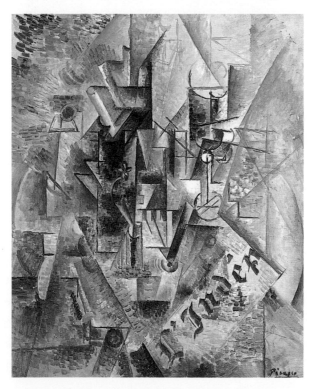

the word *'femme'*, but he will see, so to speak, a woman. The same is true of paintings; there is no difference. Fundamentally, painting has never been a mirror of the external world, nor has it ever been similar to photography, it has been a creation of signs ...

What does it mean to see painting as 'a creation of signs'? Above all, as Kahnweiler makes clear, it is to insist that pictures are seen as representations by arbitrary convention rather than because they 'mirror' or refer directly to reality. This idea of the arbitrary nature of signs is central to 'structural linguistics'. Structural linguistics was the invention of a Swiss professor Ferdinand de Saussure, developed during a series of lectures whose dates precisely match those of Cubism's invention (1907–11), although they were not published until 1916. In order to analyse the nature of linguistic meaning, Saussure isolated the infinite world of particular utterances (*parole*) from the finite system of language (*langue*) on which the former depend. Saussure was interested in describing, or better reconstructing, the formal rules of language, and in order to do so he argued that every meaningful element in a linguistic system, every 'sign', is made up of two inseparable components: a sound-image, the sound and look of the word (the 'signifier'), and the concept or meaning to which it refers (the 'signified'). Whereas it is commonly imagined that words refer to things in the world, so that 'chair' refers or points to things that are chairs, Saussure insisted that the stuff of any word (written letters or sound) refers only to a concept, and only in virtue of its negative relation to other signifiers within the system of which it is a part. In English, for example, 'chair' is able to mean something precise because it is *not* written like 'choir' or 'chain', and does not sound like 'char' or 'cheer'. For this reason, Saussure declared that 'in language there are only differences without positive terms'.

Since any language is a social phenomenon, it would be theoretically possible to change signifiers for the same concept by agreement. This is because, as Saussure famously insisted, the relationship between signifier and signified in any linguistic sign is almost entirely arbitrary. Meanings, according to structural linguistics, are produced through the differences between signifiers being mapped arbitrarily on to the

differences between signifieds, and no sign means anything without being part of the system, without us hearing or seeing the entire system ('German' or 'Urdu') as an ever-present background. Although signifier and signified have an arbitrary relation, and each is identified by its negative difference to other signifiers and signifieds, the sign that they comprise has a value in the system that is the function of two things. First, the word 'chair' is part of a word group (a 'lexicon') one of whose members could be substituted for 'chair' in any sentence (*eg* stool, bench); and second it appears in any sentence in a particular position ('The *chair* is comfortable'), that is in a relation to other signs.

Saussure studied language on the basis of this idea of the complete system, which meant that, unlike his most eminent predecessors, he was not interested in the evolution of language over time, or in etymology. Thus Saussure's treatment of all linguistic signs as virtually co-present provided the basis for the translation of his science of signs, 'semiology', to the non-temporal and spatial character of visual images, since in the two-dimensional space of pictures 'signs' are by definition co-present. The translation from language to visual images is fraught with difficulty, however, since it is not obvious what kinds of image would constitute the equivalent of discrete letters, phonemes (significant units of sound), words or sentences; nor of nouns, verbs and so on. Although Italian Renaissance art theorists had tried to establish such a matching of linguistic and pictorial codes, they also recognized that pictures often had a greater power to move an audience than speech. It might thus seem that the difficulty of establishing a parallel with structural linguistics echoes the old-fashioned idea of the immediacy and plenitude of pictures when compared to language. Describing a picture in words is always selective, temporal and partial, whereas the picture seems complete and self-evident. This is because pictures, unlike nearly all words, depend on rich iconic resemblance to what they represent. Thus the marks in paintings and pictograms as signifiers are normally precise analogies (according to such rules as single-viewpoint perspective) for things seen; they are not at all arbitrary (in Saussure's sense) in their connection to what they signify (a green triangle would not usually be taken to represent the sun, although a yellow circle might).

Trompe l'oeil painting took this idea of the immediacy of painting to its extreme, in its attempt to make the viewer marvel at the painter's ability to efface the painted surface and deceive the eye into seeing 'real objects' in 'real space'.

From the point of view of semiotics, the fascination of Cubism lies in its refusal of the idea of pictorial immediacy. Cubism can hardly be said to attempt to efface the surface or the means of the painter, and does not offer anything that could be taken as an immediate resemblance of actual objects and settings. Unlike *trompe l'oeil*, Cubism makes a show of *not* resembling, and of adopting a conspicuously extreme or arbitrary set of analogies for visual experience. In this view, the presence of words or other linguistic signs in Cubism is not about the failure of words when compared to images but about the fact that, as Rosenblum pointed out, the equally conventional nature of both does not diminish their power to represent. Cubism has thus provided a special case for the semiologist, since Braque and Picasso are relentless in their pursuit of inventing a basic set of Cubist signs and in overlaying them with signs drawn from other pre-established codes, proving repeatedly that neither words nor pictures have their meaning guaranteed by reference to 'real' things.

In Céret Picasso and Braque adopted something approaching a universal Cubist sign language, which consisted of a deliberately limited vocabulary: lines, broken circles and (stippled) chiaroscuro shading and austere sepia coloration. The whole composition was sometimes held together by a large pyramid or a parallax weaving together of broad planes. A coarse oil sketch on paper of a *Bottle and Glass* by Picasso from late 1911 (141) shows how attenuated these elements could become and yet still conjure up objects. Similar radicalism is evident in Braque's contemporary prints (142). The important point about this vocabulary is that it rendered explicit in a very economical way the artifice or provisional nature of Cubist representation – a semicircle is the lip of a glass here, but 'space' there – such that everything depends on an ability to be flexible in reading the same forms in different ways. The meaning of the

semicircle in this Cubist painting is highly dependent on contiguity, or on what it is next to in the composition.

Similarly, taking chiaroscuro as an example in several Braque paintings, it is evident that the value of chiaroscuro (and of stippling itself) is also never stable. In *Harmonica and Flageolet* (143), Braque makes objects and their relations disappear just where most of the stippling and build-up of paint occurs. The crude drawing of the flageolet on the right and the harmonica on the left is complemented by a loose network of lines and curves. The areas of bare canvas at the

141
Pablo Picasso,
Bottle and Glass,
1911.
Oil on paper;
63 × ·35·5 cm,
24¼ × 14 in.
Musée Picasso,
Paris

142
Georges Braque,
Still life with Glass (Figure with a Guitar),
1911.
Etching with drypoint;
34·8 × 21 cm,
13¾ × 8¼ in

Cubist object world makes itself felt. The paradox is especially striking in Braque's Céret work *Woman Reading* (144), where the blank canvas in the area of the woman's 'head' and 'torso' is like a blind spot at the centre of one's vision. It is the 'region of intensity' (or perhaps invisibility) that Braque felt his Cubism sometimes needed at its very core. Again, the dark stippled areas hover around the pale empty space that is an inverted sign for the substance of the woman. In *Still life with Violin* (145), on the other hand, Braque builds up the dark strokes just where the core of the still-life objects is located, while paleness and exposed canvas stand for space. The chiaroscuro element of the 'universal

hand, Braque builds up the dark strokes just where the core of the still-life objects is located, while paleness and exposed canvas stand for space. The chiaroscuro element of the 'universal language' is semantically versatile: it can stand for 'presence' or 'absence' according to its position in the picture. The stippling, as material 'signifier', swaps one 'signified' for another before the viewer's eyes.

The reduction of the vocabulary of Cubism to such a limited number of signs means that each has to take on a wide range of meanings or values (stippling must sometimes stand for presence, sometimes

143
Georges Braque, *Harmonica and Flageolet*, 1910–11. Oil on canvas; 33·3 × 41·3 cm, 13⅛ × 16¼ in. Philadelphia Museum of Art

144
Georges Braque, *Woman Reading*, 1911. Oil on canvas; 130 × 81 cm, 51¼ × 32 in. Private collection

for absence; sometimes for figure, sometimes for ground). The same instability of meaning emerges, as has been seen, in the associations and anagrams prompted by the use of fragmentary lettering. The fact that meanings shift for both pictorial elements and lettering in the same composition leads to another significant point, which depends on the ability to see the same painted marks in relation to two different signifieds from entirely different 'languages', this time by exploiting rather than defeating iconic resemblance. In other words, Braque and Picasso made visual rhymes. The visual rhyme in Braque's *Pedestal Table*, painted in Céret in the autumn of 1911

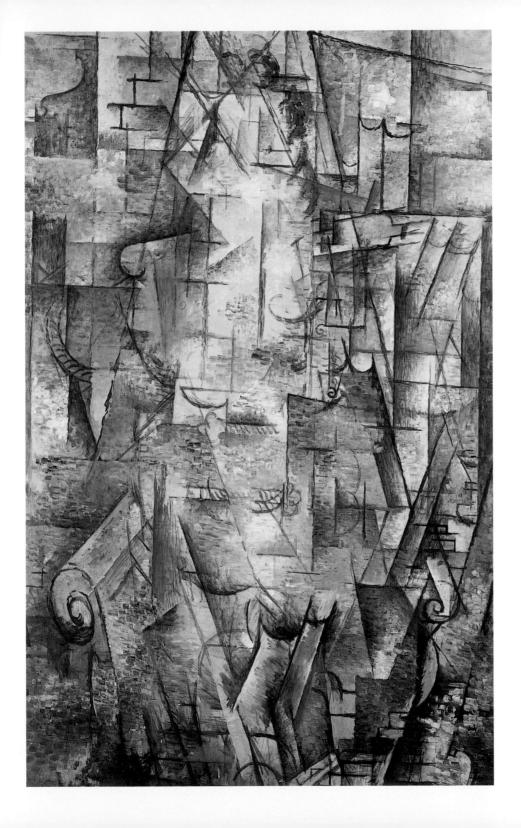

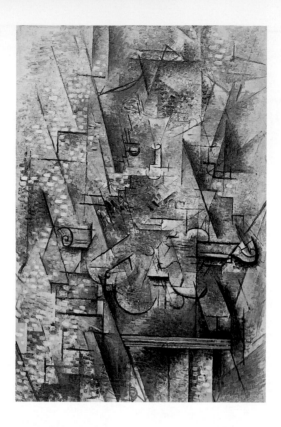

145
Georges
Braque,
*Still Life with
Violin*,
1911.
Oil on canvas;
130 × 89 cm,
51'₄ × 31 in.
Musée
National d'Art
Moderne,
Centre
Georges
Pompidou,
Paris

(146), of the scroll of paper to the left of centre with the scroll of the violin is perhaps straightforward. The musical notation functions as a sign for 'music' itself, but something is missing. The suggestion of rhyme (or better substitution) of the '*f*' hole with the sign for the treble clef in music fills the gap through semantic interference, or cross-fertilization among configurations from different visual codes (Cubist code for violin and musical notation). This double meaning is possible because the position of the '*f*' hole is just close enough to the stave to allow it to take on another signification, but also because the '*f*' looks enough like a treble clef. This interplay of what Kahnweiler termed 'real' elements — letters, numerals, '*f*' holes, musical notes — is thus a process that can juggle with the values of all representational elements. On this basis the gap insisted on by Kahnweiler between the elements' reality and the polyvalent abstractions of the 'schemas' of Cubism starts to close.

As Braque and Picasso became increasingly preoccupied with the arbitrariness of signs, the play of difference and contiguity in

146
Georges Braque,
Pedestal Table,
1911.
Oil on canvas;
116·5 × 81·5 cm,
45⁷⁄₈ × 32 in.
Musée
National d'Art
Moderne,
Centre
Georges
Pompidou,
Paris

representation, and visual rhyming to make double meanings, so they became more and more enamoured of the corniest aspects of illusionism. Braque included bunches of grapes in several paintings from 1911 as a symbol for illusion in painting. These grapes probably refer to one of the most famous stories about art from ancient Greece, told by Pliny of the painter Zeuxis (later fifth century BC). In an effort to prove his superiority over rival Parrhasius, Zeuxis painted a bunch of grapes on the wall of his studio that was so realistic that birds tried to eat it. Referring to this symbol of the triumph of painting as deception, Braque seems to suggest that Cubism is the new *trompe l'oeil* style, destined to give us a more profound sense of illusion, not of things seen but of things imagined. The grapes could be there to show the redundancy of painting according to the senses, the kind of painting that supporters of Cubism rejected when they claimed that Cubism was a higher form of (conceptual) realism. Pliny's story adds another level, however. Parrhasius invited Zeuxis to see his latest painting, which he claimed would outdo the phoney grapes. When Zeuxis arrived

he strode across the room to draw back the curtain covering his rival's work, only to discover that the curtain itself was painted. Parrhasius had deceived a human being, not a mere bird. The trumping of illusion is effected only by another illusion, and one can read Braque's grapes not as the symbol of phoney realism overcome, but as a parodic foil to the supposed higher representational truth of Cubism itself.

If Braque and Picasso were posing as the Zeuxis and Parrhasius of Cubism, vying in a contest of deliberately cheap illusionism, it

LE ...BISME EXPLIQUÉ

— Je ne vous dis pas que c'est comme ça que vous la voyez.
Je ne vous dis pas que c'est comme ça que je la vois.
Je vous dis que c'est comme ça qu'ELLE EST.

147
Luc Métivet,
... bism
Explained.
From
Le Journal
amusant,
9 November
1912.
The caption
reads: 'I don't
say that is how
you see her, I
don't say that
is how I see
her, I say that
is how she is'

was in ironic recognition of the fact that the semiotic play of their works from 1911 onwards was being taken as a new and better illusionism – a higher (conceptual) realism. Luc Métivet captured the absurdity of this theory, ever popular with the Salon Cubists, in a hilarious cartoon of autumn 1912 (147).

According to Braque and Picasso, no sign was better than another for creating resemblance, but this unravelling of painting deliberately undermined the idea that Cubism could be a new language. Certainly the material character of the signifier in Cubism is marvellously

palpable and literal, thanks to the emphasis on the figurative aspects of lettering and the fragmentation of musical and other signs.
The stability of reference to the signified is disrupted not only by fragmentation but also by infectious visual rhymes. The '*f*' holes become treble clefs, become the letter '*S*'. The places where things should be present is where they are absent, and vice versa. Yet many of these semiotic twists and turns rely on patterns of recognition learnt from other pictures, and no Cubist painting ever pursues them systematically enough to make perfect the analogy with structural linguistics. If they are taken too seriously as a 'new language', Métivet's chaos ensues. The intelligent but hostile conservative critic Jacques Rivière wrote in March 1912 that 'the cubists behave as if they were parodying themselves. By carrying their new-found principles to the point of absurdity, they deprive them of meaning.'

The idea that the 'semiotics of Cubism' don't really add up to a new language has led some to say that it was a failure. Further, as according to structural linguistics language is the centre of social life, it has even been called a political failure. Braque and Picasso had so refined their Cubism in 1911 that many have since suggested that it is difficult to distinguish between their Céret canvases. In his landmark study of 1960 *Cubism and Twentieth Century Art*, for example, Robert Rosenblum picked Picasso's *The Accordionist* (148) and Braque's *Man with a Guitar* (149) to make the point. Braque laid the basis for such a comment in some remarkable later statements about this phase of Cubism:

You know, when Picasso and I were close, there was a moment when we had trouble recognizing our own canvases ... I reckoned the personality of the painter ought not to intervene and therefore the pictures ought to be anonymous. It was I who decided we should not sign our canvases and Picasso followed suit for a while.

Picasso did sign *The Accordionist*, which he commenced around the time of Braque's arrival in Céret on 17 August 1911. This signature was probably added much later, in order to please a dealer or collector, and it is likely that this was the case for many of the paintings of this period by both artists. *The Accordionist* has many striking similarities with *Man with a Guitar*, especially in the use of the pyramidal frame

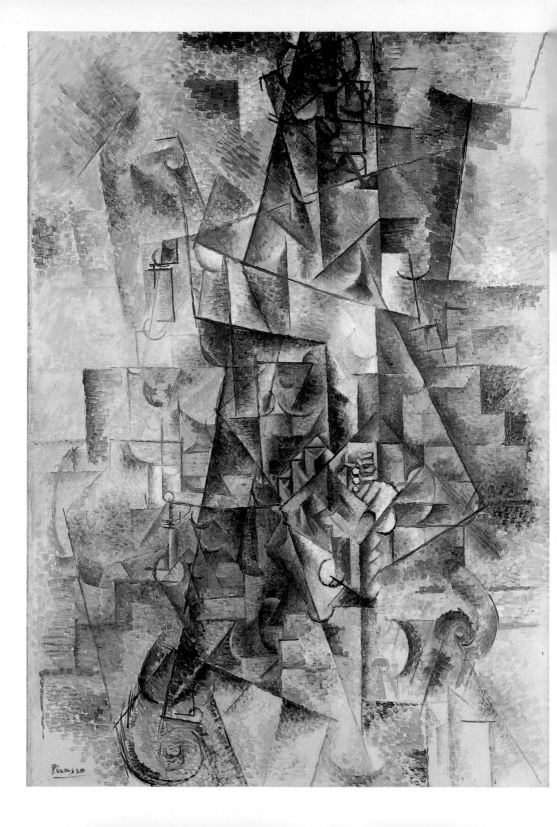

148
Pablo Picasso,
The Accordionist,
1911.
Oil on canvas;
130 × 89·5 cm,
51¼ × 35¼ in.
Solomon R
Guggenheim
Museum,
New York

149
**Georges
Braque**,
*Man with a
Guitar*,
1911.
Oil on canvas;
116·2 × 80·9 cm,
45¾ × 31⅞ in.
Museum of
Modern Art,
New York

for the figure, the high contrast between figure and stippled space, and the delineation of the pose in a series of linear angles. Yet in later life Braque and Picasso both tempered their talk of an 'anonymous' moment in their Cubism, and suggested that this had been no more than a kind of fantasy or youthful dream: 'Afterwards I understood that all that was untrue,' said Braque. Picasso put matters more clearly:

It was because we felt the temptation, the hope, of an anonymous art ... we were trying to set up a new order and it had to express itself through different individuals. Nobody needed to know that it was so-and-so who had done this or that painting. But individualism was already too strong and that resulted in a failure ...

In the same way Rosenblum acknowledged that however strong the resemblance between *The Accordionist* and *Man with a Guitar*, a difference of style is still discernible. There is no doubt from Picasso's tone that he saw the stakes as more than merely stylistic, however. The British Marxist critic John Berger famously wrote (in the utopian year 1968) of 'The Moment of Cubism' in which, he believed, a more liberated human or social situation was posited. Cubism, according to Berger, defined 'desires which are still unmet'. T J Clark has more recently suggested that Céret's anonymity was also a kind of imaginary or even fake 'collectivity' – a language shared, but only between two artists, and then only in a sarcastic make-believe fashion. For these writers the idea of collectivity is opposed to the individualism of 'bourgeois' capitalism, and so Céret Cubism in particular is a political symbol, even if its 'collective' is of the bare minimum sort and, as the artists' statements reveal, was only equitably shared for the briefest of periods. However, for Clark in particular, the collective 'language' of Cubism at Céret hardly deserves the name, since this self-consciously sham language could not really say anything new or be learnt by anyone else. What could be seen as the wistful aura of Céret Cubism, its ethereal evocation of a cast of silent musicians and floating words, may be a tacit or gently ironic recognition of the sham.

Picasso left Céret in early September 1911, but Braque stayed on for several months. On his return to Paris, Picasso was visited by the American photographer and impresario Alfred Steiglitz, and of course

by Severini and other Futurists. Braque wrote to Picasso regularly, informing him of the discovery of 'an imperishable white' or of the work on 'the pretty *Woman Reading*' (see 144). Picasso's mind was on other things as well – his relationship with Fernande Olivier deteriorated, and he took up with Louis Marcoussis' partner Marcelle Humbert (real name Eve Gouel), whom Picasso called 'Eva'. Taking a studio in the Bateau Lavoir again for a while, Picasso worked on a painting that is thought to be the first of many covert love tokens to Eva, *Woman with a Zither or Guitar*, generally known as *Ma Jolie* (150). Using some of the structural devices he had arrived at with Braque during the summer, Picasso hardened edges and made the chiaroscuro more smoky. 'Ma Jolie' and 'Jolie Eva' were pet names Picasso used for Eva. 'Jolie' means pretty or lovely, but in the tradition of modern love 'Ma Jolie' was borrowed from a music-hall song ('Dernière Chanson') then in vogue. 'Dernière Chanson' ('Last Song') was a big hit for its composer and performer Harry Fragson (151); in the days when gramophones and records were not affordable by all but there was a piano in every bar, popular tunes and lyrics were often reprinted in newspapers. In his autobiography, Severini tells how the Futurist Boccioni tried to learn all the latest popular hits in Paris in 1912, including 'Ma Jolie' and 'Ah! Love is a Beautiful Thing'. Picasso may have lighted on the song as the perfect expression of his personal ups and downs at the time, since 'Dernière Chanson' was, as the title suggests, a rather sad tale moving from the joy of new-found romance to the disappointment of the male singer as his lover's affections move on to another, and tears cloud his eyes.

Picasso placed the painted words 'Ma Jolie' with great care, making them double and treble their meaning. The drop in level from 'MA' to 'JOLIE' – the words separated by a Cubist 'facet' – when read in the context of the neighbouring treble clef and musical stave, is like the modulation from one note to another in the song. The placement of the words also implies that they form a sort of inscription or captioning of the image. Picasso shows not 'Prettiness' but 'My Pretty'. Métivet's cartoon Cubist artist claimed he painted woman as she really was, whereas Picasso might be taken as saying 'this is *my* personal idea of female beauty.' Or perhaps the words form only part of an ironic phrase,

which should read 'My Pretty Canvas'. Picasso soon expanded his means as a painter with the introduction of sand and sawdust into the mix; these ingredients were intended, he wrote to Braque, to abuse the 'horrible canvas' of traditional painting.

While Braque and Picasso kept a low profile in Paris, Kahnweiler made sure their work was seen abroad. In 1909, for example, thanks to contacts established by Mercereau, the 'Salon of the Golden Fleece' in Moscow featured Braque's *Large Nude* (see 46), and the 1912 'Golden Fleece' featured Picasso (alongside some Salon Cubists). The Mexican artist Marius de Zayas (1880–1961) organized a Picasso show at the '291' gallery in New York in 1911, and there

150
Pablo Picasso,
*Ma Jolie
(Woman with a
Zither or
Guitar)*,
1911–12.
Oil on canvas;
100 × 65·4 cm,
39⅜ × 25¾ in.
Museum of
Modern Art,
New York

151
Harry Fragson,
1904

was a Picasso retrospective in Munich during March 1913. His work also featured heavily in the extremely influential 'Post-Impressionist' exhibitions (1910 and 1912) organized in London by painter, theorist and curator Roger Fry (1866–1934).

As well as laying the ground for the rapid spread of the Cubist aesthetic worldwide, this internationalization of the most challenging Cubist art led to some brilliant commentaries by people who were not close to the Paris scene, and who were therefore able to provide fresh approaches. Fry reproduced Picasso's *Portrait of Gertrude Stein* (see 17) alongside Raphael's *La Donna Gradiva* (see 4) in an issue of *The Burlington Magazine* in 1917 not, as might be expected, in order

to point out the enormous contrast between them. Instead, Fry argued for 'the common preoccupation of both artists with certain problems of plastic design and their solutions'. Fry believed that there was an essential continuity in art that had only been disrupted by the aberration of Impressionism. Although Fry thought that the crude worldly materialism of Impressionism, its emphasis on transitory visual effects, was opposed to art's real concern with form, the very fact that he could make the comparison shows that he saw the Picasso as a portrait of someone (and not just a collection of random marks), and indeed a portrait (a type of painting in a tradition). These two facts are important because they underpin the dazzling development of the Cubism of Braque and Picasso during the years 1910–12. Fry's comparison is not as challenging as it might be, however, since the Stein portrait is pre-Cubist, and certainly much more conventional than, for example, Picasso's portrait of Kahnweiler (see 138). Nevertheless, Fry did insist on a continuity between more difficult Cubist paintings and earlier art in other contexts, and his point remains valuable in this regard. No matter how apparently abstract or semiological a Cubist work was in the so-called 'Analytical' phase, it always pulled off its trick: resemblance to something (human face, violin etc.) *in spite of* arbitrariness. A work by Braque or Picasso did this just *because it resembled other paintings*.

In this respect, by taking painting to an extreme, their Cubism of the period of 1910–12 says as much about painting as an art form, and about particular works from the tradition of the art form, as it does about the semiotics of visual representation. This is not to reject the semiotic interpretation of Cubism, however. Braque and Picasso began to manipulate the very materiality and strangeness of the word – what the great Russian poet Khlebnikov called 'The Word as Such' – and to see the language of painting afresh. The next chapter examines the invention of collage, which is widely regarded as a final and radical twentieth-century break with the tradition of painting, an art long based on realist notions of representation, and its 'horrible canvas'.

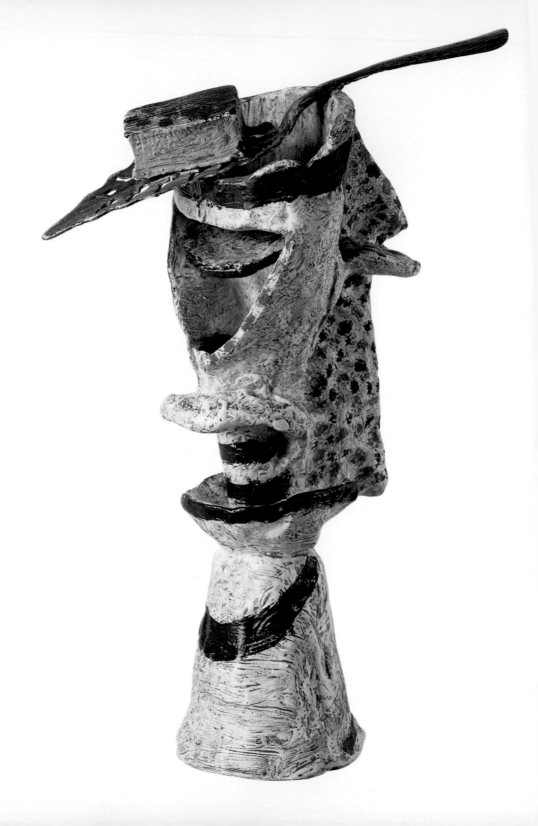

The year 1912 is of crucial importance in the history of Cubism. In the salons the public ambition of the movement was fulfilled. The Salon des Indépendants in the spring launched Gris, who would become one of the most accomplished Cubist artists, and also sowed the seeds of Duchamp's disaffection with Cubism. Duchamp-Villon's contribution to the Salon d'Automne revealed Cubism as a new style of decoration and architecture. The Salon de la Section d'Or declared the supposedly scientific and metaphysical foundations of the movement, while Delaunay, Kupka and Picabia came close to making abstract art. The Futurists also exhibited in the spring of 1912, and their campaign to surpass Cubism as the leading movement in Europe spurred artists and critics associated with both groups to publish important manifestoes and declarations, including Gleizes' and Metzinger's influential *On 'Cubism'* and the texts that would be collected in Apollinaire's *The Cubist Painters* of 1913.

For Braque and Picasso 1912 was no less auspicious: it saw the invention of a technique (effectively a new medium) that would revolutionize Cubism and open up many of the avenues explored subsequently in twentieth-century art. This technique was collage, whose name derives from the French word for glue, *colle*. Collage involves pasting on to the canvas foreign elements, usually 'found' coloured papers and printed text, creating a hybrid work in which pasted and painted elements remain distinct. Collage led in turn to a more subtle procedure known by its French name, *papiers collés* ('pasted papers'), in which coloured and printed pieces of paper were cut out and glued to a larger sheet of paper, and interpreted with drawing in charcoal, pencil, ink, etc. By the autumn of 1912, these two related techniques inspired an entirely new departure in sculpture: the Cubist construction. There is little doubt that the extraordinary transformation of the art of sculpture in the twentieth century – which was much more rapid than the evolution of modern painting – springs almost entirely from Cubist

152
Pablo Picasso,
Glass of Absinthe,
1914.
Painted bronze and silver-plated spoon;
22 × 16.5 × 5 cm,
8⅝ × 6½ × 2 in.
Staatlichen Museen, Berlin

construction. For hundreds of years the art of sculpture had been almost exclusively preoccupied with monumental studies of the human figure, employing two main techniques: either carving of materials such as stone and wood, or modelling in clay (the modelled sculpture might then be cast in metal). Braque and Picasso began making sculpture by assembling found objects and miscellaneous junk materials, and extended their pictorial fascination with the relatively lowly genre of still life into this hitherto noble art of the idealized human form. The assembled or constructed nature of their sculptures departed from both modelling and carving, and exposed the process of making art to the viewer – a thoroughly modern approach to the work of art.

Before looking in detail at these inventions, it is worth recalling that the term 'Synthetic Cubism', often used to describe the new methods introduced in 1912 and their subsequent development, is in many ways even more misleading than 'Analytic Cubism' is for the pre-1912 work. Cubism after 1912 is said to be 'synthetic' because Braque and Picasso abandoned the analysis or dissection of objects in favour of reassembling them. Some writers have gone further, to claim that the methods associated with 'Synthetic Cubism', such as simplified composition using large rectangular shapes, the use of bright colour, and the introduction of found materials, led to the creation of self-sufficient art objects as opposed to representational works of art. This claim sounds more impressive than it really is, since none of the works concerned are non-representational. Yet as many recent writers have found, it is hard to avoid the convenient 'analytic/synthetic' terminology as a shorthand for the complex change that took place in 1912.

It has been said that Picasso revealed a collage 'instinct' as early as 1908, when he found a piece of card on to which an advert for shops near the Louvre had been glued, and used it to make a drawing entitled *Bathers* of nude figures lounging among trees in a forest with a boat in the background. In 1907 he had also integrated a decal or transfer into a watercolour. In both cases, however, it is not clear that Picasso did the pasting or rubbing, and so it would be stretching a point to call either work the site of the invention of collage. More significantly, Picasso included an Italian postage stamp in a painting known as *The Letter*

153
Pablo Picasso,
Still Life with Chair Caning,
1912.
Oil, oilcloth and pasted paper on canvas, surrounded by rope;
27×35 cm,
10⅝×13¾ in.
Musée Picasso, Paris

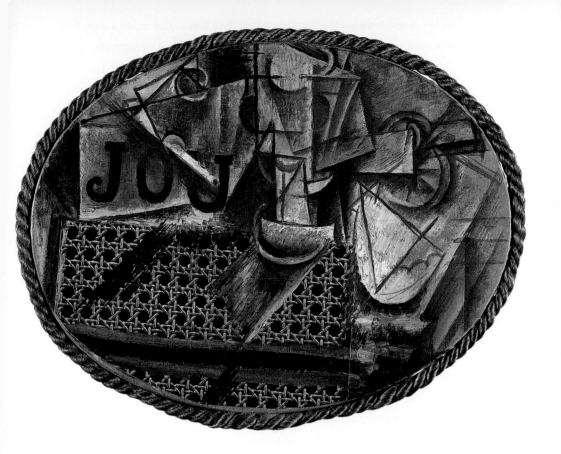

of early 1912. The idea of painting a letter, complete with the artist's name (as signature?) and address, undoubtedly sprang from the variety of uses to which painted words and lettering had been put in the preceding six months (see Chapter 6). Picasso relished the fact that the viewer sees the real stamp through the side of a depicted glass, but our attention is not drawn to it as a foreign object in the painting, since the act of collaging here merely imitates the sticking of a real stamp.

It is generally agreed, then, that the first collage proper, using a glued-on foreign element to challenge traditional painting, is Picasso's *Still Life with Chair Caning* of May 1912 (153). In this remarkable work he cut and glued a sheet of oilcloth (the type used to cover café tables and chairs so that they can be easily wiped clean) printed with an illusionistic caning pattern. In other words, Picasso included in his painting a piece of material appropriated from 'everyday life' that has been left relatively intact. The obstinate oilcloth is allowed to remain what it is,

as if it is embedded in the painting rather than thoroughly made a part of it. The act of including the oilcloth thus challenges the traditional demand that artists should strive for stylistic unity. Picasso had in a way already challenged this notion when he repainted the right-hand figures of *Les Demoiselles d'Avignon* (see 37), but here the disunity is expressed in the very materials used. In both cases it is clear that the precedent of African art was important: in the *Demoiselles* for the formal distortions of the figures; in the collage for the combination of heterogenous materials, which echoes the use of nails, hair, shells and so on in tribal objects. Through its combination of the authentic work of the painter with the products of an industrial process, *Still Life with Chair Caning* demanded a new definition of artistic originality. Such a demand was intimately connected, as will be seen, with what Picasso later called the 'strangeness' of modern life.

Looking more closely at this collage, it appears that the painted parts of the work depict a glass in the centre, behind which lies a copy of the newspaper *Le Journal* (hence the letters 'JOU') and a white clay pipe. To the right are two lemon slices and a knife, and below them what might be an oyster shell. The shadows or refractions from the glass lie across the oilcloth, and towards the bottom edge of the canvas a brown strip seems to represent the front edge of the table. There is of course another striking feature of this painting: its oval shape is 'framed' by a piece of 'endless' real rope. Oval canvases had first been used for Cubist work by Braque in the spring of 1910. Both he and Picasso had resorted to them regularly after that, perhaps because oval canvases allowed an instant alternative to the fading out of the Cubist grid so often seen in the four corners of the conventional rectilinear picture. The fading perhaps occurred because connecting the grid with the edge or frame would flatten out the space in the picture too much, killing off the essential balance between illusion and surface. It seems just as likely, however, that the oval format was embraced for the energizing effect it had on basically rectilinear compositions, or even in homage to the oval canvases favoured for some decorations by eighteenth-century French painters. In *Still Life with Chair Caning* the oval has been seen as either the seat of a chair or the surface of the café table on which the objects sit. The French word for an easel picture is *tableau* and, as Christine

Poggi has argued, Picasso is delighting in the joke that his picture is a (vertical) *tableau* which is also a (horizontal) *table*. What of the rope itself? In what has been seen as another telling attack on the 'hand of the artist' as the guarantor of the originality of a work of art, Picasso ordered this element of the composition from a specialist mariner's ropemaker. The rope border makes the imitation rope patterns on gilded picture frames literal, but it is also a decisive statement of the painting's existence as a physical object, a move that would be more fully exploited later on in Cubist constructions.

Although Picasso had created the first collage in *Still Life with Chair Caning*, Braque played a very significant role in leading him to his invention. Braque returned to Paris from Céret in January 1912. One of the works he showed Picasso straight away was *Homage to J S Bach* (154), in which he had employed a technique learnt during his apprenticeship as a painter and decorator, *faux-bois* or imitation wood graining. In the bottom left-hand corner of the painting, Braque carefully rendered the pattern around a knot in a wooden plank. In the area above this he dragged a specialist tool – known as a decorator's comb – through the same brown paint, to create a more dense and wavering wood-grain pattern. Decorator's combs came in different sizes for different types of effect, and were generally used in combination with other techniques to produce a convincing illusion of dark wood panelling in bars and restaurants, and on the front doors of bourgeois homes. Similar tricks were employed to produce the illusion that columns made of wood or plaster were in fact costly marble. Picasso was undoubtedly impressed by this innovation in Braque's repertoire – it short-circuited the gap between the complex high art of their 'analytic' Cubism (and the music of Bach) and the lowly decorator's craft. Since both artists were by now affecting workmen's clothing and manners (and they could only be pretending, since both, and Picasso in particular, earned a great deal more than the average workman), this combination of high and low culture must have seemed a brilliant move. Yet as was so often the case in their dialogue, Picasso did not respond to Braque immediately.

During the run of the Salon des Indépendants, Picasso decided to join Braque for a weekend in Le Havre. Braque wrote to his partner

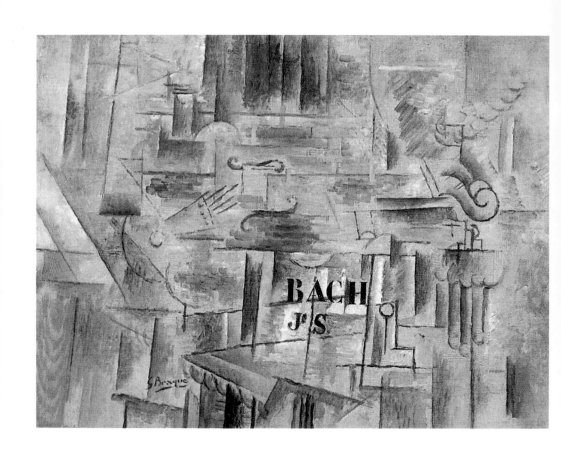

Marcelle on 27 April, 'Tomorrow we are going to Honfleur. This morning I awoke Picasso with the sound of the phonograph. It was charming.' Perhaps Braque played a recording of his favourite Bach piece, or of Picasso's adopted love song for Eva Gouel, Harry Fragson's 'Dernière Chanson'. Whatever melody roused Picasso from his dreams, when he returned to Paris he made two large oval paintings that were 'souvenirs' of his visit (see 26, 156). In the style of the cheapest tourist souvenir postcards, the names Le Havre and Honfleur appear in both, and in the former also Picasso's coded 'MA JO[LIE]'. In *Souvenir du Havre* Picasso revealed that he had not forgotten Braque's wood-grain device. Furthermore, he developed the planar colouring of the 'wood' in the whole left-hand side of the painting, allowing the almost shocking appearance – given the long period of 'analytic' Cubism's sombre monochrome – of a rich blue in the scroll at the bottom edge. The shuffled planes of the French flag above 'HONF' were painted using an industrial product, 'Ripolin' enamel. The sudden injection of colour into Cubism – and 'injection' seems the right word – thus coincided with the adoption of a tradesman's *faux-bois* and crudely commercial enamel paint.

Several other oval canvases included flags (again in Ripolin) as the site of a burst of colour: *The Scallop Shell: 'Notre Avenir est dans l'Air'* (155) – one of a series of three pictures – and the *Spanish Still Life* (now in the Musée d'Art Moderne, Villeneuve d'Ascq). Aside from the richly semiotic considerations that might spring to mind, these flags may also point to Picasso's awareness of the rising tide of nationalism in pre-war France. The summer of 1911 had seen a military stand-off between the French army and a German warship in Morocco, a region that had already been the focus of tension between the two European nations in 1905. The diplomatic resolution of the situation in November 1911 did nothing to dissipate the belief that war with Germany was a real prospect. By March 1912 scenes of spontaneous military patriotism were taking place on the streets of Paris. In *The Scallop Shell* Picasso incorporated the French flag – from the cover of a propaganda pamphlet in favour of aviation – perhaps as an attempt to insist on his patriotic credentials. Aviation was a special topic of debate among those anxious to insist on the expansion of France's military capacity, and was

154
Georges
Braque,
*Homage to
J S Bach*,
1911–12.
Oil on canvas;
54 × 73 cm,
21¼ × 28¾ in.
Private
collection

moreover 'a symbol of the courage and vitality of the French race', according to a report of 1913. Yet Patricia Leighten and others have insisted that Picasso's early sympathies with anarchist circles in Barcelona remained with him. It is difficult to prove that Picasso was still interested in anarchist politics, but, if he was, he would not have indulged in such a craven attempt to celebrate French nationalism. It is just as likely that Picasso picked up on the slogan and the graphic potency of the flag on the cover of the pamphlet as part of his private joke with Braque that they were the 'French' artistic rivals of the pioneer aviators, the Wright brothers. This appropriation of public imagery for private use became a frequent tactic in their work after 1912.

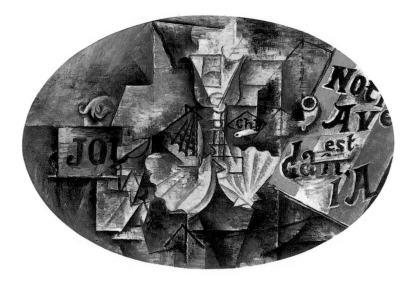

The French flags in Picasso's Cubism have no straightforward political reading, but the contemporary inclusion of the word 'KUB' in more than one painting (157) points to an awareness of burgeoning nationalism in France in the first half of 1912, this time one more in keeping with what is known of Picasso's generally ironic temperament. The 'Maggi-Kub' was a popular stock cube of Swiss–German manufacture. The ubiquitous advertising and the bright yellow packaging for Kub products (158) undoubtedly amused Braque and Picasso, since it seemed to live up to the latest journalistic clichés about the geometric art of Cubism better than their art ever could. The Kub tin even had a *trompe l'oeil* stock cube on the lid, providing an industrial example of the

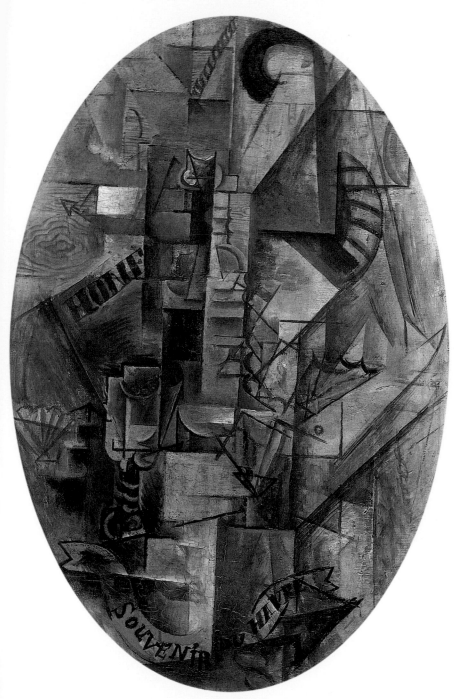

155
Pablo Picasso,
*The Scallop
Shell: 'Notre
Avenir est dans
l'Air'*,
1912.
Oil on canvas;
38 × 55.5 cm,
15 × 21¾ in.
Private
collection

156
Pablo Picasso,
*Souvenir du
Havre*,
1912.
Oil on canvas;
92 × 65 cm,
36¼ × 25⅝ in.
Private
collection

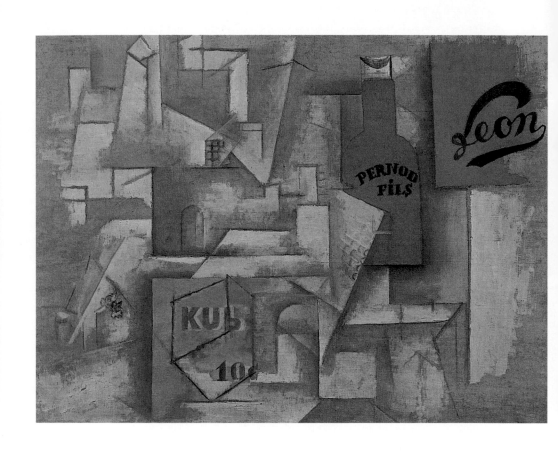

Cubist play of reality and representation. The frequent sight of the Kub advertisements was taken as joking proof of the success of the style. Braque made subtle allusion to the Kub by including the name of the violinist Jan Kubelik in a still life of 1912 (now in a private collection). On 28 April 1911 Kubelik had given a recital on a violin once owned by the painter Ingres, and so Braque's picture alludes to the high art kinship of music and painting as much as to the mundane stock cube.

The sub-text of these references to the 'Maggi-Kub' becomes clearer in the light of Vauxcelles' description of Picasso as 'a kind of Père Ubu–KUB' in his review of the 1912 Salon des Indépendants. Père Ubu, the main

157
Pablo Picasso,
Landscape with
Posters,
1912.
Oil on canvas;
46 × 61 cm,
18⅛ × 24 in.
National
Museum of
Art, Osaka

158
Maggi-Kub tin,
c.1920.
Private
collection

character in the scandalous play *Ubu Roi*, was the anarchic and nihilistic creation of the poet Alfred Jarry, admired by Picasso. By putting Ubu and Kub together, Vauxcelles' joke implied that Picasso's art, and that of his followers, was both morally degenerate *and* foreign. The attacks on supposedly foreign Cubism became more frequent throughout 1912, even surfacing in the French parliament (see Chapter 5). For the time being Braque, and especially Picasso, could be amused by the substitution of the German letter 'K' for the French 'C' (few French words begin with K). Their friend Marcoussis even did some cartoons later in the year, under the pseudonym 'Markub', in which everything

was 'kubified' (159). The joke would lose its charm for the Cubists at the outbreak of World War I, when 'Maggi-Kub' billboards, now considered strategic markers and bearers of coded information for invading German troops, were the subject of an absurd destruction order, and some grocers selling the stock cubes were arrested as spies. Accusations that Cubism was a 'Boche' ('Hun' or 'Kraut') conspiracy against French art were rife at that time, and the evidence of Cubism's own 'Kub' gags played straight into the hands of aggressive extreme right-wing nationalists.

It is important to remain aware of the increasing dialogue between the private language forged in Analytic Cubism and aspects of the everyday 'outside' world when asking why Braque and Picasso should suddenly adopt these new techniques – wood-graining, bright colour and collage. At one level, the motives for the changes in Cubism in 1912 were to be found in the tension between its inventors and its public followers. Patches of Ripolin colour and fragmented words were the new currency for Braque and Picasso, a currency relatively unfamiliar to the artists who were busy admiring and emulating them. The identification of Picasso as the leader of Salon Cubism rankled with him. Salon Cubists and Futurists had caught on to the letter if not yet the spirit of their Cubism, although they were desperate to know more. Boccioni wrote to Severini in Paris in June, for example, asking him to buy photographs of the latest works by Braque and Picasso so as to ensure up-to-date intelligence. The critics were already implying that Picasso was the benefactor of artists for whom he had no regard, and whom he certainly did not intend to 'lead'. He read reviews of the Salon des Indépendants and in April even sent Kahnweiler a cutting from a paper called *Le Sourire*: 'The Cubists have courageously changed weapons after having liquidated their last cube', it said, in what was probably an early example of a pun on the 'Maggi-Kub'.

This idea of a change of weapons must have struck the two artists, for it appears in an apocryphal story told by Severini, who was in the Bateau Lavoir studio when Picasso nonchalantly let Braque see his new Ripolin paintings. Apparently, Braque was both astonished and defensive: 'The weapons have been changed,' he said. Picasso replied with just

159
Markub (Louis Marcoussis), *Style 'Cubique'*. From *La Vie Parisienne*, 26 October 1912

a smile, as if to say 'A fine joke, eh?' He revealed his Ripolin pictures to Braque like a hand in a game of poker, saying 'beat this!' Had the mood changed so much from the previous summer's earnest struggle to invent a new order for painting? Was the struggle now to stay ahead, and to mock those who could not follow the game? Uhde and Shchukin, former admirers and collectors of Picasso's Cubism, were baffled by his latest efforts with stencilled letters and industrial paints. In a letter to Kahnweiler Picasso expressed sardonic delight at the achievement of alienating even his patrons: 'You tell me that Uhde does not like my recent paintings where I use Ripolin and flags. Perhaps we shall succeed in disgusting everyone, and we haven't said everything yet ...'

It would be too simple to argue, however, that staying ahead of Salon Cubists and Futurists, and cutting lose from patrons who were not considered brave enough for the latest innovations, were the only

'outside world' reasons for the two artists' developments in the course of 1912. The invention of collage in particular was not simply a negative gesture, for collage meant that art could be made in an entirely novel way. This new medium created a new understanding of form and simultaneously embodied – as will be seen – a new subject matter: the strangeness and complexity of modern life.

Picasso sent his letter to Kahnweiler from Céret in the south of France, where he was hiding with Eva Gouel from the estranged Fernande Olivier in June 1912. Fearing Fernande's arrival, however, Picasso left for the village of Sorgues near Avignon, where he rented a house called the Villa des Clochettes. He wrote to Kahnweiler to tell him 'DO NOT GIVE MY ADDRESS TO ANYONE', and for a while he and Eva were enormously happy. Away from Braque again, his punning mentality

enabled him to arrive at a new use of the decorator's comb. Rather than use the metal comb to fake wood grain, he employed it like a proper comb to smooth the moustache and hair of the figures in *The Poet* (now in the Kunstmuseum, Basel) and *The Aficionado* (160). As in the table/*tableau* gag, the viewer is asked to tune into a pun which is, so to speak, outside the picture. Although some authors have identified these paintings as portraits of specific individuals (*eg The Poet* as André Salmon, smoking a white clay pipe), their faces crop up so many times in the next few years that they are just as likely to be stock characters or types. *The Aficionado* pays homage to those Mediterranean men who are obsessed with the bullfight. This eminently Spanish sport was also practised in the south of France, and Picasso inserts the place-name Nîmes at the top left of his picture in memory of a bullfight he attended there on 7 July 1912. This expert on matadors and their art, an art Picasso thought supremely 'intelligent about itself', sits in front of a Spanish guitar and clutches a *banderilla* (a highly decorated harpoon used to weaken the bull's neck muscles). His refined tastes are represented by his stiff collar, top hat and the specialist newspaper *Le Torero*, as well as by the bottle of *manzanilla* sherry to his left.

160
Pablo Picasso,
The Aficionado,
1912.
Oil on canvas;
135 × 82 cm,
53⅛ × 32¼ in.
Kunstmuseum,
Basel

Picasso made a number of drawings in order to work out the composition of *The Aficionado*, especially since he was transforming a picture that had begun as a man playing bagpipes. Other drawings Picasso made that summer show further signs of the changing weapons of Cubism, and of his continued interest in the ideas suggested by *Still Life with Chair Caning* (see 153) and the planarity of *faux-bois* and Ripolin flags. A series of ink drawings of a figure with a guitar transforms it into an elemental assemblage, sometimes suggesting that the imaginary structure is made up of such ready-made objects as a coffee table, a canvas, ball and sheet (161); or an easel and canvas stretchers. These drawings reveal Picasso's growing awareness of the idea of construction as naturally related to Cubism. They are also an early example of an idiom connected to his Surrealist imagery of later years, in which inanimate objects can gather together in the painted world to form monstrous figures. This anthropomorphic tendency (and its opposite, imagining the human form as a collection of objects) was crucial to the evolution of Picasso's constructed sculpture in late 1912.

Braque and Marcelle arrived at Sorgues around the beginning of August carrying Picasso's camera, which was put to work documenting his progress on various canvases. Two significant events are connected with Braque's presence: a trip to Marseille and the creation of paper sculptures. Even though none by Braque survive, a letter to Kahnweiler of late August reveals that he was the first of the two artists to invent paper sculpture (there is in fact some inconclusive evidence to suggest that he invented it a year earlier):

Not much that is new in Sorgues. We are having a most complete calm. Picasso and I do a lot of cooking. The other night we had *ajo blanco*, a Spanish dish, as its name indicates. We very much regretted your not being here to share this dessert-like soup with us ... I am working well and taking advantage of my stay in the country to do things that cannot be done in Paris, such as paper sculpture, something that has given me much satisfaction ...

Perhaps paper sculpture could not be done in Paris since there it would either be laughed at or imitated by Salon Cubists and Futurists. There is no real evidence of what Braque's early paper sculptures were like, which is frustrating since the works Picasso made in a similar

161
Pablo Picasso,
*Seated Figure
with a Guitar*,
1912.
Ink on paper;
21·2 × 13·2 cm,
8⅜ × 5⅛ in.
Musée
Picasso, Paris

162
Georges
Braque,
*Fruit Dish,
Bottle and
Glass:
'Sorgues'*,
1912.
Oil and sand
on canvas;
60 × 73 cm,
23⅝ × 28¾ in.
Musée
National d'Art
Moderne,
Centre
Georges
Pompidou,
Paris

vein have assumed such importance. At Sorgues Braque also experimented with mixing sand and other materials into his oil paint (162). There is no doubt, then, that his experimental attitude to his medium continued to provoke Picasso, and that these experiments formed part of the process of 'changing weapons' in an effort to outwit feeble Parisian acolytes as well as academicians.

The trip to Marseille took place in mid-August 1912. The Braques hoped to find a place to stay for the rest of the summer near Marseille or L'Estaque, but this plan was somehow overtaken by a shopping spree for African artefacts in the flea markets of the busy port. The artists bought at least half-a-dozen objects, and Picasso's purchases almost certainly included an impressive mask, then thought to be made by the Wobé people but now known to be a Grebo mask from the Ivory Coast (163). Picasso was proud of this particular mask, and no doubt bought it for motives similar to those that led him to

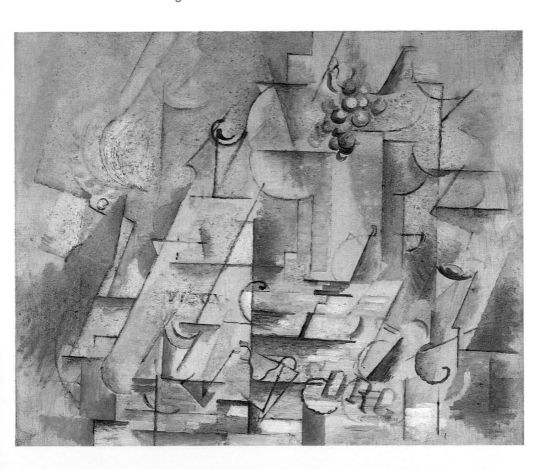

acquire his first tribal objects in 1908. Indeed, there is evidence for this in the fact that Salmon's account of Picasso's earlier interest in 'negro art' was written in 1912. Yet the subsequent studio encounters with this mask have been singled out as an 'epiphany' by Yve-Alain Bois, who sees it as the catalyst for Picasso's famous cardboard *Guitar* of October 1912, of which he also made a sheet-metal version (164). Kahnweiler earlier argued that the *Guitar* marked a decisive shift away from the mimetic traces still present in 'analytic' Cubism towards the thoroughly semiotic language of 'synthetic' Cubism. Rather than seeing the mask as merely another moment in the history of Picasso's primitivism, Bois (following Kahnweiler) points in particular to the extraordinary device of turning the solid top of the guitar into a vacant space, and the sound-hole as a protruding tube. Kahnweiler thought that the Grebo mask is interpreted as a face not because the viewer sees its surface as a skin but reads the volume of the face as 'in front of the plane surface of the mask, at the ends of the eye-cylinders, which thus become eyes seen as hollows'. According to this view the illusion of the whole outer surface of the guitar is generated through similar contextual oppositions. There is indeed an undoubted similarity between Picasso's sound-hole device and the protruding cylindrical 'eyes' in the mask. Furthermore, the drawings of anthropomorphic constructions that Picasso was making at this time obviously prepared him to think of the visual language of the mask in terms of an object like the guitar. However, a full account of the origins and significance of the guitar also needs to consider the impact of Braque's next invention: *papiers collés*.

Picasso returned to Paris at the beginning of September with a view to moving studios. While he was away Braque had a brilliant idea. ('The bastard. He waited until I'd turned my back,' Picasso later joked.) Wandering around Avignon, he came across a decorator's shop selling rolls of wallpaper with a simulated wood-grain pattern. This printed version of the *faux-bois* effects he had already made using house-painter's combs became the main ingredient in the first *papier collé*, with its unmistakable grapes of Zeuxis (see Chapter 6), *Fruit Dish and Glass* (165). Braque used the wallpaper in two ways: first, to stand for wood panelling in the background of the still life; second, to stand for the wooden drawer of the table (with a Chardinesque round knob) on

163
Grebo mask from the Ivory Coast. Painted wood and fibre; h.63·8 cm, 25⅝ in. Musée Picasso, Paris

164
Pablo Picasso, *Guitar*, 1912–13. Sheet metal; 77·5 × 35 × 19·3 cm, 30½ × 13¾ × 7⅝ in. Museum of Modern Art, New York

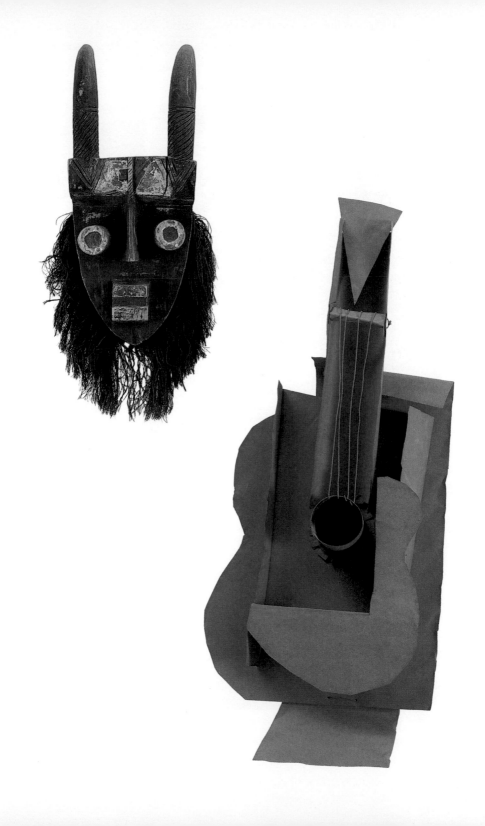

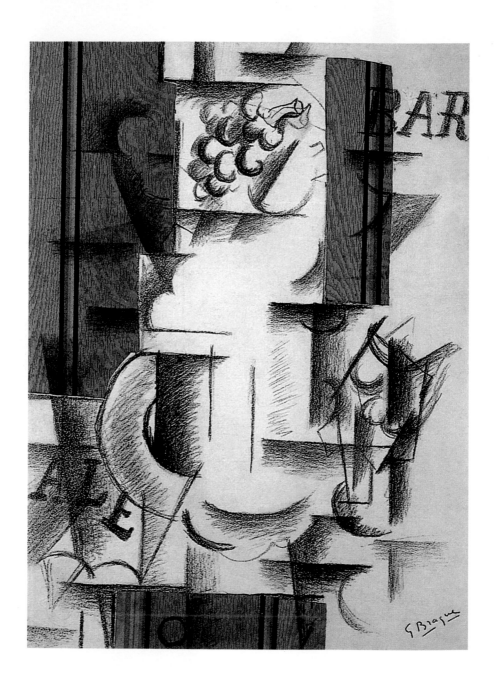

which the still life sits. On the left is a beer mat or poster for Burton's Ale, brewed by Bass, recognizable by the double triangle on its label. In this context the word 'BAR' might recall the English-style Austin Fox Bar near the Gare St Lazare in Paris, a favourite Cubist haunt that served Bass beers. This bar had a long avant-garde pedigree: it had been the scene of an imaginary journey to England by Des Esseintes, the hero of J K Huysmans' 1884 novel of decadence À Rebours (Against Nature).

Braque crowns his fruit dish with the tell-tale bunch of grapes, drawn, like the rest of the composition, in charcoal. At first glance it may seem that all that has happened is that Braque has remade a painted composition (Fruit Dish, 'Quotiden du Midi') with printed paper, and is simply extending the idea Picasso had introduced in Still Life with Chair Caning (see 153) four months earlier. Yet both Braque and Picasso recognized that this modest object raised new questions. Braque said: 'After I had made the [first] papier collé I felt a great shock, and it was an even greater shock for Picasso when I showed it to him.' In Still Life with Chair Caning Picasso had introduced a foreign element into painting, had made heterogeneity a compositional rule, but Braque's use of the wood-grain wallpaper did this and more. The fact that the pieces of faux-bois paper, elements undeniably stuck on to the white sheet, represent both something in the background and something in the foreground, contradicts or undermines the depth of the represented space. Secondly, the uniform colour and pattern of the wood-grain make them attributes of a material apparently independent of the effects of light.

This seemingly objective sense of matter – objective because it implies the perception of the 'true' and essential qualities of things independent of any particular time and place from which they are perceived – is acknowledged as a wistful fantasy by the fake nature of the material. Colour is always an effect perceived by an embodied human subject, and is never really 'local'. By using the faux-bois as 'woodness', Braque introduces the paradox of inherent local colour in visual art. Braque has discovered fake pieces of 'woodness' to cut up and manipulate, that do not have to be drawn or painted, that are always the same no matter what the 'light' in the picture, and that can appear independently

165
Georges
Braque,
Fruit Dish and
Glass,
1912.
Charcoal and
pasted paper;
62 × 44.5 cm,
24⅜ × 17½ in.
Private
collection

of the shape of the object of which they are meant to be a part. Braque's use of sand as well as *faux-bois* is about separating the qualities of material things (shape, colour, texture) as compositional elements. Each fragment functions according to the rules of synecdoche, the rhetorical figure whereby a part stands for a whole, or vice-versa. Here the cut-out shapes of paper are a part-for-whole synecdoche for strips of wood panelling, whose cutting and pasting emulates sawing and nailing.

Braque's first *papier collé* was a rejection of the rational Impressionist and Post-Impressionist idea that intense patches or strokes of colour alone express both shape and light. It suggested the separation of these elements as the distinct materials of painting. The radical 'materialism' that Braque ushers in can be seen in another *papier collé* of late 1912, *Still Life with Guitar* (166). Here Braque draws the shape of the guitar with his usual linear elegance, marks out the work of light and shade with Cubist facets, but also pastes a strip from his roll of wallpaper across the surface. The incongruous shape and angle, and implied 'transparency' of the wood-grain, show that it does not stand only for the visibility of the wooden guitar but also for the substance of the wood itself (its smell, texture, hardness, flatness, local colour, etc.).

Picasso came back to Sorgues later in September to gather up his things, including the Grebo mask and some unfinished oval guitar pictures. There is no mention in his letters of the impact of Braque's new method, but on his return to Paris and his new studio at 242 boulevard de Raspail in the district of Montparnasse he set to work on both paintings and, of course, the cardboard *Guitar* sculpture. The complex shape of guitars and violins seemed to grip Picasso for some months, and led him beyond the initial shock of Braque's *papier collé* to a marvellous period of innovation. Ronald Johnson has pointed out that in 1901 an article on 'The Psychology of the Guitar' appeared in *Arte Joven*, a Barcelona journal of which Picasso was artistic editor. The author of the article, Nicolás María Lopez, imagined the guitar as resembling a person, especially as having the form of a woman on which the male guitarist 'plays'. Music has in any case long been regarded as the 'food of love'. It is possible then, that Picasso's

obsession with the guitar at this time was another example of his anthropomorphizing attitude to objects (also expressed in his fascination with masks), which even went so far as to include erotic feelings. The comic shoddiness of the constructed guitars suggests a burlesque erotica, however.

Picasso began hoarding wallpapers, newspapers, sheet music and coloured card. He exhorted friends to keep an eye out for good patterns in shops and at the bottom of old wardrobes. The work that

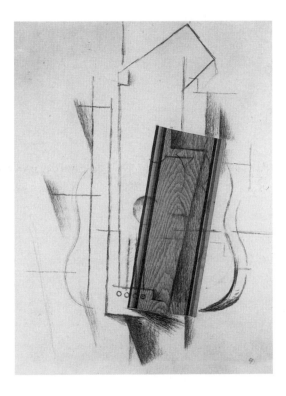

166
Georges
Braque,
*Still Life with
Guitar*,
1912.
Charcoal and
pasted paper;
62·1 × 48·2 cm,
24½ × 19 in.
Private
collection

is conventionally regarded as the first of Picasso's pure *papiers collés* is *Guitar, Sheet Music and Wine Glass* (167), which can be dated unusually precisely for a Cubist work to after 18 November 1912, due to the inclusion of the fragment of a front page from *Le Journal*. The floral patterned paper that forms the ground of the *papier collé* also appears in a more hybrid work (168) of similar but less certain date. In the latter the patterned paper is applied in numerous directions, crudely articulating spatial relationships. In *Guitar, Sheet Music and Wine Glass*, however, it is as much mere wallpaper or uniform surface as it

167
Pablo Picasso,
Guitar, Sheet
Music and
Wine Glass,
1912.
Pasted paper,
gouache and
charcoal;
47·9 × 36·5 cm,
18⅞ × 14⅜ in.
McNay Art
Museum, San
Antonio

is representational space. Picasso must have had a roll of this particular wallpaper, for it features in two further *papiers collés*, including *Glass and Bottle of Suze* (culled from the 18 November newspaper; see frontispiece), as well as being imitated in paint in several more collages. There is the sense of a theoretically endless point and counterpoint variation in these works, in which *Le Journal* of 18 November 1912, or the floral patterned wallpaper, are like counters in the game.

Earlier it was suggested that the creation of Picasso's first cardboard *Guitar* needs to be understood in relation to his adoption of *papiers collés*. If Braque used *faux-bois* to stand for qualities of material that are not necessarily visual (local colour, texture, smell, etc.), he had also lighted on a process that more than ever emphasized what the New York 'formalist' critic Clement Greenberg later called modernist painting's essential 'flatness'. In his landmark 1958 essay on collage, 'The Pasted-Paper Revolution', Greenberg argued that the powerful sense of overlapping surfaces created by a collage or especially a *papier collé* derives from the fact that every plane in view — real or

depicted – is parallel to the actual surface. The important thing is that even the illusion of depth is – paradoxically – given in planar or absolutely shallow terms. But why should this later theory be relevant to understanding Picasso's motives for adopting constructed sculpture and *papiers collés*?

The *Guitar* is clearly also organized in planar and frontal terms. The relationship between depth and plane is reversed, however, for the depth of this *Guitar* is real while its surfaces are illusion. As already suggested, the face of the instrument is conjured up through its negative relation to the solid front edge of the sound-hole and the silhouette of both the pieces of card to the front at bottom right and at rear left. The visual assimilation of these front and rear real planes, necessitated by the representational idea of a guitar, corresponds to the collapsing of represented depth in the *papiers collés*, necessitated by the material flatness of the papers themselves. The constructed *Guitar* plays on the tradition of sculpture by making void stand for solid, but it does so only through its closeness to the concerns of drawing and painting. (Greenberg points out that the sculptor

168
Pablo Picasso,
*Guitar and
Sheet Music*,
1912.
Pasted paper,
pastel and
charcoal;
58 × 61 cm,
22½ × 24 in.
Private
collection

Julio González later called construction 'drawing in space'.) The dialectic between depth and surface might be thought trivial, but its significance to Picasso should not be underestimated, as painting since the Renaissance had been concerned to imply depth, to suggest that things in pictures exist in a space and have a (pictorially invisible) back.

That Picasso's work on the *Guitar* and *papiers collés* gave him an alternative way of alluding to the back of things, to their presence, has been brilliantly demonstrated by Rosalind Krauss in relation to a *papier collé* from after 3 December 1912 (169). In this work two pieces of newspaper float within a charcoal drawing. The lower piece overlaps with the body of a violin, and has a small '*f*' hole drawn on it as counterpart to a larger one to the right. The differential scale of the two holes is a clear semiotic suggestion that the front plane of the violin is not parallel to the picture plane, but instead turns into the 'depth' of the picture. The other newspaper fragment to the right of the violin is apparently in the background 'space'. Krauss has pointed out that these two pieces are in fact cut from the same sheet of paper in a single act (two silhouettes are thus 'drawn' at once), but that one has been turned over to reveal its back. This act of flipping over the paper is a symbol for 'depth' rather than, as in the (minimal) case of the '*f*' holes, a picture of it. Furthermore, the newspaper changes role according to its position: in the 'background' it is the void of shadow, in the body of the violin it is the solidity of wood. This to-and-fro of void and solid, of front and back, of depth and surface, is Picasso's way of including what is absent from Cubism, even if only by pointing at the other missing half of a presence (*eg* 'depth' where there is only surface). And his new way of pointing is symbolic, or thoroughly semiotic, rather than iconic, or by resemblance. The ability to conjure up semiotically what is outside the limits of representational picturing was now inaugurated by newspaper cuttings: the most abstract of pictorial things (depth, shadow, light, colour) could be 'said' if not shown through the most concrete of pictorial elements (outlines, planes and colours). Furthermore, this subtle 'linguistic' evocation of ethereal depth is accompanied by the barrage of gross and worldly language from *Le Journal*. 'Painters beget pictures as princes beget children, not with princesses, but with country girls,' Picasso later joked.

169
Pablo Picasso,
Violin,
1912.
Pasted paper
and charcoal;
62 × 47 cm,
24³⁄₈ × 18¹⁄₂ in.
Musée National
d'Art Moderne,
Centre Georges
Pompidou,
Paris

The *Guitar* and the *papiers collés* were thus intimately connected, even though the former is a constructed sculpture, something apparently very different in its nature from a two-dimensional cut-and-paste. Picasso took several fascinating photographs that reveal the unity of these inventions (170). In the centre of each wall arrangement is the cardboard *Guitar*, and around it circulate various drawings and *papiers collés*, while on the bed below scraps of newspaper and other (unfinished?) *papiers collés* are scattered about. The photographs both suggest the cross-fertilization of standard structures from one subject to another (head becomes bottle becomes violin) and invite the viewer to imagine the constructed *Guitar* as emerging in an evolutionary sense from the addition of *papier collé* elements to plain drawings. In fact, as is already clear, Picasso made the *Guitar* before the *papiers collés* in the photographs, and so it hangs there more as a progenitor

than a descendant of the other works. A second photograph has two small cardboard construction guitars propped against the wall. Picasso looked after these two fabulously cheap looking sculptures, which survive today in the Musée Picasso, Paris (171, 172). They display continued invention: the frets on the fingerboard, and the scale marks, are here represented by a concertina of card. In one the dysfunctional 'strings' are really string, in the other they are drawn on either side of the sound-hole. The down-market materials and the cheapness of the early Cubist constructions, collages and *papiers collés* have intrigued many commentators. Apollinaire was the first to try to explain them. In the journal *Montjoie!* of March

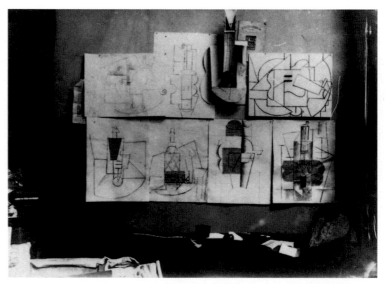

170
Pablo Picasso,
Wall
arrangement
of *papiers collés*
in the
Boulevard
Raspail Studio
(no. 1),
1912.
Gelatin silver
print;
8.9 × 11.9 cm,
3½ × 4⅝ in.
Private
collection

1913 he claimed that introducing 'a twopenny song, a real postage stamp, a piece of newspaper, a piece of oilcloth imprinted with chair-caning' represented an expansion of the painter's freedom, and a recognition that nothing could be added by the painter to the truth of those objects. Whatever the means, Apollinaire was not afraid:

Mosaicists paint with pieces of marble or coloured wood. Mention has been made of an Italian painter who painted with faecal matter; at the time of the French Revolution, someone who painted with blood. They can paint with whatever they wish – pipes, postage stamps, postcards

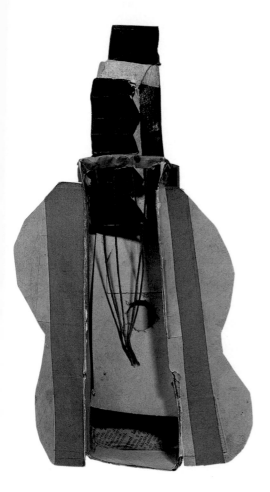

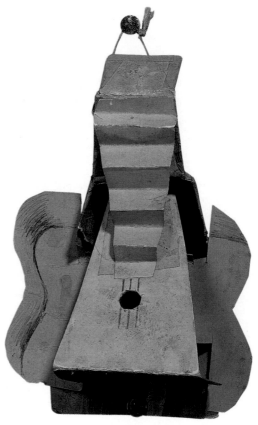

171
Pablo Picasso,
Guitar,
1912.
Pasted paper,
cloth, string,
oil and
crayon;
33 × 18 × 9.5 cm,
13 × 7⅞ × 3¾ in.
Musée Picasso,
Paris

172
Pablo Picasso,
Guitar,
1912.
Cardboard,
pasted paper,
cloth, string
and crayon;
22 × 14.5 × 7 cm,
8⅝ × 5¾ × 2¾ in.
Musée Picasso,
Paris

or playing cards, candelabras, pieces of oilcloth, starched collars ...
For me it is enough to see the work, one must be able to see the work.

The idea that all materials were now legitimate was hardly universally accepted, however. Both of the small guitars are datable from the constituents of their papier mâché backs to after 3 December 1912, the date of the debate on Cubism in the French parliament. This was stirred up not by the collage and *papiers collés* of Braque and Picasso but by the Cubism of the Salon d'Automne and the Section d'Or. Nevertheless, the latter did include Gris' first experiments in collage, *The Washstand*, with its fragments of real mirror glued to the canvas, and *The Watch* (173), featuring pages of poetry by Apollinaire. When Apollinaire reproduced four constructions in his new journal *Les Soirées de Paris* in November 1913 there was much uproar – thirty-nine out of the forty subscribers to the magazine cancelled their subscriptions. Readers were appalled by the desultory finish of the constructions, and were inflamed by their hybrid mix of painting and sculpture. Once artists later developed the possibilities of constructed sculpture in the twentieth century, these vices would be turned into virtues. Notwithstanding Apollinaire's perspicacious and courageous early defence of the inclusion of ready-made materials, the dialectical precision of the move from one *papier collé* to another or the relation of collage to construction was lost on supporters and enemies of the new art alike. A careless attitude was evident in Gleizes and Metzinger's pompous defence of Cubism in their highly influential and widely translated essay of late 1912. By April 1913, possibly after reading Apollinaire's *Aesthetic Meditations: The Cubist Painters*, to which he had contributed the frontispiece, Picasso wrote to Kahnweiler to express his 'disappointment with all this chatter'.

So what was the relationship between the high formalism of Picasso's art at this time and the use of such crude materials as cardboard and newspaper advertisements? What made Braque and Picasso introduce colour and pasted papers, and allude to current affairs and popular culture so frequently after 1912? One suggestion comes from a reported conversation, which took place much later in Picasso's life, with his then partner Françoise Gilot:

We tried to get rid of *trompe l'oeil* to find a *trompe l'esprit* ['deception of the mind/spirit']. We didn't any longer want to fool the eye; we wanted to fool the mind. The sheet of newspaper was never used in order to make a newspaper. It was used to become a bottle or something like that. It was never used literally but always as an element displaced from its habitual definition at the point of departure and its new definition at the point of arrival. If a piece of newspaper can become a bottle, that gives us something to think about in connection with both newspapers and bottles, too. This displaced object has its strangeness. And this strangeness was what we wanted to make people think about because we were quite aware that our world was becoming very strange and not exactly reassuring.

This old man's rumination may of course owe much to Picasso's contact with Surrealism in the inter-war period, and particularly to Louis Aragon's famous 1930 text 'In Defiance of Painting', where the poet mused that collage emerged as a form of black magic. Marxist and Existentialist friends in the 1940s may have encouraged him to think this way, too. Nevertheless, *papiers collés* by Picasso and Braque did indeed court the estrangement as well as the diversity of modern life. The textual content of the newspaper fragments may suggest why this is so.

Parisian newspapers of the early twentieth century pioneered the heady mix of current affairs, entertainment, gossip and advertising that is now commonly associated with 'the media'. Advertising – the key element in lowering the price of newspapers so that they could break out of a subscription-only audience and reach a mass market – began to appear in papers only in the 1830s. Thrilling suspense novels were serialized in the new and expanded papers in order to keep readers interested, and by the 1860s large display adverts appeared on the back pages that disrupted the customary sober layout of columns. Around the turn of the century new technology allowed for the inclusion of photographs, notably in the paper *L'Excelsior*, and improved communications accelerated the news-gathering process around the globe. The Parisian papers attained a circulation well into the millions by 1914, and fierce competition between the big four

173
Juan Gris,
The Watch,
1912.
Oil and pasted
paper on
canvas;
65 × 92 cm,
25⅝ × 36¼ in.
Private
collection

papers led to increasingly sensational reporting and bold and exciting advertising content.

The typographically diverse front page of *Le Journal* of 18 November 1912 (174), which Picasso cannibalized for his first *papier collé* (see 167), featured news of the Balkan war and a dispatch from Constantinople alongside a portrait of a recently-wed clockmaker who brutally cut his wife's throat in the night with his razor. Meanwhile, Picasso cut the page so as to make the phrases 'LE JOU' (a word which can be completed in various ways to mean toy, play or orgasm) and 'LA BATAILLE S'EST ENGAGÉ' ('battle commences'), editing out the story about the private passion of the clockmaker. A sentimental note is sounded in the collage, however, by the fragment of a lyric from a song by Marcel Legay '... dant qu'êtes bel ...' ('while you are beautiful'). This picture of a guitar is made out of the public matters of war and popular song, and is haunted by a homicide. Yet the 'play' is a game between Picasso and Braque, for whom 'battle commences' both mutually and against Salon Cubism, and where the words of a popular song can serve as code for Picasso's most secret feelings for his lover. The *papiers collés* were in this way the nodes or sites of a traffic between the complex and overwhelming world of public affairs on the one hand, and the private codes and affections of the urban dweller on the other.

174
Front page of
Le Journal,
18 November
1912

The two brief Balkan wars (1912–13 and summer 1913) that presaged the 'Great War' are frequently mentioned in the newspapers in Picasso's *papiers collés*. *Glass and Bottle of Suze* is replete with discussions of the Balkans, as well as of socialist and anarchist anti-war demonstrations (see frontispiece). The political content is, however, bizarrely juxtaposed with an excerpt from a serialized novel. The combination of frivolous entertainment and deathly serious news is symptomatic, then, of the new form of newspaper that Picasso appropriates. The knowing cutting-up of the headlines to produce schoolboy innuendoes (*eg* in one work *Le Journal* becomes 'URNAL', a truncated 'urinal') and in-jokes ('battle commences' – referring to the competition with Braque as well as to the race to outwit Salon Cubist acolytes) is itself a product

of the daily newspaper, since then as now displays on racks in street kiosks produced unexpected juxtapositions of half-concealed banner headlines.

At one level *papiers collés* and collage represented an affront to the distinction between high art and popular culture. Just as James Joyce would pun on vulgar language, newspaper journalism and poetry in his novel *Ulysses* (1922), and would thus celebrate the culture of the commonplace, so the choice of brash adverts and bargain basement brands combines with sometimes lewd jokes to undermine the high

ideas of reportage and lofty ideals of fine art. In this vein it has been pointed out that Picasso's preoccupation with the newspaper is a kind of rebuff to the Symbolist poet Stéphane Mallarmé, who thought the press an abomination against poetic language, the ideal site for which was the printed book. In several essays of the 1890s the poet argued that the large open pages of the newspaper, where commercialization of language and social hierarchies were translated into a monotonous layout, were depthless parodies of the book, whose folds and turning pages expressed the spiritual development of a poem or novel.

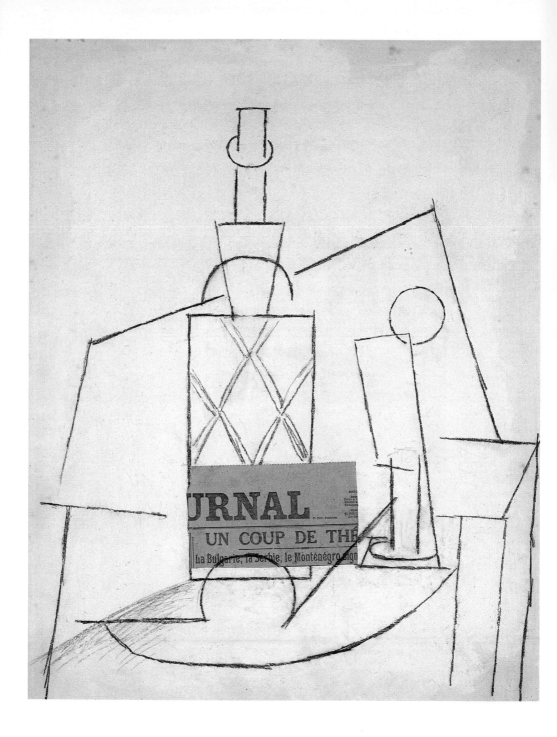

Mallarmé's most famous poem is 'Un coup de dés jamais n'abolira le hasard' ('A throw of the dice will never abolish chance') of 1897, in which the printed lines of the poem poignantly cross the centre fold of the book, changing font sizes are used to express rhythm and meaning, and scattered words conjure up images pictorially (ships, constellations) in an early example of a 'shape poem'. The idea that Picasso was overtly rejecting this precious kind of poetry, and its anti-populist stance, might be borne out by his parodic *Table with Bottle, Wineglass and Newspaper* (175), in which the cosmic '*Un coup de dés ...*' is rendered banal by cutting the Balkan War front page item (itself a pun on 'Un coup de théâtre') to form 'Une coup[e] de thé ...' ('a cup of tea'). In the same vein Picasso's friend Apollinaire appeared to reject Mallarméan élitist opposition to the newspaper as a form of literature, when he wrote in the unpunctuated 1913 poem 'Zone':

175
Pablo Picasso,
*Table with
Bottle,
Wineglass and
Newspaper*,
1912.
Pasted paper,
charcoal and
gouache;
62 × 48 cm,
24⅜ × 18⅞ in.
Musée
National d'Art
Moderne,
Centre Georges
Pompidou,
Paris

You read the handbills catalogues posters that sing

out loud and clear

That's the morning's poetry and for prose there are

the newspapers

There are tabloids lurid with police reports

Portraits of the great and a thousand assorted stories

Recent debate has focused on the question of whether or not Picasso shared in Apollinaire's celebration of the advert as poetry and the newspaper as prose, but perhaps what is important is that not only can Apollinaire's poem be read as a manifesto in favour of 'pop culture', but also as an evocation of the experience of the modern city-dweller. The poem suspends the modern self amid the turbulent interchange of high and low classes, high and low cultural spheres, and in the inescapable gap between the personal or private and the barrage of world news and commercial trafficking that is the act of reading the daily newspaper.

It has often been pointed out that, in the case of the *Suze* collage, the newspaper forms a literal background to the still-life objects in the composition. Alongside the guitar compositions, Picasso was already making *papiers collés* based around the idea of the café still life. This

subject matter, which was brilliantly taken up by Gris in particular, enshrines the peculiarly alienated – or in Picasso's words 'not exactly reassuring' – dialogue between self and the world. The café still life, with its array of coffees, cheap liqueurs and beers magically woven together with clay pipes and glasses, evokes, from the standpoint of a city morning or intoxicated afternoon, and through the material presence of the newspaper, the unreality of the Balkan War. In Gris' *The Tea Cups* (176) the international crisis appears alongside a lingerie sale or the clean-up of posters on a town monument in a sheet of newspaper. As has already been shown, Braque and Picasso often appropriated commercial language, fragments of entertainment culture and product slogans for their own private games. Picasso made 'Ma Jolie' his own in this way, and Braque became Wilbur Wright. The distant sound of 'Dernière Chanson' was cherished as a secret token of a love affair, but the song was never really 'our song' at all – it was only ever borrowed from the ebb and flow of the new leisure economy, and that was part of its thrill. The thrill of borrowing one's identity from the modern world is double-edged, however, since it requires ever more wit and psychological agility to sustain it, and since it hollows out the centre where the self used to be. Now, the *papiers collés* seem to say, people are made up of fragments of borrowed phrases, advertisements and worldwide events.

The pressing and shuffling planes of *papiers collés* led Picasso to a new way of conjuring up things normally absent from painting. The newspapers and other fragments of modernity that were instrumental in this magic led in turn to the conjuring of other 'absences' (war, capitalism, literature, love). Yet the biggest absence from the café still lifes of this period was a rounded subjectivity – the integrated and harmonious mind – to match this new world. In Gris' *Man at the Café* (177), the shadowy figure of modern man hides behind, but perhaps also lurks within, his newspaper. Gris makes the whole person out of the newspaper itself. Talking to Gilot, Picasso linked the strangeness of Cubism, its elision of bottle to glass to table, with the disturbing nature of the modern world. This is because the subjectivity created by modern life is so dissociated, so fragmented, so invested in the

176
Juan Gris,
The Tea Cups,
1914.
Collage, oil and
coal on canvas;
65 × 92 cm,
25⅝ × 36¼ in.
Kunst-
sammlungen
Nordrhein-
Westfalen,
Düsseldorf

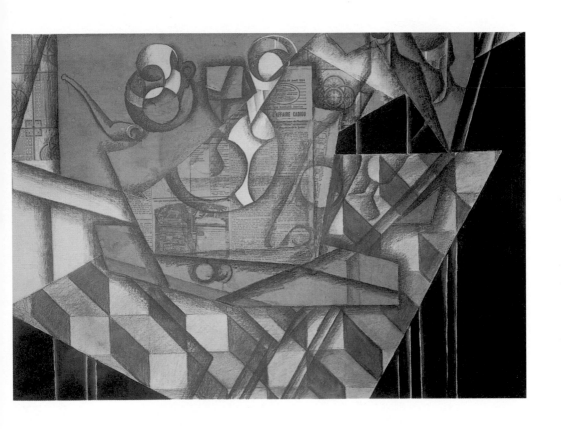

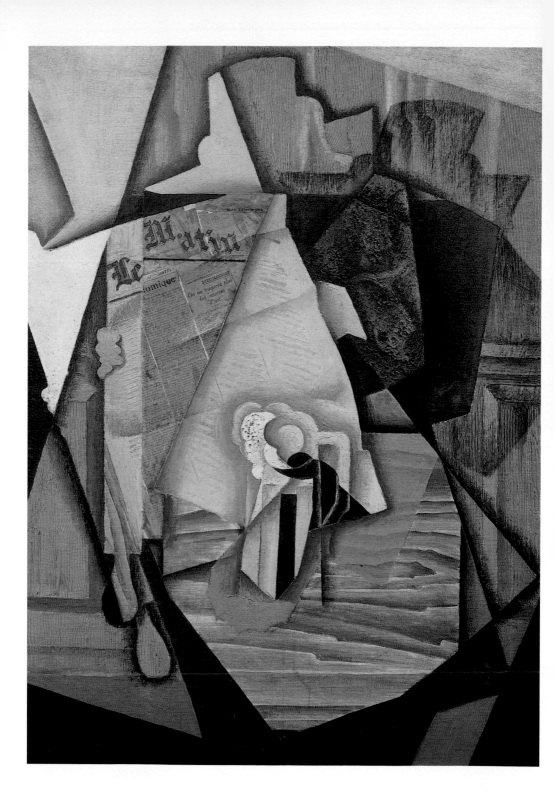

chaos of jostling advertisements and blaring headlines, that perhaps it can be embodied only in the shifting and shallow spaces and Babel language of a Cubist collage, in the ethereal melody of a music-hall song crackling on a gramophone. In this sense, the hybrid nature of collage is a symbol for the thrilling but disturbing heterogeneous subjectivity of modern life. The work of art no longer reveals 'nature seen through a temperament' (as in Émile Zola's famous dictum), but temperament structured by modern culture.

The new definition of originality demanded by *Still Life with Chair Caning* (see 153), for example, does not really entail viewing Picasso as a mere cipher for the cacophony of modern culture, because he very clearly demonstrates control and creative manipulation of the found elements in the work. For all its appearance of an attack on the idea of artistic authorship, his 'collaboration' with the ropemaker is not so different from that with a conventional framer. Nevertheless, while it is true that the practices of collage and *papiers collés* drew attention to personal acts of choice in the making of works of art, and thus heightened the sense of artistic control and the artist's subjectivity, they also played out the resistance of 'reality' to artistic manipulation. The crudeness and elementary character of many of the works discussed in this chapter are in one sense deliberate hints that the newspaper fragments and pieces of wallpaper are only just made into art – they hang on to their identities in the face of the artist's will.

The year 1913 saw Braque in Paris until June and then in Sorgues until December. Picasso travelled principally to Barcelona and Céret until August, spending the rest of 1913 through to June 1914 in Paris. Thus the two artists continued to exchange ideas in Paris during the first half of 1914, as the prospect of war loomed ever larger. Braque's formal inventiveness found infinite delights in the musical or café still life, with only an occasional foray into figure painting. Picasso, on the other hand, worked on compositions featuring ridiculously comic heads and figures playing guitars, as well as a variety of still-life paintings and constructions in paper, wood, metal and 'found' materials. No sooner had the two artists invented the collage principle than they set about imitating it in oil on canvas, with Braque often adding charcoal drawing,

177
Juan Gris,
Man at the Café,
1914.
Oil and pasted papers on canvas;
99·1 × 71·8 cm,
39 × 28¼ in.
Private collection

as in his *Woman with a Guitar* of autumn 1913 (now in the Musée National d'Art Moderne, Centre Georges Pompidou, Paris). In Picasso's hands the idea of a 'painted collage' led to a further set of spatial conundrums, as the rectangular forms of collage are depicted as floating in space, casting shadows on the planes behind. The amazingly grubby painting *Violin* of 1913/14 (also in the Musée National d'Art Moderne, Centre Georges Pompidou, Paris) shows just this effect, as a diagonal brown 'sheet' lifts from the painted wallpaper beneath. Perhaps the climax of this game of puzzle pictures is *Portrait of a Girl* (178). The layers of representation in this painting, with its lovingly painted wallpaper fragments and marble fireplace, took Picasso much effort, as we know from the existence of paper cut-out versions of parts of the composition (*eg* of the 'hands' at the bottom and the comic 'log and flames' in the grate). Picasso presumably used these to determine the final position of the elements, but also to help him capture their collaged appearance in paint. The polka dots that articulate areas of the figure nod ironically in the direction of Neo-Impressionist colour theory and Delaunay's adaptations of it around 1910 (see 89).

On rare occasions the *papiers collés* made by Braque and Picasso reached a degree of simplicity verging on abstraction (179). The attraction of the medium was not its metaphysical nature, however, but rather its workaday materialism. Picasso continued to delight in approaches that emulated, albeit in an entirely unprofessional manner, forms of artisanal craft. As Elizabeth Cowling has observed, the pins Picasso used instead of glue in several paper works impersonate the work of laying out a dressmaking pattern (180). The structures of the cardboard guitars impersonate the design of a cardboard box that must be similarly folded and hinged together, and at the same time may reflect an awareness of the instrument-maker's craft itself, which is based on the gluing of shaped elements around a frame. Craft is of course travestied in the wooden constructions Picasso made, but for all these gestures seeming to undermine the skill of the artist as well as the artisan, the sheer bravado of making an entirely new kind of art is never far from view, and the distinction between 'art' and 'life', though reinterpreted, is not in question.

178
Pablo Picasso,
Portrait of a Girl,
1914.
Oil on canvas;
130 × 96.5 cm,
51⅛ × 38 in.
Musée National d'Art Moderne, Centre Georges Pompidou, Paris

179
Pablo Picasso,
Head,
1913.
Pasted paper,
charcoal and
pencil on
cardboard;
43·5 × 33 cm,
17⅛ × 13 in.
Scottish
National
Gallery of Art,
Edinburgh

180
Pablo Picasso,
*Guitar on a
Table*,
1912–13.
Chalk and
pasted and
pinned paper;
61·5 × 39·5 cm,
24¼ × 15½ in.
Private
collection

This point is exemplified by a comparison of one of Picasso's most famous Cubist sculptures in the round, the *Glass of Absinthe* of 1914 (see 152), and Duchamp's 'readymade' of the same year, *Bottlerack* (181). Absinthe was a working-class drink of astonishing strength (then manufactured by Pernod, among others), whose exalting effects were often equated with those of opium. Temperance leagues began to protest against the sale of absinthe around 1900, and rates of consumption caused increasing anxiety in the French establishment during the so-called 'great collective binge' before the expected war with Germany finally broke out. Absinthe was often drunk in the following manner: a perforated spoon bearing a lump of sugar was placed across the glass, and ice cold water was poured over the sugar, producing a cloudy sweetness in the green liquor. Picasso's original wax sculpture incorporated a real silver-plated absinthe spoon, and when cast in conventional bronze six times at the behest of Kahnweiler, each cast was given its own real spoon. Picasso then painted and decorated each cast in a different manner, thus subverting the conventional bronze patina while rendering each cast-cum-readymade an 'original'. It is tempting to interpret this work, with its inclusion of real elements, as blurring the distinction between the work of art and the everyday object. The absinthe spoon refers beyond the world of art to the delirium of alcohol and working-class leisure (the sculpture is even said to resemble a drunken figure wearing a hat), but this pull is countered by Picasso's wit, visual skill and reinvention of the very idea of sculpture. If modern life heightened the sense of complexity and contradiction, it also introduced intoxicating new creative possibilities. Picasso embraced the cheapness of mass production in the form of the spoon, but transformed it into a precious series of originals for an exclusive clientele.

By contrast, Duchamp's *Bottlerack* was an early (and very pure) example of his so-called readymades, objects deliberately conceived in part to challenge the ability to distinguish art from non-art, and to question the role of the artist in the modern world. Indeed, for a time the disaffected Duchamp did not consider these objects as works of art at all. He did not make this utilitarian object, but purchased it in a department store. His only creative act was to sign it, and to inscribe it with a phrase lost with the 'original' when he moved to New York in 1915. For Duchamp, the

notion of valuing artists as privileged makers of beautiful objects was put into question by the sheer beauty and variety of mass-produced articles. The idea that the work of an individual should be prized as an 'original' was equally absurd. Whereas Braque and Picasso found inspiration in the modern world for the most vigorous transformation of art in centuries, Duchamp saw the new era of commodity consumption and production, technological innovation and dazzling communications, as the clearest challenge yet to the very idea of the artist's supposedly magical craft. The arid appearance of his readymades reflected his pessimistic view of the future of modern art, but as the next chapter demonstrates, extraordinary creative possibilities in Cubism were taken up by many other artists across the globe.

181
Marcel Duchamp,
Bottlerack,
1961 replica of
1914 original.
Galvanized
iron;
59×36·8 cm,
23¼×14½ in.
Private
collection

'Despite the opinion of certain grumpy critics, modern French painting is gaining more and more importance in Europe every day,' wrote Apollinaire in May 1914. The poet was absolutely right: in the few years since Cubism had become a public phenomenon it had been taken up by artists in all kinds of surprising ways, and had spread not only across Western and Eastern Europe but as far afield as North and Latin America. Apollinaire rejoiced in the dazzling success of the new French art, but he was no crude nationalist, embracing instead the truly international dimension of Cubism's appeal. The remarkable speed of its spread was equalled by the diversity of its impact: Cubism influenced sculpture, architecture and design, as well as painting. In some cases Cubism was adopted for its avant-garde credentials, its ability to rile conservatives in various national academies of art; in other cases it was the sheer artistic potential of pictorial Cubism that inspired artists in all media to rethink their work.

182
Alexander
Archipenko,
*Médrano II
(Dancer)*,
c.1913–14.
Painted tin,
wood, glass
and oilcloth;
126.5 × 51.5 ×
31.7 cm,
49⅞ × 20¼ ×
12½ in.
Solomon R
Guggenheim
Museum,
New York

Cubism was not necessarily distinguished from other closely related 'movements' from the point of view of foreign onlookers, however. Indeed, even in Paris the once fierce rivalries between Cubism and Futurism, for example, were soon forgotten. One social event symbolized the rapprochement: Futurist painter Gino Severini, long resident in Paris, married the Symbolist poet Paul Fort's daughter Jeanne on 28 August 1913, and then visited the studios of Braque, Picasso, Léger, Gleizes and Metzinger. The exchange of ideas meant that, while 'Cubism' attained more recognition, it became even harder to define. 'One must not take literally the names of the various schools: cubists, orphists, futurists, simultaneists, etc.,' wrote Apollinaire in *Paris-Journal*. 'For some time they have meant absolutely nothing. Today there are only modern painters who, having achieved their art, are now forging a new art in order to achieve works that are materially as new as the aesthetic according to which they were conceived.'

Apollinaire's new breed of modern artist was certainly not necessarily French, nor working in France. Many foreign nationals who became Cubists returned to their countries of origin taking the new art with them. As word spread, artists from around the world were eager to learn more of exciting developments in Paris, and to absorb Cubism at first hand. A host of exhibitions featuring Cubism across Europe and the United States were complemented by the growing number of avant-garde reviews and magazines featuring reproductions of Cubist works and interviews with and articles on Cubist artists, which were avidly consumed by a new generation of modernists. This chapter looks at the international spread of Cubism, first examining the astonishing changes in sculpture in Paris after 1912, and then tracing the new versions of Cubism that sprang up in Czechoslovakia, Germany, the Netherlands, Russia and the United States.

Cubism's transformation of sculpture had roots in the late nineteenth century, in the work of Impressionist painter and sculptor Edgar Degas (1834–1917), for example. Yet by and large sculpture had resisted the innovations of modernism in the arts to a much greater extent than painting. This was largely because sculpture was by definition a more expensive and time-consuming art, factors that discouraged experimentation. Furthermore, most sculptors aimed to gain large public commissions (for monuments or architectural decorations), and were thus more mindful of the establishment values of their potential patrons than were painters who had begun to benefit from a private art market and gallery system catering to an informed and self-consciously progressive audience.

183
Auguste Rodin,
The Age of
Bronze,
1875–6.
Bronze;
h.175 cm,
71 in.
Victoria and
Albert Museum,
London

Sculpture was conventionally executed in clay or plaster, and usually exhibited in the salons in plaster on the understanding that it would be cast in bronze or carved in stone once an interested party agreed to foot the bill. The figure who became the dominant force in sculpture at the turn of the century was Auguste Rodin (1840–1917), who succeeded in breaking some of the established rules with his one-man show at the 1900 Universal Exposition in Paris. A cult of personality developed around Rodin, whose figure sculpture (183), evoking powerful physical presence, psychological drama and eroticism, was understood as

deeply personal in its origins. Rodin occupied an ambiguous position for the avant-garde, however, since he was in many respects a mainstream artist. His sculpture still revolved around an idealized vision of the human form and he continued to employ modelling in clay and plaster as his principal means. Furthermore, his recent success enabled him to set up a large studio with numerous apprentices who flocked to Paris to learn his craft, churning out copies and casts of his work to meet increased demand. Other sculptors who received some of the more adventurous public commissions in France in the early decades of the century, such as Émile-Antoine Bourdelle (see 2), worked for Rodin to supplement their income. Overall, though, the world of sculpture was dominated by the values of the academicians and of the bourgeois great and good who tended to control the public and commercial spaces and buildings for which most sculpture was destined.

As we have seen in earlier chapters, some artists who were primarily known as avant-garde painters, such as Derain and Gauguin, resisted such conventions by carving directly in wood or stone, thus rejecting the idea of testing the work on the public beforehand in favour of spontaneity of expression. Another important figure in changing attitudes among the avant-garde was Matisse, who developed a thrilling sense of vitality in his early sculptures by modelling them in a bold style that bore a close relation to his painting. Matisse made use of photographs as sources for his sculptures, and this rather unusual practice points to the close relationship that he perceived between three-dimensional sculptures and his pictorial inventions. However, none of the sculptors mentioned so far engaged in any sustained questioning of the fundamental link between sculpture and the human figure, nor did they interrogate the materials or processes of sculpture to any profound extent.

It is against this background that Picasso's early isolated experiments with Cubism in sculpture should be seen. The two plaster versions of *Head of Fernande*, of which numerous bronzes were cast (see 66) and then sold and exhibited abroad, became a landmark for the pre-war generation. The head remains figurative, of course, and though it impersonates the look of 'direct carving' it was made like

any academic monumental piece, worked in plaster and then cast in bronze. But the originality of the work lies in its form: the application of Cubist pictorial faceting to a three-dimensional object. This act of transference is more complex than it seems at first glance. It is often said that the *Head of Fernande* merely proved to Picasso that Cubism was more interesting as painting than as sculpture – and the fact that he did not continue to make such works might be thought to prove the point. Yet this would be to miss the force of the work as a remarkable departure from the conventions of the medium: the ideal of the beautiful female face is remade in a vision of dramatic and rhythmic chiaroscuro. This apparition erupts into our object world thanks to the tough physicality evident in the tactile and massive character of the modelling. If these strange effects remained relatively unexploited for some time by Picasso, they were taken up by others, some of whom, such as Boccioni, were ostensibly concerned with Futurist rather than Cubist ideas.

Among the first to be associated with Cubist sculpture apart from Duchamp-Villon (see chapters 5 and 9) were the Russians Alexander Archipenko and Ossip Zadkine (1890–1967; 184), and the Hungarian Joseph Csáky (185). The now little-known sculptors Auguste Agéro and Ernest Friederich Wield (1880–1940) also featured in reviews. Of these, Archipenko was the most innovative and productive, and his pre-war work developed in a complex way that took in recent inventions in pictorial Cubism and, through his contacts with Boccioni, brought about a synthesis of Futurist and Cubist devices.

Born in Kiev, Archipenko arrived in Paris from Moscow in late 1908, and probably took a studio in the Montparnasse building known as La Ruche ('the beehive'). Whether or not he lived in La Ruche, he certainly befriended the other artists who rented studios there, including Zadkine, Csáky and Fernand Léger, and got to know the poet-critics Apollinaire, Maurice Raynal and Blaise Cendrars. Archipenko began showing sculptures in the Salons in 1910, and he contributed regularly thereafter. His early works were abstracted figure sculptures combining the vigour of Rodin with archaizing form and surface effects. This kind of sculpture does not appear as Cubist in the way that Picasso's

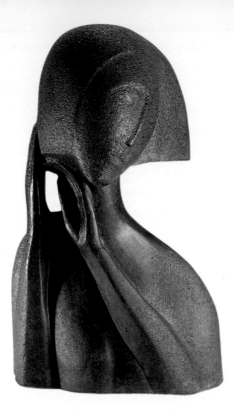

constructions do, but the archaic figure style that Archipenko was
developing alongside Zadkine and Csáky became the main route
whereby sculptural interest in elemental forms and structure was
developed. He exhibited at the Salon de la Section d'Or in October
1912, but publicly rejected Cubism in December 1912, following his
friend Delaunay, who had already renounced the movement in the
autumn. Nevertheless, in that same year, Archipenko began making
a few sculptures of a more experimental character that inverted the
relationship between solid and void.

Archipenko recalled that he also commenced work on mixed-media
constructions in late 1912. His *Médrano I*, a sculpture of a circus juggler,
is now known only through a photograph (186). Archipenko made
the juggler in wood, glass, sheet metal and wire, to which he applied
colour. The juggler immediately brings to mind ideas of circulating
forms and movement; the figure is partly made up of the same
spherical elements he tosses into the air. This creation of formal

184
Ossip Zadkine,
*Bust of a
Woman*,
1914.
Bronze;
56 × 35 ×
32 cm,
22 × 13³⁄₄ ×
12⁵⁄₈ in.
Musée Zadkine,
Paris

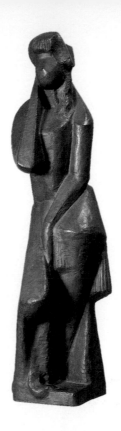

185
Joseph Csáky,
*Standing
Woman*,
1913.
Bronze;
80 × 21 × 22 cm,
31½ × 8¼ ×
88⅝ in.
Musée
National d'Art
Moderne,
Centre Georges
Pompidou,
Paris

structures or frameworks that could adapt themselves to different readings echoed the universalizing character of Braque's and Picasso's visual language. By 1912, of course, both artists were making paper sculptures and mixed-media constructions. Braque's paper and cardboard sculptures (187) were accessible only to those who visited his studio, but Picasso's constructions of early 1913 were both celebrated and reproduced by Apollinaire in *Les Soirées de Paris* in November of the same year (see Chapter 7).

Archipenko's use of materials almost certainly not only reflects some knowledge of the work of Picasso and Braque, but is also an exchange of ideas with Boccioni, who had visited Archipenko's studio in 1912. Boccioni's important exhibition of 20 June–16 July 1913 at the Galerie La Boétie fulfilled the promise of his 'Technical Manifesto of Futurist Sculpture' of a year earlier, which insisted on the integration of objects and surrounding space and called for the use of all sorts of non-traditional materials, including 'transparent planes, glass,

strips of metal sheeting, wire, street-lamps or house-lights.' In the exhibition, Boccioni showed drawings and sculptures, including the impressive *Development of a Bottle in Space* and painted sculpture.

Médrano I was apparently rejected by the Salon d'Automne of 1913, but Archipenko's mixed-media *Médrano II* (182) inaugurated the form for which he would become renowned, which he called 'sculpto-painting'. This work is a curious modernization of medieval polychrome altarpieces, although it also resembles a shop sign or child's toy. Apollinaire singled out the 'grace' of this work for special praise in his review of the Salon des Indépendants of 1914, and it was purchased by the Italian painter Alberto Magnelli (1888–1971). But the wider public response to Archipenko's work remained hostile. *L'Intransigeant*, the newspaper that published Apollinaire's review, also illustrated

Médrano II on its front cover, with the disclaimer 'We reproduce here a photograph of the work of art praised elsewhere in this issue by our collaborator Guillaume Apollinaire, who assumes sole responsibility for his opinion.' Apollinaire also praised the extraordinary polychrome mixed-media sculpture exhibited by little-known Russian Vladimir Baranoff-Rossiné (1888–1942), the now-lost *Symphony No. II*. Its predecessor, *Symphony No. I* (188), gives a good idea of the approach that Baranoff-Rossiné took, and suggests that he knew of Boccioni's advocacy of unorthodox materials, and of Picasso's improvisatory approach to the construction of his sculptures. Baranoff-Rossiné used eggshells and cardboard in *Symphony No. I*, and his application of paint anticipates the striations and fake Neo-Impressionist polka dots of some of Picasso's painting on the bronze casts of the *Glass of Absinthe* (see 152). This arbitrary patterning of the surface of constructed sculpture gave it added vibrancy, and Archipenko's work in particular explored the relationship between colour and the spatial articulation of his figures.

For all the innovations evident in the work of Archipenko and others, the Cubist sculpture of the pre-war Paris Salons remained heavily indebted to Futurist representation of figures in movement, and had not yet addressed the other quintessential Cubist subject, the still life. Nor had it forged a coherent link – one that would make sense of

the new sculpture – between the use of diverse materials and the application of polychromy. Two sculptors, Jacques Lipchitz (1891–1973) and Henri Laurens (1885–1954), who took up the cause slightly later, almost at the start of the war, managed to produce a more searching and identifiably Cubist sculpture. The Lithuanian-born Lipchitz arrived in Paris in 1909. After training in various Parisian academies and a brief period of military service in Russia, he took a studio next to the Romanian sculptor Constantin Brancusi (1876–1957) in Montparnasse. Brancusi was never closely allied to Cubism, but he had a profound impact on the emergence of a new idea of sculpture in the twentieth century. His strong sense of the organic relationship between his materials and the form to which they could be shaped, and of the circumstances in which sculptures should be viewed, undoubtedly struck those who came to his studio. Brancusi's convictions and originality helped Lipchitz to develop as a sculptor. Lipchitz also got to know Picasso in the spring of 1914, which was when he began making Cubist work. From 1915 onwards, Lipchitz produced sculptures based on the idea of collapsible components. In fact, this conceit was central to Picasso's cardboard *Guitar* of October 1912 (see 164), as Picasso joked to Salmon: 'You'll see, I am going to hold onto the Guitar, but I shall sell its plan. Everyone will be able to make it for himself.'

Archipenko had already responded to this notion of constructed-sculpture-as-DIY-kit with the toy-like *Médrano I*, as had Baranoff-Rossiné in his mixed-media constructions. Both these works embodied Futurist ideas of movement, however, and preferred exuberant dynamism to the planar austerity of the *Guitar*. Lipchitz got closer to the spirit central to Cubism and clearly showed his sensitivity to Picasso's incorporation of caricatural elements in his recent paintings with his first collapsible or detachable figures of 1915. In a choice of materials and using an elemental approach, Lipchitz assembled carved wooden elements in such a way as to make the method of construction self-evident. In one of several works entitled *Detachable Figure: Dancer* (189) he used screws to fix the wooden components, clearly suggesting the possibility of disassembly. The crucial difference between Lipchitz' work and that of Brancusi, Archipenko and others was in his sustained exploration of the dialogue between plane and

188
Vladimir Baranoff-Rossiné, *Symphony No. I*, 1913. Polychrome wood, cardboard and crushed eggshells; 160·6 × 72·4 × 63·5 cm, 63¹⁄₄ × 28¹⁄₂ × 25 in. Museum of Modern Art, New York

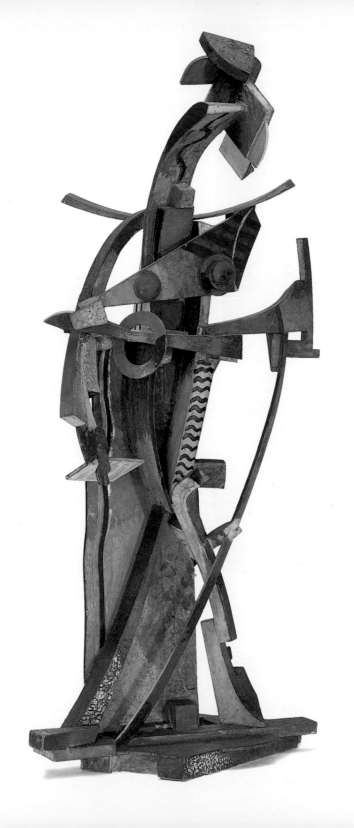

depth in his sculptures, and his ability to interpret the figure in such a way as to suggest both architecture and still-life objects (190). By concentrating on ideas of constructive or additive sculpture, and by thinking in resolutely planar terms, Lipchitz might be thought to be blurring the boundary between sculpture and painting. This suggests once again that speaking of independent Cubist sculpture is misleading, insofar as these works remain dependent on pictorial values for their coherence. Yet in the Cubist sculpture of Lipchitz the difference is that the language of painting upon which he draws is no longer one of Renaissance illusionism, but has been reconstituted as one of formal oppositions – of light and dark, solid and void, straight and curved, plane and depth. So although Cubist sculpture proper was insistently pictorial in its origins, those origins were already the thoroughly reinvented Cubist depiction, and of course, Cubism had itself evolved partly through a dialogue with the most pictorial form of sculpture, carved relief (see Chapter 3).

189
Jacques
Lipchitz,
*Detachable
Figure: Dancer*,
1915.
Ebony and oak;
h.98·1 cm,
38⅝ in.
Cleveland
Museum of Art

190
Jacques
Lipchitz,
Seated Figure,
1916.
Bronze,
h.76·2 cm,
30 in.
Scottish
National
Gallery of Art,
Edinburgh

The dialectical aspect of Cubist sculpture – its love of conceptual oppositions – is one of its most important contributions to the reinvention of the art in the twentieth century. Opposition provided a framework within which heterogeneous materials and colour could have a coherent place, and thus explicitly opened up new questions for sculptors, such as the interaction of space and light, or the relationship between visual and tactile perception. Perhaps the most challenging question that Cubist sculpture could now ask concerned the relationship between the sculptural object and the ordinary non-art object. While Duchamp raised this question in a bald form with his 'readymades' (see Chapter 7), Cubist sculpture took delight in it through still-life compositions.

Of all the sculptors who took up Cubism in Paris and tried to build a career around it, Henri Laurens was undoubtedly the most dedicated to the cause, and in many ways the most talented Cubist exponent (along with Picasso) of the sculptural still life. Parisian-born Laurens had trained in sculpture from an early age, and moved to Montmartre as early as 1902. In 1910 he spent some months living in La Ruche, where he got to know Léger, Archipenko and others. His most

important acquaintance in the pre-war years was Braque, however, whose close neighbour he became in late 1911. Whereas some artists who came into contact with Cubism underwent an instant and dramatic conversion, Laurens appears to have responded only slowly to the *papiers collés* and constructions that he must have seen in Braque's studio in 1912 and 1913. Although it is known that Laurens exhibited in the Salon des Indépendants of both 1913 and 1914, his earliest surviving constructions and *papiers collés* are from the next year. These are of such sophistication that it is tempting to imagine that Laurens had already been developing these aspects of his practice in 1914. Some works, such as *Clown* (191), draw conspicuously on Archipenko's *Médrano* pieces and on Léger's 'tubular' *Contrast of Forms* (see 95), while others take up the idea of frontal polychromy from *Médrano II* (see 182). What comes across very clearly in these early pieces, in contrast to the gleeful shoddiness of Picasso's painted objects from the same period (see 1), is a highly crafted, well articulated but energized aesthetic. This is equally clear in *papiers collés* such as the erroneously titled *Josephine Baker, Dancer* (192). This 1915 collage pre-dates the famous African-American dancer's debut as a young woman by some ten years, so it cannot be a portrait, as the received title suggests. In Laurens' work a dancer is transformed into a geometric assemblage that would be worthy of an architect's drawing board, but for the caricatural accentuation of the dancer's lips and oiled hairdo.

191
Henri Laurens,
Clown,
1915.
Painted wood;
h.63.5 cm,
25 in.
Moderna
Museet,
Stockholm

Laurens continued to refine his Cubist constructions throughout the war, working back and forth from two-dimensional studies to sculptures, which often as a result demand frontal viewing. Again, it is this close dialogue between construction and *papiers collés* – between making spatial objects and depicting them – that enabled Laurens to make sense of the idea of Cubist sculpture. The *Head of a Woman* of 1916, which was recognized as Laurens' work only in 1992 (it had hitherto been attributed to Archipenko), self-consciously embodies the dialogue between the pictorial and the sculptural modes (193, 194). Careful choice of subject matter also informs Laurens' ascendancy as a Cubist sculptor, and in 1915–18 he made a series of sculptures based on the quintessential Cubist still-life subject, a glass and bottle (195).

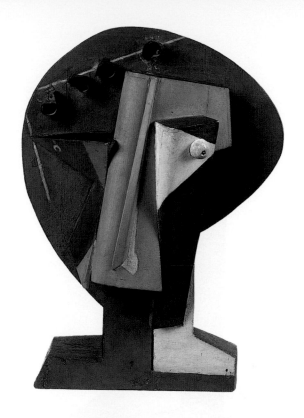

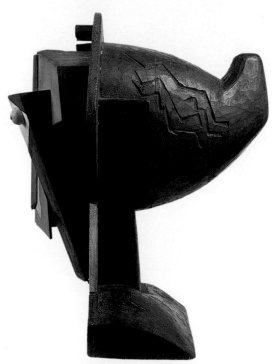

195
Henri Laurens,
Bottle of Rum,
1916–17.
Wood and
polychrome
metal;
28·5 × 25·5 cm,
11¼ × 10 in.
Musée de
Grenoble

196
Henri Laurens,
*Bottle and
Glass*,
1919.
Polychrome
stone;
34 × 11·5 ×
12 cm,
13⅜ × 4½ × 4¾ in.
Musée d'Art
Moderne de
Lille
Métropole,
Villeneuve
d'Ascq

The still-life objects in these sculptures are not in any sense meant to confuse us as to their artistic nature: there is no doubt that we are not looking at a real bottle of rum. Their play is rather with the high seriousness of figure sculpture, and the proscription of still life as a worthy subject for the sculptor. Still-life objects, in their static and moribund nature, were thought to stand for the very thing that any sculptor should seek to overcome – inanimate matter – and thus to lie beyond the pale of sculpture. Laurens demonstrated both that Cubist sculpture could deal with still life without compromising its own sculptural integrity, and that any bottle of rum could look more alive than a plaster nude. In these elegant and intriguing pieces, Laurens developed his application of colour as a means of articulating the different elements of the composition, and distinguishing shadow from light. The fixing of colour in this way recalls Braque's use of *faux-bois* wood-grain in his first *papier collé* (see 165), asserting local colour against the contingent effects of light. The resulting rhythmic patterns of shapes in Laurens' work produced clarity along with complexity.

When Laurens returned to stone carving at the end of the war he used these patterns oppositionally, to enrich awareness of surface and volume in sculptures that now functioned from all viewpoints rather than exclusively frontally (196). Although carved in stone, this work is remote from the idealized human form of Rodin (see 183), and the distance between them is ironically acknowledged in its modest scale and zesty colour.

Some parts of the world took to Cubism more quickly than others. And Cubism took on new forms in response to different regional concerns. The case of Czechoslovakia is particularly interesting in this respect, since Czech Cubism is both wonderfully creative with Cubist ideas and distinctive in its adaptation of them to new ends. Furthermore, in common with other foreign nationals striving to learn more of French modern art, the Czechs suffered from unwarranted insecurity as to their talents and futures. In his review of the Salon des Indépendants of 1912, Apollinaire tells an anecdote to the glory of Gris:

Juan Gris is exhibiting a *Homage to Picasso* that reveals a praiseworthy effort and a noble disinterestedness ... A Czech painter, on whom the Destiny that presides over the distribution of patronyms bestowed the name of Kubišta, wandered through the Indépendants yesterday in search of works by his quasi namesakes, the French Cubists. Having made a complete tour of the Salon, he stopped in front of Juan Gris' paintings and would be there still, if the merciless cry of 'Closing time!' had not interrupted his meditation.

Bohumil Kubišta (1884–1918), best known for his impressive *St Sebastian* (197), which is close in spirit to Picasso's work of 1909, was one of a number of Czech artists who were frequently in Paris to absorb Cubist exhibits. Expressing anxiety over coming from the periphery of modernism, he wrote from Paris to a friend: 'We are too wild for Prague – that's why it is difficult for us to find a base there. We are too much behind Paris where we have no base so far – we hang suspended between heaven and earth.'

The key contact for the Czechs was František Kupka, who had shown on several occasions in Prague since settling in Paris in 1895. Along

197
Bohumil
Kubišta,
St Sebastian,
1912.
Oil on canvas;
98 × 74.5 cm,
38⅝ × 29⅜ in.
Národní
Gallerie,
Prague

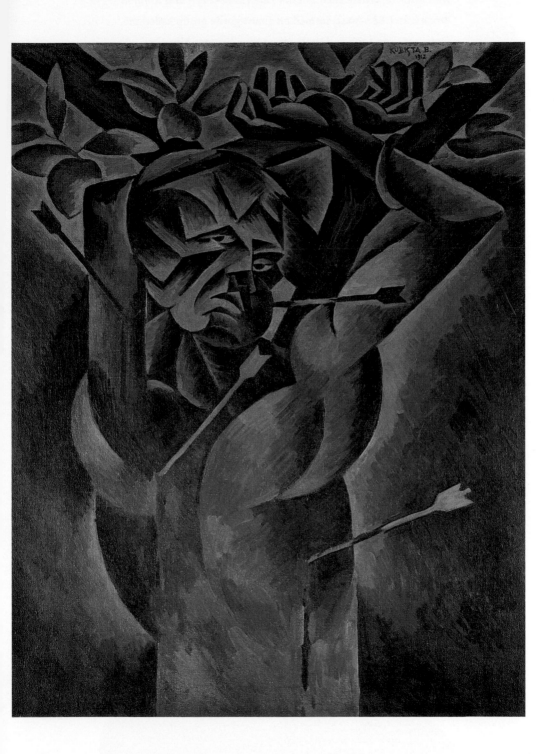

with Kubišta, artists such as Emil Filla (1882–1953) and Antonín Procházka (1882–1945) formed an avant-garde group called the Eight between 1907 and 1909, when they became absorbed into the important Mánes Union of Artists. The established Parisian sculptor Bourdelle (see 2) exhibited in Prague in 1909, and this led Otto Gutfreund (1889–1927) to join him as a student in the French capital. By 1910 the others followed Gutfreund to Paris for brief visits, while in Prague a major exhibition led to a collection for the purchase of Derain's *Bathers* of 1908–9 (see 50), a work admired at the time for its primitivism. By 1911 the younger artists in Prague had formed the Group of Plastic Artists (to 1914) as a vehicle for their avant-garde activity, publishing a journal called *Arts Monthly* and drawing upon the expertise of the art historian Vincenc Kramář, who by 1914 had amassed one of the most important collections of Cubist art in Europe, and who in 1921 wrote one of the most perceptive early monographs on the movement. Gutfreund produced some of the most interesting Cubist sculptures before World War I (198), but

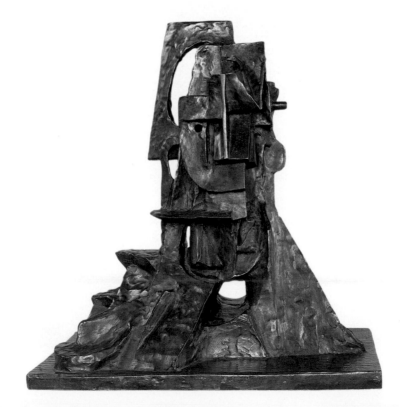

198
Otto
Gutfreund,
*Cubist Bust
(Man's Head)*,
1913.
Bronze;
h.60 cm,
23⅜ in.
Národní
Gallerie,
Prague

as he did not exhibit in Paris his work was not widely known there, and so it is difficult to say how important it was to other sculptors. Gutfreund explored the potential of complex articulations of mass to capture the vital tensions between vertical figuration and horizontal ground, and he developed his work with an equally strong sense of the changing aspects of sculpture seen in the round.

Unlike Parisian Cubism, which produced only the Cubist House installation (see 117–121) with its few examples of furniture and ceramics, Czech Cubism is remarkable for its achievements in architecture and design. A retrospective exhibition in 1991 included designs for forty realized buildings, one hundred pieces of furniture and seventy examples of ceramics and metalwork to its name. Four architect–designers in particular were behind these achievements: Josef Gočár (1880–1945), Joseph Chochol (1880–1956), Vlatislav Hofman (1884–1964) and Pavel Janák (1882–1956). Janák was particularly important both as a theorist and as the architect who installed the first exhibition of the Group of Plastic Artists, creating an environment for the works in a manner that has now become integral to our experience of exhibition display. Janák's writings reveal a gradual rejection of some of the rationalist lessons learnt during his training in Vienna with Otto Wagner, and his 'From Modern Architecture to Architecture' of 1910 argued that it was not only practical function that should dictate architecture but artistic issues, such as 'the problem of space or the problem of matter and form'. Janák's insistence in 1912 that 'the substance of space and its creative laws' was the true vocation of architecture derived from his close study of German theorists, art historians and aestheticians such as Adolf Hildebrand, Theodor Lipps, Alois Riegl and Wilhelm Worringer.

The growing interest in the Czech group in questions of the expressive character of spatial configurations was a reflection of another German connection. There were frequent exchanges with the German Expressionists in the group known as Die Brücke ('The Bridge'), of which Kubišta was briefly a member, and later with those associated with the book or 'almanac' *Der Blaue Reiter* ('The Blue Rider') or the gallery Der Sturm ('The Storm'), which also published

a periodical. Both of these publications also contained Parisian material, and the Sturm gallery hosted exhibitions by French as well as German avant-gardes. The eclecticism of theoretical and visual sources was synthesized by Janák in his 1912 article 'The Prism and the Pyramid', that called for a rejection of the naturalism of 'southern' classical architecture, and a turn to the 'spiritually abstracted' combination of prism and pyramid that he identified with northern Christian values. The visual expression of such theories emerges in Janák's *Design for a Monumental Interior* of 1912 (199), where there are clear references to Gothic ribbed vaulting and the sombre spiritual grandeur of a cathedral crypt, reminiscent of Delaunay's famous *Saint-Séverin* paintings (see 72).

While competitions such as that of 1913 for a monument to Jan Žižka, a fourteenth-century Czech national hero, produced further examples of highly visionary Cubism, it was in a series of buildings that Czech Cubist architecture began to address the relationship between interior and exterior form. In an essay of 1913 Janák had already argued that it was in the surface effects of the façade, effects of a pictorial or optical nature, rather than in the spatial organization of the plan, that the new aesthetics of architecture could best be expressed. This approach was perfectly suited to Janák's modifications to an existing Baroque house belonging to a Dr Fárá in Pelhrimov (200). The debt to Duchamp-Villon's Cubist House is shown in the prismatic articulations of the balcony and

199
Pavel Janák,
Design for a Monumental Interior,
1912.
India ink;
39.5 × 42.5 cm,
15½ × 16¾ in.
Národní
Gallerie,
Prague

200
Pavel Janák,
Dr Fárá's
House,
Pelhrimov,
1913

gable. A similarly optical approach to Cubist architecture is evident in Gočár's famous department store The Black Mother of God (201), where the interiors were conventional spaces fitted with Cubist furnishings and light-fittings (202).

The most impressive exponent of the new style was perhaps Chochol, who had the advantage of a dramatic corner site for an apartment block in Vyšehrad (203). Both Chochol and Hofman were sceptical that the surface articulations invented by Duchamp-Villon, Gočár and Janák could lead to a new architecture, and Hofman insisted that what

Opposite
201–202
Josef Gočár,
The Black
Mother of
God, Prague,
1911–12
Above
Exterior
Below
Café interior

Right
203
Josef Chochol,
Apartment
block,
Vyšehrad,
Prague, 1913

was needed was 'a new understanding of space'. The Vyšehrad site created a naturally expressive shape that Chochol emphasized by using projecting cornices. The balconies at the corner and the lozenge ground floor windows provided a sculptural dialogue between solid and void, which is enhanced by the windows set deep against projecting facets in the stories above. Despite these differences of opinion concerning the means of Cubist architecture (differences too great for Hofman to accept), in 1912 Gočár, Janák and Chochol collaborated in establishing the Prague Art Workshops (PUD). It was from this

studio that innovative Cubist designs emerged which employed the vocabulary of Cubism as a sign of a new approach to applied art (204).

In his text of late 1912, 'Of Furniture and Other Matters', Janák explained the philosophy behind these objects, which must have appeared extraordinarily audacious but also out of place in the interiors of the day. For Janák, the PUD did not aim to integrate the values of art and technological utility, but rather to demonstrate that these two spheres of human activity could coexist in the modern environment. Janák believed that human beings need to order their living spaces according to both practical need and the entirely separate imperatives of art – particularly spatial ones. The need

204
Josef Gočár,
Sofa,
1913.
Black-stained,
veneered and
upholstered
oak;
118.5 × 230 ×
75 cm,
46⅝ × 90½ ×
29½ in.
Private
collection

for spatial order was, he claimed, best satisfied by art, and least of all by box-like shapes. The design approach he advocated, and which is clearly evident in Gočár's PUD Clock (205), for example, is one that emphasizes an overall sense of plastic shape – the image evoked by the edges and surfaces of the object – rather than the diversity of materials used or the construction. In a sense, then, it is true that PUD products were exercises in Cubism as a style, since they deliberately refused a functional approach to the employment of Cubist vocabulary, and instead saw their sofas and chairs as having double lives as both objects of art and utility. Such a position was the absolute opposite to that developing in Germany in the same period, where a greater integration of practical and aesthetic values was being pursued.

205
Josef Gočár,
Clock,
1913.
Brass;
24×29×13.5 cm,
9½×11⅜×5⅜ in.
Private
collection

In 1914 the PUD exhibited at the Deutsche Werkbund (established in 1907), a public show mounted by a group of progressively minded German designers and architects. German artists and architects were already even better informed than many of their counterparts in Paris regarding the most recent Parisian developments in Cubism (there had been a Picasso retrospective in Munich in March 1913, for example), and *The Blue Rider* had reproduced Cubist works and printed a translation of an essay by Roger Allard. Several artists associated with the almanac experimented with Cubist faceting and grid-like structures in their work. The brilliant colourist Franz Marc made rich and inventive portraits of animals using such Cubist devices. His *Foxes* (206) uses the natural forms and movements of the animals to dictate the rhythms of the faceting. Paul Klee (1879–1940) made an abstract oval oil painting entitled *Homage to Picasso* in 1914, and in the same year his delicate watercolour *Remembrance of a Garden* (207) recalled the surface patterning of Picasso's Cubism of 1910. Overall, however, German artists, despite being astute critics and admirers of Parisian Cubism, did not adopt it in any straightforward manner, and this fact has been commonly but dubiously interpreted as a sign of the inappropriateness of Cubist rationalism for the romanticism predominant in German culture.

206
Franz Marc,
Foxes,
1913.
Oil on canvas;
87×65 cm,
34¹⁄₄×25⁵⁄₈ in.
Stadtische
Galerie im
Lenbachhaus,
Munich

Nevertheless, by 1914 the critic Adolphe Behne had begun to articulate a theory that amalgamated Cubism with currents in German Expressionism. Following the Czech architect and theorist Joseph Čapek, he admired later (Synthetic) Cubism for its creation of an autonomous language of construction, and – echoing the Bergsonian theses of Salon Cubism (see Chapter 5) – saw this 'crystalline' vision as penetrating and expressing the essential nature of life in the universe. Behne admired artists such as Delaunay and Léger, and after the war, the German-American Lyonel Feininger (1871–1956) whose 'architectonic' work was, he believed, 'striving for final unity'. This striving was only to come to fruition in Germany after World War I in the Bauhaus project (see Chapter 10).

Two artists whose work has had an immense impact in the twentieth century, and who travelled to Paris with the more or less explicit

207
Paul Klee,
Remembrance of a Garden,
1914.
Watercolour on linen paper mounted on cardboard;
25·2 × 21·5 cm, 9⅞ × 8½ in.
Kunst-sammlung, Nordrhein-Westfalen, Düsseldorf

purpose of finding out about Cubism, were Dutchman Piet Mondrian (1872–1944) and the Ukrainian Vladimir Tatlin. Mondrian undertook a slow apprenticeship in Paris, while Tatlin benefited from a whirlwind tour. Mondrian first came to Paris 1911, but he was already a member of the Société des Artistes Indépendants and came to see the Indépendants show, which included one of his paintings. Returning to Amsterdam, he helped to assemble an exhibition of modern art that included early Cubist works by Braque and Picasso. Mondrian's own contributions to the show were criticized for succumbing to the influence of Cubism, and this negative reception may have prompted him to move to Paris in early 1912. Mondrian exhibited in the Cubist room at the Indépendants of 1912 and by the late summer of that year was producing works of a pronounced systematic character (208).

Apollinaire's review of the 1913 Indépendants noted that Mondrian's Cubism was 'very abstract' in contrast to the work of Braque and Picasso (which was not on show, of course). Mondrian's development

towards this abstract Cubism has been the topic of numerous studies that clearly demonstrate a conscious effort to refine and clarify the elements of painting. His motivation, according to a letter written in early 1914, was the 'construction of lines and colour combinations on a flat surface with a view to visualizing *general beauty* as consciously as possible'. His *Painting No. 1* (209), shown in the Indépendants that year, is a remarkably structured picture. The grid-like compositional approach, modulated with occasional curves and 'T' shapes, filled in with a narrow range of tones, takes the spatial language of Cubism and turns it into a schematic web in which figure and ground almost disappear. Mondrian's fading structure shadowed Braque and Picasso in their reticence at the edges of the grid, and his meticulous attention to the framing of his works even heightened his consciousness of their existence as real objects in space. Researchers have uncovered the sketchbooks full of naturalistic drawings that formed the basis of his abstractions, including one example featuring the Maggi-Kub advert so amusing to Braque and Picasso (see 158), yet these sources were for him nothing but the external manifestations of the hidden orders Mondrian wished to objectify. Mondrian was in the Netherlands when World War I broke out, so the astonishing unravelling of representation evident in pictures from the *Pier and Ocean* series of 1914–15 (210) took place far from the then widespread return to classical values (see Chapter 9). Yet the para-mechanical pattern in these pictures converts the logic of figure and ground that still motivated even the most abstract of Cubisms into a rationalist harmony of space and incident, horizontal and vertical. The symbolic nature of this pictorial order was not lost on the Dutch theorist, architect and painter Theo van Doesburg (1883–1931) in October 1915:

Spiritually, this work is more important than all the others. It conveys the impression of Peace; the stillness of the soul ... Mondrian is conscious of the fact that a line has acquired a profound significance. A line on its own has almost become a work of art, and one can no longer treat it as casually as one could when art concerned itself with depicting things seen. The white canvas is so solemn. Each extraneous line, each misplaced line, each colour applied without sufficient care and respect, can destroy the whole, that is to say, the spirit.

208
Piet Mondrian,
*Flowering Apple
Tree*,
1912.
Oil on canvas;
78.5 × 107.5 cm,
$30\frac{7}{8} \times 42\frac{3}{8}$ in.
Gemeente-
museum,
The Hague

209
Piet Mondrian,
Painting No. 1,
1914.
Oil on canvas;
120·6 × 101·3 cm,
47½ × 39⅞ in.
Kimbell Art
Museum,
Fort Worth

210
Piet Mondrian,
*Composition 10
in Black and
White, Pier and
Ocean*,
1915.
Oil on canvas;
85 × 108 cm,
33½ × 42½ in.
Kröller-Müller
Museum,
Otterlo

Tatlin was one of the key figures in the creation of the Constructivist idea. He arrived in Paris sometime between 2 and 15 April 1914 and made use of Lipchitz as interpreter on his famous visit to Picasso's studio. He almost certainly also visited Braque, and in those two studios he encountered the Cubist constructions and collages from which his mature career would originate. His relief constructions, 'counter reliefs' and 'corner reliefs' (211) from 1914 to 1917, most of which are now known only through photographs and brilliant reconstructions, form one part of the Russian Constructivist quest for the authentic character of material. The corner reliefs abandoned the Cubist dialogue between real depth and pictorial representation, and focused attention – partly through the choice of metal and glass as well as wood – on the interaction of the materials. The 'materialism' of this art was the counterpart of its existence as 'construction' – but this term took on meanings in the context of the 1917 Russian Revolution that it lacked in commentaries on Tatlin's objects. Before October 1917 the constructive aspect of his work was probably taken as a sign of engineering, a kind of technical or even industrial approach to the art object (perhaps Tatlin found some inspiration for this in the worker outfits beloved of Braque and Picasso). Later, for many, construction appeared to be diametrically opposed to the idea of art. The differing interpretations of the idea of construction that evolved after the Revolution radicalized the tensions, in the first collages, paper sculptures and *papiers collés*, between the imperatives of compositional unity and the desire to integrate found materials, between the autonomy of the art work and the vital heterodoxy of modern life.

Tatlin sought Picasso out, revealing that Cubism was not unknown in Moscow. Far from it, in fact, since as early as 1909 an avant-garde periodical *The Golden Fleece* had organized an exhibition including Braque's *Large Nude* (see 46), and the Abbaye de Créteil luminary Mercereau was its Paris correspondent. More importantly, a private collector in Moscow, Sergei Shchukin, had eagerly acquired major works by Picasso (as well as impressive paintings by Matisse), which he made accessible to some artists, and in early 1912 one of the so-called 'Knave of Diamonds' shows in Moscow featured Gleizes and Léger as well as Picasso.

211
Vladimir Tatlin,
Complex Corner Relief,
1915,
reconstructed
by Martyn
Chalk,
1966–80.
Wood, iron
and wire;
78.5 × 80 ×
70 cm,
30⅞ × 31½ ×
27½ in.
Private
collection

These revelations, and an awareness of other aspects of Parisian modern art, inspired several gifted Russian women to go to Paris, where they soon registered in the most well-known of the new 'academies' of Cubist art that were being established by various Salon Cubists at the time, the Académie de La Palette. Two of these women were profoundly affected by their contact with Cubism, and were able to make their own contributions to it in an impressively short space of time. Nadezhda Udaltsova (1888–1961) later described how she and Liubov Popova (1889–1924) began their careers as Cubists:

In November 1912, I went to Paris with Liubov Popova ... Our intention had been to work with Matisse, but his school was already closed, so we went over to Maurice Denis' studio. But there we ran into a Red Indian with feathers sitting against a red background and we ran away. Someone then told us about La Palette, the studio of Le Fauconnier. We went there and immediately decided that it was what we wanted.

Le Fauconnier, Metzinger, and [Dunoyer de] Segonzac used to visit the studio once a week. Le Fauconnier offered pictorial solutions for the canvas, while Metzinger spoke of Picasso's latest accomplishments. That was still the time of classical Cubism without all the ordinary life – which first appeared in the form of wallpaper and appliqués in the works of Braque.

Le Fauconnier was a ferocious expert, and many a student trembled before the canvas. Both Le Fauconnier and Metzinger responded positively to my works ...

Both Udaltsova and Popova returned to Russia in 1913, having made the acquaintance of Archipenko. Their surviving early Cubism unsurprisingly shows the strong influence of Le Fauconnier and Gleizes, but they also made every effort to find out what the reputed originators of Cubism, Braque and Picasso, were up to, as a letter that Popova wrote to Udaltsova in March 1913 shows:

There's a lot I need to tell you and my head is simply reeling, but at least I can mention the important news. I saw the new Picassos

at Uhde and Kahnweiler's ... They are uncommonly good. I think that they are even more essential than the period of precise form that we all like so much (although that, too, is amazing). *Man with a Guitar* at Uhde's is a very large work. I've never seen anything with such a diversity of planes and formal balance. As for its colours, the marble is green and painted photographically, while the rest consists of well-defined white, black and an entire spectrum of greys.

Such commentary makes clear the degree of intelligence with which Popova and Udaltsova approached the new art. Their own mature efforts with Cubism, exhibited in Russia from 1914 onwards, reveal the same qualities. Udaltsova in particular marshalled complex compositions with great vigour. In the large painting *Restaurant* of 1915 (212) she combined the bold slabs of later 'Synthetic' Cubism with the complicated small facets of Braque and Picasso's pre-1912 works. The white fan-like shape to the left recalls Gris' compositional method of around 1914, while the grapes in the fruit bowl make clear reference to Braque and the comical moustache and cigarette smoke nod in Picasso's direction. A year later Udaltsova simplified her work considerably, producing elemental planar works and constructions. Popova made a number of brilliant relief constructions in 1915 (213), which create a baffling sense of chiaroscuro in photographic reproduction, and a marvellous awareness of texture and depth when seen in the flesh. Both Udaltsova and Popova worked with Tatlin in Moscow on their return from Paris, and their stories of Braque and Picasso may have been the decisive factor in inspiring his own trip the following year.

Another important sign of Parisian awareness among the Russian avant-garde was the two-person movement called Rayonism – the artists were Mikhail Larionov (1881–1964) and Natalia Goncharova (1881–1962), who had visited Paris in 1906 thanks to Diaghilev – which combined Cubist, Orphist and Futurist ideas into brightly coloured abstractions. But as well as Rayonism, there were the achievements of an artist who never visited Paris at all, Kasimir Malevich.

212
**Nadezhda
Udaltsova**,
Restaurant,
1915.
Oil on canvas;
134 × 116 cm,
52³₄ × 45⅝ in.
State Russian
Museum,
St Petersburg

213
Liubov Popova,
*Portrait of a
Lady*,
1915.
Oil on
cardboard
relief;
66·4 × 48·6 cm,
26⅛ × 18⅛ in.
Museum
Ludwig,
Cologne

Malevich created the most significant synthesis of pre-war visual art in Russia – Cubo-Futurism (214). Aside from its obvious combination of the devices of faceting and 'lines of force', this style forged a connection with the avant-garde in Russian poetry. The Russian Futurist poets, including Velimir Khlebnikov, Alexei Kruchenik and Vladimir Mayakovsky, were engaged in a wholesale attack on conventional language. It was they who wished to renovate 'The Word as Such' and to unravel every context that made the word into something less than a kind of pure semantic gold. There was some similarity with Marinetti's poetry based on the idea of 'Words in Freedom', launched in early 1913, but the Russians had more programmatic aims. Malevich's early Cubo-Futurism developed first along similar lines to Léger's 'tubism' and then crucially began to incorporate collage and word elements, often in a vaguely iconoclastic manner (215). This coincided with his work on an opera by Kruchenik – *Victory over the Sun* – and the development of his own thoroughly abstract art form, 'Suprematism'. Tatlin and Malevich rivalled each other for the leadership of the avant-garde in St Petersburg on the occasion of the 0–10 exhibition in December 1915, at which Malevich famously exhibited thirty-five Suprematist abstractions including the extremely minimal *Black Square* (216). Malevich published a pamphlet with *Black Square* on its cover entitled *From Cubism to Futurism to Suprematism*. He described his new work as 'the first step of pure creation in art' as opposed to a mere abstraction from natural forms. Malevich situated himself at the end of a process begun by Cubism, an end that would also form the origin of a new kind of artistic creation.

In the United States Cubism hit public awareness in a grand fashion with the International Exhibition of Modern Art (staged at the Sixty-Ninth Regiment Armory and thenceforth known as the Armory Show) of February–March 1913. Duchamp's *Nude Descending a Staircase No. 2* (see 110) made the headlines in New York, and two years later Duchamp himself arrived, becoming something of a guru for the American avant-garde. Even before the Armory Show, Cubism was not unknown; two American visitors to Paris before the war, Stanton Macdonald-Wright (1890–1973) and Morgan Russell (1886–1953), who exhibited at the Parisian Bernheim-Jeune gallery

214
Kasimir Malevich, *The Knife Grinder*, 1912–13. Oil on canvas; 79.5 × 79.5 cm, 31⅛ × 31⅛ in. Yale University Art Gallery, New Haven

215
Kasimir Malevich, *Composition with the Mona Lisa*, c.1914. Oil and collage on canvas; 62.5 × 49.3 cm, 24⅝ × 19⅜ in. State Russian Museum, St Petersburg

in October–November 1913, established their own variant on Cubism, Futurism and Orphism, which they called Synchromism. The photographer and avant-gardist Alfred Steiglitz lent a bronze cast of Picasso's *Head of Fernande* (see 66) for the Armory show, but he had already been promoting modern art through his '291' gallery. In 1914 he and Marius de Zayas organized a show of recent works by Braque and Picasso, exhibiting them alongside African tribal objects.

Apart from the Synchromists, the two other American artists who produced work most strongly affected by Parisian Cubism before World War I were Max Weber (1881–1961) and Marsden Hartley

Cubism and Twentieth-Century Art

216
0–10 exhibition installation, St Petersburg, 1915

217
Marsden Hartley, *Portrait of a German Officer*, 1914. Oil on canvas; 173·4 × 105·1 cm, 68¹⁄₄ × 41³⁄₈ in. Metropolitan Museum of Art, New York

(1877–1943). Weber was born in Russia but emigrated to the United States at the age of ten. Having had some artistic training there, he set off for Paris in 1905, studying with various artists including Matisse until his return to New York in 1909. Weber became a key figure in the Steiglitz circle, organizing an important show of Douanier Rousseau's work for the 291 gallery, and instigating the first (and large) show of Picasso's work there in 1911. His own paintings of around 1915 were lively Cubist interpretations of the New York urban scene, and his work as a teacher at the same time raised awareness of the technical aspects of Cubism.

Marsden Hartley had two exhibitions at Steiglitz's gallery before he left for Paris in 1912. He spent most of his time in Germany, however, coming into close contact with members of the Blue Rider circle. His Cubist interests were thus filtered and inflected by German Expressionist painting, and by discussions with artists such as Kandinsky and Marc. In Berlin, Hartley became personally involved with a German army officer, Karl von Freyburg. Hartley's well-known *Portrait of a German Officer* (217) was once owned by Steiglitz, who undoubtedly admired its embrace of recent 'Synthetic' Cubism. The mysterious symbols in the painting include banners, flags and the Iron Cross; but also Freyburg's initials (K.v.F.), his age (24), and his regiment number (4). The combination of bold Expressionist colour with sensitive brushwork make this painting a poignant memorial to Hartley's friend, who was killed in action, an early casualty of the war in 1914. Like many other artists who discovered Cubism around this time, Hartley soon abandoned this kind of painting, perhaps feeling that it was inappropriate in the context of the terrible events in Europe with which the next chapter deals.

For countries directly involved in World War I, a chain reaction set off in the Balkans brought dramatic changes affecting all aspects of life – including attitudes towards art. On 28 June 1914 Franz Ferdinand, Archduke of Austria, and his wife were shot by Bosnian students in Sarajevo, capital of Bosnia Herzogovina. The country was then part of the Austro-Hungarian Empire, but the students were demanding its immediate integration into the Kingdom of Serbia. Moves to settle the turbulence in the Balkans by military force against Serbia were now afoot in Austria-Hungary. The Balkan wars of the preceding years had drawn the different European powers into a complex web of alliances, and political and military tensions were running high between them. With Austria-Hungary's declaration of war on 28 July, therefore, the Russians, old allies of the Serbs, mobilized, and Germany responded with an ultimatum calculated to justify its own declaration of war on 1 August. At the same time, long-standing anti-German feeling in France resulted in what the Socialist leader Jean Jaurès called a 'mad panic'. Jaurès was shot dead on 31 July 1914 by a fanatical patriot, and his assassination symbolized the sorry fate of the European socialist parties in the face of the military build-up. Whereas many had earlier sworn to resist war with general strikes and other pacifist gestures, by summer 1914 in-fighting between different left-wing factions and the fear of repression led many to fall into line with the nationalism of the generals, the heads of state and the interests of capitalism. So France, Britain and Turkey all joined in the fray. When war was declared across Europe in August 1914, it was greeted by many as an opportunity for heroism and national pride.

'We will glorify war, the world's only hygiene.' So said Marinetti in his 'Founding and Manifesto of Futurism' of 1909. Militarism, patriotism, machine technology, 'masculine' values and the denigration of women, the romance of aggression: with these mantras the Futurist artists and writers cheered Europe into war with an enthusiasm that today is difficult to comprehend. But Futurism was far from being an

218
Edward
Wadsworth,
*Dazzle-ships in
Drydock at
Liverpool,*
1919.
Oil on canvas;
304·8 ×
243·8 cm,
120 × 96 in.
National
Gallery of
Canada,
Ottawa

aberration: Marinetti's posturing and the bellicose content of Futurist painting were instead more provocative versions of attitudes that were widely shared among the pre-war avant-garde, including many of the Salon Cubists in France, and artists in other European capitals who had absorbed a mix of Futurist and Cubist ideas. The view was widely held that the war was the means to overthrow the old European world, and usher in a more virile and technological era. Nationalism and chauvinism played a fundamental role in this vague utopianism, and many artists fought in the war not because they were unwillingly conscripted but because they subscribed to notions of a heroic defence of the national character. In this atmosphere of excitement at the prospect of a new world order, however, ideas of renewal and regeneration, often linked to the modern machine age, mixed oddly with atavism and an exaltation in the energies of the supposedly 'primitive'. On 29 May 1913 Igor Stravinsky's ballet *The Rite of Spring* scandalized the establishment and even the more cautious avant-gardists with its celebration of a primordial and violent sexuality. Duchamp-Villon wrote of being 'dominated by the music ... [as if] gripped by an iron fist'. His simile shows how the machine was a fluid symbol for both a polished new world and the resurgence of what many imagined to be the most ancient and brutally authentic one.

The machine cult, best expressed by Futurism, combined with Cubist formal innovations in two remarkable sculptures of 1914: *Rock Drill* by Jacob Epstein (1880–1959; 219) and *Great Horse* by Duchamp-Villon. Neither is a Cubist sculpture in the sense explored in Chapter 8, but both works merged mechanical and organic imagery and, in the case of *Rock Drill*, integrated real machinery with traditional materials. Epstein was born in New York but spent several years in Paris before settling in London in 1905. He returned to Paris in January 1913 along with a fellow young radical from London, David Bomberg (1890–1957). It was after this visit that Epstein conceived *Rock Drill*; its menacing combination of a US-designed drill and robot-like operator owed as much to primitivist ideas as to progressive technological ones. Epstein's drawings for *Rock Drill* show that it began as a copulating couple, the male figure thrusting a drill-like penis into an inverted woman beneath him. This male insemination was also, then, an aggressive and dehumanizing act.

Epstein was at this time in the orbit of the philosopher T E Hulme (killed in action in 1917) and the painter and writer Percy Wyndham Lewis (1882–1957), who was the leader of the avant-garde art group in London known as the 'Vorticists'. Vorticism borrowed freely from Cubism and Futurism and, born with the war, was one of the most right-wing avant-garde movements, with Lewis as its brilliant spokesman. His manifesto–journal *Blast* (first issue June 1914) proclaimed:

We are proud, handsome and predatory.
We hunt machines, they are our favourite game.
We invent them and then hunt them down.
This is a great Vorticist age, a great still age of artists.

Lewis advocated an art of hard-edged forms to symbolize his aggressive and anti-liberal political stance. In a typical example

219
Jacob Epstein,
Rock Drill
(original and
incomplete
state),
1913–15.
Photographed
in the artist's
studio

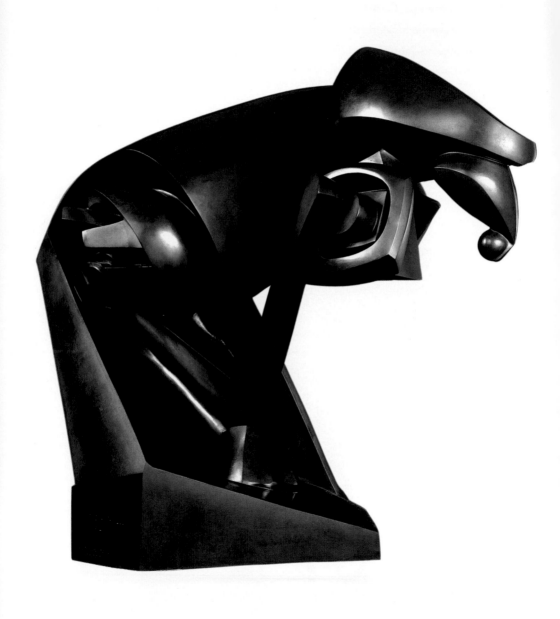

of avant-garde rivalry, Lewis rejected the Futurist interest in states of mind and the emotions in favour of an 'external' approach to human life. He also rejected the organic dynamism of Futurist machine art in favour of a kind of frozen but asymmetrical mechanical world, his 'great still age of artists'. For him, humanity was merely fodder for the artist's powers; in particular he believed that what he perceived as the crude energy of the working classes should be harnessed by creative individuals in order to overthrow the corrupt democracies of Europe. Lewis's 'great Vorticist age' was thus a proto-fascist utopia in which artists would be the dictators, and where the inner lives of individuals were of little concern when compared to a new social order. Meanwhile T E Hulme, drawing upon the ideas of the German thinker Wilhelm Worringer, insisted that the hard-edged mechanical language of Vorticist art emanated from the same terror in the face of uncontrollable nature that Worringer believed was the inspiration behind the geometric tendency in the art of 'primitive' peoples.

220
Raymond
Duchamp-
Villon,
Great Horse,
Enlarged
bronze version,
1966, based on
plaster original,
1914.
Bronze;
150 × 97 ×
153 cm,
59 × 38⅛ ×
60¼ in.
Musée
National d'Art
Moderne,
Centre Georges
Pompidou,
Paris

Vorticist art is all rigid surface pattern, renouncing the organic human form as a mirror of the depths of the soul. In *Rock Drill*, publicly exhibited in March 1915, Epstein created an image of the new man–machine, a robot incapable of emotion, both brutalized and brutalizing, surveying the terrifying new world while penetrating and subjugating woman in the guise of nature. Nestling in the abdomen of the robot is a homunculus or foetus, an ominous sign of the anti-humanity destined to emerge from the marriage of human and machine. Yet when Epstein showed *Rock Drill* again in the summer of 1916 he discarded the drill and the operator's head and limbs, casting just the torso in bronze. These decisions reflected a tempering of his enthusiasm for the machine age under the pressure of the realities of war. The machine age was by then identified above all with the machine gun, and for Epstein fantasies of a manly mechanical utopia had given way to a searching quest for enduring 'human values' in traditionally modelled portraits of English military leaders and wealthy society women.

By contrast Duchamp-Villon's *Great Horse* (220) was the climactic work of his short career. Unlike Epstein, Duchamp-Villon was no

straightforward idolater of machinery; nor were his views influenced so directly by political thinkers such as Hulme and Lewis. Around 1909, for example, he wrote in his journal that:

– Machines can imitate life in quantity but never in quality. Error of photos, phonos, mechanical pianos, etc. ...
– When mechanical means manage completely to imitate nature in movement, the people will begin to feel the need for art.

By November 1913 his position had changed, and he published a text on the Eiffel Tower in the cultural review *Poème et drame* celebrating the achievements of architecture in iron. In effect, the *Great Horse* was a thoroughly abstracted version of that most technically ambitious of sculptural subjects beloved of Roman emperors and Italian Renaissance rulers, the horse with rider. Unlike *Rock Drill*, its modernity rested on its method rather than its subject matter. Duchamp-Villon originally conceived it in fairly naturalistic terms when working on the Cubist House (see 117–121) for the Salon d'Automne of 1912, but the fantastic forms of the final version first appeared in a drawing on the sheet of paper containing his thoughts on *The Rite of Spring*. Conscripted as a medical orderly in 1914 but posted near Paris, Duchamp-Villon was able to continue working on a plaster version of his horse, which he then commenced to double in size in a second (unfinished) plaster version. The largest version – though still smaller than the full equestrian size that Duchamp-Villon planned – was cast in bronze long after his death under the supervision of his brother Marcel in 1966. Duchamp-Villon's *Great Horse* is an astonishing amalgam of mechanical and organic forms, unified in a dynamic twisting of more or less Futurist 'lines of force'. The horse does not have the sinister character of Epstein's *Rock Drill* and lacks its overt primitivism. Yet, especially when cast in bronze as the artist intended, it shares similar alien and anti-humanist characteristics. Writing in October 1915 from the front, Duchamp-Villon mused on the effects of the war:

My situation [as an orderly] giving me a sort of independence, I have been able to see everything worth seeing, get close to and follow all aspects of the war, appreciate the effects of its infernal genius ... Is it the

221
French soldiers advancing on the Western Front, Champagne, 1915

idea of death, always present in the rolling thunder of cannons and the falling shells ... is it the idea of life, assembled in powerful masses ... for whatever reason, synthetic thinking is making great progress here ...

The persistence of a belief that the war would bring about purgation and renewal seems remarkable – at least until it is related to the presence of such beliefs in many wars before and since, and the powerful symbolic association of mass destruction with primal creation. But the romantic notion of 1914 that the mass actions of the war and the almost ritualistic encounter with mechanized human slaughter on a vast scale could result in progress was hard for those directly

involved to sustain (221). Léger (222), who was mobilized soon after 1 August 1914 and saw service as a sapper (a soldier who digs trenches) and then a stretcher-bearer for much of the war, wrote regular letters from the front. On 12 August 1915, in the thick of battle in the Forest of Argonne where 26,000 French troops died in four months of bombardment, he tried to capture the extremity of his situation:

Alongside that, winter weather, two days in blood and mud, two of the hardest days I've ever known, so you need to have your head screwed on if you don't want to lose it. And the finer details? I had to jump into the grave of a guy I'd just buried to avoid a shell. I was lying face down

on top of him. Some footsoldiers went one better, told me they were having something to eat behind a ridge when a shell sent half a human head flying into their food. For two weeks they've been hanging on to a graveyard left behind a month ago with at least 800 dead in it from December. The whole lot ploughed up by shellfire! Those poor devils are living in a horrific charnel house and they have to hold on. They have to hold on in there. It's a terrible war.

The horrific nature of Léger's daily experience is hard to imagine. Just over a year before this, he had been lecturing on modern painting at the Academy Wassilief and, having abandoned the abstract look of his *Contrast of Forms* series of 1913, was painting pictures with identifiable and slightly comic subjects, such as *The Alarm Clock*. Despite his flirtation with Futurist ideas as well as with abstraction in earlier works, Léger told his audience at the Academy Wassilief and readers of *Les Soirées de Paris* that modern subject matter as such was no longer the issue. For Léger the 'modern' was purely a question of the artist's method or approach to painting, but he did believe that everyday subjects (though not necessarily machine-age ones) were the obvious source material for modern painting. In his sketchbooks from the Western Front Léger pursued this idea, capturing the daily life of soldiers in the trenches, modifying rather than abandoning the avant-garde style he had developed by 1914.

There were traumatic effects of loss of life among the avant-garde; among the Futurists Boccioni was the key loss. The gifted sculptor

(and Vorticist) Henri Gaudier-Brezska (1891–1915) was also killed in action, and Duchamp-Villon contracted typhus and died of kidney failure in 1918. Apollinaire died in the flu epidemic of the same year, having been wounded and weakened in the fighting. Braque suffered a serious head injury in 1915, and the poet close to the Delaunays, Cendrars, lost an arm. Nearly all the French artists who had exhibited as Cubists were mobilized, and other nationals in the movement either enlisted for France or saw out some difficult years in Paris or elsewhere. Those remaining in France included Picasso and Gris, citizens of neutral Spain; Lipchitz, who had been declared unfit after a period of military service in 1912; and Laurens, who had had a leg amputated in 1909 as a result of tuberculosis. Morale was inevitably low, and the comfortable financial relationship some had enjoyed with Kahnweiler was abruptly cut off when the rue Vignon gallery and its contents were sequestered by the French state as the property of a German. Luckily for him, Kahnweiler was not in France when the war broke out, and he managed to avoid arrest by staying in Italy and then moving to Switzerland. The absence of dealers such as Kahnweiler and Uhde was an advantage for some, however, and as the prospect of victory in the war increased, much jockeying for position went on among poets, critics, dealers and artists. The clear distinction between Kahnweiler's artists and the Salon Cubists, so important in this book hitherto, was quickly eroded. There was – unsurprisingly – an enormous contrast between the experiences of those artists who had served at the front and those who remained in Paris, and the unreal and uncomfortable situation of the latter was instrumental in the further development of Cubism.

The surge of French nationalism brought about by the war made being a Cubist very difficult. The ludicrous old accusation that Cubism was a foreign, especially German, import began to stick. The art historian Kenneth Silver has brought to light the extreme views that were in circulation at the time. For example, a lecture given by one Tony Tollet in Lyon in 1915, 'On the Influence of the Judeo-German Cartel of Parisian Painting Dealers on French Art', pulled no punches:

223
Gino Severini,
*Cannon in
Action
(Words in
Freedom and
Forms)*,
1914–15.
Oil on canvas;
50 × 60 cm,
19⅝ × 23⅝ in.
Museum
Ludwig,
Cologne

I want to show you by what manoeuvres [the dealers] came to falsify French taste; what influence they exerted to force the specimens with which they had first furnished their offices on our great public collections, and how they had imposed works stamped with German culture – Pointillist, Cubist and Futurist, etc. – on the taste of our snobs ... Everything – music, literature, painting, sculpture, architecture, decorative arts, fashion, everything – suffered the noxious effects of the asphyxiating gases of our enemies.

Magazines founded during the war promulgated a version of racial theory based on the specific soil, climate, culture and history of France. Although such ideas had nineteenth-century origins, and could be expressed in apparently neutral terms, they took on precise meanings. In *La Race*, founded in 1915, one writer argued 'The fatherland is ... a certain form of feeling ... a certain manner of understanding and expressing the truth.' This manner was still to be defined, but in the face of such onslaughts, no one could have felt secure in their avant-gardism, and no artist could have felt comfortable with being labelled a Cubist.

Just as Epstein would neuter the *Rock Drill* and resort to portraiture, so many Parisian avant-gardists themselves called for a 'return to order'. The 'order' in question was the supposedly French classical tradition of painting and sculpture. Some artists appeared to abandon Cubism (and/or Futurism) altogether in a most dramatic fashion. Severini responded to the war, for example, by painting Cubist-cum-Futurist pictures such as *Cannon in Action* (223) that he exhibited in January 1916 in his 'Futurist Plastic Art of War' show at the Galerie Boutet. In the same year, however, he exhibited a very traditional painting of his French wife as a kind of contemporary Madonna (224) and defended his astonishing change of style in the press. Most of the major Cubist artists did not undergo such extreme conversions to classicism and order; instead they each reformed Cubism from within in accordance with the imaginary precepts of French tradition. There was no ready-made consensus as to where Cubism was going, of course. The choices individual artists made – whether to exhibit, who with, and what kind of art to make – often undermined their pre-war friendships with bitterness. At the same time, an artist such as Severini was able

224
Gino Severini,
Motherhood,
1916.
Oil on canvas;
92 × 65 cm,
36¼ × 25⅝ in.
Museo
dell'Accademia
Etrusca di
Cortona

to return to more modernist work, even gravitating towards Cubism at the expense of his Futurist pedigree, as the war progressed.

The most conspicuous case of a change of direction, which had every appearance of a renunciation of pre-war avant-garde values and an adoption of the most ostentatiously 'French' of tastes, was Picasso's. In January 1915 he made a portrait drawing of Max Jacob in the style of Ingres (225), which was followed by a similar portrait of Vollard. Curiously, this gesture by a national from neutral Spain was taken as the clearest signal of an artistic response to the emerging calls for a revival of a specifically French form of artistic expression. By paying homage to Ingres, Picasso seemed to abandon his career as an avant-garde and make contact with academic method and the notionally 'eternal' values of classicism. In particular the use of a hard pencil on high-quality paper, and the fact that only certain parts of the figure were worked up, were clear signs of debt to Ingres' method.

More than this, however, was at stake. Some close friends of the artist sensed more than a hint of mockery or irony in this flagrant return to the most conservative kind of art, but for many Picasso's 'Ingres' drawings would soon become radiant symbols of conversion. In the writings of zealous patriots at this time the classical tradition was defined as synonymous with the Latin inheritance of France and opposed to the barbarian German hordes, demonized as cultural vandals after the bombing of the great French cathedral of Reims in September 1914. The idea of a Latin and Mediterranean cultural alliance against the brutality of Germany gained force when Italy joined the Allied side in April 1915. One of the most important figures in the construction of the avant-garde 'return to order', the poet and playwright Jean Cocteau, commemorated this event on the cover of his magazine *Le Mot* of 15 June 1915 with the phrase 'Dante on our side' (226). As well as the laurels of victory, Dante is shown wearing the Phrygian cap of the French Revolutionary, creating an allegory of the binding of the two peoples in war. Cocteau probably wanted to acknowledge the Italian poet and nationalist Gabriele d'Annunzio's 'Ode to the Latin Resurrection' published in *Le Figaro* the previous year.

225
Pablo Picasso,
Portrait of Max Jacob,
1915.
Pencil on paper.
46·4 × 31·7 cm,
18⅜ × 12½ in.
Private collection

226
Jean Cocteau,
Dante on Our Side.
Cover of
Le Mot,
15 June 1915

Picasso's change of direction was neither as sudden nor as simply dogmatic (or opportunist) as it looked. He had adopted a lyrical classicism in Avignon during the summer of 1914, while his partner Eva Gouel was becoming increasingly ill (she died on 14 December 1915). In the work on linen known as *The Painter and His Model* (227), which remained a well-kept secret from the public, Picasso produced a naturalistic version of a male figure from his recent Cubist paintings, moustached and pensively leaning on his hand in a pose echoing Cézanne's *The Smoker* of 1891–2. Recalling Courbet's major work of 1855, *The Painter's Studio*, the male figure is accompanied by a naked model. Despite these avant-garde precedents, the artistic spirit haunting the painting was clearly that of Ingres. Since Ingres was widely touted as one of the main bearers of the French classical tradition in the nineteenth century, Picasso's pastiche of his style was significant.

Furthermore, Picasso's first attempt at a kind of classicism coincided with the presence in Avignon of his old friend Derain, whose *Girl with a Shawl* (now in the Musée Picasso, Paris) Picasso had just purchased. Derain, of course, had been an early contributor to the development of Cubism but had never fully explored its possibilities, preferring instead to work on a bold modern reinterpretation of French 'Old Masters' and artists from the Byzantine period to the Early Renaissance, who were often called 'primitives' (see Chapter 3). At the time such art was actively celebrated as more authentically Latin and truthful to the spirit of France by such luminaries of the cultural right as the writer and politician Maurice Barrès.

For Picasso in the decade of the war, large-scale and highly finished Cubist works still had a place in his activity, particularly when tragic events occurred. Eva Gouel's illness was marked not only by the naturalism of *The Painter and His Model* but also perhaps by the rather frightening Cubist *Woman in an Armchair* of late 1913. Around the time of Eva's death Picasso produced a menacing and sardonic Cubist *Harlequin* of which he was extremely proud. Not long after, perhaps in a bid to overcome the isolation of his war situation and bereavement, Picasso agreed to work with the solicitous Cocteau, who had been wooing Picasso since the summer. Cocteau was on ambulance duty,

227
Pablo Picasso,
The Painter and His Model,
1914.
Oil and pencil on linen;
58 × 55.9 cm,
22⅞ × 22 in.
Musée Picasso, Paris

but on leave in spring 1916 he began to hatch a plan for a ballet called *Parade*. For this he would persuade the now supposedly classicist Picasso to design the sets and costumes; Léonide Massine (leading dancer of Sergei Diaghilev's famous *Ballets Russes*) to do the choreography; and the composer Erik Satie to write the music. *Parade* is now seen as a turning-point in the history of Cubism, involving as it did the first presentation of Picasso's Cubism to a wide Parisian public. For Picasso *Parade* marked his integration into Parisian bourgeois society, and in early 1917 led to a trip to Rome, one of the great sites of classical antiquity and Mediterranean culture.

Beyond these circumstantial facts, *Parade* was important for the allegory Cocteau set out. A *parade* was a theatrical side-show presented by circus groups on a makeshift stage, in an effort to attract an audience for the main event elsewhere. Cocteau imagined three acts in his *Parade*: a Chinese magician, acrobats and a little American girl. Their brief skits were to be co-ordinated by three 'managers' who, according to his text, 'communicate in their terrible language that the crowd is taking the *parade* for the main show, and coarsely try to make them understand'. Since no audience appears in the ballet, it is obvious that, according to Cocteau, it is the real theatre audience who are mistaking the publicity stunt for the real ballet. In other words, the allegory says that the audience that has accepted modern art has not really understood what it is about at all, and has settled for superficial stunts instead of artistic substance. Cocteau was nevertheless amused by the superficiality of his own scenario, and it is unlikely that the original idea was deliberately polemical.

Picasso designed a set based on a Cubist mix of buildings and a proscenium arch. While the costumes for the three acts were rather attractive fantasies, the managers (228) appeared as bizarre Cubist constructions, hybrids of architecture, sculpture and Synthetic Cubist figuration (compare his 1912 Céret drawings; see 161). The shock of these costumes was enhanced by the lyrical mock-classicism that first greeted the audience, a drop-curtain showing circus characters. Yet it is difficult to situate *Parade* in terms of its politics, and in terms of the avant-garde in 1917, since the ballet was almost deliberately ambiguous

228
Pablo Picasso
and assistants,
New York
Manager
costume for
Parade, 1917

in its message and style. *Parade* was first performed at the Théâtre de Châtelet on 18 May that year, and like many other avant-garde theatrical ventures it got a mixed response from its audience. The event was prefaced by two texts, Apollinaire's programme note '*Parade* and the New Spirit', and Cocteau's 'Before *Parade*', which appeared in a popular newspaper. Apollinaire invented an extraordinarily prophetic term – 'surrealism' – in his text:

This new alliance [between painting and dance] ... has given rise, in *Parade*, to a kind of surrealism, which I consider to be the point of departure for a whole new series of manifestations of the New Spirit that is making itself felt today and that will certainly appeal to our best minds.

Both Apollinaire and Cocteau presented the ballet as in part a manifestation of French or Latin artistic virtues – but Jeffrey Weiss has argued convincingly that this was as much to make the work seem serious (after it had evolved in a more or less uncontrollable manner from Cocteau's point of view) as to pander to the political climate. Most criticism of *Parade* expressed irritation at what was perceived as its unfunny or failed burlesque. Apollinaire created his own play a month later, *Les Mamelles de Tirésias* (*The Breasts of Tiresias*), which he christened (using his new term) a 'surrealist drama'. Supported by the magazine *SIC* (an acronym for Sounds, Ideas, Colours) edited by Pierre Albert-Birot, it received only one performance, on 24 June. Curiously, while many of Apollinaire's friends (including Gris) cruelly condemned this absurdist play, with costumes by a Russian convert to Cubism, Serge Férat, popular critics found its more extreme humour easier to accept than that of the rather puzzling *Parade*. In the newspaper *La France* one critic wrote that 'Guillaume Apollinaire is a traditionalist, and beneath the apparent disorder of his ideas, beneath his noisy, clownish and *guignolesque* fantasy, he demands a return to order.' An avant-garde banquet, with 'Cubist, Futurist and Orphist *hors d'oeuvres*', had been held in Apollinaire's honour at the end of 1916 (the poet had been slowly recuperating from his trepanation earlier in the year). In another act of homage, the poet Reverdy founded the review *Nord-Sud*, named after the metro line linking the two centres of the Parisian

avant-garde so beloved by Apollinaire, Montmartre and Montparnasse. *Nord-Sud* played an important role in the continuation and modification of the Cubist aesthetic until the review's demise in October 1918.

The concerns over Picasso's artistic direction generated by his work on *Parade* only amplified those expressed over his *Portrait of Max Jacob* when it was reproduced in the magazine *L'Élan* (March/April 1916), indicating the high stakes involved in his apparent U-turn for the Parisian avant-garde. (It is worth noting that the Jewish poet was a recent convert to Catholicism.) Amédée Ozenfant's *L'Élan*, like Cocteau's *Le Mot* and Reverdy's *Nord-Sud*, was one of the many journals founded during the war that provide evidence of the shifting values and internal alliances within the avant-garde. *L'Élan* ran from April 1915 to December 1916. Its aim was to provide a forum for artists and intellectuals who had been mobilized as well as those still at home, and thus to provide a link between Paris and the front. The final issue carried an article criticizing Cubism for its lack of rules while praising its 'purism'. This word was made into the name of a movement by Ozenfant in November 1918 when, together with his new Swiss acquaintance, the painter Charles Édouard Jeanneret (better known as an architect by the name Le Corbusier, which he began to use around 1920; 1887–1965), he published a manifesto entitled *Après le cubisme* (*After Cubism*).

Ozenfant and Jeanneret offered a critique of what they considered the undisciplined and merely decorative character of Cubism. Declaring Cubism a thing of the past, they announced the arrival of Purism. They exhibited their Purist paintings in the same month, presenting them as a more rational and universally valid form of expression. In language redolent of academic classicism, they praised order and restraint as eternal values, and stated their wish to purify the imperfections of everyday objects and spaces in accordance with the principles of reason. These values were most fully articulated in the pages of another journal, *L'Esprit nouveau* (*The New Spirit*), the first number of which appeared in October 1920, and which ran until January 1925. Originally edited by the poet Paul Dermée, it was taken over by Ozenfant and Jeanneret, and became the principal organ for the promotion of a return to order or a 'Purist' avant-garde aesthetic. The magazine developed its argument

as much through photographs and graphic design as through texts, and juxtaposed pictures of ancient Greek and Roman artefacts, works by the French 'primitive' Fouquet and the seventeenth-century Le Nain brothers, and recent works by Braque, Gris, Léger and Picasso.

While Picasso apparently began to vacillate dangerously between Cubism and classicism, and to be suspected by some of the mercenary betrayal of Cubism, Gris established himself as one of its leading reformers. Gris was already regarded in 1912 as a more intellectual and coolly systematic Cubist than either Braque or Picasso. At the outbreak of war he was in Collioure in southwest France, and on his return to Paris in October he found that Kahnweiler was in exile, and that his income had dried up. Picasso came to Gris' assistance by introducing him to the dealer Léonce Rosenberg, who signed a contract with Gris on 18 April 1918. Rosenberg was an army auxiliary and later interpreter for the (British) Royal Army Flying Corps headquarters at the Somme, but he maintained an almost weekly correspondence with many of his artists, especially Gris, and periodically returned to Paris on leave.

Rosenberg was the son of an art dealer, and had collected Cubist art sporadically before the war. Kahnweiler's absence presented a golden opportunity: by 1918 he had snapped up the four big names: Braque, Gris, Léger and Picasso (who never signed a contract), and was also showing work by Lipchitz and Laurens. Rosenberg wanted his artists to take him seriously as a critic, but unlike Kahnweiler his knowledge of Cubism was only superficial. His contracts were demanding, and his letters to Gris reveal his unforgiving exploitation of his artists. Gris sold 195 canvases and 53 drawings to Rosenberg (including the rights to their photographic reproduction) over the course of their financial relationship – a level of productivity far in excess of Gris' earlier working methods. The exigencies of Rosenberg's contracts may well account for the decline into repetition sometimes discerned in Gris' work around 1918, in which Pierrot subjects and still-life compositions are recycled with little variation (the American critic Clement Greenberg was later particularly worried by this 'decorative' aspect of Gris' work). More recent research has countered that Gris deliberately focused on certain compositions in an effort to explore the effects of subtle

variation in a series, and that Rosenberg's only real control over Gris'
output was in terms of limiting his production of large canvases.
Indeed, Rosenberg seems to have discouraged his artists from engaging
in commissions that might be construed as 'decorative'. Nevertheless,
Rosenberg rapaciously sought to enlarge his stable of artists throughout
the war, and not only seems to have stimulated excessive production
from Gris but also created new Cubists out of rather mediocre painters
such as the Polish Henri Hayden (1883–1970).

229
Juan Gris,
Woman with
a Mandolin
(after Corot),
1916.
Oil on canvas;
92 × 60 cm,
36¼ × 23⅝ in.
Kunstmuseum,
Basel

If dealer pressure was affecting Gris' production, he was also conscious
of how he was perceived by the French. In May 1916 Gris wrote to
Rosenberg that he had decided not to participate in a forthcoming
exhibition because as a foreigner he was concerned to keep a low public
profile during the war. Having painted a large number of immensely
impressive still lifes from 1913 onwards, Gris' worries about his status
may have prompted a return in September 1916 to figure painting (229)
with a variation on the nineteenth-century idol of French painting,

Camille Corot (1796–1875). He also made a version of one of Cézanne's paintings of *Bathers*, then owned by Matisse. As Christopher Green has shown, the Spaniard's reference to French tradition was a part of his strategy to represent himself as a purveyor of timeless and universal essences in his later Cubism. Gris admired poets, and translated and illustrated the work of his friend the Chilean poet Vincente Huidobro, but he also kept close to Reverdy, who had defended Cubism in the first issue of *Nord-Sud* in 1917, and to Raynal, who would praise him in an article in *L'Esprit nouveau* in February 1921: 'If one is strict about the term beauty, one could say that the work of Gris is beautiful like Virtue.'

As the war came to an end Rosenberg established what was to become the leading gallery for the new, restrained and classicizing version of Cubism, the Galerie de L'Effort Moderne. In December 1919, just after the Armistice, he raised the profile of this combatively named institution with an exhibition of work by Laurens, including recent polychrome reliefs in stone and terracotta. The talented Laurens had flourished among the small group who remained in Paris during the war. Turning away from the rough improvisatory, anti-academic, even anarchic spirit of Braque and Picasso in the pre-war period, he moved towards a more restrained, lyrical approach then identified with the values of classicism. At the same time Ozenfant and Jeanneret mounted their first Purist exhibition at the Galerie Thomas; by 1923 Rosenberg would play host to their last Purist manifestation. In the intervening period he gave solo shows to Braque, Gris, Léger, Metzinger, Severini and others, privileging individual artists over any perceived 'movement'. Yet at the same time, an exhibition such as Severini's in May 1919 gave a powerful demonstration of the degree to which the vocabulary of Cubism continued to inspire original and intelligent work (230). This did not prevent Severini himself from a further shift in artistic loyalties; by 1921 he was painting Commedia dell'arte figures and had published a book entitled *From Cubism to Classicism*.

It was Gris who, in a letter, urged Rosenberg to recruit Braque (as well as Picasso, who hardly needed more publicity):

[Braque and Picasso are] the only two who are indispensable, truly indispensable, for anyone wanting to have a firm grasp of this

movement in painting ... If the one [Picasso] has considerable authority, which needs to be capitalized on, the other needs help to achieve the reputation and authority he deserves for his talent and the significance of his *oeuvre* ...

Braque's adherence to Rosenberg was an important development, especially since the artist modified his pre-war Cubism in favour of a clearer and more refined set of values when he began painting again in early 1917. There is a now famous dictum, quite possibly penned by Reverdy but published in Braque's name in *Nord-Sud* in December of

231
Georges Braque, *Still Life: The Newspaper,* 1919. Oil on canvas; 25⅜ × 31⅞ in. Musée d'Art Moderne, Centre Georges Pompidou, Paris

that year, redolent of the ethos of the 'return to order': 'Nobility comes from contained emotion. I love the rule which corrects emotion.' Yet a painting such as *Still Life: The Newspaper* (231) is rich in sensuous line and colour, hinting at the direction his later work would follow. After his exhibition at Rosenberg's in 1919, Braque's work became less solidly based on his Cubism. The best expressions of his self-conscious retrenchment in French classical values were the pendant paintings known as *Basket-carriers* (or *Canéphores*; 232), which he exhibited in his room of honour in the Salon d'Automne of 1922 along with sixteen other works. This pair of canvases look as if they have been made as

232
Georges
Braque,
Basket-carrier,
1922.
Oil on canvas;
180·5 × 73·5 cm,
71 × 29 in.
Musée
National d'Art
Moderne,
Centre
Georges
Pompidou,
Paris

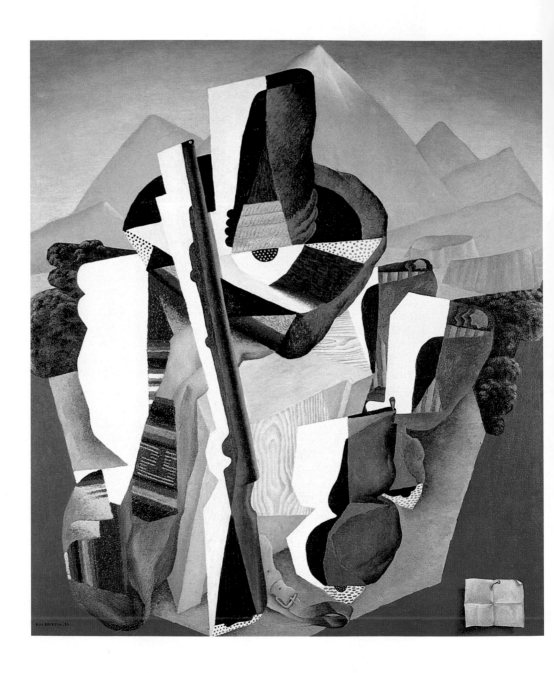

decorations for a specific interior setting, but in fact they were the artist's own invention. They are, however, clearly based on reliefs by the French Renaissance sculptor Jean Goujon (*c.*1510–68) for the Fountain of the Innocents, which still stands today in the Les Halles precinct in Paris.

They were snapped up by Paul Rosenberg, Léonce's brother, who then became Braque's dealer, and were reproduced in *L'Esprit nouveau*. Salmon criticized them as the result of artistic doubt, but one of Cubism's earliest allies, Roger Allard, applauded their rejection of Cubism:

One has to go back to the aestheticians, the abstractors of the quintessence ... to say to them, once and for all, that the work of Georges Braque has nothing to do with that international Cubism, bazaar merchandise of elementary art and intellectual deception.

In 1918 that old intelligent enemy of Cubism, Vauxcelles, developed a running attack on Léonce Rosenberg's promotion of a new Cubism in the work of Laurens, Léger and Lipchitz, *et al*. Vauxcelles declared that 'Integral Cubism' was dead, and that Gris was 'tired of mechanical fabrication' and wanted to go back to painting from nature. He had

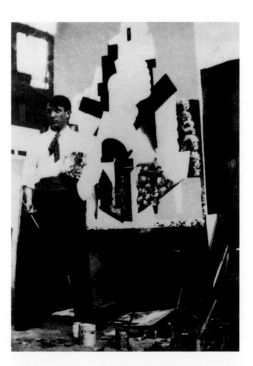

233
Diego Rivera,
*Zapatista
Landscape:
The Guerrilla,*
1915.
Oil on canvas;
144 × 123 cm,
56⅝ × 48⅜ in.
Museo
Nacional
d'Arte,
Mexico City

234
Pablo Picasso,
Self-portrait
with *Man
Leaning on a
Table* in
progress,
1915.
Gelatin silver
print;
6·5 × 4·7 cm,
2½ × 1⅞ in.
Musée
Picasso, Paris

been inspired in this attack by the recent work and antics of Mexican Diego Rivera (1886–1957) and his friend André Lhote. Rivera is now best known for his impressive work as a political muralist in Mexico and the United States after 1930. He first visited Paris in 1909, but did not become a disciple of Cubism until late 1912. Most of Rivera's Cubist work dates from between 1913 and 1917, during which time he made over two hundred paintings. By 1914 he was exhibiting alongside the major Salon Cubists and confidently mixing Cubist and Futurist ideas in brightly coloured figure compositions.

In 1915 Rivera turned for his subject matter to the Mexican Revolution, which began in November 1910 when the liberal Francisco Madero led a revolt against the repressive ruler Porfirio Díaz. Rivera produced a series of works referring to Francesco Pancho Villa and Emiliano Zapata, leaders of the insurgency in southern Mexico. One of these works (233) was the cause of the first of several amusing feuds between Rivera and various fellow Cubists, since he accused Picasso of plagiarizing it. Picasso was working on a large *Man Leaning on a Table*, originally intended to be an outdoor scene, and he does appear to have filched Rivera's scumbled greenery, at least as far as can be discerned from a studio photograph of Picasso's work in its earlier state (234). According to one story this accusation led many artists to begin hiding their work from Picasso, but it also gave Rivera notoriety. Rivera kept up his reputation as a tough character when, in April 1917, he took umbrage at being criticized in Pierre Reverdy's essay 'On Cubism' in *Nord-Sud*. Léonce Rosenberg, who was at the time Rivera's dealer, organized a dinner after which Rivera and Reverdy had a punch-up. Rivera's behaviour appalled Braque, Gris and others, while Reverdy vilified Rivera as 'a mercenary greaseball'. By 1918, together with Lhote, in whose house the brawl had taken place, Rivera was seen as an opponent of the Cubists, and he became a confidante of reactionary critics Vauxcelles and Elie Faure.

235
André Lhote,
Rugby,
1917.
Oil on canvas;
127.5 × 132.5 cm,
50¼ × 52⅛ in.
Musée
National d'Art
Moderne,
Centre Georges
Pompidou,
Paris

Lhote had been a minor participant in Salon Cubism in his earlier career, but had become friendly with Gris and Severini in 1916. His work in the late teens showed continued enthusiasm for aspects of Salon Cubism, but in general he applied coloured faceting in a fairly

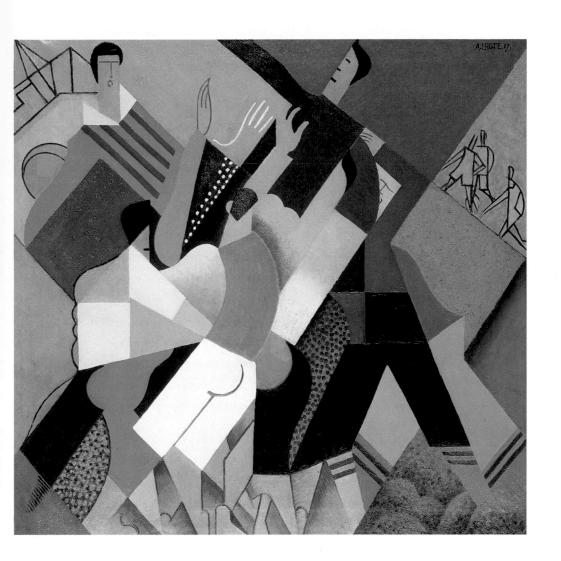

pedestrian manner to naturalistic subjects, to occasionally comic effect (235). By 1918 naturalism, especially in relation to the nude and portraiture, seemed to dominate over the Cubist elements of his style. It was on this basis that Vauxcelles not unreasonably took Lhote for another defector from Cubism. Although Vauxcelles made Lhote and Rivera staunch examples of 'return to order' classicism, such pronouncements and public conflicts probably helped Rosenberg in his own crusade to represent Cubism as a vital and challenging art form, rather than a tired hangover from the pre-war period, to his progressively minded buying public.

Vauxcelles was wrong to pronounce Cubism dead: the vicissitudes of Cubism during the war guaranteed its survival, and made it into an essential part of the artistic vocabulary of the 'School of Paris' between the two world wars. Furthermore, in 1920 both the Salon de la Section d'Or and the Salon des Indépendants were revived. The Indépendants included a substantial number of works in the Cubist mode associated with Rosenberg's L'Effort Moderne exhibitions, and Gleizes (recently returned from self-imposed exile) organized a similar showing for Cubism in the Section d'Or. Cubism was no longer the avant-garde movement of the pre-war period – all its artists were relatively senior figures with established careers who were no longer deliberately seeking to challenge the public – but, as a style at least, it remained a recognizable force in the post-war artistic landscape, promoting the 'purity' (the independence from naturalism) of painting and sculpture.

There is one further deeply ironic facet to the story of Cubism and the Great War. According to Gertrude Stein, on seeing some camouflaged vehicles on the way to the front, Picasso remarked 'We did that.' This was more true than it sounds. André Mare, the artist behind the Cubist House in 1912 (see Chapter 5), became a leading camouflage artist for the French Army along with many other former moderns. It has been discovered that the camouflage units named their regimental mascots 'Picasso' and 'Matisse'! Even the British Navy made the most of its home-grown Vorticist talent in the guise of Edward Wadsworth (1889–1949), who designed the stunningly beautiful camouflage patterns for vessels that he called 'Dazzle-ships' (see 218).

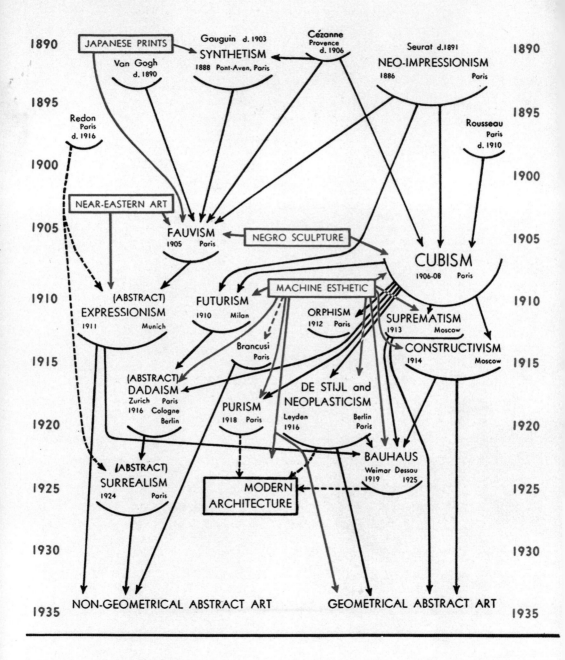

1890 JAPANESE PRINTS Gauguin d. 1903 Cézanne Seurat d.1891 1890
 SYNTHETISM Provence NEO-IMPRESSIONISM
 Van Gogh 1888 Pont-Aven, Paris d. 1906 1886 Paris

1895 Rousseau 1895
 Paris
 Redon d. 1910
 Paris
1900 d. 1916 1900

 NEAR-EASTERN ART

1905 FAUVISM NEGRO SCULPTURE CUBISM 1905
 1905 Paris 1906-08 Paris

1910 (ABSTRACT) FUTURISM MACHINE ESTHETIC 1910
 EXPRESSIONISM 1910 Milan ORPHISM SUPREMATISM
 1911 Munich 1912 Paris 1913 Moscow
 Brancusi
 Paris CONSTRUCTIVISM
1915 (ABSTRACT) 1914 Moscow 1915
 DADAISM DE STIJL and
 Zurich Paris PURISM NEOPLASTICISM
 1916 Cologne 1918 Paris Leyden Berlin
 Berlin 1916 Paris
1920 1920

 (ABSTRACT) BAUHAUS
1925 SURREALISM MODERN Weimar Dessau 1925
 1924 Paris ARCHITECTURE 1919 1925

1930 1930

 NON-GEOMETRICAL ABSTRACT ART GEOMETRICAL ABSTRACT ART
1935 1935

The challenge of charting the legacy of Cubism is neatly summed
up in John Richardson's phrase: 'No question about it, Cubism
engendered every modern movement.' This is not simply a matter
of Cubism's chronological priority. In 1936 Alfred H Barr Jr., the first
director of the Museum of Modern Art in New York, designed a chart
for the jacket of his extraordinary exhibition catalogue *Cubism and
Abstract Art*, which reserved its largest lettering for 'Cubism', as if
to suggest that Cubist achievements not only engendered but in
some sense outweighed those of the later 'isms' (236). Both book
and exhibition were conceived in an effort to explain modern art to a
supposedly hostile and naïve American public, and Barr's pedagogic
framework transformed modern art from a controversial and
confrontational avant-gardism into a 'historic' phenomenon rather
like Renaissance or Baroque art. Barr interpreted Cubism as a
stepping-stone on the road to abstract art, making use of a simple
contrast between realism and abstraction, which neither captured
the diversity of Cubism nor, as his contemporary adversary Meyer
Schapiro pointed out, the nature of representation in general. The
chart passed from disparate 'Post-Impressionist' origins in the 1890s
to the complex middle period from 1905 to the early 1920s to the
clarity of the two complementary tendencies in abstract art of 1935.
The confusion and technical diversity of the high or middle period
in the central section of the diagram are legitimated by the elegance
of the outcome. The directional arrows give to the notion of artistic
'influence' a sense of inevitability.

236
Alfred H Barr Jr.,
Chart for the
jacket of the
exhibition
catalogue
*Cubism and
Abstract Art*,
Museum of
Modern Art,
New York, 1936

The diagram assures the reader that modern art's mixed parentage,
painful gestation and wild adolescence have all worked out for a
mature best. In one fell swoop, Cubism has become a thing of the
past. Barr was a brilliant scholar and told his story through the work of
different artists as if it had just that kind of inexorable logic expressed
in his diagram. But such trajectories are made out of the messy lives

and circumstances of many individuals, and through collective projects that are full of false starts and breakdowns of confidence. Furthermore, the processes whereby Cubism impacted on later movements such as De Stijl or Constructivism are much more two-way than the arrows in the diagram suggest: if Cubism 'influenced' Constructivism, so Constructivism made something new out of Cubism. Today, in other words, Cubism looks different – looks richer and more comprehensive than it did in 1914 – as a result of its recasting and expansion by painters, sculptors, photographers, architects, musicians, poets, film-makers, graphic and fashion designers, as well as through its revision in countless books and exhibitions. It might be said that, insofar as Cubism is still vital to us, it remains part of our visual language and power of self-expression. Insofar as Cubism belongs to art history, it has ceased to function in this way and has become something one can reflect on and make sense of from another historical position. The myriad legacies of Cubism thus comprise an important expression of the achievements and disappointments of modernism in the twentieth century.

It is testimony to Barr's brilliance that the 'movements' that comprise the lower part of his diagram will all be addressed in this chapter, and that 'Modern Architecture' takes a central role in an exploration of the legacy of Cubism. The fascinating twists and turns of modernism in Europe between the wars were driven by the interrogation of pre-war Cubism (as well as Futurism and Expressionism, as Barr makes clear). But they were also shaped by the imperatives and pressures created by the rise of state communism and fascism. The public utopianism of the Salon de la Section d'Or in 1912, or the private utopian language of Braque and Picasso in 1911, looked more compelling to some and more dangerous to others in this context. Much of this chapter is concerned with the inter-war tension between the continued appeal for artists of formal and technical aspects of Cubism, and the desire to translate them into new artistic utopias, or even base social utopias on them.

In Chapter 8 the embrace of Cubism in Germany before World War I was situated in relation to the Expressionism of the Blue Rider artists. The theoretical work of the Expressionist circle, including that of

critics such as Adolphe Behne, together with the catholic mix of art available in reproduction and on show in Germany, meant that the terms 'Cubism', 'Expressionism' and 'Futurism' became effectively interchangeable into the mid-1920s. The romantic utopianism of the Blue Rider group had a direct impact on architecture even before the war. The idea of building as a symbol of spiritual renewal found favour with the German architect Bruno Taut (1880–1938), who designed a famous glass pavilion for the Cologne Werkbund in 1914, and with Walter Gropius (1883–1969) who, with his colleague Adolphe Meyer (1881–1929), had already contributed an astonishingly modern-looking factory building to the same event. The possibility of a humanist renewal of German society appeared even more urgent to some members of the avant-garde after the debacle of the war and the disgrace of the Treaty of Versailles of 1919, which brought the conflict to an end and imposed punitive reparation payments on Germany with the aim of crushing its militarism. It is, of course, a part of the tragedy of German history in the inter-war period that this yearning

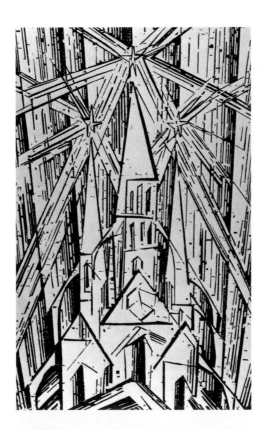

**237
Lyonel
Feininger**,
Bauhaus
manifesto,
1919.
Woodcut

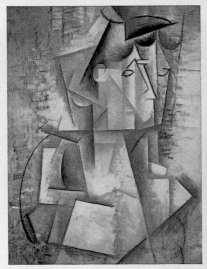

298. PICASSO, "L'Arlésienne," 1911–12. *Oil.* "*In the head may be seen the cubist device of simultaneity — showing two aspects of a single object at the same time, in this case the profile and the full face. The transparency of overlapping planes is also characteristic*" (Catalogue of the Picasso Exhibition, Museum of Modern Art, New York, 1939, p. 77).

490

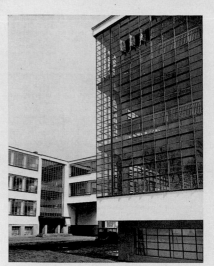

299. WALTER GROPIUS, The Bauhaus, Dessau, 1926. *Corner of the workshop wing.* *In this case it is the interior and the exterior of a building which are presented simultaneously. The extensive transparent areas, by dematerializing the corners, permit the hovering relations of planes and the kind of "overlapping" which appears in contemporary painting.*

491

for renewal would be hijacked as a key element of the fascist ideological programme in the 1930s.

Among the avant-garde, however, it was left-wing politics that captured the imagination of a new generation. Gropius joined Behne in forming the utopian Workers' Council for Art in 1919, which led directly to the establishment of the famous Bauhaus art school in Weimar in the same year. One of Behne's favourite newer Cubists, the German–American Feininger, made a woodcut for the Bauhaus manifesto (237) representing a mystic cathedral with Cubist faceting that was no longer a coolly rational or even mildly ironic exploration of representation, but expressed the idea in Gropius' manifesto:

> Let us together desire, conceive and create the new building of the future, which will combine everything – architecture and sculpture and painting – in a single form which will one day rise towards the heavens from the hand of a million workers as the crystalline symbol of a new and coming faith.

238
Spread from
Siegfried
Giedion's
*Space,
Time and
Architecture:
The Growth
of a New
Tradition*, 1941

Notwithstanding this extraordinary rhetoric, the Bauhaus did not dwell for long in the realms of nostalgia for medieval guilds, and established one of the most industrially oriented art training programmes in Europe. Its teaching was in many respects dependent on ideas concerning form and materials derived directly from Cubism, particularly after an early visit from Dutch artist and theorist Theo van Doesburg, who had been speculating on an architecture based on Cubism since 1916.

The story of the Bauhaus is beyond the scope of this book, but it is the Bauhaus building in Dessau, designed by Gropius and Meyer in 1926, as interpreted in photographs by Lucia Moholy (1894–1989), which has had a crucial role in the notion of Cubism's contribution to modern architecture, or the so-called 'International style'. Moholy's photograph was reproduced opposite Picasso's 1912 *L'Arlesienne* in one of the most influential books on modern architecture, Siegfried Giedion's *Space, Time and Architecture: The Growth of a New Tradition* of 1941 (238). This book took up the increasingly commonplace idea that Cubism had in some fundamental sense been, as the Hungarian artist and photographer Laszló Moholy-Nagy

(1895–1946) put it, 'like Einstein in physics'. Giedion's term 'space–time' referred to the new subjective experience of the world originating in Cubism's transparency, simultaneity and intersecting planes. Giedion chose *L'Arlesienne* for its combination of frontal and profile views of a face; to support this reading he cited Alfred H Barr Jr. from a ground-breaking 1939 Picasso exhibition catalogue. He then glossed the comparison with the Bauhaus building:

Two major endeavours of modern architecture are fulfilled here, not as unconscious outgrowths of advances in engineering but as the conscious realization of an artist's intent; there is the hovering, vertical grouping of planes which satisfies our feeling of relational space, and there is the extensive transparency that permits interior and exterior to be seen simultaneously, *en face* and *en profil*, like Picasso's *L'Arlesienne* of 1911–1912: variety of levels of reference, or of points of reference, and simultaneity – the conception of space–time, in short.

A similar celebration of transparency, which took the reader on a historical trajectory from Braque's *papiers collés* to the Dessau Bauhaus, was suggested in another double-page spread in the book. Here the 'international' nature of post-war modernism was on display, as Cubism passed from France (Braque) to Holland (Mondrian) to Russia (Malevich) to Germany (Gropius). Leaving events in Holland and Russia to one side for the moment, it is worth stressing that this powerful formal interpretation of Cubism's influence on architecture, which works so successfully in book form, was maintained in several subsequent landmark publications. Henry Russell Hitchcock followed the pattern in *Painting toward Architecture* (1948), and Reyner Banham, associate of the 1950s Independent Group in London, published the brilliant *Theory and Design in the First Machine Age* in 1960. These books argued for a substantial connection between the supposed transparency of Cubism and the spatial openness of modernism in architecture. All stressed the subject's experience of moving through such buildings as the equivalent of what Metzinger had first called 'mobile perspective' in 1910.

The Bauhaus counted among its staff Wassily Kandinsky and Paul Klee, and pioneered the integrated study of problems of abstract form

and practical design. There are good reasons to accept Giedion's reading of Gropius' architecture, then, but only if we also recognize the practical and socially utopian aspects of it at the same time. The Bauhaus developed some of the most socially progressive housing projects of the twentieth century under the leadership of Gropius and the then Marxist Swiss architect Hannes Meyer (1889–1954) in the late 1920s, but it was the embrace of this politically informed architecture by the student body, as much as Bauhaus promotion of a Cubist influenced modern art, that led to its final closure by the Nazis in 1933.

A very different version of utopia emerged in the post-war work of Piet Mondrian, and in the architecture and design of his Dutch followers. Most important among these was Van Doesburg, whose importance as a promoter and interpreter of Mondrian's new art was surpassed by his own contribution as an artist and leader of the European avant-garde in the 1920s. Van Doesburg became a close friend of Mondrian as a result of his favourable reviews of the latter's early shows (see Chapter 8), and the two collaborated on one of the most important post-war art publications in Europe, and organ of their new movement, *De Stijl*. Mondrian was developing as a theorist as well as a painter, and the first issue of *De Stijl* in November 1917 included the first instalment of his treatise 'New Plastic in Painting'. In 1918–19 he painted a number of works featuring regular grid patterns. But in line with the developing dialectic of his writing he abandoned this rigid mechanism on his return to Paris in June 1919 – where he was soon taken up by Léonce Rosenberg for the Galerie de L'Effort Moderne – in favour of compositions in which balance would be achieved not through a mathematical rationale but through the integration of appropriate fields of primary colours (239). It was this kind of 'Neo-Plastic painting' that Mondrian settled on for some time, and which he considered an embodiment not merely of artistic principles but of the very principles of human social activity.

Mondrian thought of his paintings as the models for a society based on the idea of 'equivalent opposition' and believed they represented a conscious universal vision that would expand at first into architecture. His architectural vision never developed much beyond the serene

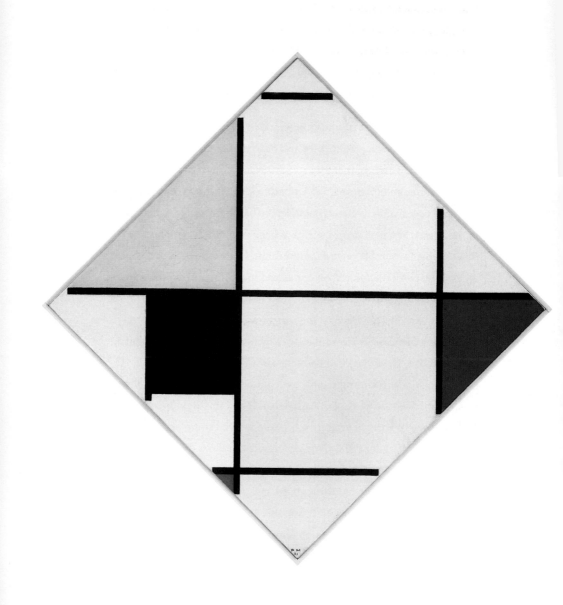

confines of his Paris studio in the 1920s (240), but in the Netherlands members of the De Stijl movement – Robert van 't Hoff (1887–1979), J J P Oud (1890–1963), Gerrit Rietveld (1888–1964) and Van Doesburg – created exhilarating coloured furniture in wood (241) and buildings in concrete, steel and glass that in many respects interpreted the geometries Mondrian had extracted from his contact with Cubism. At the same time, however, neither Mondrian's utopianism nor Rietveld's design vision were simply contained within Salon Cubism's pre-war utopias, nor Braque and Picasso's ironic universal language. Furthermore, in the Netherlands, there was already a rift among the De Stijl architects in 1921, with Van Doesburg arguing for a theory of

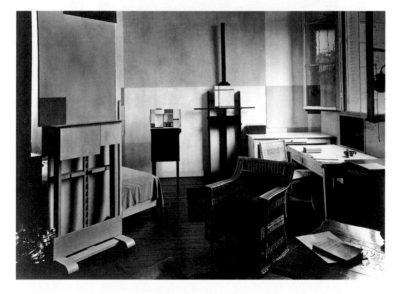

239
Piet Mondrian,
Lozenge Composition with Yellow, Black, Blue, Red and Grey,
1921.
Oil on canvas;
60×60 cm,
23×23 in.
The Art Institute of Chigaco

240
Paul Delbo,
Studio of Piet Mondrian,
rue de Départ,
Paris, 1926

architecture based on colour and Oud for one based on function and construction, even though all agreed that Cubism was the starting point for their new 'elementarism'.

During the early 1920s De Stijl was closely affiliated with Constructivism. From the achievements of Tatlin and Malevich (see Chapter 8) emerged Russian Constructivist artists, such as Aleksandr Rodchenko (1891–1956), who set about turning their artistic ideas into the new language of social transformation. The First Working Group of Constructivists (the term was used in this specific sense only in March 1921) considered their work to be outside the realm of art and instead to

embody 'communistic expression of material structures'. The members of the Obmokhu (Society of Young Artists) were engaging in laboratory research for the Revolution, discovering 'practical ways of working and using new materials' according to Vladimir Stenberg. The pursuit of material structures and the resistance to artistic convention largely originated in the Cubism that Tatlin and Malevich had absorbed one way or another. But the Russians reinterpreted these aspects of Cubism in a sustained and highly theorized manner.

In particular, there are clear parallels between Constructivist pronouncements and the treatment of Cubism by the school of literary analysis known as Russian Formalism. One of the creators of Russian Formalism, Roman Jakobson, often compared his own structural understanding of language to the nature of Cubist paintings that he had encountered in Shchukin's collection. Another leading Formalist, Viktor Shklovsky, drew attention to the distancing or estranging devices of art that allow one to grasp representation together with

241
Gerrit Rietveld,
'Red–Blue'
chair,
1923.
Plywood;
h.87 cm,
34¼ in.
Stedelijk
Museum,
Amsterdam

242
Installation in
the third
Obmokhu
exhibition,
Moscow, 1921

its material texture or *Faktura*. These kinds of critical practice, and Constructivist art, were of course difficult to maintain in the climate of material need and political struggle that characterized the early 1920s in Russia. The tension between Constructivism's 'materialist research' and its artistic forms and social values were evident enough. There are some marvellous photographs of Obmokhu exhibitions that show how the non-art objects made by the early Constructivists were still displayed as if they were works of art (242). This artistic quality was one factor that encouraged interest in photography and film as new avant-garde media — if apparently abstract art and sculpture were suspiciously bourgeois in nature, photomontage posters had instant propagandist appeal. (In this spirit 'Constructivism' was quickly supplanted by the term 'Productivism'.) Sergei Eisenstein's innovative feature films such as *Battleship Potemkin* (1925) were marvellously and directly proletarian, but were created using a new cinematic language of montage based in part on Cubist collage.

The Russian Constructivists thought up many dramatic architectural projects for such structures as propaganda kiosks and radio masts.

The most famous unbuilt project is Tatlin's *Monument to the Third International* of 1919–20, a vast and complex symbolic structure to rival the Eiffel Tower. The only Constructivist building to be seen outside the Soviet Union was a temporary pavilion for the 1925 Exposition des Arts Décoratifs et Industriels Modernes in Paris (the exhibition from which the term Art Deco derives) by Konstantin Melnikov (1890–1974). Rodchenko designed a reading room for a workers' club in the Soviet Pavilion, and his use of simple materials and a utilitarian approach deliberately contrasted with the luxury of some western European designs on display elsewhere in the Exposition. The closest thing to Melnikov's building was perhaps Le Corbusier's Pavillon de L'Esprit Nouveau, whose elegant white spaces housed not information for workers but the post-war work of Léger, as well as examples of Le Corbusier's Purist paintings. The pavilion was conceived as a model of a cellular housing unit that could be repeated to form large housing blocks. This cellular or modular approach to accommodation was part of Le Corbusier's

wider utopian–capitalist vision for smoothly functioning machine cities, but its basic notion of the repetition of cells has recently been connected by art historian Paul Overy with Mondrian's monastic studio and a purified version of the grid implicit in Cubist painting.

Le Corbusier had already in 1923 designed two luxury studio-cum-cell semi-detached houses, known collectively as the Villa La Roche-Jeanneret (243). Raoul La Roche was a Swiss banker and collector of Cubism (he later bequeathed his important collection to the Kunstmuseum, Basel), and he commissioned the house in part as a gallery to promote the new art. Select visitors included Léger and Giedion, but there was such interest that La Roche began opening his house to the public on Tuesdays and Fridays. Le Corbusier wrote a description of his building:

You enter: the architectural *spectacle* at once offers itself to the *gaze*; you follow an itinerary and the views develop with great variety; you play with the flood of light illuminating the wall or creating twilights. Large windows open up views on the exterior where you find again the architectural unity. In the interior the first attempts at polychromy ... allow the '*architectural* camouflage', that is, the affirmation of certain volumes or the contrary, their effacement.

This interpretation of the villa as spectacle is in many ways made possible by the visual delirium of Braque and Picasso's Cubism. It challenges the sense of a viewing position: Le Corbusier interprets his building literally through a 'mobile perspective' in which its order and unity emerge through a play of interior and exterior, shadow and light. A similarly phenomenological approach to modern architecture is evident in the house designed by Robert Mallet-Stevens (1886–1945) in 1922 for the collectors Charles and Marie-Laure de Noailles, and in the garden of the same villa designed by Gabriel Guévrékian (1900–70; 244). Mallet-Stevens had been impressed by Duchamp-Villon's Cubist House in 1912 (see 117–120), but his villa for the Noailles (his first commission) shunned surface faceting in favour of a spatial drama closer to Le Corbusier. Guévrékian, often referred to at the time as a 'Cubist' garden designer, created a geometric chessboard pattern in masonry with tilting tulip beds in a triangular plot. In 1929 *Ideal Home*

magazine described it as a 'flat garden for one point of view and a sloping garden for the other'. Once again, a feeling of shifting perspectives, and even disorientation, was conjured by this 'Cubist' architecture; in 1928 the Surrealist Man Ray (1890–1977) made a film at the villa in which the characters ask themselves 'the human question: where are we?'. There is evidently some similarity here with Le Corbusier's phenomenological approach to his own buildings, as if modern architecture in a post-Cubist idiom is necessarily experiential.

Recently this kind of approach to architecture, combined as it was with a vehement machine aesthetic and admiration for the products of modern industry, has been criticized for its well-heeled masculine

244
Gabriel
Guévrékian,
Garden of Villa
Noailles,
Hyères, 1925–7

245
Sonia
Delaunay in
'Simultaneous'
costume.
From
Montjoie!, 1914

consumer bias. Le Corbusier's obsession with streamlined luxury products of utility such as Hermès leather bags and Church's shoes is simply the consumerist version of the tasteful viewer posited by Purist paintings. In some ways this was a rather passive way of closing the gap between avant-garde art and social life, the opposite of that proposed in the Constructivist movement. Even within Cubism and its immediate circle, there was never such a comfortable acceptance of the styling of consumer objects, but rather a desire to transform the given world. Sonia Delaunay's famous designs for Simultaneist couture (245), lampshades and book-bindings, which were reproduced in *Montjoie!* in April 1914 in an article on 'Modern Decorative Art',

were far more radical than anything then on offer from the department stores. Despite the interest of the leading couturier Paul Poiret in Sonia Delaunay's work at the time, the 1999 exhibition 'Cubism and Fashion' in Washington could only document the adoption of certain 'Cubist' geometric patterns and more free-flowing garments by the mainstream designers. Even Poiret, well-connected to the avant-garde, knew he had to dilute Sonia Delaunay's notions for the purposes of the market, as indeed did Delaunay herself.

In *Après le Cubisme* and in issues of *L'Esprit nouveau* Ozenfant and Le Corbusier articulated their new masculine 'machine aesthetic', the purity of which overcame what they regarded as the old world confusions of pre-war Cubism. The idea of a 'machine aesthetic' also fascinated Léger in this period, and he wrote an essay on the subject in 1921. His nude figure composition *Le Grand Déjeuner* (now in the Museum of Modern Art, New York) was singled out for praise in *L'Esprit nouveau* by Ozenfant. But Léger's real achievement in this direction was his landmark film *Ballet Mécanique* (*Mechanical Ballet*) of 1925, probably the closest thing there is to Cubist cinema. Despite the historical coincidence of Cubism and cinema there are no Cubist films from before World War I. On the edges of the movement, Robert Delaunay worked with film director Abel Gance on a project called the *Luminous Organ* in 1913, which would consist of a large screen comprising of different coloured light-bulbs that could be 'played' on a keyboard. Neither this experiment nor Baranoff-Rossiné's similar efforts ever came to fruition. The Russian Cubist Léopold Survage (1879–1969) described another such project called *Coloured Rhythm* in the last issue of *Les Soirées de Paris* (July–August 1914), which would use the technique of stop-frame animation. For his three-minute abstract film Survage would have needed about two and half thousand gouache paintings. The central idea was to set form in motion (here is the aesthetic version of Le Corbusier's experiential architecture):

A static abstract form is still not expressive enough ... Only when set in motion, undergoing change, entering into relations with other forms, is it able to evoke feeling ... it is in the way that visual rhythm is analogous to sound rhythm in music.

The idea of filming paintings reappeared in a much more literal manner in 1918 when, as Étienne-Alain Hubert demonstrated in 1994, it is almost certain that Picasso's *Les Demoiselles d'Avignon* (see 37) was propped in the street and presented to the camera by Apollinaire. Perhaps one day this film will resurface, but even then it would probably not merit the name 'Cubist Cinema'. Nor perhaps would Survage's project, if realized, since its colour abstraction would remove it from Cubism's engagement with the structure and nature of pictorial representation, and suggest a closer kinship with the Delaunays' Orphism. Léger's 1925 film (made in collaboration with American Dudley Murphy) was his first attempt at direction, but he had been involved as a designer in a science fiction film, *The Inhuman*, directed by Marcel L'Herbier in 1923. For *Ballet Mécanique* Léger abandoned narrative conventions and made a time-based collage of abstract shapes, fragments of real objects, prismatic shots, moving body parts and machinery. These are presented in contrasting temporal modes – from rapid-fire cuts to steady rhythm to slow revolutions. The whole is a hymn to the energies of the modern machine age, but articulated (unlike for example Charles Sheeler and Paul Strand's hymn to New York, *Manhatta* of 1922) through the formal devices of film and with a strong emphasis on human perception and action.

The importance of photomontage in Russian Constructivism has already been mentioned. Photomontage, the collaging of photographs, was an extension of Cubist collage that had a tremendously vital existence in Germany between the wars. The authority of the photograph as a document of reality made photomontage both a powerful political weapon, as in the work of John Heartfield (Helmut Herzfelde; 1891–1968), and a potent means for the subversion of everyday experience through bizarre juxtapositions (as in the work of Hannah Höch; 1889–1978). Photomontage is generally associated with Dada, an avant-garde movement whose members both abhorred Parisian Cubism and adopted and elaborated many of its notions. The Franco-German artist Hans Arp (1887–1966), for example, made abstract collages in Zurich during 1916 based on the random fall of scraps of paper, rather than on their careful placement on the page; this was collage 'according to the laws of chance'.

But perhaps the most sustained engagement with collage was that of Kurt Schwitters (1887–1948), the Hanover-based painter–poet who created his own version of Dada, Merz. Schwitters' collages (246) incorporated personal fragments as well as the usual newspapers and prints. His incredible sense of the fascination and expressive power of ephemera extended to the creation of Merzbau ('Merzbuilding'), studio interiors about as far removed as possible from the geometric order of Mondrian's cell in Paris (see 240). Another anti-rational version of collage exploiting its unintelligible juxtapositions emerged through the early work of Max Ernst (1891–1976). Collage in Surrealism, the movement that emerged out of Dada in Paris and was launched in André Breton's *First Surrealist Manifesto* of 1924, became the means both to capture the workings of the unconscious and to circumvent notions of artistic intention associated with 'bourgeois morality'.

In general, however, and surprisingly, it took some time for the visual arts to find a place in Surrealism, and the reasons for this go back to its origins in the literary experiments of Dada and the primacy given to poetry by Breton in his manifesto. At Dada's Cabaret Voltaire in Zurich in 1916, Hugo Ball had recited strange nonsense poems dressed in a bizarre costume. Such performances were at once a challenge to the perceived corruption of language and value in Western civilization, and an attempt to found a new language on the basis of a poetics of mere sounds (there are parallels with Russian Constructivism here). Schwitters' famous poem 'On Anna Bloom' (1919) by contrast did use recognizable words in sentences, but the results were nevertheless fantastical and hilarious as a result of his exaggeration of sound effects and rhythms at the expense of meaning. These currents in poetry during and after the war owed much to the Cubist poetry of Apollinaire, in particular his 'Calligrammes' or visual poems, first published in *Les Soirées de Paris* in 1914. Here Apollinaire drew on Marinetti's Futurist poetics or 'Words in Freedom' to make shapes on the page out of found fragments and random thoughts. Some of the calligrammes featured snippets of conversations overheard in the street or newspaper headlines glimpsed in a café, and in this way they directly paralleled the Cubist collages discussed in Chapter 7. The fundamental principle of all these experiments in poetics was in fact a combination of the

246
Kurt
Schwitters,
Merzbild 32A.
The Cherry
Picture,
1921.
Cloth, wood,
metal,
gouache, oil,
cut-and-pasted
papers and ink
on cardboard;
91.8 × 70.5 cm,
36⅛ × 27¾ in.
Museum of
Modern Art,
New York

Bergsonian flux of Salon Cubism and the extreme juxtapositions of aspects of modern life in collage and *papiers collés*. In 1918, another Cubist poet, Reverdy, had written in *Nord-Sud* that 'the more the relationship between the two juxtaposed realities is distant and true, the stronger the image will be.' It was this latter principle of linguistic collage, producing new metaphors of powerful strangeness, that particularly fascinated Breton and other founder members of the Surrealist movement. For them, the chance juxtaposition of unrelated things produced a poetic shock analogous to the uncanny effects of a dream. In each case, Breton thought, the creative powers of the Freudian unconscious were at work, bringing what he called the beauty of 'the marvellous' into banal and uncreative daily existence. The *First Surrealist Manifesto* defined Surrealism in terms of avant-garde literature and poetry, then, paying virtually no attention to visual art other than in a footnote, and declaring that 'the true functioning of thought should be expressed in the absence of any control exerted by reason, and outside all moral and aesthetic considerations.' The visual play of Cubist collage, or of Cubist painting, even if fundamental to Surrealist poetic theory, was apparently to be abandoned in the new movement.

At the same time, however, other visual artists who would become key figures within Surrealism found Cubism a stimulus in their early careers. Cubism offered an artist such as Joan Miró (1893–1983), a Catalan who arrived in Paris in 1919, a means to explore the patterns and textures of things seen within a tight formal framework. His interest in Cubist method was one factor that led him to his mature Surrealist style, dependent as it was on a capacity to see one thing as another, to find in the image of a jug the form of a person, or in the forms of a face to see a fragmented set of signs for stars and comets. This method was Surrealist in a manner ostensibly different to that of Ernst, although once again it questioned the idea of the stable identity of the visual world. A painting such as *The Hunter (Catalan Landscape)* of 1923–4 (247) does not appear Cubist at all, and was certainly conceived of as a departure from the Cubism latterly promoted by Léonce Rosenberg, for example. Yet it depends on the same ability to make a restricted vocabulary of signs stand for a diverse range of objects, the same spreading compositional grid, as is deployed in the

247
Joan Miró,
*The Hunter
(Catalan
Landscape)*,
1923–4.
Oil on canvas;
64·7×100·3 cm,
25'₂×39'₂ in.
Museum of
Modern Art,
New York

work of Braque and Picasso around 1911. The caricatural elements also echo those increasingly used by Picasso from around late 1913.

Similarly, André Masson (1896–1987), another major figure in early Surrealism, exploited the compressed palette of 1911 Cubism, its recurrent framework of a central area of dense lines which fade to the edges of the canvas, and its versatile system of marks into and out of which objects and figures can emerge, in order to make tantalizing paintings which are inventories of symbols overlaid with linear anatomies (248). Where once the shimmering realm of *Le Portugais* (see 19) stood for an alternative way of making pictures, now Masson made the same basic effect the veil behind which the mysteries of the unconscious may be thought to lurk. In his 1925 essay 'Surrealism and Painting', Breton turned his attention to the visual arts, and eloquently captured what he regarded as the proto-Surrealist mysteriousness of the pre-war Cubism of Braque and especially Picasso. This was but one instalment in a campaign, in which Picasso was both quarry and collaborator, to colonize Cubism as Surrealist. There is no doubt that Breton's reinterpretation of Picasso's art, which was taken up later as a cause by Surrealists of other persuasions (*eg* Michel Leiris and Georges Bataille), had a profound impact on the meaning of Cubism for subsequent viewers and for the artist himself.

248
André Masson,
*The Four
Elements,*
1923–4.
Oil on canvas;
73 × 58.4 cm,
28¾ × 23 in.
Musée
National d'Art
Moderne,
Centre Georges
Pompidou,
Paris

Like Surrealism, twentieth-century Anglo-American poetry was also arguably heavily indebted by the collage aesthetic of Cubism. Some have seen the same basic principles at work in poems as diverse as those by the pre-1914 'imagists', such as the American Hilda Doolittle and the Englishman T E Hulme, and post-war work of the Americans T S Eliot, Ezra Pound, William Carlos Williams and Wallace Stevens. Among these poets, imagery plays a central role and is allowed to appear without context. In the case of Eliot, found fragments of literature or conversation are assembled in an apparently random fashion. Certainly all these poets were in close contact with artists connected to Cubism (Stevens knew Duchamp, for example), and learnt to recast their own methods partly as a result. It is clear, on the other hand, that the term 'Cubism' can only be applied here in a fairly general way, and that the impact of Pound's studies of Japanese haiku

poetry on all these figures was equally profound. Such broad uses of the term Cubism go with its long history (and it is worth noting that art historical books explaining it to a wide public appeared as early as 1925). Whereas much of this chapter has been concerned with Cubism's contribution to the artistic and political utopias of the inter-war period, the aftermath of World War II in Europe and especially the United States led to a profoundly influential flowering of increasingly de-politicized abstract art in the late 1940s and 1950s.

One artist, Stuart Davis (1894–1964), made an impressive career out of his engagement with late Cubism. His scintillating townscapes (249) take in aspects of Gris and Léger as well as Braque and Picasso to form an urban decoration akin to the 'graffiti art' of the 1980s. The leading sculptor of the 1950s, David Smith (1906–65), learnt much about Cubism from the Czech Cubist Jan Matulka (1890–1972), who moved to the United States before World War I, and from studying the welded sculpture of Julio González (1876–1942) in the influential periodical *Cahiers d'art*. Barr's shows at the Museum of Modern Art were immensely significant in the developing appreciation of Cubism as a resource for the much-touted advent of a new kind of modern art that would be uniquely American. The critic Clement Greenberg claimed that such an art had arrived in the late 1940s with the work of Dutch-born Willem de Kooning (1904–97) and bona fide American Jackson Pollock (1912–56), basing his argument on the close relationship between their abstraction and Parisian Cubism.

249
Stuart Davis,
New York under Gaslight,
1941.
Oil on canvas;
81·3 × 114·3 cm,
32 × 45 in.
Israel Museum,
Jerusalem

De Kooning trained in the Netherlands but emigrated to the United States in 1926. His paintings of the late 1930s conduct a paradoxical dialogue with both Cubist and Surrealist Picassos and the eroticism in the work of Old Masters such as Titian (c.1487–1576) and Raphael. His figurative style of the 1940s, centred on images of women, amalgamated low culture advertising and high culture paintings of the nude in violent and energetic canvases, and led de Kooning to his equally successful abstract work. In *Excavation* (250), he turned the early Cubist device of faceting to rhythmic ends, creating a sense of hidden incident by punctuating what became known as the 'all-over' composition – an effect of the reduced palette of 'analytic' Cubism – with stabs of colour.

250
Willem de Kooning,
Excavation,
1950.
Oil on canvas;
206·2 × 257·3 cm,
81⅛ × 101⅜ in.
The Art
Institute of
Chicago

The Art Institute of Chicago made the bold decision to purchase the work in 1951, and a spokesperson told the press that 'The spectator is held by the forcefulness and energy of the action in the picture, and the tensions between the paint surfaces. But he is simultaneously spellbound by the radiant beauty that glows out.' In 1952 the critic Harold Rosenberg alluded to this kind of art, and the large-scale 'dripped' work of the period by Pollock, in his essay 'The American Action Painters', suggesting that in some sense the work of art had become 'an arena in which to act'. Both de Kooning and Pollock made something new and challenging out of Cubist devices, but Pollock in particular saw his 'Action Painting' not as pure spatial investigation, but as a kind of tracing of the (Freudian and Jungian) unconscious. His art was thus a product of Surrealist theory and practice as well as Cubist visual language.

A more intellectually subtle interrogation of Cubism in American art might, however, be thought to come after the work of such 'Abstract Expressionists' as de Kooning and Pollock, in the paintings, collages, assemblages and combine-paintings made by Jasper Johns (b.1930) and Robert Rauschenberg (b.1925). Johns' famous 1954 *Flag* (251) is at first glance a simple painting of the stars and stripes, yet it is built up in painstaking layers of collaged newspaper, concealed by industrial paint. In some ways this paradoxical work recalls the ironies of Picasso's

251
Jasper Johns,
Flag,
1954–5.
Encaustic,
oil and collage
on fabric
mounted on
plywood;
107 × 154 cm,
42⅛ × 60⅝ in.
Museum of
Modern Art,
New York

flag paintings from 1912 (which also used industrial paint), but here the irony is more dominant and the meaning of the work more elusive.

Rauschenberg extended the collage principle and the idea of construction in his combine-paintings or assemblages (252). Here 'real' elements are turned into art through painting and other forms of manipulation, recalling the use of the absinthe spoon in Picasso's small sculpture of 1914 (see 152). Recently Robert Rosenblum has made a case for a link between Cubism and the early 1960s phenomenon known as Pop Art, in which such artists as James Rosenquist (b.1933), Roy Lichtenstein (1923–97) and Andy Warhol (c.1928–87) appropriated the visual and verbal language of advertising and consumer culture. Rosenblum's highly influential and imaginative book of 1960, *Cubism and Twentieth Century Art*, did not cover Pop Art of course, but it included other figures in its view of the legacy of Cubism. In particular, Rosenblum gave an important place to the English artist Ben Nicholson (1894–1982), whose lyrical reliefs (254) as well as paintings and drawings were part of a significant abstractionist trend in Britain in the 1930s. This kind of moderate and sensitive post-Cubism continued after the war in the work of such artists as Victor Pasmore (1908–98).

The ways of Cubism are myriad. Cubism touched the lives and work of many other artists beyond those mentioned here, not all of them

252
Robert Rauschenberg,
Monogram,
1955–9.
Freestanding combine;
107 × 162.5 ×
164 cm,
42 × 64 × 64½ in.
Moderna Museet,
Stockholm

well-known. While researching this book, for example, I came across a press cutting in the files of the Musée National d'Art Moderne in Paris (253). It depicts the artist Evie Hone (1894–1955), an Irishwoman who trained initially at the Byam Shaw School of Art in England, and then travelled to Paris in 1920 to study with the former Cubist Lhote. The crucial event in her career, however, was her period of study with Gleizes from 1922 to 1930. Gleizes had established himself as a painter and teacher of considerable importance; another Irishwoman, Mainie Jellet (1897–1944), and an Australian, Ann Dangar (1887–1951), would also study with him. From around 1920 he had adopted an explicitly religious mission for his Cubism, which he related to the art of the thirteenth century. (This is yet another instance of Cubism's strange relationship between the 'Gothic' and 'medieval' that has surfaced from time to time in this study.) Gleizes aspired to make large-scale

253
Evie Hone at
her exhibition
of Cubist
paintings,
London, 1929

254
Ben
Nicholson,
1935 (White
Relief),
1935.
Oil on carved
mahogany,
98·9 ×
164·9 cm,
39 × 64⅞ in.
Tate Gallery,
London

religious murals and stained-glass decorations, and some late Cubist works depict a Mother and Child or the Descent from the Cross. Hone was profoundly affected by this religious version of Cubism, and after her 1929 London exhibition of works strongly derivative of Gleizes' style, she built a reputation in Ireland as a stained-glass artist.

It is hard to imagine a trajectory more removed from the heady days Braque and Picasso shared in Céret in 1912. From the point of view of the two inventors of Cubism, its subsequent history and identity remained a distinct phenomenon. Of course, both Braque and Picasso made many innovative paintings and sculptures in the remainder of their long careers, a great deal of them clearly indebted to Cubist approaches to form and colour, method and subject. As such, their work played a pivotal role in the history of art in the first half of the

twentieth century, and has more recently been reappraised for its value even down to some present-day painting and sculpture. Braque in particular, apart from occasional forays into classicism and naturalistic still life, remained largely faithful to the tight disciplines of Cubism, making paintings that played with the nature of pictorial space – with the mystery of visual worlds so imaginatively replete, conjured out of such meagre stuff as coloured pigment on a flat ground. His lyrical series of paintings on the theme of the studio, executed in the late forties and early fifties, wove an endless cat's cradle out of the shadows and lights of a painter's means. *Studio II* (255) is dominated by a white bird, a presence in another painting leaning against his studio wall at the time, which Braque allowed to float free

from its own canvas in an allegorical flight across the Cubist painter's terrain. This subtle picture teems with incident: from sculpted classical head on the left; artist's palette, jug and fruit dish on the right. Yet many marks make no more sense than those facets and lines evident in the warp and weft of *Le Portugais* (see 19) – the grid lines and shapes simply navigate the seams of representation that Braque and Picasso had opened together nearly forty years earlier.

Picasso's capacity for invention meant that he turned Cubism to many different ends, including everything from the political Surrealism of *Guernica* in 1937 to some marvellous sheet metal figure sculptures in the early 1960s. For a wide public, it is through Picasso's portraits

of his partners in the 1930s, Marie-Thérèse Walter and Dora Maar, that 'Cubism' is best known. In a 1937 painting of Maar (256), Picasso characteristically seems to have pulled both eyes round to one side of the nose, giving both frontal and profile views of the face at once. A closer look shows that the two eyes are different: one, with a crimson red pupil, stares straight out; the other seems to point inwards, as if taken from the other side of the nose and flipped over. The left-hand eye is not solely frontal, however, since the lower lash echoes that on the right eye. Such splits in the representation

255
Georges
Braque,
Studio II,
1949.
Oil on canvas;
131 × 162·5 cm,
51¹₂ × 64 in.
Kunst-
sammlung
Nordrhein-
Westfalen,
Düsseldorf

256
Pablo Picasso,
*Dora Maar
Seated*,
1937.
Oil on canvas;
92 × 65 cm,
36¹₄ × 25⅝ in.
Musée
Picasso,
Paris

of the face are repeated in many of Picasso's portraits, but it is easy to pass over the real import of these pictures by labelling them as mere examples of 'Cubism'. In these remarkable paintings, Picasso reinvigorated portraiture as a bearer of effects of human presence and psychological meanings. The double aspect of the face frequently seems to refer to the inner turmoil or light and dark sides of the soul. In this particular work, the acidic colours and strident linear shapes of the closeted space all seem to underline the psychic

intensity. At the same time, Cubist devices here are put in service of a Surrealist vision of the self: too palpable and too mutable to be mere reality.

Even though they never abandoned the lessons of Cubism in their later careers, both artists were circumspect in their old age when asked to comment on their partnership in Paris before 1914. In an interview published in 1957, Braque said that 'instead of having made things clearer, I should like to have made them more obscure'. Picasso, fond of speaking in parables, said that after the day he went to the train station in Avignon on 2 August 1914, to bid farewell to Braque and Derain as they set off to join the war effort, he never saw his fellow pioneers again. This was patently false (for he saw both Braque and Derain many times after that), but Picasso meant to suggest that World War I represented a watershed beyond which the youthful intensity and purity in which Cubism was born could not pass. Certainly, for Picasso, Cubism became a potent and immensely versatile instrument for making art – and for interrogating it, as his famous 1957 variations on *Las Meninas* by Diego Velasquez (1599–1660) show. But while Braque was slowly able to retrieve something of the strange combination of sensuousness and austerity which their Cubism had created, Picasso always used Cubism very self-consciously – as if acknowledging that it carried personal meaning for him while making it into a style alongside others in his art. In conversation, he viewed it with a strong element of nostalgia, suggesting that he could no longer quite believe that he had been brave enough to participate in its fervent but free-wheeling beginnings. 'How crazy or cowardly we must have been to abandon this', he said in the 1950s to Laurens when looking at some *papiers collés* from 1914. 'We had splendid means. Look how beautiful that is – not because I made it, of course. We had this, and then I went back to oil and you to marble. It's insane.' Picasso's remark is not only nostalgic, though. It is also a reminder that one utopian aspect of Cubism was to show that the human imagination can redeem the most humble and humdrum aspects of modern life.

Glossary | Brief Biographies | Key Dates | Map |
Further Reading | Index | Acknowledgements

Glossary

Analytic Cubism A term applied to early Cubism up to the invention of collage in 1912. Like **Synthetic Cubism**, it derives from a misapplication in early Cubist criticism of terminology found in philosophy, specifically in the *Critique of Pure Reason* (1781) by Immanuel Kant. Roger Allard was among the first to apply 'analytic' and 'synthetic' to Cubism in 1910. The real systematization of the terminology was in the writings of **Juan Gris** and **Daniel-Henry Kahnweiler** between 1915 and 1921, and it became firmly entrenched in art history in Alfred Barr's 1936 exhibition and catalogue, *Cubism and Abstract Art*. According to these accounts, Cubism up until 1912 was based on the 'analytical' dissection of objects in space, breaking them down into their component parts as seen from multiple viewpoints. These fragments would then be assembled on the canvas to create a more complete and intellectually satisfying picture than that offered by conventional perspective. Reduced colour and a strong linear framework is regarded as the complement of this intellectual bias. The high-points of this method are usually considered to be the works by **Pablo Picasso** and **Georges Braque** between 1910 and 1911, and by Gris in 1912.

Avant-garde Originally a military term meaning 'vanguard'. It was adopted by French utopian socialists in the 1820s and applied to all artists on the basis that art should be a force for social transformation. In the early twentieth century the term began to be applied to artists who challenged traditional artistic values. Avant-garde artists were now those perceived as rebels, and the ambiguity as to whether their rebellion was artistic or political was deliberate. As the century progressed, many artists self-consciously formed themselves into quasi-political groups and published manifestos (eg **Futurism**), and identified themselves (paradoxically) with a 'tradition' of avant-gardism thought to go back to the work of Gustave Courbet and Édouard Manet.

Collage A term derived from the French verb 'to glue' (*coller*). It describes the technique developed by **George Braque** and **Pablo Picasso** in 1912 involving the inclusion of ready-made materials in paintings and drawings. Although 'found' elements had been attached to works of art before, especially in folk and non-Western art, it is generally agreed that the first collage is Picasso's *Still Life with Chair Caning* of 1912. Collage was one of Cubism's lasting contributions to modern art.

Constructions A Cubist sculptural idiom invented by **Pablo Picasso** (probably with **Georges Braque**) in 1912–13. Construction is based on the idea of **collage** but extends its assemblage of heterogenous elements to three dimensions, challenging the traditions of carved and modelled sculpture. Picasso's interest in non-Western and especially African tribal art undoubtedly contributed to his invention. Cubist constructions are typically made of poor-quality materials, such as offcuts of wood, tin cans and buttons, and are normally painted and often textured using sand etc.

Expressionism A term with a broad range of meanings, applied to works from a variety of times and places. Expressionism centres on the notion of the direct expression of emotions in art, typically rejecting technical skill and the academic values of beauty in favour of distortion, exaggerated use of colour and crude finish. In France, the work of Paul Gauguin and Vincent van Gogh was an important precedent for the expressionist style of **Fauvism**. The German Expressionists are identified with two groups active in the period before World War I, Die Brücke (founded 1905) and Die Blaue Reiter (founded 1911). Artists included Ernst Kirchner, Franz Marc and Wassily Kandinsky.

Fauvism The name given to the style of painting adopted by **André Derain**, Othon Friesz, **Henri Matisse**, Maurice de Vlaminck and others between roughly 1904 and 1908. The name derives from Louis Vauxcelles' comment on seeing a classicizing bust in the centre of the room where their work was displayed at the 1905 Salon d'Automne: 'Donatello amongst the wild beasts' (*fauves*). Fauvist paintings are characterized by acid colouring and vigorous application of paint, and in this way they developed a pictorial language of spontaneity, suggesting the expression of emotional states. **Georges Braque** and Raoul Dufy adopted the style in 1906. Fauvism was never a coherent **avant-garde** movement, but it did have a lasting effect on modern painting.

Futurism An Italian **avant-garde** movement, launched by the poet Filippo Tomaso Marinetti. His 'Founding and Manifesto of Futurism' (1909) is one of the seminal documents of twentieth-century art. He attacked traditional cultural values, proclaiming cars more beautiful than classical sculpture, and scorning liberal values and pacifism. Leading Futurists included Giacomo Balla, **Umberto Boccioni**, Carlo Carra and **Gino Severini**. These artists developed a radical form of art capturing the speed and 'dynamism' of modern urban life.

Orphism A name appropriated from Symbolist theorists by **Guillaume Apollinaire**, and used to designate the work of **Robert Delaunay**, **Marcel Duchamp**, **Fernand Léger**, Francis Picabia and (to an extent) **Pablo Picasso** that revealed a tendency towards colour abstraction. Though hardly any of the artists accepted the label, Apollinaire argued that they shared a common interest in 'pure' painting, which would give a 'pure aesthetic pleasure'.

Papier collés French term meaning 'pasted papers'. A form of **collage**, invented by **Georges Braque** in 1912, involving the pasting of found pieces of wallpaper, newspaper, etc. on to a paper ground.

Primitivism A recurrent feature of **avant-garde** artistic practice, involving the adoption of aspects of the art of supposedly 'primitive' peoples, especially tribal cultures in Africa and Oceania. Modernist primitivism ranges from simple acts of stylistic imitation or borrowing to the expression of supposed conceptual affinities. Both are evident in *Les Demoiselles d'Avignon* by **Pablo Picasso**; the former in the appearance of the figures, and the latter in Picasso's later comments on the work as an exorcism-painting, having a magic function akin to those he imagined for African masks. The 'primitive' is valorized through such acts of appropriation as more authentic than western European culture, but is also viewed, speciously, as closer to natural sexual energy and violence. Primitivism is in this way a highly paradoxical phenomenon, marked by the contradictions of colonialist history.

Purism A movement launched by Amédée Ozenfant and Charles-Édouard Jeanneret in 1918 as a challenge to Cubism. Their essay 'After Cubism' called for a more rational and universal art, and they exhibited their rather austere still-life paintings at the same time. The work of **Fernand Léger** in this period shares some of the same traits. Ozenfant and Jeanneret (better known as the architect Le Corbusier) edited the journal *L'Esprit Nouveau* ('The New Spirit', which ran from 1920 to 1925), the most important expression of Purist aesthetics.

Puteaux group A group of artists and writers that, towards the end of 1911, gathered every Sunday at the Puteaux studios of **Raymond Duchamp-Villon** and **Jacques Villon**. The group included **František Kupka**, **Guillaume Apollinaire**, **Marcel Duchamp** and Francis Picabia.

Salon Cubism A term long used to distinguish between Cubists exhibiting in the Paris Salons and those 'Gallery Cubists' associated with **Daniel-Henry Kahnweiler** and other private dealers who did not participate in such shows after 1909 – principally **Georges Braque** and **Pablo Picasso**. The most important Salon Cubists were **Robert Delaunay**, **Albert Gleizes**, **Henri Le Fauconnier**, **Fernand Léger** and **Jean Metzinger**. **Juan Gris** began his Cubist career in the Salons of 1912, but soon joined Kahnweiler's stable. Salon Cubism was synonymous with Cubism in the eyes of the contemporary public.

Surrealism A French **avant-garde** movement founded in 1924 and vital until the late 1930s, led by the poet André Breton. It emphasized the notion of revolt and had a long but difficult relationship with the French Communist Party. Surrealism also drew upon the ideas of Freud, specifically the notion of the unconscious as the creative force behind the bizarre character of dreams. The name 'Surrealism' was invented by **Guillaume Apollinaire** in 1917 in his programme note for the ballet *Parade*, which featured designs by **Pablo Picasso**. Breton admired Picasso's art, illustrating his Cubism in Surrealist journals and writing about it on many occasions. Breton promoted the idea of Surrealist painting, arguing against those who found the notion problematic, and encouraged artists such as Max Ernst, André Masson and Joan Miró in their experiments with Cubist techniques.

Synthetic Cubism This term refers to Cubism after 1912 and the invention of *papier collé* and **collage** techniques by **Georges Braque** and **Pablo Picasso**. Whereas **Analytic Cubism** is considered to have deconstructed objects according to their appearance from every position in space, Synthetic Cubism is based the creation of new forms. Synthetic Cubist works feature elementary shapes, bold colour and heterogenous materials. The idea that Synthetic Cubism was concerned with creating new autonomous objects was important for movements such as De Stijl and Constructivism, and for the invention of the 'Surrealist Object' in the 1930s.

Trompe l'oeil A French phrase (literally 'eye-fooling') referring to the genre of painting that imitates natural appearances as faithfully as possible, in an apparent effort to trick the spectator into seeing 'real' things where there is only paint on canvas. The genre was popular in seventeenth- and eighteenth-century painting, since it allowed artists to show off enormous skill. On the other hand, the ultimately superficial nature of *trompe l'oeil* always prevented it from being accepted as a high art. The Cubism of **Georges Braque** and **Pablo Picasso** plays on these aspects of *trompe l'oeil* – the striving for effects that are at once trivial and display great skill.

Vorticism An English **avant-garde** movement led by the painter, novelist and philosopher Percy Wyndham Lewis and launched in 1914 in the periodical *Blast* (there was a second and final issue in 1915). Vorticist art borrowed its ideas from Henri Bergson, Georges Sorel and Wilhelm Worringer; and much of its look from Cubism and Italian **Futurism**. Its major artists included Jacob Epstein, Henri Gaudier-Brzeska and Edward Wadsworth. The movement had right-wing inclinations, largely thanks to Lewis. During World War I many members of the group rejected Vorticism in favour of figurative art.

Guillaume Apollinaire (1880–1918) Born in Rome the illegitimate son of a Pole and an Italian, he was brought up under the charge of the Bishop of Monaco. He moved to Paris with his mother in 1899. His first important suite of poems was *Chanson du mal-aimé* (1903). Apollinaire entered the circle of *La Plume* around 1903 and got to know Alfred Jarry and André Salmon. He met **Pablo Picasso** around 1904, and published the first important reviews of his work in 1905. In 1907 he took **Georges Braque** to Picasso's studio. One of the leading theorists of **avant-garde** art in the pre-war period, he had columns in *L'Intransigeant* and *Paris-Journal*. In 1912 he published articles that would be included in *The Cubist Painters: Aesthetic Meditations* (1913). He contributed to *Les Soirées de Paris*, where he first published his 'calligrammes', or shape-poems. Apollinaire volunteered for the army in 1914 and was severely wounded in 1916, the year he became a French citizen. He coined the term '**Surrealism**' in his programme note for the 1917 ballet *Parade*, and produced a 'surrealist drama', *Les Mamelles de Tirésias*, shortly after.

Alexander Archipenko (1887–1964) Born in Kiev, where he began his artistic training, he went to Moscow in 1906 and then Paris in 1908. He left the École des Beaux-Arts, studying independently in the Louvre. He exhibited with the Salon Cubists at the Indépendants of 1910, and in the Salon d'Automne between 1911 and 1913. Pursuing the idea of integrating figure and space, he drew on Cubist and Futurist innovations as well as Byzantine, medieval and non-Western art. By 1914 Archipenko was experimenting with polychromy in 'sculpto-paintings'. He moved to Berlin in 1921 and the United States in 1923, becoming a successful teacher. In the 1930s he turned to classicism, though he returned to sculpto-painting in the 1950s.

Umberto Boccioni (1882–1916) Born in Reggio, Calabria, he went to Rome in 1898 where he met Giacomo Balla and **Gino Severini**. He travelled widely during 1902–8 and began depicting modern industrial society. He settled in Milan in 1908 and had his first one-man show in Venice in 1910. In that year, he joined the Futurists, and signed the two manifestos of Futurist painting. He visited Paris with Carlo Carrà and Luigi Russolo in 1911. In 1912 he began to make sculpture and wrote the *Technical Manifesto of Futurist Sculpture*. In June 1913 he exhibited in Paris. With the outbreak of war, Boccioni enlisted in the Italian Army. He was wounded in 1915 and killed in a riding accident in 1916.

Georges Braque (1882–1963) Born at Argenteuil-sur-Seine, Braque was the son of a successful painter and decorator. He grew up in Le Havre and in 1900 went to Paris to continue his training in the family trade. While studying painting at the Académie Humbert in 1902–4, he met **Marie Laurencin** and Francis Picabia. He befriended Raoul Dufy and Othon Friesz and painted landscapes in a Fauve style in 1906–7; he was also impressed by the Cézanne retrospective at the Salon d'Automne 1907. Braque visited **Pablo Picasso** with **Guillaume Apollinaire**, where he saw such recent works as *Les Demoiselles d'Avignon*. From 1908 to 1914 his work developed in close collaboration with Picasso. In 1908 his first one-man show at Kahnweiler's gave rise to the name 'Cubism'. *Papiers collés* and paper sculpture were among his many inventions. Although he exhibited widely across Europe and the USA before World War I, he did not show in Paris. In 1915 Braque suffered a severe head wound, but he returned to painting in 1917 and became an exponent of classicizing Cubism in the 1920s. In later life Braque produced impressive canvases exploring space in still lifes and interiors.

Joseph Csáky (1888–1971) He studied at the school of decorative arts in Budapest from 1904 to 1905, then in 1908 moved to Paris, where he met **Fernand Léger**, **Alexander Archipenko** and **Henri Laurens**. He adopted the Cubist idiom and exhibited in the Salon de la Section d'Or in 1912. In 1914 he joined the French army. Csáky's post-war work was more abstract but with decorative qualities similar to Art Deco. His sculptures after the late 1920s were influenced by Laurens.

Robert Delaunay (1885–1941) Born in Paris, he began painting in a Neo-Impressionist style around 1906. His Eiffel Tower paintings and views of the city show a fascination with colour and urban experience. He married Sonia Terk (**Sonia Delaunay**) in 1910 and exhibited in the Cubist room at the Salon des Indépendants in 1911. By the end of 1912, however, he had renounced Cubism and begun to make his first colour abstractions. His first one-man show was at the Galeries Barbazanges in Paris in 1912. Apollinaire coined the term **Orphism** for Delaunay's colourist version of Cubism. Delaunay spent much of World War I in Spain and Portugal. In post-war Paris he painted figurative works, but returned to colour abstractions for decorations at the 1937 Paris World Fair.

Sonia Delaunay (1885–1979) She was born in the Ukraine as Sonia Terk and went to Paris in 1905, where she studied at the Académie de

la Palette. In 1909 she married the dealer Wilhelm Uhde but divorced in 1910 to marry **Robert Delaunay**. From 1912 the couple pioneered colourist abstractions and Sonia experimented with book-bindings, furnishings and clothing design as well as painting. She supported herself and her husband by working as a decorator in Spain and Portugal 1915–20. Active in the post-war period as a designer of fabrics and clothes, she did not have her first solo show until 1953.

André Derain (1880–1954) He studied under Eugène Carrière in Paris in 1898–9, and met Maurice de Vlaminck and **Henri Matisse**. He became an important figure within the Fauves group, painting alongside Matisse in the South of France. Around 1907 he became a close friend of Braque and Picasso and was a key figure in early Cubism, though he later destroyed many early works. From 1911 Derain abandoned Cubism and became interested in the Italian 'primitives', making paintings of traditional subjects in a bold style. During World War I he served in the French army, and in the post-war period attained international recognition with figure paintings.

Marcel Duchamp (1887–1968) The brother of **Jacques Villon** and **Raymond Duchamp-Villon**, he studied at the Académie Julian in 1904–5 and painted in a variety of progressive styles before coming into contact with Cubism and Futurist ideas around 1910–11. Duchamp devoted serious study to scientific theory, leading to his invention of 'elementary parallelism' in 1911, a painting style based on chronophotography. He was forced to withdraw his *Nude Descending a Staircase, No. 2* from the Salon des Indépendants of 1912, but made his reputation in 1913 at the Armory Show in New York. Duchamp moved away from Cubism in 1913 and began a critique of the notion of art using objects he called 'readymades'. His most famous readymade is *Fountain* (1917), a porcelain urinal. He became a key figure of twentieth-century art.

Raymond Duchamp-Villon (1876–1918) Brother of **Jacques Villon** and **Marcel Duchamp**. Around 1900 he abandoned medicine and took up sculpture, changing his name from Duchamp to Duchamp-Villon, in response to his elder brother's adoption of 'Villon'. He became involved in **Salon Cubism** around 1910, and his and Villon's studios at Puteaux became a meeting place for the group. Duchamp-Villon designed the Cubist House at the Salon d'Automne in 1912 and had a one-man exhibition in Paris in 1914. His most important work, the *Great Horse* of 1914, was cast in bronze posthumously. He joined the army in 1914 as an auxiliary medic but contracted typhoid in 1916. He never fully recovered and died two years later.

Albert Gleizes (1881–1953) He was closely associated with the Abbaye de Créteil, an artistic community based on the ideals of utopian socialism, and his earliest works are experiments with Impressionism. Around

1909 he met **Henri Le Fauconnier** and **Jean Metzinger**, and became a leading figure in **Salon Cubism**, exhibiting major works in the Salons from 1910 to 1912. He wrote the influential treatise *Du 'Cubisme'* with Metzinger (1912). In 1914 Gleizes began painting more abstract works, and in 1915 he moved to New York. He had a one-man show at the Dalmau Gallery, Barcelona, in 1916. From 1927 to 1951 he became an important teacher through his artistic community, Moly-Sabata, in Sablons, promoting modern religious art based on Romanesque style. In 1931 he co-founded Abstraction-Creation.

Juan Gris (1887–1927) Born in Madrid, he studied mathematics and engineering before training as a painter. Gris settled in Paris in 1906 and began working as an illustrator for Parisian and Barcelona periodicals. By 1908 he had befriended **Picasso**. Gris made his first Cubist paintings in 1911–12, exhibiting them at Clovis Sagot's gallery in early 1912 and at the Salon des Indépendants later that year. In 1912 he associated with the **Puteaux group**. However, Gris signed a contract with the dealer **Kahnweiler** in 1912, distancing himself from the Salon Cubists. By 1914 he had introduced *papier collés* and **collage** into his drawings and paintings, and became a brilliant and witty exponent of Cubist composition with word and image. As a foreigner, he was able to continue working throughout World War I, developing a 'pure' or **Synthetic Cubism**. The Paris Surrealists were interested in his work in the mid-1920s.

Daniel-Henry Kahnweiler (1884–1979) Born into the Jewish community in Mannheim, Germany, he moved to Paris in 1907 to set up a small gallery on the rue Vignon. He purchased works by **Georges Braque**, **André Derain** and **Henri Matisse** at the Indépendants that year, and visited **Picasso** in the Bateau-Lavoir. Kahnweiler responded to the work of Picasso and Braque, and organized Braque's landmark show of 1908, which gave rise to the name of the Cubism. He was in contact with wealthy collectors across Europe and signed exclusive contracts with Braque, **Gris** and Picasso in 1912, and with **Fernand Léger** in 1913. His collection was sequestered on the outbreak of war, and he remained in Switzerland until 1920, writing *The Way of Cubism*. In 1920 he established the Galerie Simon in Paris and re-recruited most of his former artists, except for Picasso. His pre-war collections were sold off cheaply by the state between 1921 and 1923, but he remained one of the most important figures in the Paris gallery world until his death.

Bohumil Kubišta (1884–1918) He studied art in Prague and Florence, before founding the Czech artistic group The Eight with Emil Filla and Antonin Procházka. He originally painted in an Expressionist style, but on visits to Paris in 1909–10 and again in 1912, he was impressed by Cubism and made several Cubist works based on narrative themes.

František Kupka (1871–1957) Born in Eastern Bohemia, he was apprenticed to a master saddler, who introduced him to spiritualist ideas. Kupka studied in Prague during 1889–92 and in Vienna in 1892–3. He became interested in Theosophy. In 1896 he moved to Paris, earning a living as a cartoonist. He met **Jacques Villon** in 1901 and joined him in Puteaux in 1906, becoming a key figure. He exhibited abstract works in 1912, and has been linked with **Orphism**. His role as mentor to Czech artists in Paris in the pre-war period was formalized when he was appointed professor by the Prague Academy in 1922.

Marie Laurencin (1885–1956) Laurencin studied at the Académie Humbert. She knew most of the important Cubists and she painted *Apollinaire, Picasso and their Friends* in 1909. Though her work was not closely related to Cubism, it was included in the Cubist showing at the Salon des Indépendants of 1911. After World War I Laurencin was active as a theatrical designer and book illustrator.

Henri Laurens (1885–1954) He began working in the style of Auguste Rodin, and then became interested in pre-Renaissance sculpture. In 1911, he befriended **Georges Braque**, and began making Cubist **collages** and **constructions** around 1914–15. Having had a leg amputated in 1909, he remained in Paris during World War I, making skilful and intelligent Cubist sculpture. In the 1920s he turned towards the depiction of the female figure, moderating his Cubist formal language. He also worked on designs for Serge Diaghilev's *Ballets Russes*. During World War II Laurens remained in Paris and continued to model monumental figures.

Henri Le Fauconnier (1881–1946) He left the study of law for art, attended the Académie Julian in 1902, and exhibited at the Salon des Indépendants in 1905. His early work was linked to **Fauvism** but by 1908 he shifted towards concern with volume. In 1907 he eloped with Russian artist Maroussia Rabanikoff. Some regard his text 'The Work of Art', which discusses a synthesis of cerebral and sensual content, as an early statement of Cubist aesthetic theory. His studio became a centre for Salon Cubism. As chairman of the hanging committee of the Indépendants in 1911, he set up Room 11 as a Cubist display in which his painting *Abundance* had an important place. In 1913 he showed works in an Amsterdam exhibition for which he also wrote the catalogue essay, and he remained the in The Netherlands during World War I. On his returned to Paris he was unable to regain his pre-war standing.

Fernand Léger (1881–1955) Born in Argentan, Normandy, he moved to Paris in 1900 and worked as architect's draughtsman. Léger studied at the École des Arts Décoratifs and the Académie Julian. He met **Robert Delaunay** around 1909 and became a key figure of Salon Cubism, producing important

works for the Salons in 1911 and 1912. Léger had a solo exhibition at the gallery of **Daniel-Henry Kahnweiler** in 1912. His *Contrast of Forms* paintings of 1913 are among the earliest near-abstract paintings and earned him the epithet 'tubist'. In 1914 Léger gave important public lectures on modern art. From 1914 to 1917 he fought in the French army and was excited by the beauty of machine forms, if appalled by the carnage of the trenches. After the war Léger became interested in **Purism**; his work became more ordered, making use of industrial forms. In 1925 he collaborated on the experimental film *Ballet Mécanique*. He spent World War II in the United States, later returning to France where, in the context of left-wing politics, he established himself as a leading painter of public decorative art.

André Lhote (1885–1962) He trained as a sculptor in the École des Beaux-Arts, Bordeaux. In 1905 Lhote took up painting showing at the 1907 Salon d'Automne, and with the Cubists in the 1911 Salon d'Automne and at the 1919 Salon de la Section d'Or. Close to the Mexican painter **Diego Rivera** during the war, Lhote became identified with a rejection of Cubism through his association with the critic Louis Vauxcelles. From 1917 to 1940 he was himself an art critic for the *Nouvelle Revue Française* and taught painting in Paris from 1918 at the Académie Notre-Dame des Champs, and from 1922 at the Académie André Lhote.

Jacques Lipchitz (1891–1973) Born of Jewish parents in Lithuania, he went to Paris in 1909 and studied at the École des Beaux-Arts and the Académie Julian. In 1912 he moved into a studio next to Constantin Brancusi. He met **Alexander Archipenko**, Max Jacob and **Diego Rivera**, who introduced him to **Pablo Picasso**. He became increasingly interested in non-Western art. Around 1915–16, he produced impressive Cubist sculptures mostly in clay or plaster. Some of these he copied in stone but most of the bronze casts date from 1960s. Towards the end of World War I his work became less abstract, in line with the trend of the times. After the German invasion of France in 1940, he emigrated to the United States.

Henri Matisse (1869–1954) Matisse gained a legal degree in Paris in 1889 but took up painting and abandoned law to study art at the Académie Julian in 1891, and then with Symbolist painter Gustave Moreau from 1892 to 1898. He exhibited successfully in the official Salon in 1896 and began to emulate Impressionist paintings, becoming a friend of Camille Pissarro. In June 1904 he had a one-man show at the gallery of **Ambroise Vollard**, and over next two summers painted bold and shockingly coloured landscapes in the south of France. When he exhibited with Derain and Vlaminck at the Salon d'Automne in 1905 they were dubbed the 'Fauves' (wild beasts). Matisse met **Pablo Picasso** in 1906 and formed a friendship with him that also had aspects of rivalry. In 1908 he published the important text 'Notes of a Painter'.

Matisse went on to become one of the most important artists of the twentieth century.

Jean Metzinger (1883–1956) A favourable response to his work at the Salon des Indépendants of 1903 led him to abandon his medical studies in Nantes. In 1905 he moved to Paris, where he met **Robert Delaunay**. In 1907 he met Max Jacob and **Guillaume Apollinaire**, who introduced him to **Pablo Picasso**. In 1910 he exhibited in the Salon d'Automne and in 1911 he was closely involved with the Cubist showings at the Salon des Indépendants. He became one of the key spokesmen for **Salon Cubism**, but was always more informed than most of the latest work of **Braque** and Picasso. An enthusiastic participant in theoretical discussions in Puteaux, he wrote the major text *Du 'Cubisme'* with **Gleizes** (1912). Metzinger fought briefly in World War I but was discharged in 1915, becoming an important artist in Leonce Rosenberg's gallery. He abandoned Cubism in the 1920s but remained an important figure in French art.

Pablo Picasso (1881–1973) Picasso is one of the two artists (the other being **Georges Braque**) normally credited with the invention of Cubism. Picasso was academically trained in art schools in La Corunna, Madrid and Barcelona. He exhibited in the Universal Exposition of 1900, came to Paris that year and moved back and forth between Barcelona and Paris until 1904, when he settled permanently in France. In 1905 he was befriended by **Guillaume Apollinaire**. Picasso travelled to Holland and Spain in 1906, and began imitating aspects of ancient Iberian sculpture. This interest in 'primitive' art continued in 1907 with the African imagery of *Les Demoiselles d'Avignon*, encouraged by **André Derain**. Picasso met Braque in 1907, and their close collaboration gave birth to Cubism in 1908. Picasso did not fight in World War I; during the war his art made what appeared to be a return to academic values. Prolific throughout his life, Picasso became the most renowned artist of his generation.

Diego Rivera (1886–1957) Born in Mexico, he was awarded a travel scholarship to Europe and in 1907 went to Spain, moving to Paris in 1909. He was in Mexico in 1910 for an exhibition, which opened on the day the Mexican Revolution erupted. He returned to Paris in 1911 and adopted Cubism, exhibiting successfully in the Salons. During the war he fell out with **Picasso**, accusing him of plagiarism. Rivera's art returned to traditional subjects and a mix of styles. He went to Italy in 1920 to study Renaissance frescos, then returned to Mexico to become one of the most celebrated political mural artists of the century, working there and the United States.

Gino Severini (1883–1966) In 1900 Severini met **Umberto Boccioni** and decided to become a painter. Giacomo Balla taught him the Divisionist painting technique. He moved to Paris in 1906 and became a key link between Italian **Futurism** and French avant-garde artists, including the Cubists. Severini was close to **Pablo Picasso** and introduced him to Boccioni. He painted near-abstract Futurist works in 1913, and wrote an important but unpublished manifesto. In January 1916 he staged the exhibition 'Futurist Plastic Art of War' in Paris, but soon after he abandoned Futurism in favour of classicism and then a restrained **Synthetic Cubism** close to that of **Juan Gris**. In 1921 Severini published *Du Cubisme au Classicisme* and was painting in a Neoclassical style. In the late 1940s he returned to his Futurism.

Jacques Villon (Gaston Duchamp; 1875–1963) French painter. The eldest brother of **Raymond Duchamp-Villon** and **Marcel Duchamp**, he trained as a legal clerk while attending fine art classes in Rouen. He moved to Paris in 1895 and adopted the pseudonym Jacques Villon when he began to publish cartoons in satirical magazines. In 1899 Villon took up engraving, which enabled him to earn a living throughout his career. He exhibited in the Salon d'Automne from 1904, but only took up painting in earnest in 1910. In 1906 he moved to a studio in Puteaux, which around 1911 became the focus for meetings with many other **avant-garde** artists. In 1914 he joined the French army and was sent to the front. He worked as a camouflage artist in Amiens in 1916. After World War I he joined the Abstraction-Creation group, but achieved wide recognition only after World War II.

Ambroise Vollard (1867–1939) Born on the island of Réunion, he moved to Paris in 1890 to study law. He set up a gallery in the rue Lafitte in 1894, and caused a stir with his exhibition of the work of Paul Cézanne in 1895. Vollard made enough money from dealing in Cézanne's works to enable him to buy up a wide range of now famous late nineteenth- and early twentieth-century artists, including **André Derain** and **Pablo Picasso**.

Ossip Zadkine (1890–1967) Born into a Jewish family in Belarus, he visited England in 1905 and began training as a woodcarver. He was again in Russia in 1909 and then in Paris for an unsuccessful period of study at the École des Beaux-Arts. After an exhibition in Russia in 1910 he returned to Paris to move into La Ruche studios, meeting **Ferdinand Léger**, **Joseph Csáky** and **Alexander Archipenko**. He exhibited sculpture at the Salons and in 1912 became acquainted with **Guillaume Apollinaire** and **Pablo Picasso**. Zadkine was a volunteer in the French Army 1915–17. In the post-war years his work became more Cubist, though it remained figurative. He became successful around 1930 and spent most of World War II in the United States, returning to Paris in 1945 to run sculpture classes.

Cubism

1900 Guillaume Apollinaire, Georges Braque and Pablo Picasso in Paris. Picasso exhibits *Last Moments* in the Spanish Pavilion of the Universal Exposition. Picasso returns to Spain in December

1901 Picasso back in Paris. First Paris show at Ambroise Vollard's gallery in July. He meets the poet Max Jacob. Begins to paint predominantly in blue

1902 Braque sets up a permanent base in Montmartre. Albert Gleizes exhibits in the Parist Salon de la Societé Nationale

1903 Foundation of the Salon d'Automne. Jean Metzinger moves to Paris

1904 Picasso settles permanently in Paris; takes studio in the Bateau Lavoir. Gleizes exhibits at the Salon d'Automne, and an entire room is devoted to Paul Cézanne. Marcel Duchamp moves to Paris

1905 Earliest possible date for Braque and Picasso to have met for the first time. Picasso meets Apollinaire. Henri Matisse shows *Luxe, calme et volupté* [10] at the Salon des Indépendants. Picasso impressed by *The Turkish Bath* [38] at the Ingres retrospective at the Salon d'Automne. Braque sees the Fauve room at the same Salon

1906 Foundation of the Abbaye de Créteil. Beginning of Picasso's 'Iberian' style; Vollard buys twenty paintings from Picasso for 2,000 francs. Braque shows seven works at the Salon des Indépendants. Braque visits Antwerp with Othon Friesz

1907 Daniel-Henry Kahnweiler opens his first gallery in Paris and buys works by Braque, André Derain, Friesz and Maurice de Vlaminck at the Salon des Indépendants. Cézanne retrospective at the Salon d'Automne. Picasso paints *Les Demoiselles d'Avignon* [37]; probably visits the Trocadéro Ethnographic Museum to see non-Western art. Braque visits La Ciotat with Friesz, then visits Derain at Cassis, moving on to L'Estaque. Braque shows his L'Estaque painting. Apollinaire and Braque visit Picasso

1908 Braque responds to the *Demoiselles* with his *Large Nude* [46]. Kahnweiler meets Juan Gris at the Bateau-Lavoir. Braque returns to L'Estaque. Picasso visits La Rue-des-Bois on the Oise. Six of Braque's recent canvases, described by Matisse as made up of little cubes, are rejected by the Salon d'Automne. Kahnweiler offers to

A Context of Events

1900 France: Universal Exposition in Paris. Henri Bergson, *Laughter: An Essay on the Meaning of the Comic*. Sigmund Freud, *The Interpretation of Dreams*. Death of Friedrich Nietzsche

1901 Britain: Death of Queen Victoria. Foundation of the Labour Party. Exhibition of Impressionist paintings in London. Nietzsche, *The Will to Power*

1902 French realist novelist Émile Zola asphyxiated by domestic gas leak

1903 Russia: Pogroms against Jews. USA: Wright brothers first successful flight. Bergson, *Introduction to Metaphysics*

1904 China: Famine affects four million. Russia and Japan declare war. All Nietzsche's major works now available in French translation

1905 Russia: Strikes in St Petersburg repressed at the cost of thousands of lives. Mutiny by crew of battleship *Potemkin*. The Tsar Nicholas II issues *October Manifesto*. Albert Einstein's Theory of Special Relativity. Germany: The artistic group Die Brücke (The Bridge) is formed in Dresden

1906 France: Constitutional separation of Church and State. Dreyfus exonerated of high treason. Death of Cézanne. First meeting of new Russian parliament, the Duma

1907 First transmission of photographs by telegraph. Germany: Foundation of the Deutsche Werkbund for promotion of good design. France: Manet's *Olympia* enters the Louvre. Bergson, *Creative Evolution*

1908 Schoenberg's second String Quartet performed. Congo colonized by Belgians. Austria-Hungary annexes Bosnia Herzegovina with the support of Germany. USA: Launch of Pathé weekly newsreels in cinemas.

show them at his gallery in November.
December: Group show at Wilhelm Uhde's
gallery featuring Braque, Derain, Raoul Dufy,
Metzinger, Picasso and Sonia Terk (later Sonia
Delaunay)

France: The leader of the Action Française,
Charles Maurras, founds the Camelots du Roi,
a vigilante organization designed to intimidate
political opposition and intellectuals.
Diaghilev's *Ballets Russes* arrive in Paris

1909 Robert Delaunay, Gleizes, Henri Le Fauconnier,
Fernand Léger, André Lhote and Metzinger all
become interested in Cubism. Léger moves to
La Ruche studio complex. Braque shows at the
Indépendants for the last time until 1920 and
spends the summer at La Roche-Guyon. Picasso
travels to Barcelona with Fernande Olivier, then
visits Horta de Ebro. Braque and Derain exhibit at
Kahnweiler's in September. Picasso makes first
Cubist sculptures

1909 USA: First Model T Ford car produced.
Louis Blériot flies across English Channel.
Belgian chemist L H Baekeland invents the first
synthetic resin, Bakelite.
Robert Peary reaches the North Pole.
Political crisis in the Balkans.
Spain: Anti-militarist and anti-clerical unrest in
Barcelona.
'Founding and Manifesto of Futurism'
published in Paris

1910 Roger de la Fresnaye joins Cubists, along with
the Duchamp brothers, Louis Marcoussis and
Josef Csáky. Delaunay begins his city paintings
and meets Léger. Salon des Indépendants
features works by Delaunay, Le Fauconnier,
Gleizes, Léger and Metzinger. Braque and
Picasso begin making oval paintings. Picasso
shows works of 1908–9 at Uhde's gallery, visits
Florence and sets up a summer studio at
Cadaqués. 'Braque–Picasso' exhibition in
Munich. Younger Cubists show at the Salon
d'Automne. Metzinger publishes his 'Note on
Painting'. First Post-Impressionist Exhibition in
London, including works by Picasso and
Derain. Picasso has a major show at Vollard's
in December

1910 Germany: Foundation of the International
Association of Psychoanalysis in Nuremberg,
President C G Jung.
France: Marie Curie and André Debierne isolate
radium. Radio mast on the top of the Eiffel
Tower begins emitting a daily signal to mark
midnight.
Britain: Death of Edward VII, succeeded by
George V.
Revolution in Mexico.
'Technical Manifesto of Futurist Painting'
published in Milan and Paris

1911 Salon Cubists begin to meet regularly at
Puteaux. Francis Picabia, František Kupka and
American painter Walter Pach join this circle.
This group show together in Room 41 at the
Salon des Indépendants. Picasso shows at
Steiglitz' 291 gallery in New York. Braque and
Picasso work side by side in Céret: high-point of
'analytic' Cubism. Braque invents *papiers collés*.
Apollinaire arrested in connection with theft of
the *Mona Lisa* from the Louvre. After Salon
d'Automne, Cubism becomes subject of public
debate in the press. Futurists Umberto
Boccioni, Carlo Carrà and Gino Severini visit
Picasso

1911 Germany: First exhibition of the Blaue
Reiter group in Munich. Wassily Kandinsky
publishes *On the Spiritual in Art*. Death of
composer Gustav Mahler.
Marie Curie receives Nobel prize for chemistry.
Germany grants independence and a new
constitution to Alsace-Lorraine. 'Morrocan
Crisis' between France and Germany, when a
German warship is sighted at Agadir.
Britian: Discovery of the nucleus of the atom by
Ernest Rutherford

1912 First show of work by Juan Gris at Sagot's;
Salon des Indépendants features his *Homage
to Picasso* [113], which attracts attention of
Kahnweiler. Picasso in Sorgues during the
summer. Two important shows open in
October: The Salon d'Automne, featuring the
Cubist House [117–121], and the Salon de la
Section d'Or. Delaunay paints first abstractions

1912 First Balkan War.
Cruise liner *The Titanic* sinks in the Atlantic.
Germany: Social Democratic Party wins a
majority of the Reichstag.
France: Jean Jaurès warns against the
imminence of a world war brought on by the
Balkan crisis.
Henri Poincaré, *Science and Method*

1913 Apollinaire publishes *Les Peintres Cubistes*.
Armory Show in New York includes Duchamp's
Nude Descending a Staircase No. 2 [110]. Picasso
in Céret during summer; Braque in Sorgues.
Picasso's earliest Cubist constructions first
reproduced in *Les Soirées de Paris*

1913 Second Balkan War.
Russia: Malevich paints *Black Square*.
Mikhail Larionov, *Le Rayonisme*.
Freud, *Totem and Taboo*.
Marcel Proust, *Swann's Way*, first part of
Remembrance of Things Past

1914 Léger begins his *Contrast of Forms* [95] series.
Picasso's *Glass of Absinthe* [152] is cast in
bronze. Tatlin visits Picasso's studio. Braque
and Derain set off for the war. Léger, Metzinger,
Gleizes, Villon, Apollinaire, Salmon and Raynal

1914 World War I begins.
Britian: Publication of *Blast* in London.
USA: Exhibition of African sculpture at *291* in
New York, along with works by Braque and
Picasso. First film of Charlie Chaplin – *Caught*

Cubism	A Context of Events
also mobilized. Kahnweiler's collection is sequestered by the French authorities	*in a Cabaret.* Italy: Benito Mussolini founds Il Popolo d'Italia
1915 Picasso's classicizing *Portrait of Max Jacob* [225] published in Ozenfant's *L'Elan*. Braque suffers a serious head wound. Duchamp sails for New York where he joins Picabia; Gleizes follows in autumn. Laurens begins making Cubist sculpture. Death of Picasso's partner Eva Gouel	**1915** Italy enters war against Germany and declares war on Austria-Hungary. First use of gas at the front. Russia: Exhibition of works by Malevich and Tatlin at Tramway V in St Petersburg and at The Last Futurist Exhibition 0-10
1916 Apollinaire receives head wound. First public showing of *Les Demoiselles d'Avignon* at the Salon d'Antin. Léger in Battle of Verdun	**1916** France: Battle of the Somme. Death of Auguste Rodin. Ferdinand de Saussure, *Course in General Linguistics.* Einstein's theory of relativity. Switzerland: Tristan Tzara declares the word 'Dada' at the Cabaret Voltaire in Zurich; first and only issue of the dadaist review *Cabaret Voltaire.* Death of Boccioni in a riding accident
1917 First issue of Picabia's *391* and Reverdy's *Nord-Sud*. Braque begins painting again. Cocteau's *Parade*, with costumes and sets by Picasso [228]. Apollinaire invents the term 'surrealist'. Gris and Léger sign contracts with Léonce Rosenberg	**1917** Russian Revolution. USA declares war on Germany. Finland gains independence. First issue of periodical *De Stijl*
1918 Rosenberg opens Galerie de L'Effort Moderne promoting Braque, Gleizes, Gris, Laurens, Léger, Lipchitz and Picasso. Picasso marries Russian ballet dancer Olga Khoklova. Apollinaire dies in Spanish flu epidemic. Ozenfant and Jeanneret publish 'After Cubism', a manifesto for their new movement, Purism	**1918** Armistice ends war on the Western Front. Russia: Malevich's *White on White* exhibited in Moscow. Tsar Nicholas II and his family executed. Britain: First stage in granting of women's suffrage
1919 First Purist exhibition at the Galerie Thomas. Rosenberg stages series of exhibitions of major Cubists. Mondrian develops his 'neo-plastic' painting in Paris	**1919** France: Negotiation of Treaty of Versailles. Russia: Founding of the third International in Moscow, for which Tatlin designs a monument. USA: First screen appearance of Felix the Cat. Germany: Founding of the Bauhaus
1920 Salon de la Section d'Or and the Salon des Indépendants revived. First issue of *L'Esprit Nouveau*. Kahnweiler publishes *The Way of Cubism*, returns to Paris. Exhibition of 'Young French Painters' organized in Geneva by léonce Rosenberg. Gris terminates his contract with Rosenberg	**1920** Germany: Robert Wiene directs *The Cabinet of Dr Caligari*. Foundation of the German National Socialist German Workers' (NAZI) Party. Foundation of the British Communist Party. Women's suffrage in the USA
1921 Picasso paints two versions of *Three Musicians* using Cubist vocabulary. Jules Romains publishes *Le Fauconnier*	**1921** Germany: Adolf Hitler becomes Chairman of Nazi Party. Southern Ireland becomes Irish Free State; civil war ensues (to 1923)
1922 Braque's *Basket-Carriers* [232] shown at the Salon d'Automne. Mondrian's fiftieth birthday retrospective. Mallet-Stevens designs villa for vicomte de Noailles [244]	**1922** Union of Soviet Socialist Republics (USSR) formed. Stalin becomes General Secretary of the Party. Italy: Fascist government comes to power
1923 Le Corbusier designs Villa La Roche-Jeanneret [243]	**1923** Germany: Communist Party and Nazi Party banned Italy: Mussolini establishes permanent Fascist militia
1924 André Breton's first *Surrealist Manifesto* and launch of periodical *La Révolution Surréaliste*	**1924** USSR: Death of Lenin. First Labour government in Britain
1925 Final issue of *L'Esprit Nouveau*. First exhibition of Surrealist painting at Galerie Pierre. Picasso's	**1925** Germany: Bauhaus moves to Dessau. Hitler restructures Nazi Party from within.

Cubism	A Context of Events
Les Demoiselles d'Avignon illustrated in *La Revolution Surréaliste. Exposition des Arts Décoratifs et Industriels Modernes.* Léger directs *Ballet Mécanique.* Ozenfant and Jeanneret publish *Modern Painting*	USSR: Eisenstein directs *Battleship Potemkin.* Italy: Mussolini assumes dictatorial powers
1926 Opening of Galerie Surréaliste. Picasso paints *The Milliner's Workshop*	**1926** Germany joins League of Nations. Formation of Hitler Youth. General Strike in Britain
1927 Death of Juan Gris. In London R Wilenski publishes *The Modern Movement in Art*	**1927** USSR: Stalin triumphs over Trotsky, who is expelled from the Communist Party
1928 Uhde publishes *Picasso and the French Tradition: Notes on Paintings Today*	**1928** Fascist Party constitutionalized in Italy. Five Year Plan (to 1931) announced in USSR
1929 Final issue of *La Révolution Surréaliste* presents *Second Surrealist Manifesto.* Launch of journal *Documents,* including essay 'Notes on Cubism'. Guillaume Janneau publishes *Cubist Art*	**1929** USA: Alfred Barr asked to direct new Museum of Modern Art in New York. Wall Street Crash. Spain: World Exhibition in Barcelona
1930 Launch of *Le Surréalisme au Service de la Révolution.* 'Homage to Picasso' special issue of *Documents.* Aragon publishes *In Defiance of Painting,* and an essay on collage	**1930** German cabinet makes first Nazi appointment, leading to 'Ordinance against Negro Culture'. Unemployment in Germany at 4.4 million
1932 Christian Zervos begins publishing his catalogue of Picasso's work (last volume 1978)	**1932** Foundation of British Union of Fascists
1933 Launch of Surrealist periodical *Minotaure.* Special issues of Zervos' periodical *Cahiers d'Art* on Gris and Léger, published on occasion of major exhibitions in Zurich. Fernande Olivier publishes *Picasso and his Friends*	**1933** Hitler becomes Chancellor of Germany. First concentration camps established in Germany. Establishment of right-wing Falango Espanola in Spain
1935 Death of Malevich. René Huyghe publishes *History of Contemporary Art: Painting*	**1935** Germany: Nuremberg Laws deprive Jews of civil rights. Italy invades Abyssinia (Ethiopia)
1936 Alfred Barr's *Cubism and Abstract Art* exhibition at the Museum of Modern Art, New York	**1936** Spanish Civil War; General Franco unconstitutionally declared head of state. Popular Front government in France. Germany: Berlin Olympic Games. German troops reoccupy Rhineland in breach of Versailles Treaty
1937 Picasso exhibits *Guernica* in the Spanish Pavilion at the 1937 Paris World Fair. Braque shows recent works at Paul Rosenberg's gallery. Foundation of Museum of Non-Objective Painting, later Solomon R Guggenheim Museum, New York	**1937** Germany: Great German and Degenerate Art exhibitions in Munich. Nuremberg Rally. Creation of the Republic of Ireland. Spain: Bombing of Basque town of Guernica by German Condor Legion

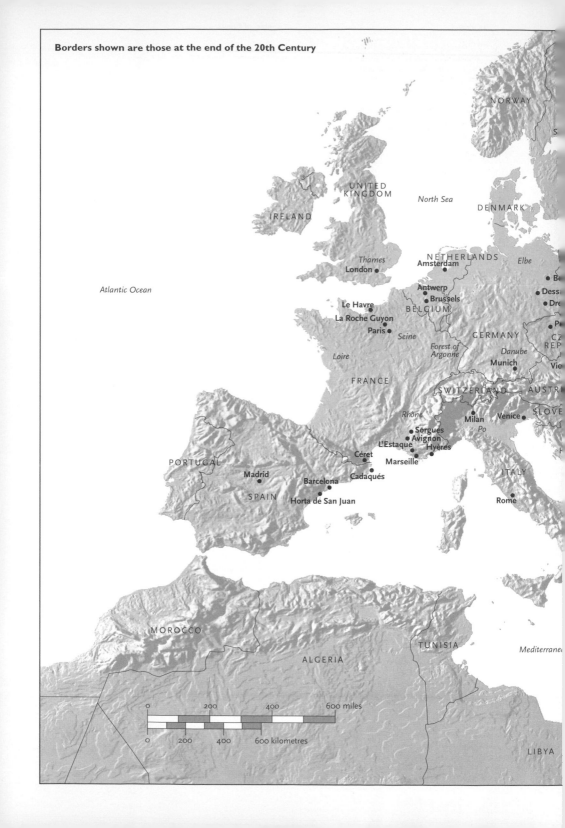

Borders shown are those at the end of the 20th Century

NORWAY

S

UNITED
KINGDOM

North Sea

DENMARK

IRELAND

Atlantic Ocean

NETHERLANDS
Amsterdam

Elbe

Thames
London

Antwerp
Brussels

B

Dess

Dre

BELGIUM

Le Havre
La Roche Guyon
Paris

Seine

GERMANY

P

Loire

Forest of
Argonne

Danube

CZ
REP

Munich

Vie

FRANCE

SWITZERLAND

AUSTR

Rhône

Milan

Venice

SLOVE

Sorgues
Avignon
L'Estaque
Hyères

Po

Céret

PORTUGAL

Marseille

Madrid

Barcelona

Cadaqués

ITALY

SPAIN

Horta de San Juan

Rome

MOROCCO

TUNISIA

Mediterrane

ALGERIA

0 200 400 600 miles

0 200 400 600 kilometres

LIBYA

Further Reading

General

Guillaume Apollinaire, *The Cubist Painters – Aesthetic Meditations* (trans. Lionel Abel, New York, 1949)

Art Journal, 47, 4 (Winter 1988; special issue on Cubism edited by Patricia Leighten)

Douglas Cooper, *The Cubist Epoch* (London, 1970)

— and Margaret Potter, *Juan Gris: Catalogue raisonné de l'oeuvre peint*, 2 vols (Paris, 1977)

— and Gary Tinterow, *The Essential Cubism: Braque, Picasso and Their Friends* (exh. cat., Tate Gallery, London, 1983)

David Cottington, *Cubism* (London, 1998)

—, *Cubism in the Shadow of War: The Avant-garde and Politics in Paris 1905–1914* (New Haven and London, 1998)

Pierre Daix and Joan Rosselet, *Picasso: The Cubist Years 1907–1916* (London, 1979)

Carl Einstein, 'Notes sur le cubisme', *Documents 3* (June 1929), pp.146–55

Edward F Fry, *Cubism* (London, 1966)

Lynn Gamwell, *Cubist Criticism* (Ann Arbor, 1980)

John Golding, *Cubism: A History and an Analysis 1907–1914* (3rd edn, London, 1988)

Christopher Green, *Juan Gris* (exh. cat., Whitechapel Art Gallery, London, 1992)

—, *Léger and the Avant-Garde* (London, 1976)

Le Cubisme, Travaux IV, (Saint-Etienne, 1971)

Les Années cubistes (exh. cat., Musée d'Art Moderne de Lille Métropole, Lille, 1999)

J M Nash, *Cubism, Futurism, Constructivism* (London, 1974)

Nadine Pouillon and Isabelle Monod-Fontaine, *Braque: Oeuvres de Georges Braque 1882–1963* (exh. cat., Paris, 1982)

John Richardson, *A Life of Picasso*, I, *1881–1906* (London, 1987)

John Richardson, *A Life of Picasso*, 2, *1907–1917: The Painter of Modern Life* (London, 1996)

Robert Rosenblum, *Cubism and Twentieth-Century Art* (rev. edn, New York, 1966)

Mark Roskill, *The Interpretation of Cubism* (Philadelphia, 1985)

William Rubin (ed.), *Picasso and Braque: Pioneering Cubism* (London, 1989)

O Winthrop Judkins, 'Toward a Reinterpretation of Cubism', *The Art Bulletin*, 30 (December 1948), pp.270–78

Nicole Worms de Romilly and Jean Laude, *Braque: Le Cubisme, fin 1907–1914* (Paris, 1982)

Lynn Zevelansky (ed.), *Picasso and Braque: A Symposium* (New York, 1992)

Chapter 1

Guillaume Apollinaire, *Alcools* (Paris, 1913)

Pierre Daix and Georges Boudaille, *Picasso: The Blue and Rose Periods* (Greenwich, Connecticut, 1967)

John Elderfield, *The Wild Beasts: Fauvism and its Affinities* (exh. cat., Museum of Modern Art, New York, 1976)

William R Everdell, *The First Moderns: Profiles in the Origins of Twentieth-Century Thought* (London, 1997)

Robert Gildea, *Barricades and Borders: Europe 1800–1914* (Oxford, 1987)

James D Herbert, *Fauvism: The Making of a Cultural Politics* (New Haven and London, 1992)

H Stuart Hughes, *Consciousness and Society: The Reorientation of European Social Thought 1890–1930* (New York, 1958)

Billy Klüver and J Martin, *Kiki's Paris: Artists and Lovers 1900–1930* (New York, 1989)

Marilyn McCully (ed.), *Picasso: The Early Years 1900–1906* (exh. cat., National Gallery of Art, Washington DC, 1997)

Alvin Martin, *Georges Braque: Stylistic Formation and Transition 1900–1909* (unpublished PhD dissertation, Harvard University, 1979)

John Milner, *The Studios of Paris: The Capital of Art in the Late Nineteenth Century* (London, 1988)

Hilary Spurling, *The Unknown Matisse: A Life of Henri Matisse*, 1, *1869–1908* (London, 1998)

Gertrude Stein, *Picasso* (Boston, 1959)

Chapter 2

Anne Baldassari, *Picasso and Photography: The Dark Mirror* (Paris, 1997)

Leroy C Breunig (ed.), *Apollinaire on Art: Essays and Reviews 1902–1918* (trans. Susan Suleiman, New York, 1972)

Rosalind Krauss, *The Picasso Papers* (London, 1998)

Marilyn McCully (ed.), *A Picasso Anthology: Documents, Criticism, Reminiscences* (London, 1981)

Fernande Olivier, *Picasso and His Friends* (London, 1964)

William Rubin (ed.), *Picasso and Portraiture* (exh. cat., Museum of Modern Art, New York, 1996)

Chapter 3

Susan L Ball, 'The Early Figural Paintings of André Derain 1905–1910: A Reevaluation', *Zeitschrift für Kunstgeschichte*, 43, 1 (1980), pp.79–96

Anna C Chave, 'New Encounters with *Les Demoiselles d'Avignon*: Gender, Race and the Origins of Cubism', *The Art Bulletin*, 76, 4 (December 1994), pp.597–611

Elizabeth Cowling and John Golding, *Picasso: Sculptor/Painter* (exh. cat., Tate Gallery, London, 1994)

Edward F Fry, 'Cubism 1907–08: An Early Eye-Witness Account', *The Art Bulletin*, 48, 1 (March 1966), pp.70–3

Beth S Gerth-Nesic, *The Early Criticism of André Salmon: A Study of His Thoughts on Cubism* (New York, 1991)

Jane Lee, *André Derain* (Oxford, 1990)

Colin Rhodes, *Primitivism and Modern Art* (London, 1994)

William Rubin (ed.), *Cézanne: The Late Work* (exh. cat., Museum of Modern Art, New York, 1977)

Richard Shiff, *Cézanne and the End of Impressionism* (London, 1984)

Paul Smith, *Interpreting Cézanne* (London, 1996)

Leo Steinberg, 'The Philosophical Brothel', (Part 1), *Art News*, 71, 5 (September 1972), pp.22–9; (part 2) *Art News*, 71, 6 (October 1972), pp.38–47

—, 'Resisting Cézanne: Picasso's Three Women', *Art in America*, 66, 5 (November–December 1978), pp.115–33

—, 'The Polemical Part', *Art in America*, 67, 2 (March–April 1979), pp.115–27

Kirk Varnedoe (ed.), *Les Demoiselles d'Avignon*, Studies in Modern Art, no. 3 (New York, 1994)

Chapter 4

Bruce Altshuler, *The Avant-garde in Exhibition: New Art in the 20th Century* (New York, 1994)

William Camfield, *Francis Picabia, His Art, Life and Times* (Princeton, 1979)

Robert Delaunay: 1906–1914, de l'impressionisme à l'abstraction (exh. cat., Centre Georges Pompidou, Paris, 1999)

Christian Derouet (ed.), *Fernand Léger* (exh. cat., Centre Georges Pompidou, Paris, 1997)

Duchamp-Villon (exh. cat., Musée des Beaux-Arts, Rouen, 1999)

Peter de Francia, *Fernand Léger* (London, 1983)

Michel Massenet, *Albert Gleizes* (Paris, 1998)

Jean Metzinger, *Le Cubisme était né: souvenirs* (Chambéry, 1972)

Ann H Murray, 'Henri Le Fauconnier's "Das Kunstwerk": An Early Statement of Cubist Aesthetic Theory and its Understanding in Germany', *Arts Magazine*, 56 (December 1981), pp.125–33

Daniel Robbins, 'From Symbolism to Cubism: The Abbaye de Créteil', *Art Journal*, (Winter 1962–3), pp.111–16

Daniel Robbins and Anne Varichon, *Albert Gleizes 1881–1955: Catalogue Raisonné*, 2 vols (Paris, 1998)

Peter Vergo (ed.), *Abstraction: Towards a New Art, Painting 1910–1920* (exh. cat., Tate Gallery, London, 1980)

Chapter 5

Dawn Ades, Neil Cox and David Hopkins, *Marcel Duchamp* (London, 1999)

Jean Adhemar, 'Les journaux amusants et les premiers peintres cubistes', *L'Oeil*, 4, April 1955, pp.40–3

Mark Antliff, *Inventing Bergson: Cultural Politics and the Parisian Avant-Garde*, (Princeton, 1993)

— 'Cubism, Futurism, Anarchism: The "Aestheticism" of the Action d'Art Group 1906–1920', *Oxford Art Journal*, 21, 2 (1998), pp.99–120

— 'Cubism, Celtism and the Body Politic', *The Art Bulletin*, 74, 4 (December 1992), pp.655–68

Umbro Apollonio (ed.), *Futurist Manifestos* (London, 1973)

Günter Berghaus, *Futurism and Politics: Between Anarchist Rebellion and Fascist Reaction 1909–1911* (Oxford, 1996)

Henri Bergson, *Creative Evolution* (London, 1911)

—, *Laughter: An Essay on the Meaning of the Comic* (London, 1935)

—, *An Introduction to Metaphysics* (London, 1913)

Paul Crowther, 'The Structure of Cubism', in *The Language of Twentieth-Century Art: A Conceptual History* (London, 1997), pp.32–48

Linda Dalrymple Henderson, *The Fourth Dimension and Non-Euclidean Geometry in Modern Art* (Princeton, 1983)

Albert Gleizes, *Puissances du Cubisme* (Chambéry, 1969)

Albert Gleizes and Jean Metzinger, *Du 'Cubisme'* (Paris, 1912), trans. in R L Herbert, *Modern Artists on Art* (Englewood Cliffs, 1964)

R Stanley Johnson, 'Cubism and La Section d'Or: Reflections on the Development of the Cubist Epoch 1907–1922', in *Cubism and La Section d'Or* (exh. cat. Phillips Collection, Washington DC, 1991), pp.7–28

Paul Laporte, 'Cubism and Science', *Journal of Aesthetics and Art Criticism*, 7 (March 1949), pp.243–56

—, 'The Space-Time Concept in the Work of Picasso', *Magazine of Art*, 41 (January 1948), pp.26–32

Fernand Léger, *Functions of Painting* (London, 1973)

Marianne W Martin, *Futurist Art and Theory, 1909–1915* (Oxford, 1968)

Timothy Mitchell, 'Bergson, Le Bon, and Hermetic Cubism', *Journal of Aesthetics and Art Criticism*, 36, 2 (Winter 1977), pp.175–83

Jean Moser (ed.), *Jean Metzinger in Retrospect* (exh. cat., Iowa Museum of Art, Iowa City, 1985)

J M Nash, 'The Nature of Cubism: A Study in Conflicting Explanations', *Art History*, 3, 4 (December 1980), pp.435–47

Jacques Nayral, 'Préface', in *Exposicio d'Art Cubista* (exh. cat., Galleries J Dalmau, Barcelona, 1912)

André Salmon, 'Préface', in *Exposition des sculptures de Raymond Duchamp-Villon* (Paris, 1914)

Virginia Spate, *Orphism: The Evolution of Non-figurative Painting in Paris 1910–1914* (Oxford, 1979)

Chapter 6

Yve-Alain Bois, *Painting as Model* (London, 1990)

John Berger, 'The Moment of Cubism', in *Selected Essays and Articles* (London, 1972)

T J Clark, 'Cubism and Collectivity', in *Farewell to an Idea: Episodes from a History of Modernism* (London, 1999) pp.168–223

Roger Fry, 'The New Movement in Art and its Relation to Life', *Burlington Magazine*, 33 (1917), pp.162–8

Charles Harrison et al., *Primitivism, Cubism, Abstraction: The Early Twentieth Century* (London, 1993)

Roland Penrose, 'Picasso's Portrait of Kahnweiler', *Burlington Magazine*, 116, 852 (1974), pp.124–33

Alex Potts, 'Sign', in R S Nelson and R Shiff (eds), *Critical Terms for Art History* (London, 1996), pp.17–30

John Rocco, 'Drinking Ulysses: Joyce, Bass Ale, and the Typography of Cubism', *James Joyce Quarterly*, 33, 3 (1996), pp.399–409

Robert Rosenblum, 'Picasso and the Typography of Cubism', in John Golding and Roland Penrose (eds), *Picasso in Retrospect* (New York, 1981), pp.33–47

R Scholes, *Structuralism in Literature* (London, 1974)

Randall Slettene, 'New Ways of Seeing the Old: Cubism and Husserlian Phenomenology', *The European Legacy*, 2, 1 (1997), pp.104–9

John Sturrock, *Structuralism and Since* (Oxford, 1979)

Jeffrey Weiss, *The Popular Culture of Modern Art: Picasso, Duchamp and Avant-Gardism* (New Haven and London, 1994)

Chapter 7

Elizabeth Cowling, 'The Fine Art of Cutting: Picasso's Papiers Collés and Constructions in 1912–1914', *Apollo*, 142, 405 (November 1995), pp.10–18

Pierre Daix, 'Des bouleversements chronologiques dans la révolution des papiers collés (1912–1914)', *Gazette des Beaux-Arts*, 82 (October 1973), pp.217–27

Ron Johnson, 'Picasso's Musical and Mallarméan Constructions', *Arts Magazine* 51, 7 (March 1977), pp.122–27

Lewis Kachur, *Themes in Picasso's Cubism, 1907–1918* (unpublished PhD dissertation, Columbia University, New York, 1988)

—, 'Picasso, Popular Music, and Collage Cubism 1911–1912', *Burlington Magazine*, 135, 1081 (1993), pp.252–60

Daniel-Henry Kahnweiler, *The Rise of Cubism* (trans. Henry Aronson, New York, 1949)

—, *Juan Gris: His Life and Work* (2nd rev. ed., London, 1969)

—, *My Galleries and Painters* (trans. Helen Weaver, New York, 1972)

Pepe Karmel, *Picasso's Laboratory: The Role of His Drawings in the Development of His Cubism, 1910–1914* (unpublished dissertation, Institute of Fine Arts, New York University, 1993)

Brigitte Léal, *Picasso, Papiers Collés* (Paris, 1998)

Patricia Leighten, 'Cubist Anachronisms: Ahistoricity, Cryptoformalism, and Business-as-usual in New York', *Oxford Art Journal*, 17, 2 (1994), pp.91–102

—, *Re-ordering the Universe: Picasso and Anarchism 1897–1914* (Princeton, 1989)

Isabelle Monod-Fontaine, *Georges Braque: les papiers collés*, (exh. cat., Centre Georges Pompidou, Paris, 1982)

Christine Poggi, *In Defiance of Painting: Cubism, Futurism, and the Invention of Collage* (New Haven and London, 1992)

—, 'Mallarmé, Picasso and the Newspaper as Commodity', *Yale Journal of Criticism*, I, 1 (Fall 1987), pp.133–51

Robert Rosenblum, 'Picasso and the Coronation of Alexander III: A Note on the Dating of Some Papiers Collés', *Burlington Magazine*, 113 (October 1971), pp.604–7

Gino Severini, *The Life of a Painter* (Princeton, 1995)

Chapter 8

Eve Blau and Nancy J Troy (eds), *Architecture and Cubism* (Cambridge, MA, 1997)

John E Bowlt and Matthew Druit (eds), *Amazons of the Avant-Garde* (exh. cat., Guggenheim Museum, New York, 1999)

Penelope Curtis, *Sculpture 1900–1945* (Oxford, 1999)

Abraham A Davidson, *Early American Modernist Painting 1910–1935* (New York, 1994)

Camilla Gray, *The Great Experiment: Russian Art 1863–1922* (London, 1962)

Henri Laurens: Retrospective (exh. cat., Musée d'Art Moderne de Lille Métropole, Lille, 1992)

Henri Laurens: Le Cubisme: Constructions et papiers collés 1915–1919 (exh. cat., Centre Georges Pompidou, Paris, 1985)

Sylvain Lecombre, *Ossip Zadkine, l'oeuvre sculpté* (Paris, 1994)

Ivan Margolius, *Cubism in Architecture and the Applied Arts: Bohemia and France, 1910–1914* (North Pomfret, Vermont, 1979)

K J Michaelson, *Archipenko: A Study of the Early Works 1908–1920* (New York, 1977)

John Milner, *Mondrian* (London, 1992)

—, *Vladimir Tatlin and the Russian Avant-Garde* (London, 1983)

Angelica Rudenstine (ed.), *Piet Mondrian 1872–1944* (exh. cat., New York, 1995)

Deborah Stott, *Jacques Lipchitz and Cubism* (New York, 1978)

Alexander von Vegesack (ed.) *et al.*, *Czech Cubism, Architecture, Furniture and the Decorative Arts 1910–1925* (exh. cat., Vitra Design Museum, Weil am Rhein, Princeton, 1992)

Alan Wilkinson, *The Sculpture of Jacques Lipchitz: A Catalogue Raisonné*, 1, *The Paris Years 1910–1940* (London, 1996)

Chapter 9

Leroy C Breunig (ed.), *The Cubist Poets in Paris: An Anthology* (Lincoln, Nebraska, 1995)

Jean Cassou, *Duchamp-Villon: Le Cheval Majeur*, (exh. cat., Galerie Louis Carré, Paris, 1966)

Elizabeth Cowling and Jennifer Mundy (eds), *On Classic Ground: Picasso, Léger, de Chirico and the New Classicism, 1910–1930* (exh. cat., Tate Gallery, London, 1990)

Simon Dell, 'Production, Consumption and Purism: Juan Gris between *Nord-Sud* and *L'Esprit Nouveau*', *Word and Image*, 15, 2 (April–June 1999), pp.155–69

—, *Fernand Léger: une correspondance de guerre à Louis Poughon, 1914–1918* (2nd rev. ed., Paris, 1990)

Christian Derouet, 'Le cubisme "bleu horizon" ou le prix de la guerre: correspondance de J Gris et de Léonce Rosenberg 1915–1917', *Revue de l'art*, 113, 3 (1996), pp.40–64

—, *Juan Gris: Correspondance, Dessins, 1915–1921*, (exh. cat., IVAM Centre Julio Gonzalez, Valencia, 1990)

Linda Downs and Ellen Sharp (eds) *Diego Rivera: A Retrospective* (exh. cat., Hayward Gallery, London, 1987)

Ramon Favela, *Diego Rivera: The Cubist Years* (exh. cat., Phoenix Art Museum, Phoenix, 1984)

Christopher Green, *Cubism and its Enemies: Modern Movements and Reaction in French Art 1916–1928* (New Haven and London, 1987)

Elizabeth Kahn, *The Neglected Majority: 'Les Camoufleurs', Art History and World War I* (New York, 1984)

Billy Klüver, 'A Day with Picasso', *Art in America*, 74 (September 1986), pp.96–107, 161–63

Evelyn Silber (ed.), *Jacob Epstein: Sculpture and Drawings* (Leeds, 1987)

Kenneth Silver, *Esprit de Corps: The Art of the Parisian Avant-Garde and the First World War 1914–1925* (London, 1989)

Denys Sutton, 'The Singularity of Gino Severini', *Apollo* (May 1973), pp.448–61

P Wyndham Lewis (ed.) *Blast*, 1 (London, 1914)

Chapter 10

Alfred H Barr Jnr, *Cubism and Abstract Art* (exh. cat., Museum of Modern Art, New York, 1936)

Briony Fer *et al.*, *Realism, Rationalism, Surrealism: Art Between the Wars* (London, 1993)

Matthew Gale, *Dada and Surrealism* (London, 1997)

Siegfried Giedion, *Space, Time and Architecture* (Princeton, 1941)

Romy Golan, *Modernity and Nostalgia: Art and Politics in France Between the Wars* (London, 1995)

Derek Hill, 'Evie Hone', *The Month*, 3, 3 (March 1950), pp.188–90

Standish D Lawder, *The Cubist Cinema* (New York, 1975)

Christina Lodder, *Russian Constructivism* (London, 1983)

Steven A Nash and Jörn Merket (eds), *Naum Gabo: Sixty Years of Constructivism* (exh. cat., Dallas Museum of Art, 1986)

Richard Martin, *Cubism and Fashion* (exh. cat., Metropolitan Museum of Art, New York, 1998)

Frank Whitford, *Bauhaus* (London, 1984)

James White, *Evie Hone 1894–1955*, (exh. cat. Arts Council of Great Britain, London, 1959)

Willem de Kooning (exh. cat., National Gallery of Art, Washington DC, 1994)

Abbaye de Créteil 141—3, 146,
173, 212, 345; **75**
abstract art 222–4, 261
Académie des Beaux-Arts 15
African art 79–82, 89, 90–2,
264, 277–8; **41**, **163**
Agéro, Auguste 206, 313
Allard, Roger 144, 146, 162,
191, 208, 339, 385
Analytic Cubism 144–5, 208,
262, 272, 415
Apollinaire, Guillaume 14, 36,
46, 54, 78, 83, 90, 108, 125–6,
129, 138, 144, 148, 155, 159,
161, 179, 189–91, 199–201,
205, 206, 209, 212–15,
218–19, 222, 229, 261,
288–90, 297, 309–10, 317,
328, 365, 376, 408; **16**, **124**
Archipenko, Alexander 176,
313–15, 317, 346
Médrano I 314–15, 317, 318,
322; **186**
Médrano II (Dancer) 317,
322; **182**
architecture 211, 212, 331,
332–5, 393–7, 399, 401–5
avant-garde art 17–18, 135–70

Baker, Josephine 322; **192**
Balla, Giacomo, Streetlight
162–5; **87**
Baranoff-Rossiné, Vladimir
318, 406
Symphony No. I 317; **188**
Symphony No. II 317
Barr, Alfred H Jr 391, 392, 396,
415; **236**
Bauhaus 339, 395–7; **237**
Behne, Adolphe 339, 393, 395
Bergson, Henri 170, 191–8, 220
Bernard, Émile 31, 98–9
Der Blaue Reiter ('Blue Rider')
14, 331–2, 339, 354, 392–3
Boccioni, Umberto 196, 199,
255, 272, 313, 315–17, 364
The City Rises **86**
Development of a Bottle in
Space 317
States of Mind I 196, 198; **108**
States of Mind II 196, 198;
109
Bouguereau, Adolphe-William
15
Bourdelle, Émile-Antoine 312,
330
Monumental Dying Cedar 4; **2**
Braque, Georges 4, 11, 25–6,
85, 136–7; **25**, **27–8**, **31–2**; at
Céret 244–8, 251–4; and
Cézanne 92–105, 107;
chiaroscuro 245–6; collage

261, 265, 301–2; exhibitions
84, 107–9, 129, 352; Fauvist
work 28–31; Gris and 205;
illusionism 229–33, 249–50;
as inventor of Cubism
105–11, 116–17; later work
421, 424; lettering 227–9,
239–40; papiers collés
278–82, 285, 302, 322, 327,
396; photographs 52, 62–5,
67–70; and Picasso 44–8,
52–4, 57–61, 73, 82–3, 117;
rejects Cubism 381–5; and
Salon Cubists 136–40, 143,
229; sculpture 262, 276–7,
315; **187**; Surrealism and 412;
use of grid 126, 264, 341; use
of signs 244–5, 246–8; in
World War I 365
Basket-carrier 382–5; **232**
The Candlestick 239; **139**
Castle at La Roche Guyon
118; **63**
Checkerboard: 'Tivoli
Cinéma' 47; **22**
Fruit Dish and Glass 278–82,
327; **165**
Fruit Dish, Bottle and Glass:
'Sorgues' 277; **162**
Homage to J S Bach 265; **154**
Harbour 129, **132**
Harmonica and Flageolet
245; **143**
House at L'Estaque 104; **56–7**
Houses at L'Estaque 11, 104,
105, 108; **3**
Jetty at L'Estaque 46; **21**
Large Nude 90, 138, 257,
345; **46**
Lighter and Newspaper:
'Gil Blas' 227, 229; **129**
Man with a Guitar 44,
251–4; **149**
Mandora 126; **70**
Pedestal Table 248; **146**
The Port of Antwerp 28–31; **12**
Le Portugais 43–4, 62, 64,
70, 239–40, 412, 421; **19**
Still Life: The Newspaper 382;
231
Still Life with Glass (Figure
with a Guitar) 244; **142**
Still Life with Guitar 282; **166**
Still Life with Violin 245–6;
145
Studio II 421; **255**
Table with a Pipe 62
Terrace of the Hôtel Mistral
92–8; **51**
Viaduct at L'Estaque (1907)
98; **53**
Viaduct at L'Estaque (1908)

100–4; **55**
Violin and Palette 229–32; **130**
Violin and Pitcher 229–32; **131**
Woman 85–9, 108, 109; **44**
Woman Reading 245, 255; **144**
Woman with a Guitar 302
Breton, André 408, 411, 412
Die Brücke 14, 331
Burgess, Gelett 85, 86, 89, 109

Carrà, Carlo 196
Casagemas, Carles 18, 31–5
Cézanne, Paul 4, 11, 28, 31, 35,
92–105, 107, 109, 111, 116,
118, 138, 237
Bathers 379
The Cistern in the Park of the
Château Noir 92; **52**
Five Bathers 92
Large Bathers 54
Mont Saint-Victoire from Les
Lauves 31, 99; **14**
The Smoker 372
Still Life with Apples and
Peaches 100; **54**
Chardin, Jean-Baptiste-
Siméon 147
Chochol, Josef 331, 335; **203**
chronophotography 180, 199
classicism 146–7, 371–2, 377–8
Cocteau, Jean 372–6, 377
Dante on Our Side 371; **226**
Cody, 'Buffalo Bill' 47
collage 215, 261, 262–5, 273,
290–1, 295, 301–2, 407–8
Constructivism 61, 345, 392,
399–401, 405
Cooper, Douglas 122
Courbet, Gustave 4, 16, 372
Csáky, Joseph 176, 313, 314
Standing Woman **185**
Cubo-Futurism 350
Czechoslovakia 328–39

Dada 407, 408
Davis, Stuart 415
New York under Gaslight 415;
249
de Kooning, Willem 415–18
Excavation 415–18; **250**
Delaunay, Robert 129–32, 136,
143, 147, 151, 155, 162, 165–70,
176, 218–19, 220–3, 261, 314,
406
The City No. 2 165, 302; **73**, **89**
The City of Paris 199–201; **111**
Disc (The First Disc) 222–3;
76, **127**
Eiffel Tower (1910-11) 156–9;
84
Eiffel Tower (1911) 166–70; **90**
Saint-Séverin No. 1 129–32,

332; **72**
Simultaneous Windows on the City 222; **126**
Tower with Curtains 170; **93**
Delaunay, Sonia 143, 218–19, 222, 405–6; **245**
Derain, André 26, 27, 52–3, 58, 79, 81, 83, 84, 85, 92, 107, 137–40, 312; **28, 49**
Bathers 92, 138, 330; **50**
Girl with a Shawl 372
Landscape at Cadaqués 138; **74**
The Old Bridge at Cagnes 138
La Toilette 86
Divisionism 162
Donatello 13
Dorgèles, Roland, *What the Cubes Mean ...* 176, 180; **99**
Duchamp, Marcel 5, 175, 176, 184–7, 188, 195, 196, 206, 209, 219, 261, 321, 362; **96**
Bottlerack 305–6; **181**
The Bride Stripped Bare by Her Bachelors, Even 187
Coffee Mill 184; **105**
King and Queen Surrounded by Swift Nudes 218
Nude Descending a Staircase No. 1 184, 187; **106**
Nude Descending a Staircase No. 2 199, 206, 218, 350; **110**
Portrait (Dulcinea) 180; **103**
Duchamp-Villon, Raymond 173, 174–6, 180, 219, 261, 335, 358, 361–3, 365; **96**
Baudelaire 176; **97**
Cubist House 211, 212, 332, 362, 403; **117–20**
Great Horse 358, 361–2; **220**
Dufy, Raoul 26, 137
Duhamel, Georges 141; **75**

Eiffel Tower, Paris 151, 155, 156–9, 222, 362, 402; **83–5**
L'Élan 377
Engels, Friedrich 135
Epstein, Jacob, *Rock Drill* 358–9, 361, 362, 368; **219**
Ernst, Max 408, 411
L'Esprit Nouveau 377, 381, 385
Expressionism 14, 331–2, 339, 354, 392–3

Fauvism 13–14, 26–7, 28, 79, 85, 98, 105, 107, 162
Feininger, Lyonel 339
Bauhaus Manifesto 395; **237**
films 24, 401, 406–7
Fortier, Edmond 82; **42**
Fouquet, Jean 377
Portrait of Charles VII 170; **94**
Fourreau, Armand 176
'Fourth Dimension' 188–91, 214
Fragson, Harry 255, 267; 151
Freud, Sigmund 23, 81, 155
Friesz, Othon 26, 28, 85
The Port of Antwerp 28; **13**
Fry, Roger 257–8
Futurism 14, 135, 136, 162–5, 170, 195–9, 201, 208, 254,

261, 272, 309, 313, 318, 347, 350, 357–8, 359–61, 392

Galerie de L'Effort Moderne, Paris 381, 388, 397
Gallery Cubism 136–7, 140, 205
Gaudier-Brzeska, Henri 364–5
Gauguin, Paul 4, 35–6, 48, 79, 312
Germany 331–2, 336–9, 354, 357, 371, 392–7
Gérôme, Jean-Léon 15
Young Greeks Holding a Cockfight **5**
Giedion, Siegfried 395–6, 397; **238**
Gleizes, Albert 136, 141, 143, 144, 148–51, 156, 160, 173, 175, 194–5, 199, 201, 206, 212, 261, 290, 345, 388, 420; 75
Harvest Threshing 215; **122**
Portrait of Jacques Nayral 180; **99**
Woman with Phlox 151, 155; **81**
Gočár, Josef 331, 335
The Black Mother of God, Prague 335; **201–2**
Clock 336; **205**
Sofa 336; **204**
Golding, John 12
Goncharova, Natalia 347
González, Julio 286, 415
Gouel, Eva 57, 255, 267, 273, 372
El Greco, *View of Toledo* 140
Greenberg, Clement 284–6, 378, 415
Gris, Juan 5, 205, 206, 233, 261, 328, 347, 365, 378–81, 385
Cover for *L'Assiette au Beurre* 166; **91**
Homage to Pablo Picasso 205, 215, 222; **113**
Man at the Café (1912) 215; **123**
Man at the Café (1914) 298; **177**
Still Life with Flowers 205
The Tea Cups 298; **176**
The Washstand 215, 290
The Watch 290; **173**
Woman with a Mandolin (after Corot) 379; **229**
Gropius, Walter 393, 395, 396, 397
Group of Plastic Artists 330, 331
Guevrekian, Gabriel 403–5; **244**
Gutfreund, Otto 330–1
Cubist Bust (Man's Head) 330; **198**
Gysbrechts, Cornelis Nobertus, *Trompe l'Oeil with Letters and Notebooks* 232; **132**

Hartley, Marsden 352, 354
Portrait of a German Officer 354; **217**
Hofman, Vlatislav 331, 335
Hone, Evie 420; **253**
Hourcade, Olivier 116, 173
Hulme, T E 359, 361, 362, 412

Impressionism 18, 107, 143, 173, 223, 258, 282
Ingres, Jean-Auguste-Dominique 73, 271, 371, 372
The Turkish Bath 73; **38**

Jacob, Max 129, 371, 377
Jakobson, Roman 400
Janák, Pavel 331, 332, 335–6
Design for a Monumental Interior 332; **199**
Dr Fárá's House, Pelhrimov 332–5; **200**
Johns, Jasper 418
Flag 418; **251**
Le Journal 264, 284, 294–5; **174**
Joyce, James 24, 192, 295

Kahnweiler, Daniel-Henry 11, 43, 58, 79, 83, 84, 89, 104, 107–8, 129, 136, 137, 138, 205, 227, 229, 233, 237–8, 240–2, 248, 257, 258, 278, 365, 378; **48, 57, 138**
Kandinsky, Wassily 14, 146, 170, 222, 354, 396
Kant, Immanuel 108
Kirchner, Ernst Ludwig 14
Klee, Paul 396
Homage to Picasso 339
Remembrance of a Garden 339; **207**
Kubelik, Jan 271
Kubišta, Bohumil 328–30
St Sebastian 328; **197**
Kupka, František 189, 209, 219, 261, 328
Amorpha: Fugue in Two Colours 209, 220; **125**
Disks of Newton 189; **107**

La Fresnaye, Roger de 151, 175; **121**
language 227–9, 242–51
Laurencin, Marie 54, 155, 206, 209, 212
Laurens, Henri 318, 321–8, 365, 378, 381, 385
Bottle and Glass 328; **196**
Bottle of Rum 322–7; **195**
Clown 322; **191**
The Head of a Woman 322; **193–4**
Josephine Baker, Dancer 322; **192**
Le Corbusier 377, 381, 402–3, 405, 406
Villa La Roche-Jeanneret 403; **243**
Le Fauconnier, Henri 136 143, 144, 146, 147, 148, 151–4, 156, 206, 218, 346; **77**
Abundance 151, 154–5, 156; **80**
Mountaineers Attacked by Bears 209
Léger, Fernand 5, 129, 132, 136, 143, 195, 206, 219, 345, 363–4; **78, 222**
The Alarm Clock 364
Ballet Mécanique 406, 407
Contrast of Forms 223–4, 322, 364; **95**

Le Grand Déjeuner 406
Nudes in a Forest 151, 155–6; **82**
Railway Crossing 212; **121**
Study for Three Portraits 180; **102**
The Wedding 201; **112**
Woman Sewing 129; **71**
Lenin, Vladimir Ilyich 21–2
Leonardo da Vinci 222
Mona Lisa 179
Lewis, Percy Wyndham 359–61, 362
Lhote, André 143, 151, 176, 385, 386–8, 420
Rugby 386; **235**
Lipchitz, Jacques 318–21, 345, 365, 378, 385
Detachable Figure: Dancer 318; **189**
Seated Figure 321; **190**

Maar, Dora 422; **255**
Macdonald-Wright, Stanton 350–2
Maggi-Kub 268–72, 340; **158**
Malevich, Kasimir 162, 347–50, 396, 399, 400
Black Square 350; **216**
Composition with the Mona Lisa 350; **215**
The Knife Grinder **214**
Mallarmé, Stéphane 27, 295–7
Manet, Édouard 16
Olympia 17, 73–4; **7**
Marc, Franz 14, 354
Foxes 339; **206**
Marcoussis, Louis 218, 271–2
Portrait of Guillaume Apollinaire 218; **124**
Style 'Cubique' 272; **159**
Mare, André 212, 388; **121**
Marey, Étienne-Jules, Study of a Man Walking 180; **104**
Marinetti, Filippo Tommaso 135, 162, 196, 199, 350, 357–8, 408
Marx, Karl 135, 142
Masson, André 412
The Four Elements **248**
Matisse, Henri 11, 13, 18, 26–7, 36, 47, 48, 50, 79, 312, 345
The Blue Nude 36–40; **18**
Le Bonheur de vivre 28; **11**
Dance II 233
Luxe, calme et volupté 27; **10**
Music 233
The Open Window: Collioure 27
Woman with a Hat 36
Matulka, Jan 415
Mercereau, Alexandre 141, 143, 195, 257, 345; **75**
Métivet, Luc, The Cubist School Again 176; **98**
...ism Explained 250, 255; **147**
Metzinger, Jean 136, 143–4, 147–8, 151, 159, 161, 176, 194–5, 199, 205, 209, 261, 290, 346, 396; **79**
Le Goûter 176–80, 205; **101**
Two Nudes 151

Woman with a Fan **121**
Miró, Joan 411–12
The Hunter (Catalan Landscape) 411–12; **247**
Modersohn-Becker, Paula 18
Moholy, Lucia 395
Moholy-Nagy, László 395–6
Molder, Jan de, Altarpiece of the Mass of St Gregory 115, 117, 118; **62**
Mondrian, Piet 340–1, 396, 397–9, 403; **240**
Composition 10 in Black and White, Pier and Ocean 341; **210**
Flowering Apple Tree 340; **208**
Lozenge Composition with Yellow, Black, Blue, Red and Grey 397; **239**
Painting No. 1 341; **209**
Monet, Claude 17
Morice, Charles 108–9, 117, 129
Muybridge, Eadweard 180

Nash, John 82, 195
nationalism 105, 107, 147–8, 267–8, 272, 358, 365–8
Nayral, Jacques 180, 206; **99**
Neoclassicism 105, 107
Neo-Impressionism 27, 162, 302
Netherlands 397–9
Neue Künstler-Vereinigung (NKV) 146
Nicholson, Ben 419
1935 (White Relief) **254**
Nietzsche, Friedrich 22–3, 195, 208–9
Nord-Sud 376, 377, 381, 382, 386, 411

Obmokhu 400, 401; **242**
Oceanic art 79, 90–2
Olivier, Fernande 53, 54, 57, 61, 118–22, 255, 273; **24, 28, 66**
orientalism 36–40, 73
Orphism 214–15, 218–19, 347, 407
Ozenfant, Amédée 377, 381, 406

papiers collés 261, 278–301, 302, 322, 327, 345, 396, 424
Parade 372–7; **228**
Pasmore, Victor 420
philosophy 173–4, 188–98
photography 50–2, 54, 57–8, 61–70, 180
photomontage 401, 407
Picabia, Francis 208–9, 218–19, 261; **114**
Dances at the Spring II 209, 215; **115**
The Source 209
Picasso, Pablo 4, 136–7, 345; **9, 24, 43**; background 31–40; 'Blue Period' 35–6; and Braque 44–8, 52–4, 57–61, 73, 82–3, 117; at Céret 244–8, 251–4; classicism 371–2, 378; collage 261, 262–5, 273, 301–2; on Cubism 64; exhibitions 84, 257, 352; flag

paintings 267–8, 273, 418; Gris and 205, 233; later work 421, 422–4; lettering 227–9, 239, 240; papiers collés 283–301, 302; **170**; and Parade 372–5, 377; **228**; photographs 50, 52, 54, 57–8, 61–2, 65–70; **16, 23, 27–30, 33–6, 47–8, 170, 234**; portraits 233–7, 422–4; primitivism 80–2, 83, 90–2, 105, 137, 277–8; puns 273–5; relationships 57, 255; Ripolin paintings 267, 272–3, 275; and Salon Cubists 136–40, 143, 229, 272; sculpture 118–25, 262, 275, 276–7, 285–6, 305, 312–14, 315; studios 61; Surrealism and 412; 'transparency' 126; use of grid 126, 264, 341; use of signs 244–5, 246; in World War I 365, 388
The Accordionist 251–4; **148**
Acrobat's Family with a Monkey 36
The Aficionado 275; **160**
L'Arlésienne 395, 396
Bottle and Glass 244; **141**
Bottle of Bass, Glass and Newspaper 4, 322; **1**
Bread and Fruit Dish on a Table 111, 115, 117, 118; **59**
Carnival at the Bistro 111–15; **60**
Construction with Guitar Player 66; **34–5**
Cottage and Trees 105; **58**
Les Demoiselles d'Avignon 17, 40, 46, 73–85, 89–90, 111, 115, 129, 137, 138, 264, 407; **37, 39–40**
Dora Maar Seated 423–4; **256**
Friendship 90
The Glass of Absinthe 305, 317, 420; **152**
Glass and Bottle of Suze 284; **frontispiece**
Guitar (1912) 288–90; **171–2**
Guitar (1912–13) 278, 282–6, 287–8, 318; **164**
Guitar and Sheet Music 283; **168**
Guitar on a Table 302; **180**
Guitar, Sheet Music and Glass 283–5; **167**
Harlequin 372
Head 302; **179**
Head of Fernande 118–22, 146, 176, 312–13, 352; **66**
Houses on the Hill, Horta de Ebro 118; **64**
Landscape with Posters 268; **157**
Last Moments 18, 31, 35
The Letter 262–3
Ma Jolie (Woman with a Zither or Guitar) 255; **128, 150**
Man Leaning on a Table 386; **234**
Man with a Mandolin 233; **133–4**

Mandolin Player 44; 20
The Negro Boxer 53
Nude with Drapery 90
Nude with Raised Arms 54, 90
Nude Woman 126, 233; **68**
The Painter and His Model
372; **227**
The Poet 275
Portrait of Ambroise Vollard
237; **136**
Portrait of Daniel-Henry
Kahnweiler 237–8, 258; **138**
Portrait of Gertrude Stein 36,
257–8; **17**
Portrait of a Girl 302; **178**
Portrait of Max Jacob 371,
377; **225**
Portrait of Wilhelm Uhde
233–7; **135**
The Scallop Shell: 'Notre
Avenir est dans l'Air' 267–8; **155**
Seated Figure with a Guitar
275; **161**
Self-portrait in the studio **29**
Souvenir du Havre 267; **156**
Spanish Still Life 267
Still Life with Chair Caning
263–5, 275, 281, 301; **153**
Still Life with Fan 239; **139**
Table with Bottle, Wineglass
and Newspaper 297; **175**
Three Figures under a Tree 90
Three Women 90, 138; **45**
The Tub 36
La Vie 35; **15**
Violin (1912) 286; **169**
Violin (1913–14) 302
Violin, Wineglasses, Pipe and
Anchor 53–4, 267; **26**
Woman in an Armchair 125,
372; **67**
Woman with a Book 65–6; **33**
Woman with Pears
(Fernande) 118; **65**
Plato 109
Pliny 249–50
poetry 350, 408–11, 412–15
Poincaré, Henri 23, 187
Pollock, Jackson 415, 418
Pop Art 419
Popova, Liubov 346–7
Portrait of a Lady 347; **213**
Post-Impressionism 18, 143,
223, 257–8, 282
Pound, Ezra 412–15
Poussin, Nicolas 107, 138
Prague Art Workshops (PUD)
335–9
primitivism 22, 80–2, 83,
90–2, 105, 116–17, 137, 372
Princet, Maurice 143, 187, 201
Procházka, Antonín 330
Proust, Marcel 24, 192
Purism 377, 381, 402, 405

Rabanikoff, Maroussia 146, 155
Raphael 12–13
La Donna Gravida 257–8; **4**
Rauschenberg, Robert 418–19
Monogram **252**
Raynal, Maurice 26, 116–17,
206–8, 215, 313, 381

Rayonism 347
readymades 305–6, 321
Reff, Theodore 105, 107
Renaissance 12–13, 17, 107,
109–11, 115, 116, 125, 126–9,
147, 201, 228, 238, 243, 362
Reverdy, Pierre 376, 377, 381,
382, 386, 411
Richardson, John 54, 115, 391
Rietveld, Gerrit 399
'Red-Blue' chair **241**
Rivera, Diego 385–6
Zapatista Landscape: The
Guerilla 386; **233**
Rodchenko, Aleksandr 399, 402
Rodin, Auguste 310–12, 328
The Age of Bronze 310; **183**
Rood, Ogden 222–3
Rosenberg, Léonce 378–9,
381–2, 385, 386–8, 397, 411
Rosenblum, Robert 228, 244,
251, 254, 419
Rousseau, Henri 48–50, 80,
151, 352; **23**
Myself: Landscape-Portrait 201
Russia 345–50, 399–401

Sagot, Clovis 36, 205
Salmon, André 54, 78, 79,
80–1, 90, 138, 176, 205, 275,
278, 385; **47**
Salon 15–16, 73; **6**
Salon d'Automne 11, 13, 16, 26,
28, 31, 36, 47, 73, 79, 92, 144,
147, 148, 174–5, 176, 196,
209–11, 229, 290, 382; **116**
Salon Cubism 135–70, 173,
174–5, 176, 180, 189–91,
194, 201, 208, 215, 224, 229,
272, 365
Salon des Indépendants 11,
16, 27, 28, 46, 47, 82–3, 86,
129, 143, 148–55, 160–2,
176, 199–205, 229, 340, 388
Salon de la Section d'Or
215–18, 261, 290, 388, 392
Satie, Erik 24, 375
Saussure, Ferdinand de 242–3
Schelcher, André, Eiffel Tower
Seen from an Airship 159; **85**
Schwitters, Kurt 408
Merzbild 32A. The Cherry
Picture **246**
sculpture 117, 261–2, 275,
276–7, 285–6, 305, 310–28,
330–1, 415
Segonzac, André Dunoyer de
151, 346
Seurat, Georges 4, 16, 27, 222
Severini, Gino 196, 199, 254,
255, 272, 309, 368, 381, 386
Cannon in Action 368; **223**
Gypsy Playing the Accordion
381; **230**
Motherhood 368; **224**
Shchukin, Sergei 233, 345, 400
Spate, Virginia 219
Steiglitz, Alfred 254, 352, 354
Stein, Gertrude 36, 257, 388; **17**
Steinlen, Théophile-Alexandre
35, 142
De Stijl 392, 397, 399

Stravinsky, Igor 24, 358
structural linguistics 242–3
Der Sturm 222, 331–2
Suprematism 350
Surrealism 81, 275, 291, 376,
408, 411–12, 418
Survage, Léopold 406, 407
Symbolism 27, 142, 189, 309
Synthetic Cubism 144–6, 208,
262, 339, 354

Tatlin, Vladimir 61, 340, 345,
347, 350, 399, 400
Complex Corner Relief 345; **211**
Monument to the Third
International 402
Tinayre, Louis, Ice Flood 166; **92**
Toulouse-Lautrec, Henri de 4,
31, 35
tribal art 79–82, 89, 90–2,
277–8; **41**
trompe l'oeil 232, 244, 249,
268–71, 291

Udaltsova, Nadezhda 346–7
Restaurant 347; **212**
Uhde, Wilhelm 36, 83, 143,
233–7, 273, 365; **135**
United States 350–4, 415–20
Universal Exposition, Paris
(1900) 18, 20–2, 31; **8**

Van Doesburg, Theo 341, 395,
397, 399
Van Gogh, Vincent 4, 27
Vauxcelles, Louis 11, 13, 47,
48, 84, 108, 109, 143, 211,
227, 271, 385, 386, 388
Vers et prose 173–4
Vildrac, Charles 141, **75**
Villon, Jacques 173, 175, 176,
205; **96, 121**
Vlaminck, Maurice de 26,
52–3, 79
Vollard, Ambroise 16, 35, 84,
233, 237, 371; **136–7**
Vorticism 359, 388

Wadsworth, Edward, Dazzle-
ships in Drydock at Liverpool
388; **218**
Warnod, André, Venice Before
and After Futurism 165; **88**
Weber, Max 352–4
Weiss, Jeffrey 176, 376
Wield, Ernest Friedrich 313
World War I 272, 357–8,
362–71, 388, 424; **221**
Worringer, Wilhelm 331, 361
Wright brothers 47, 61, 268

Zadkine, Ossip 313, 314
Bust of a Woman **184**
Zayas, Marius de 257, 352
Zeuxis 249–50, 278
Zola, Émile 21, 31, 301

Acknowledgements

The writing of this book was made possible thanks to the generous support of the University of Essex Research Endowment Fund and a Research Leave Scheme Award from the Arts and Humanities Research Board.

The staff at the Documentation of the Musée d'Art Moderne, Centre Georges Pompidou, Paris, especially Emmanuelle Etchecopar Etcharo, Christine Sorin and Brigitte Vincens, offered excellent help with archival research. My approach has its origins in my PhD thesis on Picasso's early Cubism. I owe much of my interest in Cubism to former teachers and now colleagues at the University of Essex: Dawn Ades, who supervised the thesis and encouraged my theoretical interests, and John Nash, who taught me how much I could learn by looking closely at Cubist paintings. Valerie Fraser, Michaela Giebelhausen, Sarah Goubert, Margaret Iversen, Jules Lubbock, Whedbee Mullen, Thomas Puttfarken and Peter Vergo graciously covered for my absences from teaching and administration. Tim Laughton photographed the Kub tin, generously loaned for the purpose by Jules Lubbock and Margaret Iversen. Mickey Reid helped with endless faxes and parcels, and Libby Armstrong made all possible, as ever.

In bringing the project to its final form I have been enormously reliant on staff at Phaidon for their hard work, intelligent criticisms and excellent moral support. In particular David Anfam, Pat Barylski and Ros Gray have made major contributions to the shaping of the text, and Giulia Hetherington and Zoe Stollery have done sterling work on the visual material. I would also wish to thank Phaidon's anonymous outside reader for supportive and informed comment, and Michael Bird for his acute copy-editing.

It need hardly be said that this kind of book is enormously indebted to the efforts of previous scholarship in the field. In addition, many friends and experts on aspects of Cubism have assisted me in my struggle to get facts right and words and ideas in the right order. Important specific corrections to some sections were made by John Finlay, Margaret Iversen and Simon Richards. Simon Dell, Elizabeth Cowling, Christopher Green, Adrian Hicken, Dana MacFarlane, John Nash, Peter Read and Colin Rhodes all devoted considerable time and effort, and remarkable skill, to criticism of the entire argument. This book would have been much the poorer without them.

N C

For Maud, with thanks for her unstinting love and support over so many years.

Photographic Credits

Acquavella Galleries Inc, New York: 177; AKG London: photo Erich Lessing 176; Annely Juda Fine Art, London: 211; Art Institute of Chicago: gift of Leigh B Block 113, gift of Mrs Gilbert W Chapman in memory of Charles B Goodspeed 138, gift of Edgar Kaufman Jr (1957) 239, Mr & Mrs Frank G Logan Purchase Prize, gift of Mr & Mrs Noah Goldowsky and Edgar Kaufmann Jr (1952) 250; Art Museum, Princeton University, New Jersey: the Henry and Rose Pearlman Foundation, Inc, photo Clem Fiori 52; Artephot, Paris: photo Nimatallah 26, 46, 74; Artothek, Peissenberg: Christie's/Artothek 13, 125; Baltimore Museum of Art: the Cone Collection, formed by Dr Claribel Cone and Miss Etta Cone of Baltimore, Maryland 18; © 2000 Banco de México Diego Rivera & Frida Kahlo Museums Trust, Av Cinco de Mayo No 2, Col. Centro, Del. Cuauhtémoc 06059, Mexico, D F/Instituto Nacional de Bellas Artes y Literatura, Mexico City: 233; Bancroft Library, University of California, Berkeley: 137; Barnes Foundation, Merion, PA: 11; courtesy of Beeldrecht, Amstelveen: 81, 240; Bibliothèque Nationale de France, Paris: 228; Bildarchiv Preussischer Kulturbesitz, Berlin: 152; Bridgeman Art Library, London: 4, 45, 110, 132, 139, 208, 215; British Architectural Library, RIBA, London: 43-4, 49; British Library, London: 242, 253; Christie's Images, London: 127; Cleveland Museum of Art, Ohio: gift of the Hanna Fund (1945.24) 15, gift of Aye Simon (1972.367) 189; Fondation Beyeler, Basel: 144, photo Robert Bayer 20; Galerie Berggruen et Cie, Paris: 124; Galerie Maeght, Paris: photo Claude Gaspari 142; Photographie Giraudon, Paris: 3, 131, 135, Alinari-Giraudon 230, Lauros-Giraudon 21, 232; Solomon R Guggenheim Museum, New York: 90, 130, 148, photo David Heald 182, gift, Solomon R Guggenheim (1937) photo David Heald 149; Hamburger Kunsthalle: photo Elke Walford 126; courtesy Harry N Abrams, Inc, New York: 212; Index, Florence: photo L Carrà 108; Israel Museum, Jerusalem: 249; Kharbine-Tapabor, Paris: 85, 91-2, 99, 100, Collection Grob 8; Kimbell Art Museum, Fort Worth: photo Michael Bodycomb 209; Kröller-Müller Museum, Otterlo: 82, 210; Kunstsammlung Nordrhein-Westfalen, Dusseldorf: photo Walter Klein 93, 207, 254; Kunstmuseum Dusseldorf: 206; McNay Art Museum, San Antonio, Texas: bequest of Marion Koogler McNay 167; Metropolitan Museum of Art, New York: Alfred Stieglitz Collection (1949) 217; Milwaukee Art Museum: 102; Minneapolis Institute of Arts: the John R Van Derlip Fund, the Fiduciary Fund and Gift of Funds from Mr & Mrs Patrick Butler and Various Donors 53; Moderna Museet, Stockholm: 191, 252; Musée Bourdelle, Paris: photo Eric Emo 2; Musée d'Art Moderne de Lille Métropole, Villeneuve d'Ascq: donation Geneviève & Jean Masurel (1979), photo Philip

Bernard 56, 141, photo Jacques Hoepffner 196; Musée de Grenoble: 195; Musée des Beaux-Arts, Rouen: 97; Musée National d'Art Moderne, Centre Georges Pompidou, Paris: 41, 117, 119, 120, 146, 162, 169, 175, 185, 248, photo Jacques Faujour 55, 107, photo Philippe Migeat 112, 145, 192, photo Jean-Claude Planchet 89, 111, 178, photo Adam Rzepka 67, 220, photo J F Tomasian 71, 235; Museum Folkwang, Essen: 84; Museum of Fine Arts, Houston: gift of Esther Florence Whinery Goodrich Foundation 80; Museum of Modern Art, New York, photos © 2000: purchase 247, gift of the artist 164, acquired through the Lillie P Bliss Bequest 37, 149-50, Katia Granoff Fund 188, Mrs Simon Guggenheim Fund 86, Hillman Periodicals Fund 87, gift of Philip Johnson in honour of Alfred H Barr Jr 251, Mr and Mrs A Atwater Kent Jr Fund 246, Eugene and Agnes E Meyer Collection 115, Nelson A Rockefeller bequest 64, 109, Florene M Schoenborn bequest 65; Národní Galerie, Prague: 50, 198, photo M Souková 197; Národní Technické Museum, Prague: 199-203; National Galleries of Scotland, Edinburgh: Scottish National Gallery of Modern Art 179, 190; National Gallery of Art, Washington DC: Ailsa Mellon Bruce Fund, photo Lyle Peterzell 68; National Gallery of Canada, Ottawa: purchased (1951) 12, transfer from the Canadian War Memorials (1921) 218; Öffentliche Kunstsammlung Basel: photo Martin Bühler 14, 19, 39, 59, 160, 229; Oskar Reinhart Collection, Am Romerholz, Winterthur: 54; Peggy Guggenheim Collection, Venice: photo David Heald 106; Philadelphia Museum of Art: A E Gallatin Collection 40, 143; Louise and Walter Arensberg Collection 101, 123; Photothèque des Musées de la Ville de Paris: 184, photo Pierrain 231; Pulitzer Collection, St Louis: 180; Pushkin Museum of Fine Art, Moscow: 58; Rheinisches Bildarchiv, Cologne: 213, 223; RMN, Paris: 16, 23, 27, 60–1, 66, 95, 170, 234, photo Bellot 225, photo Berizzi 255, photo Blot 62, photo Blot/Jean 5, 38, photo Coursaget 9, 24, photo Hatala 1, 163, 171–2, photo Ojeda 47, 133–4, 153, 227, photo Schormans 10; Roger-Viollet, Paris: 6, 83, 104, 151, 221; Collection Rosengart, Lucerne: 22; Scala SpA, Bagno-a-Ripoli, Florence: 7, 136, 224; courtesy Arturo Schwarz, Milan: 181; Science Photo Library, London: 69; Stedelijk Museum, Amsterdam: 241; Tate Gallery, London: 70, 105; Tel Aviv Museum of Art: gift of the Goeritz Family 193, 194; Marc Treib, California: 244; Umüleckoprůmysové Museum, Prague: 205, photo Miloslav Sebek 204; Van Abbe Museum, Eindhoven: 63; Washington University Gallery of Art, St Louis: university purchase, Kende Sale Fund (1946) frontispiece; Yale University Art Gallery, New Haven: gift of Collection Societe Anonyme 214

447 Acknowledgements

Phaidon Press Limited
Regent's Wharf
All Saints Street
London N1 9PA

First published 2000
© 2000 Phaidon Press Limited

ISBN 0 7148 4010 6

A CIP catalogue record for this book is
available from the British Library.

Typeset in Scala Sans

Printed in Singapore

Cover illustration Pablo Picasso, *Guitar*, 1912
(see p.289)